TEN
PRECISIONIST
ARTISTS

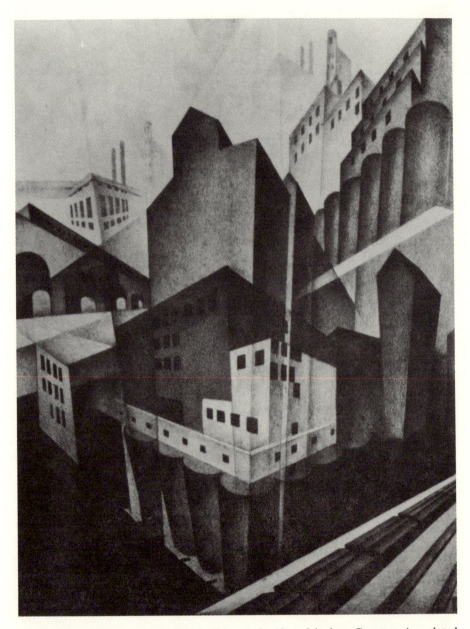

Louis Lozowick. *Minneapolis*, 1925. Lithograph, 12 × 9 inches. Courtesy Associated American Artists, New York.

TEN
PRECISIONIST
ARTISTS

Annotated Bibliographies

Compiled by
R. SCOTT HARNSBERGER

DAVID L. HENDERSON,
Technical Editor

Art Reference Collection, Number 14

GREENWOOD PRESS
Westport, Connecticut • London

Library of Congress Cataloging-in-Publication Data

Harnsberger, R. Scott.
 Ten precisionist artists : annotated bibliographies / compiled by
 R. Scott Harnsberger ; David L. Henderson, technical editor.
 p. cm.—(Art reference collection, ISSN 0193-6867 ; no. 14)
 Includes indexes.
 ISBN 0-313-27664-1 (alk. paper)
 1. Precisionism—Bibliography. 2. Artists—United States—
 Bibliography. 3. Art, Modern—20th century—United States—
 Bibliography. I. Henderson, David L. II. Title. III. Series.
 Z5961.U5H38 1992
 [N6512.5.P67]
 016.75913'09'041—dc20 92-14511

British Library Cataloguing in Publication Data is available.

Library of Congress Catalog Card Number: 92-14511
ISBN: 0-313-27664-1
ISSN: 0193-6867

First published in 1992

Greenwood Press, 88 Post Road West, Westport, CT 06881
An imprint of Greenwood Publishing Group, Inc.

Printed in the United States of America

The paper used in this book complies with the
Permanent Paper Standard issued by the National
Information Standards Organization (Z39.48-1984).

10 9 8 7 6 5 4 3 2 1

For my son

Michael Richard Woodruff
RSH

Contents

Acknowledgments

My chief acknowledgment goes to technical editor David L. Henderson, Professor of Education, Sam Houston State University, who was solely responsible for preparing the camera-ready copy of this book for the publisher. I would like to thank my colleague William G. Bailey for helpful advice on various matters throughout the writing of this book. Thanks go also to two support staff members of the Newton Gresham Library, Sam Houston State University: Mary Durden, who typed the manuscript, and Shirley Parotti, who assisted me through the interlibrary loan office.

A number of individuals, institutions, libraries, museums, and galleries were particularly helpful in providing me with information, and I would like to acknowledge their assistance: Darryl L. Patrick, Associate Professor of Art, Sam Houston State University; Virginia Hagelstein Marquardt, Assistant Professor of Art, Marist College; Patricia C. Willis, Curator of American Literature, Beinecke Rare Book and Manuscript Library, Yale University; James S. Rush, Jr., Assistant Chief, Civil Reference Branch, National Archives and Records Administration; Archives of American Art; Associated American Artists; Cincinnati Art Museum; Dallas Museum of Art; George Arents Research Library for Special Collections, Syracuse University; Hirschl & Adler Galleries; James Maroney, Inc.; Joan and Donald E. Axinn Library, Hofstra University; Museum of Modern Art; Newark Museum; Princeton University Libraries; Richard York Gallery; Rutgers University Library; Salander O'Reilly Galleries; Terry Dintenfass, Inc.; Washburn Gallery; and the Whitney Museum of American Art.

Introduction

This annotated bibliography is intended to serve as a research guide to ten American artists who were the most important and influential Precisionists. For some, like Charles Sheeler, Precisionism was a dominant feature of their works; for others, like Peter Blume, Precisionism played a smaller, but nonetheless significant role. The reader should bear in mind that while Precisionism is the principal focus of this bibliography, all phases of each artist's career will be covered, including photography.

The opening chapter contains citations to monographs, exhibition catalogues, articles, essays, exhibition reviews, book reviews, dissertations and theses, and reference works which deal with Precisionism generally or which analyze, critique, discuss, or list the works of two or more of these artists. Depending on the availability of sources, the subsequent chapters on the individul artists are subdivided along the following lines:

I. Writings, Statements, and Interviews of the Artist. Separately published writings, statements, and interviews of each artist are cited in this section. For some artists, these entries are listed alphabetically; for others, chronologically, depending on what provides the most logical arrangement. It is important that the reader consult the cross-references because material relevant to this section frequently appears in later sections (for example, statements of the artists published in exhibition catalogues).

II. Monographs and Exhibition Catalogues. This section contains citations to monographs, exhibition catalogues of major one-man shows, and selected catalogues of group and thematic exhibitions from the 1930s to the 1980s in which the artists' works are represented. I have used the generic term 'catalogue' to designate any publication issued in conjunction with an exhibition from a pamphlet to a monograph. The annotations will serve to clarify the nature and scope of each entry.

III. Articles and Essays. Periodical articles, essays from anthologies, and self-contained parts of monographs are cited in this section.

IV. Exhibition Reviews. The exhibition reviews are drawn chiefly, but not exclusively, from the major art history periodicals. Selected newspaper reviews are also listed, particularly when these are reprinted in other sources. In most cases, the annotations only note the originating site for traveling exhibitions unless the review pertains to a different venue on the tour. The reviews are arranged chronologically by the date of the exhibition and then alphabetically by the last name of the reviewer.

V. Book Reviews. These comprise a very selected group.

VI. Dissertations and Theses.

VII. Reference Sources. This section cites reference sources such as biographical dictionaries, art history encyclopedias, and the like.

VIII. Archival Sources. Sources for unpublished material on each artist are listed in this section, including the Archives of American Art, special collections in university libraries, and so forth.

IX. Annotated Reproductions. Annotated reproductions of each artist's works are arranged in this section by title. The majority of the source volumes contain critical annotations, brief essays, biographical notes, or bibliographic citations pertaining to the cited painting, drawing, lithograph, or photograph. Source volumes with briefer information (usually the title, date of execution, medium, dimensions, and provenance) have been included in order to document the presence of an artist's work in a particular exhibition, museum, gallery, or private collection. The type of material is seldom indexed comprehensively and these listings are intended to serve as a supplementary resource for those conducting in-depth research.

The format for the entries is as follows: title; date of execution; keyword for source volume; black and white (b/w) or color (c) reproduction; and the page numbers on which the reproduction and annotations appear. In the case of unpaginated or partially paginated works, reference to Plate (Pl.) numbers will be provided, sometimes in conjunction with page (pp.) numbers. With only a few exceptions, these source volumes are not referred to in other sections of this bibliography.

This bibliography has the following four indexes:

Keyword Index to Source Volumes. This index decodes the keywords used for the source volumes in the Annotated Reproductions sections.

Author Index. This index contains personal authors (both as main entries and as authors of catalogue essays appearing in the annotations) and corporate authors (principally art museums and galleries).

Short-Title Index to Exhibition Catalogues. This index has been provided as a convenience for those who are unable to access an exhibition catalogue by the main entry.

Subject Index. The subject index utilizes, so far as possible, Library of Congress subject headings because these will be familiar to most researchers. Exhibition reviews are generally not included in the subject index because, being listed chronologically, they can be easily cross-referenced from the exhibition catalogues by date.

Note: The index numbers refer to entry numbers, not page numbers.

CHAPTER ONE
Precisionism

The Precisionists, sometimes called Cubist-Realists or Immaculates, never formally united into a movement with manifestoes, programs, or group exhibitions. They did, however, frequently exhibit in the same progressive New York galleries during the 1920s and 1930s, including the Daniel Gallery, the Downtown Gallery, J. B. Neumann's New Art Circle, and the Whitney Studio Club. The Precisionists had an abiding common interest in depicting the modern industrial and urban landscape in a semiabstract style deriving from French Cubism. The burgeoning Machine Age in the post-World War I era had captured their imagination and, while they differed in their estimation of the social value of urbanization and industrial technology, they all found the clean lines and solid geometry of factories, bridges, skyscrapers, docks, cranes, and powerhouses to be ideal subjects for their artistic purposes.

The 1913 Armory Show introduced the formal Cubist vocabulary to a wide audience in this country. The Precisionists were attracted to Synthetic Cubism in particular, with its geometrical simplification, sharp angularity, intersecting planes, flattened forms, and juxtaposition of the abstract and the concrete. Charles Demuth, Charles Sheeler, and Morton Schamberg became acquainted with Marcel Duchamp and Francis Picabia—two French Dada artists living in New York in the 1910s—through the salon of the wealthy connoisseur Walter Conrad Arensberg. Duchamp and Picabia both exploited the machine with elements of irony and wit. Louis Lozowick admired the treatment of the machine in the works of a number of European artists ranging from the French Cubist Fernand Leger to the Russian Constructivist El Lissitsky.

Although the Precisionists incorporated abstraction in their compositions to varying degrees, they always strived to maintain fidelity to the object and its underlying structural integrity. They rendered industrial and urban vistas with simplified, hard-edged shapes; pronounced linearity; overlapping planes; a sharp focus extending from the foreground to the background; brilliant yet generally undeliniated light sources; elimination of extraneous details, atmospheric effects, and human subjects; smooth, unmodulated application of pigment; and an overall impersonal and objective tone. There were contemporary European parallels for this type of approach, particularly the German Neue Sachlichkeit movement (New Objectivity or New Realism) of the 1920s, which was characterized by the external clarification and

purification of the object; static, sober, and quiet compositions; and the effacement of the painting process.

The Precisionists sought an idealized state of absolute order in which the essential formal structure of the object is revealed through a process of visual editing and carefully controlled craftsmanship. Three of the Precisionists—Sheeler, Schamberg, and Ralston Crawford—were accomplished photographers and this medium played an integral role in the development of the Precisionist aesthetic. Sheeler's work in "straight" (i.e., sharp-focus) photography, pioneered by Alfred Stieglitz, was decisive in shaping his selective vision, or his "camera eye," as one critic put it. Preliminary photographic studies of his subject enabled him to directly portray the object's essential geometrical form on canvas after eliminating inessential details. Later in their careers, Crawford and Sheeler used photographs as consciously manipulated preparatory studies for their paintings through utilizing overlapping images to create abstract effects, or through modifications in the printing process such as cropping or enlargement of details in order to create a "close-up" view.

The poet William Carlos Williams was a personal friend of both Demuth and Sheeler. He encouraged them to embrace an aesthetic of place in which a heightened sense of reality could be achieved through presenting the timeless and universal pure form inherent in local commonplace objects. This functionalist objectivity led Demuth and Sheeler to turn to rural vernacular subjects like Shaker barns and grain elevators in addition to compositions involving still lifes and domestic interiors. Other Precisionists--including George Ault, Peter Blume, and O. Louis Guglielmi—had more affinity with the Surrealist aesthetic. Blume, Guglielmi, and Lozowick used Precisionist works to convey social commentary, although the Precisionists in general were not preoccupied with social themes or offering critiques of industrialization. Preston Dickinson treated industrial subjects with more brilliant colors deriving from the Post-Impressionists and the Fauves, while Niles Spencer adhered closely to formal Cubist principles and low-key colors.

Precisionism began to wane in the postwar years following the rise of Abstract Expressionism and it consequently lost the prominence it had enjoyed during the previous two decades. The Precisionists did, however, influence a number of later American styles of the 1960s and 1970s, including hard-edge abstraction, minimalism, Photo-Realism, and Pop Art. Precisionism left a significant legacy insofar as it was this country's first indigenous modernist art style to feature uniquely American iconography.

I. Monographs and Exhibition Catalogues

001 Adams, Clinton. American Lithographers, 1900-1960: The Artists and their Printers. Albuquerque: University of New Mexico Press, 1983.

In a subsection of Chapter 3 entitled "American Modernism: Cubism and Surrealism Assimilated the Precisionist Spirit," Adams analyzes the Cubist devices found in the lithographs of Crawford, Lozowick, Sheeler, and Spencer. He observes that a number of the Precisionists were drawn to lithography

because it yielded the technically flawless, vital finish they sought in deep, crisp black tones. Sheeler's lithograph Roses of 1924 is featured as the book's frontispiece.

002 Advancing American Art. Prague, Czechoslovakia: U.S. Information Service, 1947.

Catalogue of the European half of the exhibition "Advancing American Art," which was sponsored by the U.S. Department of State. Included are Crawford's Plane Production of ca. 1946, Guglielmi's The Tenements of 1939, and Sheeler's Boneyard of 1945. Hugo Weisgall provides comments on the paintings and a catalogue essay. For background information on this exhibition, see Advancing American Art: Painting, Politics, and Cultural Confrontation at Mid-Century, by Taylor D. Littleton and Maltby Sykes (Tuscaloosa: University of Alabama Press, 1989).

003 Agee, William C. The 1930's: Painting & Sculpture in America. New York: Whitney Museum of American Art, 1968.

Catalogue of an exhibition held at the Whitney Museum of American Art, New York, 15 October—1 December 1968, which includes works by Blume, Demuth, Guglielmi, and Sheeler.

004 Allentown Art Musuem. The City in American Painting: A Selection of 19th and 20th Century Works by Artists Who Employed the Urban Scene as a Principal Theme, Either Specifically or Implied. Allentown, Pa.: The Museum, 1973.

Catalogue of an exhibition held at the Allentown Art Museum, Allentown, Pennsylvania, 20 January—4 March 1973, which includes works by Blume, Demuth, and Sheeler. Introduction by Richard N. Gregg.

005 American Artists' Congress (lst : 1936 : New York, N.Y.) Artists Against War and Fascism: Papers of the First American Artists' Congress. New Brunswick, N.J.: Rutgers University Press, 1986.

The American Artists' Congress was formed in order to organize American artists in opposition to war and fascism both domestically and internationally. Signers of the "Call for the American Artists' Congress" in 1935 included Ault, Blume, Crawford, Lozowick, and Spencer. Addresses were delivered at the First Artists' Congress in 1936 by Blume (see 211) and Lozowick (see 823). This volume reprints all papers from that conference as well as the texts of several catalogues from exhibitions sponsored by the Congress. Matthew Baigell and Julia Williams provide a background essay.

006 American Prints, 1912-1963: An Exhibition Circulated Under the Auspices of
 The International Council of the Museum of Modern Art, New York. London,
 England: Arts Council of Great Britain, 1976.

 Catalogue of an exhibition held at the Leeds City Art Gallery, 16 July—22
 August 1976, which includes lithographs by Crawford, Lozowick, Sheeler, and
 Spencer.

007 Andrew Crispo Gallery. Pioneers of American Abstraction: Oscar Bluemner,
 Stuart Davis, Charles Demuth, Arthur Dove, John Marin, Georgia O'Keeffe,
 Charles Sheeler, Joseph Stella, Max Weber. New York: The Gallery, [1973].

 Catalogue of an exhibition held at the Andrew Crispo Gallery, New York, 17
 October—17 November 1973, which includes sixteen works by Demuth and
 fourteen by Sheeler.

008 Baur, John I. H. Revolution and Tradition in Modern American Art, 57-62, 103.
 Cambridge, Mass: Harvard University Press, 1951.

 Baur prefers to use the term 'Immaculates' rather than 'Precisionists' to describe
 artists whose style is exemplified by a "smooth, precise technique" and
 "compositions of sharp-edged, simplified forms painted in large areas of
 unmodulated color." Baur discusses the tension between realism and abstraction
 in the works of Schamberg, Demuth, Dickinson, Sheeler, Spencer, and Lozowick.
 He feels that Sheeler's works executed during the 1920s established the limits
 of the Immaculate style and explored most of its possible variations. Baur
 concludes that while the Immaculate movement in its pure form was somewhat
 cold and limited in its range of expression, it nevertheless was "one of our most
 spontaneous and fertile modern movements and one which may claim to have
 been the first to acclimatize abstraction in America."

009 Berman, Avis. Rebels on Eighth Street: Juliana Force and the Whitney Museum
 of American Art. New York: Atheneum, 1990.

 Berman observes that Juliana Force, the first director of the Whitney Museum
 of American Art, "had a great liking for Precisionist painting in general," and
 her acquisition of Precisionist works for the museum is discussed at various
 places in this biography. Berman also provides valuable background on
 Juliana's friendship with Sheeler in addition to discussing Sheeler's association
 with the museum and its precursors, the Whitney Studio and the Whitney Studio
 Club (two of his mid-1920s photographs of the latter are reproduced).

010 Born, Wolfgang. American Landscape Painting: An Interpretation. New Haven,
 Conn.: Yale University Press, 1948.

In his final chapter, "Toward a Technocratic Landscape," Born discusses the industrial landscapes of Demuth, Dickinson, and Sheeler, with particular emphasis on their stylistic influences. Born is sometimes erroneously credited with coining the term 'Precisionism' in this book (see 011).

011 _____. Still-Life Painting in America. New York: Oxford University Press, 1947.

In Chapter V, "The Growth of Precisionism," Born analyzes the stylistic influences, compositional elements, and subject matter found in the still lifes of Demuth, Dickinson, and Sheeler. Art historians have occasionally credited Born with coining the term 'Precisionism' in American Landscape Painting: An Interpretation (see 010). However, the following statement in this book, published one year earlier, makes it clear that he was simply following prior usage: "Precision, which again and again appeared as a characteristic of American still-life painting, eventually became the main objective of a movement that developed after the First World War and was immediately dubbed 'precisionism' by alert critics" (p. 45).

012 Brandeis University. Poses Institute of Fine Arts. American Modernism: The First Wave: Painting from 1903-1933. Waltham, Mass.: The Institute, 1963.

Catalogue of an exhibition held at the Poses Institute of Fine Arts, Brandeis University, Waltham, Massachusetts, 4 October—10 November 1963, which includes works by Demuth, Sheeler, and Spencer. Catalogue essay by Sam Hunter and "A Statement" by Edith Gregor Halpert. Referring to the founding year of her Downtown Gallery, Halpert remarks, "In returning to the earlier years it is important to recognize the fact that the painters represented in the present exhibition . . . were mature artists in 1926. They were the American Rebels of the period encompassed—a period frought with dissention, revolutions, a World War, defeats and triumps, the great Depression, and the general hostility to modern American art. However, 'The Age of Anxiety' did not divert these artists from their esthetic goals. Despite the lack of support from the majority of museums, press and public they dared to continue their explorations, and to express their own visual and inner responses. They evolved within their own philosophy and succeeded in anticipating directions which to our younger generation may appear as news."

013 Brown, Milton W. American Painting from the Armory Show to the Depression. Princeton, N.J.: Princeton University Press, 1955.

Brown discusses the Cubist-Realism in the works of Ault, Blume, Demuth, Dickinson, Lozowick, Schamberg, Sheeler, and Spencer, often amplifying and extending his earlier remarks published in Marsyas (see 090). Brown feels that Cubist-Realism was an outgrowth of Cubist aesthetic theory affecting the

formal aspects of functionalism, resulting in the simplification of objects to their basic cubic structure. Brown contends that although Demuth was the original innovator in Cubist-Realism, it was Sheeler who developed the three-dimensionality that eventually became its hallmark and he thereby was its most important and influential exponent. Brown points out that by the late 1920s Sheeler had lost the balance between painting and photography, eventually succumbing to the influence of the latter and moving away from adherence to the Cubist-Realist idiom. In fact, Brown notes that Lozowick explored the theme of industrial subject matter more consistently and conscientiously than Sheeler through utilizing a more somber and Cubist style.

014 _____. The Modern Spirit: American Painting, 1908-1935. London, England: Arts Council of Great Britain, 1977.

Catalogue of an exhibition held at the Royal Scottish Academy, Edinburgh, 10 August—11 September 1977, which includes Brown's essay "Precisionism and Mechanism" (pp. 52-55).

015 Bryant, Keith L. William Merritt Chase: A Genteel Bohemian. Columbia: University of Missouri Press, 1991.

Bryant briefly discusses Demuth, Schamberg, and Sheeler, all of whom were students of Chase at the Pennsylvania Academy of the Fine Arts in Philadelphia (pp. 192-193). Sheeler was included in the student groups who accompanied Chase on summer trips to Europe in 1904 and 1905 (pp. 198-201). Bryant's discussions contain two extracts from Sheeler's unpublished autobiography.

016 Carnegie Institute. Museum of Art. Forerunners of American Abstraction; painters: Charles Demuth, Arthur G. Dove, John Marin, Georgia O'Keeffe, Charles Sheeler, Joseph Stella; sculptors: John B. Flanagan, John Storrs. Pittsburgh, Pa.: Museum of Art, Carnegie Institute, [1971].

Catalogue of an exhibition of artists and sculptors who experimented with European modernism in the early twentieth century, held at the Museum of Art, Carnegie Institute, Pittsburgh, Pennsylvania, 18 November 1971—9 January 1972. Brief introductions precede the catalog sections for Demuth and Sheeler; each artist has five works illustrated.

017 Cincinnati Modern Art Society. A New Realism: Crawford, Demuth, Sheeler, Spencer. [S.l.: s.n.], 1941.

Catalogue of an exhibition sponsored by the Cincinnati Modern Art Society and held at the Cincinnati Art Museum, 12 March—7 April 1941, which includes ten works each by Demuth and Sheeler, and nine works each by Crawford and Spencer. "A New Realism" was historically important insofar as it was one of

the few pre-1960 Precisionist "group" exhibitions. In her introduction to the catalogue, Elizabeth Sacartoff does not use the term "Precisionism," although she states that ". . . artists like these four in this exhibition found forms and abstract qualities in America's industrial landscape that led to another 'New Realism.' To them factories, ships' funnels, bridges held immense possibilities." The catalogue includes statements by all four artists (Demuth's is reprinted from "Across a Greco is Written"). For a discussion of Sacartoff's catalogue essay, see Bryan Holme's article "The United States—Realism in Art," The Studio 122 (August 1941) 50, 52.

018 Clark-Langager, Sarah A. Order and Enigma: American Art Between the Two Wars. Utica, N.Y.: Museum of Art, Munson-Williams-Proctor Institute, 1984.

Catalogue of an exhibition held at the Museum of Art, Munson-Williams-Proctor Institute, Utica, New York, 13 October—2 December 1984, which includes works by Ault, Crawford, Demuth, Lozowick, and Sheeler. Catalogue essay by Sarah A. Clark-Langager.

019 Corcoran Gallery of Art. The Edith Gregor Halpert Collection. [Washington, D.C.]: The Gallery, 1962.

Catalogue of an exhibition held at the Corcoran Gallery of Art, Washington, D.C., 28 September—11 November 1962, which includes works by Demuth, Dickinson, Guglielmi, Sheeler, and Spencer. Catalogue foreword by George E. Hamilton, Jr.

020 Davidson, Abraham A. Early American Modernist Painting, 1910-1935. New York: Harper & Row, 1981.

Davidson's book contains two chapters relevant to Precisionism. In Chapter 2, "The Arensberg Circle," Davidson discusses Demuth, Schamberg, and Sheeler with reference to Walter Conrad Arensberg, whose New York apartment served as a gathering place for many American and European avant-garde artists, writers, poets, composers, musicians, and critics, in addition to being an important center for New York Dada during the period from 1914 to 1921. Chapter 5, "Precisionism," contains an overview of the movement with discussions of all ten artists covered in this bibliography.

021 Deeds, Daphne Anderson. Of Time and the City: American Modernism from the Sheldon Memorial Art Gallery. New York: American Federation of Arts ; Philadelphia: University of Pennsylvania Press, 1990.

Catalogue of an exhibition held at the Sheldon Memorial Art Gallery, Lincoln, Nebraska, 9 January—11 March 1990, which includes works by Ault, Blume,

Demuth, Dickinson, Schamberg, and Spencer. Catalogue essay by Daphne Anderson Deeds.

022 Delaware Art Museum. <u>Avant-Garde Painting & Sculpture in America, 1910-1925</u>. Wilmington, Del.: The Museum, [1975].

Catalogue of an exhibition held at the Delaware Art Museum, Wilmington, 4 April—18 May 1975, which includes biographical essays on Demuth (pp. 60-61), Schamberg (pp. 128-129), and Sheeler (pp. 130-133) by Wilford Scott; and on Dickinson by Catherine Turrill (pp. 64-65).

023 Detroit Institute of Arts. <u>Paris and the American Avant-Garde, 1900-1925</u>. Detroit: The Institute, 1980.

Catalogue of an exhibition held at the Kalamazoo Institute of Arts, Kalamazoo, Michigan, 12 June—21 July 1980, which includes works by Demuth, Dickinson, Schamberg, Sheeler, and Spencer.

024 Dijkstra, Bram. <u>The Hieroglyphics of a New Speech: Cubism, Stieglitz, and the Early Poetry of William Carlos Williams</u>. Princeton, N.J.: Princeton University Press, 1969.

Dijkstra discusses Williams' relationships with both Demuth and Sheeler at various places in his book, noting their common interest in combining the study of local subject matter representing the universality of place with the structural techniques of purity of line and visual simplification. In Chapter Seven, "The Poem as Still-Life," Dijkstra compares Williams' poem "Daisy," published in <u>Sour Grapes</u> (1921), with Demuth's floral watercolor <u>Daisies</u> of 1918, and he concludes that at this point in his career Williams lacked the sharp reductive focus that Demuth had mastered.

025 <u>The Downtown Gallery</u>. [New York: Delta Press, 1944].

This book contains brief biographical profiles of Crawford (with illustrations of <u>Boat and Grain Elevators</u> of 1943 and <u>Red Barge</u> of 1942); Guglielmi (with illustrations of <u>Terror in Brooklyn</u> of 1941 and <u>An Odyssey for Moderns</u> of 1943); Sheeler (with illustrations of <u>Winter Window</u> of 1941 and <u>Rolling Power</u> of 1939); and Spencer (with illustrations of <u>Connecticut Shore</u> of 1941 and <u>Waterfront Mill</u> of 1940).

026 Dreier, Katherine S. <u>Modern Art</u>. New York: Societe Anonyme, 1926.

Dreier, a founder and president of Societe Anonyme, gives a brief biographical sketch, accompanied by a portrait and a reproduction of one work, for Dickinson (p. 106), Demuth (p. 108), Spencer (p. 109), and Lozowick (p. 110).

027 Eisler, Benita. O'Keeffe and Stieglitz: An American Romance. New York: Doubleday, 1991.

Eisler discusses Demuth's friendship with Georgia O'Keeffe (pp. 244-247) and Sheeler's relationship with Alfred Stieglitz (pp. 205-206, 290-291).

028 Ernst Brown & Phillips. Six Decades of American Art: Catalogue. In Association with the Downtown Gallery, New York. London, England: Ernst Brown & Phillips : Leicester Galleries, 1965.

Catalogue of an exhibition held at the Leicester Galleries, London, England, 14 July—18 August 1965. The exhibition included four works by Demuth and two by Sheeler. Brief background notes on each artist are provided. Catalogue introductions by John I. H. Baur and Bryan Robertson.

029 Everson Museum of Art. Provincetown Painters, 1890's—1970's. Syracuse, N.Y.: The Museum, 1977.

Catalogue of an exhibition held at the Everson Museum of Art, Syracuse, New York, 1 April—26 June 1977, which includes Ault's The Green Fish House of 1921; Demuth's After Sir Christopher Wren of 1920, Early Houses, Provincetown of 1918, and Sailboats, Provincetown of 1916; and Spencer's New England Landscape of 1924. In her catalogue essay, "History of the Provincetown Art Colony," Dorothy Gees Seckler discusses Demuth (pp. 33, 37), Spencer (pp. 47, 51, 53), and Ault (p. 47), in terms of their artistic activities in Provincetown.

030 Finch, Christopher. American Watercolors. New York: Abbeville, 1986.

Chapter Nine of Finch's book, "New Directions," contains discussions of the watercolors of Demuth, Dickinson, and Sheeler. "Were it not for his early death," Finch writes of Dickinson, "he might well have won a major place among American artists of his generation."

031 Fletcher, Valerie J. Dreams and Nightmares: Utopian Visions in Modern Art. Washington, D.C.: Published for the Hirshhorn Museum Sculpture Garden by the Smithsonian Institution Press, 1983.

Catalogue of an exhibition held at the Hirshhorn Museum and Sculpture Garden, Washington, D.C., 8 December 1983—12 February 1984. In the chapter "American Precisionism and Architecture," Fletcher discusses the Precisionist aesthetics of Lozowick and Sheeler; in the chapter "Early Premonitions," she discusses Blume's Light of the World of 1932.

032 Foshay, Ella M. Reflections of Nature: Flowers in American Art. New York:

Alfred A. Knopf, in association with the Whitney Museum of American Art, 1984.

Catalog of an exhibition held at the Whitney Museum of American Art, New York, 1 March—20 May 1984. In the catalogue section "Twentieth-Century Flower Art," exhibition organizer Foshay discusses the floral pieces of Demuth and Sheeler that were included in the exhibition.

033 Gerdts, William H. Painters of the Humble Truth: Masterpieces of American Still Life, 1801-1939. Columbia: University of Missouri Press ; [Tulsa, Okla.]: Philbrook Art Center, 1981.

Catalogue of an exhibition held at the Philbrook Art Center, Tulsa, Oklahoma, May 1981. In his final chapter, "Vernacular Modernism: Cubist-Realist Still Life and Beyond," Gerdts analyzes the still lifes of a number of early American modernists including Demuth, Dickinson, Schamberg, and Sheeler.

034 Guimond, James. The Art of William Carlos Williams, 41-64. Urbana: University of Illinois Press, 1968.

Guimond compares the devices used by Williams to bring out a hard objectivity in commonplace local subjects with the way in which Demuth treats his subjects in a precise, ironical manner. Guimond also compares the quest of Williams and Sheeler to invest local materials with a universal, timeless character through the use of metaphor and allusion.

035 Heckscher Museum. The Precisionist Painters, 1916-1949: Interpretations of a Mechanical Age. Huntington, N.Y.: The Museum, 1978.

Catalogue of an exhibition held at the Heckscher Museum, Huntington, New York, 7 July—20 August 1978, which includes works by Ault, Crawford, Demuth, Dickinson, Lozowick, Schamberg, Sheeler, and Spencer. Catalogue essay by Susan Fillin-Yeh.

036 _____. The Students of William Merritt Chase. Huntington, N.Y.: The Museum, [1973].

Catalogue of a two-part exhibition held at the Heckscher Museum, Huntington, New York, with the "Major Artists" portion shown 18 November—20 December 1973. The second half of the catalogue, devoted to Chase's modernist students, is introduced by Ronald G. Pisano's essay "Chase and the Modern Movement in American Art." Each artist is represented by a work executed under Chase's tutelage and a later work. Included in the catalogue are Demuth's Landscape

and My Egypt; Schamberg's Studio Interior and Camera Flashlight; and Sheeler's Washday, Madrid and Barn Abstraction. Each pair of paintings is annotated by Pisano.

037 Hills, Patricia and Roberta K. Tarbell. The Figurative Tradition and the Whitney Museum of American Art: Paintings and Sculpture from the Permanent Collection. New York: Whitney Museum of American Art, in association with the University of Delaware Press, Newark, 1980.

This book was published in conjunction with an exhibition held at the Whitney Museum of American Art, New York, 25 June—28 September 1980. Hills points out that the surrealist devices in the works of Blume and Guglielmi have little to do with the private unconscious anxieties of individuals, but instead portray collective, environmental, and social problems associated with themes such as family roles, spiritual values in a technological age, and modern warfare (pp. 87-89). She also notes Blume's use of the crucifixion theme as a means of social commentary in works like Man of Sorrows of 1951 (p. 114).

038 Hirschl & Adler Galleries. Lines of Power. New York: The Galleries, 1977.

Catalogue of an exhibition held at the Hirschl & Adler Galleries, New York, 12 March—9 April 1977, which includes paintings and drawings by Crawford, Demuth, Guglielmi, Lozowick, Sheeler, and Spencer; and photographs by Sheeler. Exhibition organizer James H. Maroney discusses these works of art and photographs whose unifying theme is a conveyance of a sense of industrial power through the use of strong linear compositional elements.

039 Joslyn Art Museum. The Thirties: American Artists and their European Contemporaries. Omaha, Neb.: The Museum, 1971.

Catalogue of an exhibition held at the Joslyn Art Museum, Omaha, Nebraska, 10 October—28 November 1971, which includes works by Ault, Blume, Crawford, Demuth, Sheeler, and Spencer.

040 Kleeblatt, Norman L. and Susan Chevlowe, eds. Painting a Place in America: Jewish Artists in New York, 1900-1945. A Tribute to the Educational Alliance Art School. New York: Jewish Museum ; Bloomington: Indiana University Press, 1991.

Catalogue of an exhibition held at the Jewish Museum at the New York Historical Society, 16 May—29 September 1991. The exhibition featured the works of forty-nine Jewish painters, lithographers, and sculptors active in New York City during the first half of the twentieth century including two works by Blume, eight by Lozowick, and two by Schamberg. The editors' catalogue essay surveys a number of Jewish organizations and institutions formed in order

to create an interest in art within their own community in New York. These include the Educational Alliance Art School, the People's Art Guild, the Jewish Art Center, the Ten, and the Yiddisher Kultur Farband (YKUF). There are also three other essays: "'Americanizing' the Greenhorns," by Irving Howe; "An Explosion of Creativity: Jews and American Art in the Twentieth Century," by Milton W. Brown; and "From Hester Street to Fifty-Seventh Street: Jewish-American Artists in New York," by Matthew Baigell. In addition to Ralph Soyer's oil Louis Lozowick of ca. 1929-30 (p. 25), there are several photographs of Lozowick throughout the catalogue. The catalogue contains individual biographies of each artist; a checklist of the 145 works in the exhibition; and reproductions of art works and documentary photographs totaling 124 illustrations (seventeen in color).

041 Kootz, Samuel M. New Frontiers in American Painting. New York: Hastings House, 1943.
In his chapter entitled "Realism," Kootz discusses the paintings of Blume, Crawford, Demuth, Dickinson, and Sheeler.

042 Levin, Gail. Synchromism and American Color Abstraction, 1910-1925. New York: George Braziller, in association with the Whitney Museum of American Art, 1978.

Catalogue of an exhibition held at the Whitney Museum of American Art, New York, 24 January—26 March 1978, which includes five works by Schamberg and one by Sheeler, all of which are illustrated (three in color). Levin briefly discusses these works in her catalogue essay (p. 44).

043 M. H. de Young Memorial Museum. Exhibition of American Painting. San Francisco: The Museum, 1935.

Catalogue of an exhibition held at the M. H. de Young Memorial Museum, San Francisco, 7 June—7 July 1935, which includes works by Ault, Blume, Demuth, Dickinson, Sheeler, and Spencer. Catalogue essay by Walter Heil.

044 MacGowan, Christopher J. William Carlos Williams' Early Poetry: The Visual Arts Background. Ann Arbor, Mich.: UMI Research Press, 1984.

MacGowan discusses Williams' relationship with Demuth and Sheeler at various places in his book, but his most extended analysis occurs in Chapter Six which focuses on the poems in Williams' Spring and All (1923).

045 Marling, William. William Carlos Williams and the Painters, 1909-1923. Athens: Ohio University Press, 1982.

As contrasted with the material presented in his book, Marling gives a fuller analysis of the relationship between Williams and Sheeler in his 1987 Bucknell Review article (see 1069). Furthermore, Marling does not explore Williams' relationship with Demuth beyond a number of scattered references.

046 Mellow, James R. Charmed Circle: Gertrude Stein & Company, 182-183. New York: Praeger, 1974.

A brief discussion of Gertrude Stein's relationship with Demuth and Sheeler.

047 Menton, Seymour. Magic Realism Rediscovered, 1918-1981. Philadelphia: Art Alliance Press, 1983.

In Chapter 5, "The United States: Romantic Realism, Precisionism, Magic Realism," Menton surveys the elements of magic realism in the works of Blume, Crawford, Demuth, Sheeler, and Spencer. Menton feels that Blume is one of the artists most responsible for the confusion surrounding the term 'magic realism' among American artists and critics.

048 Metropolitan Museum and Art Centers (Miami, Fla.) American Magic Realists: Albright, Blume, Cadmus, Hogue, Guglielmi, Koerner, Kuniyoshi, Nichols, Pickens. Miami, Fla.: The Museum, 1977.

Catalogue of an exhibition held at the Metropolitan Museum and Art Centers, Miami, Florida, 18 February—27 March 1977, which includes seven works by Blume and three by Guglielmi. In his preface, museum director Arnold L. Lehman speaks of Guglielmi's "cold, bleak and still vision" and of Blume's "mysterious imagery."

049 Metropolitan Museum of Art (New York, N.Y.) 200 Years of Watercolor Painting in America: An Exhibition Commemorating the Centennial of the American Watercolor Society. New York: The Museum, 1967.

Catalogue of an exhibition held at the Metropolitan Museum of Art, New York, 8 December 1966—29 January 1967, which includes ten works by Demuth and one each by Blume and Sheeler.

050 Munson-Williams-Proctor Institute. 1913 Armory Show: 50th Anniversary Exhibition, 1963. Utica, N.Y.: The Institute, 1963.

Catalogue of an exhibition held at the Munson-Williams-Proctor Institute, Utica, New York, 17 February—31 March 1963. The exhibition reconstructed the original Armory Show ("International Exhibition of Modern Art") held at the Armory of the Sixty-ninth Regiment, New York, 17 February—15 March 1913. One work by Schamberg and five by Sheeler are included, as is a 1963

statement by Sheeler on the Armory Show (p. 95). Catalogue essay by Milton Brown. Various sources relating to the Armory Show are reprinted including the original exhibition catalogue and selected contemporary reviews.

051 Museum of Fine Arts, Houston. Modern American Painting, 1910-1940: Toward a New Perspective. Houston, Tex.: The Museum, 1977.

Catalogue of an exhibition held at the Museum of Fine Arts, Houston, Texas, 1 July—15 September 1977, which includes works by Crawford, Demuth, Dickinson, Schamberg, and Sheeler. Catalogue essay by William C. Agee.

052 Museum of Modern Art (New York, N.Y.) Art of the Twenties. New York: The Museum, 1979.

Catalogue of an exhibition held at the Museum of Modern Art, New York, November 1979—January 1980. Precisionist artists are represented in five of the six sections of the catalogue: Lozowick, Sheeler, and Spencer in "The City;" Lozowick and Sheeler in "The Machine;" Demuth, Dickinson, Lozowick, and Sheeler in "The False Mirror;" Demuth in "The World Transformed;" and Blume, Demuth, and Spencer in "A Modern Style." Catalogue text by William S. Lieberman; chronology by Eila Kokkinen.

053 National Collection of Fine Arts (U.S.) Pennsylvania Academy Moderns, 1910-1940. Washington, D.C.: Published for the National Collection of Fine Arts by the Smithsonian Institution Press, 1975.

Catalogue of an exhibition held at the National Collection of Fine Arts, Smithsonian Institution, Washington, D.C., 9 May—6 July 1975, which includes works by Demuth, Schamberg, and Sheeler, all of whom were former students of the academy.

054 _____. Roots of Abstract Art in America, 1910-1930. Washington, D.C.: Published for the National Collection of Fine Arts by the Smithsonian Institution Press, 1965.

Catalogue of an exhibition held at the National Collection of Fine Arts, Washington, D.C., 2 December 1965—9 January 1966, which includes works by Demuth, Dickinson, Schamberg, Sheeler, and Spencer. Introduction by Adelyn D. Breeskin.

055 New York University. Gallery of Living Art. Gallery of Living Art; A. E. Gallatin Collection. New York: The Gallery, 1933.

Albert E. Gallatin's Gallery of Living Art opened at New York University on 12 December 1927. This catalogue records the gallery's holdings as of

December 1933 with sixty-four artists being represented, including works by Demuth and Sheeler. Gallatin writes in his preface, "Especially I like the paintings of Marin, Sheeler and Hartley, because their roots are fixed in the American soil, where they belong, and I also find Demuth an important figure, if not, to as large an extent, for the same reason." Gallatin was one of the first collectors of Demuth's paintings. His gallery closed in 1943 and his collection was donated to the Philadelphia Museum of Art.

056 Newark Museum. A Museum in Action: Presenting the Museum's Activities; Catalogue of an Exhibition of American Paintings and Sculpture from the Museum's Collections with an Introduction by Holger Cahill. Newark, N.J.: The Museum, 1944.

Catalogue of an exhibition held at the Newark Museum, Newark, New Jersey, 31 October 1944—31 January 1945, which includes works by Ault, Blume, Dickinson, Guglielmi, Sheeler, and Spencer. The catalogue contains statements by Ault on From Brooklyn Heights of 1928 (p. 58); Guglielmi on his urban landscapes, reprinted from "I Hope to Sing Again" (p. 109); Sheeler on Farm Buildings, Connecticut of 1941 (pp. 132-133); and Spencer on The Cove of 1922 (p. 135). Holger Cahill provides comments on the paintings in his catalogue essay.

057 Pisano, Ronald G. The Long Island Landscape, 1914-1946: The Transitional Years. Southampton, N.Y.: Parrish Art Museum, 1982.

Catalogue of an exhibition held at the Parrish Art Museum, Southampton, New York, 13 June—1 August 1982, which includes landscapes by Ault, Crawford, Guglielmi, and Lozowick. The catalogue contains a chronology by Christine E. Bergman and an essay by Ronald G. Pisano.

058 Platt, Susan Noyes. Modernism in the 1920s: Interpretations of Modern Art from Expressionism to Constructivism. Ann Arbor, Mich.: UMI Research Press, 1985.

Platt examines modernist art in America during the 1920s through focusing on its reception by critics, dealers, collectors, and artists of the era. Among the sections of her book particularly relevant to Precisionism are "Charles Daniel" (pp. 21-23); "Charles Demuth" (pp. 55-56); "Dada in American Art" (pp. 101-103); and "The Immaculates—Charles Sheeler" (pp. 114-116).

059 Print Council of America. American Prints Today/1959. New York: The Council, 1959.

Catalogue of an exhibition which traveled to sixteen cities between 15 September 1959 and 3 January 1960. Included are Crawford's lithograph Blue, Gray, and

Black of 1957 and Lozowick's lithograph Relic of Old Rome (The Colosseum) of 1958. The catalogue contains biographical notes on the artists and a statement by Lozowick.

060 Pultz, John and Catherine B. Scallen. Cubism and American Photography, 1910-1930. Williamstown, Mass.: Sterling and Francine Clarke Art Institute, [1981].

Catalogue of an exhibition held at the Sterling and Francine Clarke Art Institute, Williamstown, Massachusetts, 31 October—6 December 1981 which includes three photographs by Schamberg and four by Sheeler. In Chapter Two, "Cubism and Self-Conscious Experimentation: Emergence of Modernism," Catherine B. Scallen discusses the photography of Stieglitz, Strand, Schamberg, Sheeler, and Steichen in the context of the influence of Cubism. A selected bibliography is included.

061 San Francisco Museum of Modern Art. Photography's Response to Constructivism. San Francisco: The Museum, 1980.

Catalogue of an exhibition held at the San Francisco Museum of Modern Art, 21 March—8 June 1980, which includes one photograph by Schamberg and two by Sheeler. Van Deren Coke's catalogue essay records the influence Constructivism exerted on those photographers in the 1920s and 1930s who straightforwardly captured the pure geometrical forms of modern architecture and machines, as well as the smooth surfaces and efficient designs of beautifully machined or molded objects such as ship and airplane propellers, ballbearings, gears, insulators, and lightbulbs. The catalogue contains a checklist of the seventy photographs in the exhibition (seven of which are illustrated).

062 Sayre, Henry M. The Visual Text of William Carlos Williams. Urbana: University of Illinois Press, 1983.

Chapter Two of Sayre's book, "Shaping America," includes discussions of the purposeful puns and ambiguities in "The Crimson Cyclamen," Williams' memorial poem to Demuth; the organizing devices Williams uses to focus his poem "The Great Figure," which inspired Demuth's 1928 poster portrait of Williams, I Saw the Figure 5 in Gold of 1928; and the common aesthetic objective shared by Williams and Sheeler of utilizing their imaginative visions to portray the formal abstract foundation of particular concrete subjects in a realistic manner.

063 Schleier, Merrill. The Skyscraper in American Art, 1890-1931. Ann Arbor, Mich.: UMI Research Press, 1986.

Schleier argues that art historians should treat the skyscraper apart from other representations of technology and urbanism given its unique iconography.

Among the sections of her book particularly relevant to Precisionism are "Charles Sheeler and the Functional Skyscraper" (pp. 78-81); "Strand and Manhatta (1921): Paradigm of Urban Ambivalence" (pp. 100-102); and "Death and Rebirth: Stella, Ault, and Hirsch" (pp. 102-105).

064 Schmidt, Peter. William Carlos Williams, the Arts, and Literary Tradition. Baton Rouge: Louisiana State University Press, 1988.

In the opening chapter of his book, "Some Versions of Modernist Pastoral: Williams and the Precisionists," Schmidt establishes the framework for his discussion through the following definition of 'Precisionist': "The term Precisionist properly applies only to painters such as Georgia O'Keeffe, Demuth, and Sheeler who were directly influenced by Stieglitz, Paul Strand, and other 'straight' photographers associated with the magazine Camera Work and Stieglitz's gallery at 291 Fifth Avenue." Schmidt proceeds to argue that Precisionism was founded on the following five premises: first, images ought to be rendered as precisely as possible; second, the two traditionally separate genres of still life and landscape can be superimposed; third, each picture, regardless of its subject matter, is primarily a portrait of emotion itself—an objective correlate; fourth, the artist's own presence must be "objective" and impersonal; and fifth, the search for freedom from European academic traditions was to be sought in a nationalistic idealism and a celebration of American technological traditions and inventiveness. Schmidt investigates how closely Williams' poetry adheres to these premises and he notes that the most important difference between Williams and the Precisionists is that Williams more frequently exploits the gap between Precisionism's pastoral ideals and America's realities as a subject matter for his poetry and other writings. The first footnote of the chapter is a lengthy literature review.

065 Societe Anonyme. Catalogue of an International Exhibition of Modern Art: Assembled by Societe Anonyme. [S.l.: s.n., 1926].

Catalogue of an exhibition sponsored by Societe Anonyme and held at the Brooklyn Museum, 19 November 1926—9 January 1927. Included are works by Demuth, Dickinson, Lozowick, and Spencer. More detailed information on this major international exhibition of modern art and on the individual works these artists exhibited can be found in Ruth L. Bohan's The Societe Anonyme's Brooklyn Exhibition: Katherine Dreier and Modernism in America (Ann Arbor, Mich.: UMI Research Press, 1982), which contains a "Checklist of the Exhibition" as an appendix.

066 Stebbins, Theodore E. American Master Drawings and Watercolors: A History of Works on Paper from Colonial Times to the Present. New York: Harper & Row, 1976.

Stebbins discusses the drawings and watercolors of Demuth (314-317), Sheeler (pp. 321-323), and Blume (p. 334).

067 Stebbins, Theodore E. and Carol Troyen. The Lane Collection: 20th Century Paintings in the American Tradition. Boston: Museum of Fine Arts, Boston, 1983.

Catalogue of an exhibition held at the Museum of Fine Arts, Boston, 13 April— 7 August 1983, which includes works by Crawford, Demuth, Sheeler, and Spencer. In his catalogue essay, "The Memory and the Present: Romantic American Painting in the Lane Collection," Stebbins discusses the art of the so-called Stieglitz painters—and those artists who came under their influence—in the context of the works in the collection of William H. and Saundra Lane. In her essay, "After Stielgitz: Edith Gregor Halpert and the Taste for Modern Art in America," Carol Troyen discusses Halpert's Downtown Gallery—which championed many American modernists (including a number of the Precisionists) during its halcyon days in the 1930s and 1940s—in terms of the collecting trends of art museums and art patrons of the period.

068 Tashjian, Dickran. Skyscraper Primitives: Dada and the American Avant-Garde, 1910-1925. Middletown, Conn.: Wesleyan University Press, 1975.

Dada artists living in New York between 1910 and 1925, particularly Marcel Duchamp and Francis Picabia, exerted a wide-ranging influence on many avant-garde American poets, painters, and photographers. Tashjian's cultural history provides a detailed examination of these influences and interactions. Chapter 10, "Painting and the Machine," deals with Dada's influence on Demuth, Schamberg, and Sheeler, including a discussion of Sheeler's and Paul Strand's 1921 film Manhatta. Tashjian concludes that while Dada led these artists to industrial technology as a subject for their art, it also led them away from a strict adherence to Cubist stylistic elements in their compositions. Tashjian argues, however, that Dada's characteristic irony can only be found in the works of Demuth.

069 _____. William Carlos Williams and the American Scene, 1920-1940. New York: Whitney Museum of American Art, in association with the University of California Press, Berkeley, 1978.

This book was published in conjunction with an exhibition held at the Whitney Museum of American Art, New York, 12 December 1978—4 February 1979. Tashjian chronicles Williams' association with various avant-garde American artists and photographers in addition to exploring the poet's aesthetic theories. Of particular relevance to Precisionism are Tashjian's chapters "Charles Demuth and the Script of Painting" (pp. 65-72) and "Precisionism" (pp. 73-88). Sheeler's interest in Shaker artifacts and his photographs of African sculpture

for Marius de Zayas are discussed in the chapter "Ethnic and Folk Identity" (pp. 108-110).

070 Tate Gallery. <u>Abstraction: Towards a New Art, Painting 1910-20</u>. London, England: The Gallery, 1980.

Catalogue of an exhibition held at the Tate Gallery, London, England, 6 February—13 April 1980 which includes one work by Schamberg and two by Sheeler. Catalogue essay on the American section of the exhibition, "The First American Experiments with Abstract Art," by Gail Levin.

071 _____. <u>Modern Art in the United States: A Selection from the Collections of the Museum of Modern Art, New York</u>. London, England: Arts Council of Great Britain, 1956.

Catalogue of an exhibition held at the Tate Gallery, London, England, 5 January—12 February 1956. The exhibition included one Crawford lithograph, five Demuth watercolors, and two oils by Blume, one by Sheeler, and two by Spencer. Homer [sic] Cahill discusses these works in "Precisionism and the Industrial Image," a subsection of his catalogue essay (pp. 16-17).

072 Tsujimoto, Karen. <u>Images of America: Precisionist Painting and Modern Photography</u>. Seattle: Published for the San Francisco Museum of Modern Art by University of Washington Press, 1982.

Catalogue of an exhibition held at the San Francisco Museum of Modern Art, 9 September—7 November 1982, which includes paintings and drawings by Ault, Crawford, Demuth, Dickinson, Lozowick, Schamberg, Sheeler, and Spencer; and photographs by Crawford, Schamberg, and Sheeler. Exhibition curator Tsujimoto discusses the European influences on Precisionism, focusing on Cubism, Futurism, De Stijl, Purism, Constructivism, and Dada. Chapter 5 is devoted to an extended discussion of Sheeler's career both as an artist and as a photographer. In Chapter 6 Tsujimoto examines the parallels between Precisionism and "straight" photography. The catalogue contains biographies and bibliographies for each artist in addition to a checklist of the works in the exhibition. Twenty-four works are illustrated in color and seventy-eight in black and white.

073 University of Connecticut. Museum of Art. <u>Edith Halpert and the Downtown Gallery</u>. [Storrs, Conn.]: The Museum, 1968.

Catalogue of an exhibition held at the Museum of Art, University of Connecticut, November 1968, which includes works by Demuth, Guglielmi, Sheeler, and Spencer. Catalogue essay by Marvin S. Sadik. Biographical notes on the artists are provided.

074 University of Minnesota. University Gallery. <u>40 American Painters, 1940-1950</u>.
[Minneapolis, Minn.]: The Gallery, 1951.

Catalogue of an exhibition held at the University Gallery, University of
Minnesota, Minneapolis, 4 June—30 August 1951. The exhibition included
two works each by Crawford, Sheeler, and Spencer. In addition to chronologies
of each artist's career, the catalogue also contains statements by the artists:
Crawford (dated 24 May 1951); Sheeler (dated 8 May 1951); and Spencer
(dated May 1951). Catalogue preface by H. H. Arnason.

075 University of New Mexico. Art Museum. <u>Cubism: Its Impact in the USA, 1910-
1930</u>. Albuquerque, N.M.: The Museum, [1967].
Catalogue of a 1967 exhibition held at the University of New Mexico Art
Museum, Albuquerque, which includes works by Ault, Demuth, Dickinson,
Schamberg, Sheeler, and Spencer. Catalogue essay by Clinton Adams.

076 University of Pennsylvania. Institute of Contemporary Art. <u>The Highway</u>.
Philadelphia: The Institute, 1970.

Catalogue of an exhibition held at the Institute of Contemporary Art, University
of Pennsylvania, Philadelphia, 14 January—25 February 1970, which includes
Crawford's <u>Whitestone Bridge</u> of 1939 and six photographs from his series
<u>Junked Cars, Boulder</u> of 1958; and Spencer's <u>Erie Underpass</u> of 1949.

077 Walker Art Center. <u>The Precisionist View in American Art</u>. Minneapolis, Minn.:
The Center, 1960.

Catalogue of an exhibition held at the Walker Art Center, Minneapolis,
Minnesota, 13 November—25 December 1960. This landmark retrospective
provided the first comprehensive overview of Precisionism ever assembled and
featured the works of sixteen artists (including all ten covered in this
bibliography). Martin L. Friedman's catalogue essay was the first extended
scholarly analysis of Precisionism to appear since the studies of John I. H. Baur
and Wolfgang Born a decade earlier. Friedman discusses Precisionism's
historical antecedents, stylistic evolution, thematic features, and major
practitioners. The catalogue contains biographical notes on the artists and a
checklist of the sixty-nine works in the exhibition.

078 Watson, Steven. <u>Strange Bedfellows: The First American Avant-Garde</u>. New
York: Abbeville, 1991.

In the author's words, this book "presents a group portrait of a small band of
cultural renegades who flourished from 1913 to 1917," and includes artists,
poets, writers, critics, and collectors. Woven into the narrative are vignettes
involving Demuth, Schamberg, Sheeler, and William Carlos Williams. The

four are included in a chart of various relationships among individuals associated with the Arensberg and Stettheimer salons (pp. 244-245), and in a "Cast of Characters" that notes their affiliations with numerous avant-garde activities and events (pp. 392-395). Watson's map, "The Heart of Greenwich Village," provides the location of Demuth's residence on Washington Square South.

079 Wechsler, Jeffrey. Surrealism and American Art, 1931-1947. New Brunswick, N.J.: Rutgers University Art Gallery, 1976.

Catalogue of an exhibition held at the Rutgers University Art Gallery, New Brunswick, New Jersey, 5 March—24 April 1977, which includes works by Ault, Blume, and Guglielmi. Wechsler's catalogue essay gives an overview of the impact Surrealism made on American art—and its critical reception—between 1931 and 1947. Wechsler analyzes Blume's South of Scranton of 1931 and his little known automatic drawings of the mid-1940s (pp. 28-30). He also notes the Surrealist elements in Ault's late work (p. 35), and the allegorical aspects of Blume's Light of the World of 1932 (p. 39). In addition, Wechsler discusses Guglielmi's prominence as a practitioner of social Surrealism (pp. 40-42). Guglielmi's Mental Geography of 1938 is featured on the catalogue's cover.

080 Whitney Museum of American Art. American Art of Our Century, 50-57. New York: Published for the Museum by Praeger, 1961.

Lloyd Goodrich discusses a number of Precisionists—including Demuth, Dickinson, Sheeler, and Spencer—by focusing on their works in the Whitney Museum of American Art.

081 _____. Between the Fairs: 25 Years of American Art, 1939-1964. New York: The Museum, 1964.

Catalogue of an exhibition held at the Whitney Museum of American Art, New York, 24 June—23 September 1964, which includes works by Crawford, Guglielmi, Sheeler, and Spencer. Foreword by Lloyd Goodrich; introduction by John I. H. Baur.

082 _____. The Decade of the Armory Show: New Directions in American Art, 1910-1920. New York: The Museum, 1963.

Catalogue of an exhibition held at the Whitney Museum of American Art, New York, 27 February—14 April 1963, which includes works by Demuth, Dickinson, Schamberg, and Sheeler. Catalogue essay by Lloyd Goodrich.

083 _____. The Whitney Studio Club and American Art, 1900-1932. New York: The Museum, [1975].

Catalogue of an exhibition held at the Whitney Museum of American Art, New York, 23 May—3 September 1975. The exhibition featured the work of artists who exhibited at the Whitney Studio Club including Ault, Blume, Demuth, Dickinson, Sheeler, and Spencer. Catalogue essay by Lloyd Goodrich.

084 Whitney Museum of American Art at Philip Morris. Precisionist Perspectives: Prints and Drawings. New York: The Museum, 1988.

Catalogue of an exhibition held at the Whitney Museum of American Art at Philip Morris, New York, 2 March—28 April 1988. The exhibition included drawings by Crawford, Demuth, Lozowick, Schamberg, and Spencer; and prints by Lozowick and Sheeler. In her catalogue essay, exhibition curator Susan Lubowsky discusses the Precisionists in the context of their use of graphic arts in the depiction of various aspects of the urban and industrial landscape.

085 Wilson, Richard Guy, Dianne H. Pilgrim, and Dickran Tashjian. The Machine Age in America, 1918-1941. New York: Brooklyn Museum, in association with H.N. Abrams, 1986.

This book was published in conjunction with a wide-ranging exhibition held at the Brooklyn Museum, 17 October 1986—16 February 1987, which explored the impact of the machine on American life and culture between the two world wars with particular emphasis on industrial design, transportation, architecture, civil engineering, and machine aesthetics. Curators Wilson and Pilgrim, following in the tradition of the 1927 Machine Age Exposition, included paintings, sculpture, decorative arts, architecture, photography, and actual machines in the exhibition. Although Precisionist artists are discussed at various places throughout the book, the most sustained treatment is provided by Tashjian in Chapter 7, "Engineering a New Art," where he analyzes the depiction of machines and urban America by Lozowick and Sheeler, with briefer discussions of Crawford, Demuth, Guglielmi, and Schamberg. Of particular interest are two seldom seen reproductions of work Lozowick executed for Lord & Taylor around 1926 involving store window displays and fashion show backdrops (pp. 66, 278).

086 Worcester Art Museum. Exhibition of American Painting of To-Day. Worcester, Mass.: The Museum, [1933].

Catalogue of an exhibition held at the Worcester Art Museum, Worcester, Massachusetts, 1 December 1933—15 January 1934, which includes works by Demuth, Sheeler, and Spencer. Catalogue foreword by Francis Henry Taylor.

II. Articles and Essays

087 Baigell, Matthew. "American Art and National Identity: the 1920s." Arts Magazine 61 (February 1987) 48-55.

Baigell focuses on American artists who searched for a national artistic identity during the 1920s, including Ault, Demuth, Lozowick, and Sheeler. Baigell observes that artists like Demuth and Sheeler tended to be concerned with the evolving present, rather than the nostalgic past, and therefore they disassociated themselves from the American Scene movement.

088 Baur, John I. H. "Beauty or the Beast? The Machine in American Art." Art in America 48 (Spring 1960) 82-87.

Baur discusses the works of Schamberg, Sheeler, Demuth, and Blume in his survey of the machine in twentieth-century American art.

089 _____. "The Machine and the Subconscious: Dada in America." Magazine of Art 44 (October 1951) 233-244.

Baur argues that Dada had relatively little direct effect on American art in general and that its influence on Demuth and Schamberg in particular was peripheral.

090 Brown, Milton W. "Cubist-Realism: An American Style." Marsyas 3 (1943-1945) 139-160.

In this influential article, Brown coined the term 'Cubist-Realism' to describe a style that depicts industrial and mechanical scenes with a feeling of mass, clarity, and precision, through utilizing the formal Synthetic Cubist device of reducing forms to simple geometrical volumes and planes. Brown discusses various works of Ault, Blume, Demuth, Dickinson, Lozowick, Schamberg, Sheeler, and Spencer which exemplify this style.

091 Doezema, Marianne. "Precisionism and the Factory." In American Realism and the Industrial Age, by Marianne Doezema, 74-91. Cleveland, Ohio: Cleveland Museum of Art ; Bloomington: Indiana University Press, 1980.

Catalogue of an exhibition held at the Cleveland Museum of Art, 12 November 1980—18 January 1981. Doezema traces the Precisionists' interest in the factory to European art movements—De Stijl, Purism, and Constructivism—on the one hand, and to sources in the vernacular tradition on the other hand. Demuth, Lozowick, and Sheeler are singled out for special discussions.

092 Fort, Ilene Susan. "American Social Surrealism." <u>Archives of American Art Journal</u> 22, no. 3 (1982) 8-20.

The three major American social Surrealist artists—Guglielmi, James Guy, and Walter Quirt—are the principal focus of Fort's article. Guy and Quirt created more visually complex compositions with more surrealistic elements than did Guglielmi; also, they focused mainly on social commentary and criticism relating to social injustices perpetrated on farmers and workers, whereas Guglielmi concentrated more on depicting the overall plight of the impoverished urban dweller. Fort analyzes a number of Guglielmi's antifacist and anticapitalist works in addition to discussing Blume's <u>The Eternal City</u> of 1934-37.

093 Friedman, Martin. "The Precisionist View." <u>Art in America</u> 48 (Fall 1960) 30-36.

Friedman's catalogue essay in <u>The Precisionist View in American Art</u> (see 077) is a revised and considerably expanded version of this article, which was published in advance of the exhibition.

094 Heap, Jean. "Machine Age Exposition." <u>The Little Review</u> 11 (Spring 1925) 22-25.

An announcement of the "Machine Age Exposition," which was sponsored by <u>The Little Review</u> and held in New York from 16 to 28 May 1927. Heap's stated purpose for staging the exposition was to juxtapose the realm of the engineer (with displays of actual machines, machine parts, and apparatuses in addition to photographs of industrial plants and constructions), with the realm of the contemporary artist (with displays of art works either depicting machines or executed in a wide range of modernist styles including Futurism, Cubism, Russian Constructivism, De Stijl, Bauhaus, and Dada). A slightly abridged version of this essay appeared in <u>The Little Review</u> 12, supp. (May 1927), "Machine Age Exposition Catalogue," which also featured Lozowick's essay "The Americanization of Art" (see 788) and illustrations of a number of his <u>Machine Ornaments</u>. Precisionism was also represented in the exposition by works of Demuth and Sheeler.

095 McCausland, Elizabeth. "The Daniel Gallery and Modern American Art." <u>Magazine of Art</u> 44 (November 1951) 280-285.

Charles Daniel played a key role in promoting modern American artists in general and Blume, Dickinson, Demuth, Sheeler, and Spencer in particular. McCausland's invaluable article is the only published overview of the Daniel Gallery from its opening in December 1913 to its closing in 1932. (It should be noted that Barbara Haskell, in her book <u>Charles Demuth</u>, gives March 1912 as

the opening date of the Daniel Gallery, citing a notice in the 16 March 1912 issue of <u>American Art News</u> as her source.)

096 Naumann, Francis. "Walter Conrad Arensberg: Poet, Patron, and Participant in the New York Avant-Garde, 1915-1920." <u>Philadelphia Museum of Art Bulletin</u> 76 (Spring 1980) 1-32.

Art patron and connoisseur Walter Conrad Arensberg's New York apartment served as a gathering place for many members of the artistic and musical avant-garde in the World War I era including Demuth, Schamberg, and Sheeler. The Arensberg circle also served as a focal point for proto-Dada activities in New York involving Marcel Duchamp, Francis Picabia, and Man Ray. In addition, Arensberg was a founder of The Society of Independent Artists. Naumann, an authority on New York Dada, gives a detailed history of the Arensberg circle. Of particular interest are the three photographs of the Arensberg apartment interior taken by Sheeler around 1918; Naumann identifies each of the thirty-seven art works shown in these photographs.

097 "Painters of Industry: The Landscape of U.S. Production Seen Through the Eyes of 17 Artists, Past and Present." <u>Fortune</u> 40 (December 1949) 136-137, 141-142.

A pictorial feature that includes color reproductions, accompanied by brief commentary, of Demuth's <u>My Egypt</u> of 1925, Crawford's <u>Aircraft Plant</u> of 1945, and Sheeler's <u>Improvisation on a Mill Town</u> of 1947.

098 Pultz, John. "Cubism and American Photography." <u>Aperture</u> no. 89 (1982) 48-61.

Pultz, one of the exhibition organizers for "Cubism and American Photography, 1910-1930" (see 060), surveys the influence of Cubism on American photographers associated with the Steiglitz and Arensberg circles, including Schamberg and Sheeler. Pultz points out that by the late 1920s this influence had merged with other European influences such as Russian Constructivism and German Objectivism to form an all-pervasive modernism.

099 "The Questioning Public—Audience Reactions to Various Artists." <u>The Bulletin of the Museum of Modern Art</u> 15 (Fall 1947) 13-15.

This survey includes comments on audience reactions to Blume's <u>The Eternal City</u> and Sheeler's <u>American Landscape</u>.

100 Roeder, George H., Jr. "What Have Modernists Looked At? Experiential Roots of Twentieth-Century American Painting." <u>American Quarterly</u> 39 (Spring 1987) 56-83.

Roeder explores the way in which American modernists broke with established artistic traditions in their interpretations of the twentieth-century urban landscape. He discusses American exhibitions of European modernism, new technological extentions of sight such as photography and motion pictures, and the fact that a number of American modernists possessed architectural or engineering training, as possible reasons for their creation of new aesthetic values. Among the artists he mentions or discusses in this article are Demuth, Lozowick, Schamberg, and Sheeler.

101 Rose, Barbara. "After the Ball: Cubism in America." In American Art Since 1900, rev. ed., by Barbara Rose, 65-92. New York: Holt, Rinehart and Winston, 1975.
Rose assesses the impact Cubism made on American artists following the Armory Show of 1913. Among the artists she discusses are Demuth, Dickinson, Schamberg, and Sheeler. Rose feels that although Precisionism was more conservative and less technically advanced than Synchromism, it was a more distinctively American adaptation of Cubism and had a longer lasting impact on American art.

102 Sayre, Henry M. "American Vernacular: Objectivism, Precisionism, and the Aesthetics of the Machine." Twentieth Century Literature 35 (Fall 1989) 310-342.

Sayre presents an astute critical analysis of William Carlos Williams' attitudes toward the machine aethetic that was a dominant influence on many modernist art movements, "straight" photography, and Objectivist poetics in the 1920s and 1930s. Sayre discusses the formal, objective style of Precisionism with reference to the works of Demuth, Lozowick, and Sheeler, all of whom attempted to reveal the patterns, organization, and design inherent in the American visual vernacular (barns, factories, skyscrapers, machines, and so forth). Sayre argues that Williams ultimately found the formal structural simplicity demanded by Objectivism, which was the literary analog of Precisionism, inadequate to reveal an inherent order in the American vernacular idiom or to accomodate the expression of his subjective sentimental 'I'.

103 Schmidt, Peter. "Some Versions of Modernist Pastoral: Williams and the Precisionists." Contemporary Literature 21 (Summer 1980) 383-406.

A revised and expanded version of this article appears as the first chapter of Schmidt's William Carlos Williams, the Arts, and Literary Tradition (see 064).

104 Schulz, Bernhard. "Made in America: Technik und Dingwelt im Prazisionismus." In Amerika: Traum und Depression 1920/40, ed. Eckhart Gillen and Yvonne Leonard, 72-137. Berlin: Neue Gesellschaft fur bildende Kunst, 1980.
Schulz's lengthy illustrated German-language essay is from the catalogue to a

1980 West German exhibition of American art. Schulz discusses all aspects of Precisionism including its influences, historical development, objectives, stylistic characteristics, and subject matter.

105 Stewart, Patrick L. "The European Art Invasion and the Arensberg Circle, 1914-1918." Arts Magazine 51 (May 1977) 108-115.

In his discussion of the Arensberg circle and European modernism, Stewart comments on the influence exerted by the French Cubist Albert Gleizes on Demuth, Dickinson, and Sheeler. He quotes Gleizes' statement, "The skyscrapers are works of art. They are creations in iron and stone which equal the most admired old world creations. And the great bridges here—they are as admirable as the most celebrated cathedrals. The genius who built the Brooklyn Bridge is to be classed alongside the genius who built Notre Dame in Paris." Stewart notes that the Precisionist device of a network of lines that cut across or define planes of space is to be found in Gleizes' Cubo-Futurist works such as Broadway of 1915.

106 Stewart, Rick. "Charles Sheeler, William Carlos Williams, and Precisionism: A Redefinition." Arts Magazine 58 (November 1983) 100-114.

In this important theoretical essay, Stewart proposes what he believes to be a more accurate and focused definition of Precisionism than has heretofore been presented by art historians. Stewart asserts that Sheeler was the sole true Precisionist and he advances two main lines of argument to support this contention. First, Stewart believes that photography was a crucial influence on the development of Precisionism and it was Sheeler who successfully merged an understanding of formal Cublist principles with the aesthetic embodied in "straight" photography. Second, Stewart explores Sheeler's collaboration with William Carlos Williams and he concludes that the poet's quest for universality through discovering a sense of place decisively influenced Sheeler's choice of subject matter, both in his urban landscapes and in his still lifes. Futhermore, Sheeler's exposure to Objectivism was instrumental in shaping the form and style of his Precisionist vision. Stewart also discusses other Precisionists— including Ault, Crawford, Lozowick, and Spencer—in terms of how closely their work adheres to his definition.

107 Tarshis, Jerome. "The Precisionist Impulse." Portfolio 4 (November-December 1982) 58-65.

This overview of Precisionism emphasizes its ties to photography and includes discussions of Crawford, Lozowick, Schamberg, and Sheeler.

108 Taylor, Joshua C. "The Image of Urban Optimism." In America as Art, by Joshua C. Taylor, 186-215. Washington, D.C.: Published by the Smithsonian Institution Press for the National Collection of Fine Arts, 1976.

Taylor surveys the response of American artists to the changing industrial urban landscape in the early part of this century. He discusses the machine aesthetic of Lozowick and the detached refinement of Demuth and Sheeler.

109 Thompson, Jan. "Picabia and His Influence on American Art." Art Journal 39 (Fall 1979) 14-21.

In discussing the influence of Francis Picabia on American art, Thompson contends that the French artist was a "catalytic source" for Schamberg's machine abstractions and Schamberg was therefore a link between Picabia and the other Precisionists such as Demuth and Sheeler who subsequently viewed the machine as a viable subject matter for their art. Thompson notes certain elements of Picabia's post-1915 machinist style that were adopted by the Precisionists such as unusual perspectives, abstraction achieved through the close-up or intimate view, abstraction tied to visual fact and to the simplified object, and the lack of human subjects, particularly when the machine becomes a stand-in for the individual as in Sheeler's Self-Portrait of 1923.

110 Zabel, Barbara. "The Machine as Metaphor, Model, and Microcosm: Technology and American Art, 1915-1930." Arts Magazine 57 (December 1982) 100-105.

Zabel explores three fundamental ways in which American artists approached the machine between 1915 and 1930—metaphorical, aesthetic, and ideological—with special reference to the influence of Duchamp and Picabia. Zabel feels that with the exception of Schamberg's assemblage God of 1918, which is primarily metaphorical, aesthetic concerns dominated his art. Although Sheeler's Self-Portrait of 1923 is also metaphorical, Zabel contends that his primary approach was ideological. The ideological approach was also paramount for Lozowick, yet he also displayed a definite aesthetic interest in the machine as exemplified by his Machine Ornaments.

III. Exhibition Reviews

111 De Zayas, Marius. "How When, and Why Modern Art Came to New York." Introduction and notes by Francis Naumann. Arts Magazine 54 (April 1980) 121.

Three reviews of the exhibition "Photographs by Sheeler, Strand, and Schamberg" held at the Modern Gallery, New York, 29 March—9 April 1917, are reprinted: The New York Sun (8 April 1917); American Art News (31 March 1917); and

New York Evening World (7 April 1917). De Zayas offers some brief comments of his own on the exhibition.

112 Fitz, W. G. "A Few Thoughts on the Wanamaker Exhibition." The Camera (April 1918) 201-207.

Review of the "Thirteenth Annual Exhibition of Photographs" sponsored by the John Wanamaker Company, Philadelphia, 4-16 March 1918, which included photographs by Schamberg and Sheeler.

113 "Immaculate School Seen at Daniel's." The Art News 27 (3 November 1928) 9.

Review of an exhibition held at the Daniel Gallery, New York 27 October—18 November 1928, which included works by Blume and Dickinson. The reviewer describes paintings of factories, bridges, and smokestacks "rendered in the precise line, flat color and clearly defined pattern that have become the trademarks of the immaculate school."

114 "Modern Museum Opens American Exhibition." Art News 28 (14 December 1929) 3-4, 6.

Review of the exhibition "Paintings by Nineteen Living Americans" held at the Museum of Modern Art, New York, 13 December 1929—12 January 1930, which included works by Demuth and Dickinson.

115 Watson, Forbes. "The All American Nineteen." The Arts 16 (January 1930) 301-311.

Review. See entry 114.

116 "Downtown Artists at Grand Central." The Art News 28 (25 January 1930) 18.

Review of the exhibition "The Downtown Gallery Exhibition of Paintings, Sculpture, Watercolors, Drawings, and Prints by 33 Contemporary Artists" held at the Grand Central Art Galleries, New York, 28 January—15 February 1930, which featured Downtown Gallery artists including Ault, Lozowick, and Sheeler.

117 Lowe, Jeanette. "New Exhibitions of the Week—Works that were Shown Abroad." The Art News 37 (15 October 1938) 13.

Review of the exhibition "Americans at Home: Paintings & Sculpture by 32 Artists Shown in Paris & London, Summer of 1938" held at the Downtown Gallery, New York, 4-22 October 1938, which included works by Demuth,

Guglielmi, and Sheeler shown at the Musee du Jeu de Paume in Paris and the Wildenstein Gallery in London.

118 "Cincinnati Faces Life's New Realities." Art News 40 (1-14 April 1941) 7, 36.

Review of the exhibition "A New Realism: Crawford, Demuth, Sheeler, Spencer" held at the Cincinnati Art Museum, 12 March—7 April 1941.

119 "The Passing Shows: 'The Third War Loan Exhibition'." Art News 42 (1-14 October 1943) 30-31.

Review of the exhibition "The Third War Loan Exhibition: Crawford, Guglielmi, Levine, Lewandowski, Siporin" held at the Downtown Gallery, New York, September-October 1943. Crawford's From the Bridge is singled out for comments and an illustration.

120 Hess, Thomas B. "Veterans: Then & Now." Art News 45 (May 1946) 44-45, 71-72.

Gallery, New York, 7-25 May 1946. The exhibition included two works by Crawford and one by Guglielmi.

121 Wolf, Ben. "Six Artists Return from War." The Art Digest 20 (15 May 1946) 13.

Review. See entry 120.

122 Coates, Robert M. "The Art Galleries—The Camera Eye." The New Yorker 36 (4 February 1961) 89-92.

Review of the exhibition "The Precisionist View in American Art" held at the Walker Art Center, Minneapolis, Minnesota, 13 November—25 December 1960, and which traveled to the Whitney Museum of American Art, New York.

123 Kramer, Hilton. "The American Precisionists." Arts Magazine 35 (March 1961) 32-37.

Review. See entry 122.

124 Savitt, Mark. "Shapes of Industry." Arts Magazine 50 (November 1975) 9.

Review of the exhibition "Shapes of Industry: First Images in American Art" held at Terry Dintenfass, Inc., New York, 4-29 November 1975, which included works by Demuth, Dickinson, Lozowick, Schamberg, and Sheeler.

125 Zucker, Barbara. "New York Reviews—Shapes of Industry: First Images in American Art." Art News 75 (January 1976) 120-121.

Review. See entry 124.

126 Brown, Gordon. "Arts Reviews—Urban Focus." Arts Magazine 51 (December 1976) 42.

Review of the exhibition "Urban Focus: Industrial Drawings by Louis Lozowick; Photographs by Berenice Abbott, Ralph Steiner, and Ralston Crawford" held at the Zabriskie Gallery, New York, 28 September—23 October 1976.

127 Frackman, Noel. "Acquisitions from Private Collections." Arts Magazine 54 (November 1979) 14.

Review of the exhibition "Acquisitions from Private Collections" held at the Barbara Mathes Gallery, New York, 6 October—1 December 1979, which included Demuth's Pansies of 1915 and Sheeler's Gray Barns of 1946.

128 Marter, Joan. "The Precisionist Vision." Arts Magazine 56 (February 1982) 12.

Review of an exhibition of Precisionist graphic works organized by Susan Fillen-Yeh and held at the School of Visual Arts, New York, 8-26 February 1982. The exhibition included works by Ault, Demuth, Lozowick, and Sheeler.

129 Albright, Thomas. "Precisionist Images of America: An Ambivalent Modernism." Art News 82 (January 1983) 86-88.

Review of the exhibition "Images of America: Precisionist Painting and Modern Photography" held at the San Francisco Museum of Modern Art, 9 September—7 November 1982.

130 Boeltger, Susan. "Reviews—San Francisco." Artforum 21 (December 1982) 84-85.

Review. See entry 129.

131 Getlein, Frank. "In Paint and Film They Saw a Precise Image of America." Smithsonian 13 (November 1982) 130-141.

Review. See entry 129.

132 Kramer, Hilton. "'Images of America': The Precisionists." The New Criterion
 1 (December 1982) 48-53. Reprinted in The Revenge of the Philistines: Art and
 Culture, 1972-1984, by Hilton Kramer, 132-140. New York: Free Press, 1985.
 Review. See entry 129.

133 Platt, Susan. "Precisionism: America's Immaculates." images & issues 3
 (March-April 1983) 22-23.

 Review. See entry 129.

134 Allara, Pamela. "The Nation—Boston: The Lane Collection, Museum of Fine
 Arts." Art News 82 (October 1983) 115-116.

 Review of the exhibition "The Lane Collection: 20th Century Paintings in the
 American Tradition" held at the Museum of Fine Arts, Boston, 13 April—7
 August 1983, which included works by Crawford, Demuth, Sheeler, and
 Spencer.

IV. Book Reviews

135 Costello, Bonnie. "William Carlos Williams in a World of Painters." New Boston
 Review 4 (June/July 1979) 11-14.

 Review of A Recognizable Image: William Carlos Williams on Art and Artists,
 edited by Bram Dijkstra (New York: New Directions, 1978), and Dickran
 Tashjian's William Carlos Williams and the American Scene, 1920-1940 (New
 York: Whitney Museum of American Art, in association with the University
 of California Press, Berkeley, 1978).

136 Zabel, Barbara. "Book Reviews." Archives of American Art Journal 26, nos. 2
 & 3 (1986) 32-36.

 Review of The Machine Age in America, 1918-1941, by Richard Guy Wilson,
 Dianne H. Pilgrim, and Dickran Tashjian (New York: Brooklyn Museum, in
 association with H.N. Abrams, 1986).

V. Reference Sources

137 Baigell, Matthew. Dictionary of American Art. New York: Harper & Row, 1982.
 S.v. "Precisionism."

138 Castagno, John. American Artists: Signatures and Monograms, 1800-1989.
 Metuchen, N.J.: Scarecrow, 1990.

The signatures and monograms of 4,500 American artists, and 600 Canadian and Latin American artists, are identified and reproduced in facsimile in this book, accompanied by brief biographical information and bibliographical references. The volume contains entries for all ten Precisionists covered in this bibliography.

139 Eskind, Andrew H. and Greg Drake, eds. Index to American Photographic Collections: Compiled at the International Museum of Photography at George Eastman House, 2d enl. ed. Boston: G.K. Hall, 1990.

This index to 540 public photographic collections in the United States contains entries for Crawford, Schamberg, and Sheeler.

140 Falk, Peter Hastings, ed. The Annual Exhibition Record of the National Academy of Design, 1901-1950. Madison, Conn.: Sound View Press, 1990.

This exhibition record of the National Academy of Design records all works exhibited in their fifty annual shows from 1901 to 1950 and in their twenty-five winter exhibitions held from 1906 to 1932. The volume contains entries for Ault, Blume, Crawford, Guglielmi, Schamberg, Sheeler, and Spencer.

141 Library of Congress. Prints and Photographs Division. American Prints in the Library of Congress: a Catalog of the Collection. Baltimore: Published for the Library of Congress by the Johns Hopkins University Press, 1970.

A descriptive catalogue of the prints owned by the Prints and Photographs Division of the Library of Congress with entries for Crawford, Lozowick, and Sheeler.

142 Marlor, Clark S. The Salons of America, 1922-1936. Madison, Conn.: Sound View Press, 1991.

The Salons of America held annual exhibitions from 1922, the year it was founded by Hamilton Easter Field, until 1936, the year it was disbanded. For each artist participating in these exhibitions, Marlor lists the year and the works exhibited. The book contains entries for Ault, Demuth, Dickinson, Lozowick, Sheeler, and Spencer. Marlor also provides a list of the directors and the years of their directorships which includes Ault, Demuth, and Sheeler.

142a _____. The Society of Independent Artists: The Exhibition Record, 1917-1944. Park Ridge, N.J.: Noyes Press, 1984.

For every member of the Society of Independent Artists, this exhibition record lists all the annual shows in which they participated between 1917 and 1944.

The volume contains entries for Ault, Crawford, Demuth, Lozowick, Schamberg, Sheeler, and Spencer.

143 Myers, Bernard S., ed. <u>McGraw-Hill Dictionary of Art</u>, Vol. 2. New York: McGraw-Hill, 1969. S.v. "Cubist Realism."

144 National Museum of American Art (U.S.) <u>Descriptive Catalogue of Painting and Sculpture in the National Museum of American Art, Washington, D.C.</u> Boston: G.K. Hall, 1983.

A descriptive catalogue of the collection of the National Museum of American Art as of 31 October 1982, with entries for Ault, Blume, Crawford, Dickinson, Giglielmi, Sheeler, and Spencer.

145 Osborne, Harold, ed. <u>The Oxford Companion to Twentieth-Century Art</u>. New York: Oxford University Press, 1981. S.v. "Cubist-Realism" and "Precisionism."

146 Smithsonian Institution. National Portrait Gallery. <u>Permanent Collection: Illustrated Checklist</u>. Washington, D.C.: Published for the Gallery by the Smithsonian Institution Press, 1982.

This volume lists and illustrates a crayon drawing of Demuth by Peggy Bacon of ca. 1935, and a pastel self-portrait by Sheeler dated 1924.

147 Whitney Museum of American Art. <u>Catalogue of the Collection</u>. New York: The Museum, 1975.

A catalogue of the collection of the Whitney Museum of American Art as of 1975 with entries under "Paintings" for Ault, Blume, Crawford, Demuth, Dickinson, Guglielmi, Sheeler, and Spencer; under "Watercolors and Drawings" for Demuth, Dickinson, Sheeler, and Spencer; and under "Prints and Photographs" for Crawford, Lozowick, and Sheeler. For updates to this catalogue see the "Annotated Reproductions" section for the individual artists in the following chapters.

148 Wilson, Raymond L. <u>Index of American Print Exhibitions, 1882-1940</u>. Metcuhen, N.J.: Scarecrow, 1988.

An index to the exhibitions at the annual salons of the most important American print societies for the period between 1882 and 1940; coverage also extends to print exhibits at international expositions and listings in notable annual print compilations. Entries for Lozowick and Sheeler are included.

VI. Dissertations and Theses

149 Celender, Donald Dennis. "Precisionism in Twentieth Century American Painting." Ph.D. diss., University of Pittsburgh, 1963.

Celender singles out Demuth, Sheeler, O'Keeffe, and Spencer as the four major Precisionists and he analyzes their work in more detail than the group he terms "immediate followers," which includes Ault, Crawford, Dickinson, Guglielmi, Lozowick, and others. Celender devotes more attention to the decline of Precisionism and its subsequent influence on the geometric abstractionists of the 1960s than is to be found in other studies of the movement.

150 Clark, Mary Helen. "The Late Precisionist Paintings of Charles Sheeler, Niles Spencer, and Ralston Crawford." M.A. thesis, Rutgers University, 1985.

151 Cox, Richard William. "The New York Artist as Social Critic, 1918-1933." Ph.D. diss., University of Wisconsin—Madison, 1973.

Chapter V of Cox's dissertation, "The American Artist and the City, 1918-1928," contains discussions of the urban landscapes of Lozowick (with whom he conducted an interview), Ault, Demuth, and Sheeler.

152 Feldman, Frances T. "American Painting During the Great Depression, 1929-1939." 2 vol. Ph.D. diss., New York University, 1963.

Feldman's dissertation contains discussions of the 1930s work of Blume, Crawford, Guglielmi, and Lozowick.

152a Kies, Emily Bardack. "The City and the Machine: Urban and Industrial Illustration in America, 1880-1900." Ph.D. diss., Columbia University, 1971.

Kies' dissertation deals with illustrations of machines and urban vistas that frequently appeared in popular magazines such as Harper's Weekly, Scribner's, Century, and McClure's between 1880 and 1900. One style dramatically emphasized the human side of industralization and urbanization, whereas the other, which she discusses in Chapter V, "Industrial Still Life and the Minimal Man," dispassionately focused on the shapes and linear aspects of machinery and city scenes with the human element minimized or absent altogether. Kies notes the similarities of this latter impersonal style with a number of Sheeler's works such as Upper Deck and Rolling Power. Looking at the illustrations Kies provides, one can also see other direct precursors of Precisionist works in terms of subject matter, formal approach, and even titles: for example, Charles Graham's "Blast Furnaces of Pittsburgh" (Fig. 35) and Spencer's Blast Furnace; Orson Lowell's "The Converting Mill" (Fig. 45) and Ault's The Mill Room; Graham's "The Great Derrick of the Columbia Exposition" (Fig. 48) and Lozowick's Derricks and Men; W. Louis Sontag's "East River Bridge Between

New York and Brooklyn" (Fig. 68) and Dickinson's <u>Bridge over Harlem River</u>; William Rogers' "Wedding in the Chinese Quarter—Mott Street" (Fig. 73) and Guglielmi's <u>Wedding in South Street</u>; and "Buffalo—Among the Grain Elevators" (Anon., Fig. 118) and Crawford's <u>Buffalo Grain Elevators</u>. This is a valuable study for those researching the historical antecedents of Precisionism.

153 Lingen, Ramone Mary. "The Place of Demuth and Sheeler in Twentieth-Century American Art." M.A. thesis, University of Colorado, 1970.

154 Moak, Peter van der Huyden. "Cubism and the New World: The Influence of Cubism on American Painting 1910-1920." Ph.D. diss., University of Pennsylvania, 1970.

Chapter III of Moak's dissertation, "American 'Cubists' (1916-1919)," contains discussions of the influence of Cubism on the works of Schamberg (pp. 148-152), Sheeler (pp. 153-158), and Demuth (pp. 166-172).

155 Ricciotti, Dominic. "The Urban Scene: Images of the City in American Painting, 1890-1930." Ph.D. diss., Indiana University, 1977.

In addition to giving a general overview of Precisionism, Ricciotti also discusses a number of individual works by Ault, Blume, Demuth, Dickinson, Schamberg, and Sheeler which depict various aspects of the urban scene.

CHAPTER TWO
George Ault

George Copeland Ault was born on 11 October 1891 in Cleveland, Ohio, and moved with his family in 1899 to London, England. Ault's artistic training took place at the University College School, the Slade School of the University of London, and the St. John's Wood School of Art. Upon returning to America in 1911, Ault settled in Hillside, New Jersey, and opened a studio in 1914. He married his first wife Beatrice the same year, although they became estranged after Ault moved to New York City in 1922.

Ault's early works were quite conservative, but by the early 1920s he was firmly committed to depicting machines (as in The Mill Room of 1923) and urban architecture (as in From Brooklyn Heights of 1925) by employing the Precisionist devices of geometrical simplification, dramatic angles, sharp-edged forms, and smooth brushwork. His canvases of the mid-1920s, such as Sullivan Street, Abstraction of 1924, were beginning to take on a dreamlike, Surrealist aura. Ault tended to be a solitary, tempermental individual, and his paintings often reflected his personal moods. A number of New York galleries, particularly the Downtown Gallery and the Whitney Studio Club, were featuring his works on a regular basis during the late 1920s.

Ault's interest in neo-primitive art was kindled during the frequent summers he spent in Provincetown. Early America of 1927 is one of the better examples of this style. Ault was the subject of a critically acclaimed one-man exhibition at the Downtown Gallery in 1927, although his disagreements with director Edith Gregor Halpert's aggressive marketing techniques eventually led him to sever ties with the gallery in 1934. He was soon working outside the gallery system altogether, a move that would prove to be financially disastrous. Ault's personal problems mounted following the death of his father and the suicides of his two brothers. His heavy drinking and erratic behavior began to alienate his friends and fellow artists alike. Ault supported himself through working for the Treasury Relief Art Project and the Public Works Art Project. His Precisionist works of this period often portray various views of the rooftops adjacent to his Greenwich Village studio.

Ault's health problems precipitated a move to Woodstock, New York, in 1937. After his divorce in 1941, Ault married his second wife Louise who found life in Woodstock difficult given their nearly impoverished status and Ault's volatile personality. Ault continued to paint urban scenes of New York, such as New Moon,

New York of 1945, based upon the sights he viewed during his frequent trips to the city. He turned to regionalist themes in Woodstock in works like Rick's Barn, Woodstock of 1939, The Plough and the Moon of 1940, and Festus Yaple and His Oxen of 1946. He also executed a series of haunting night scenes of Russell's Corners, a Woodstock intersection of three roads. Throughout his career, Ault favored painting at night in order to capture simplified contours, gradations of blackness, and the atmospheric effects of both artificial light and moonlight.

In Ault's only self-portrait, The Artist at Work of 1946, his facial features are obscured by the canvas before him, possibly symbolizing his personal and professional isolation. He merged Surrealism with non-objective abstraction in a late work, Universal Symphony of 1947. Perhaps Ault would have pursued this direction had he not been the victim of a drowning in the Sawkill River on the evening of 30 December 1948, a possible suicide. The success of Ault's mature works, with their compelling moods achieved through a successful integration of Surrealism and Precisionism, has led many critics to hail him as the most poetic of the Precisionists.

I. Ault's Writings and Statements

156 Ault, George. "The Readers Comment—Anent Klaus Mann." The Art Digest 17 (1 June 1943) 4, 27.

Ault's letter to the editor responding to Klaus Mann's article, "Surrealist Circus," which originally appeared in The American Mercury 56 (February 1943) and was partially reprinted in The Art Digest 17 (15 May 1943).

See also entries 056, 208, and 209.

II. Monographs and Exhibition Catalogues

157 Ault, Louise. Artist in Woodstock: George Ault: The Independent Years. Philadelphia ; Ardmore, Pa.: Dorrance, 1978.

Louise Ault's biography of her husband is valuable in terms of chronicling events in the artist's life, but it contains little art historical analysis.

158 Downtown Gallery. George C. Ault: Exhibition of Water Colors and Drawings. New York: The Gallery, 1927.

Catalogue of an exhibition held at the Downtown Gallery, New York, 1-19 March 1927. This was Ault's first one-man exhibition at the Downtown Gallery.

159 _____. George C. Ault: Recent Work. New York: The Gallery, 1928.

Catalogue of an exhibition held at the Downtown Gallery, New York, 19 November—8 December 1928. The exhibition included nine oils, four drawings, and fourteen watercolors.

160 Lubowsky, Susan. George Ault. New York: Whitney Museum of American Art, 1988.

Catalogue of an exhibition held at the Whitney Museum of American Art at Equitable Center, New York, 8 April—8 June 1988. Exhibition curator Lubowsky presents a detailed critical analysis of Ault's career with discussions of all his major works, which were not only in a Precisionist vein, but also ranged from primitivism to Surrealism. The catalogue includes a checklist of the fifty paintings and fourteen drawings in the exhibition, an exhibition history, and a selected bibliography. In addition to numerous black and white illustrations, fourteen works are reproduced in color.

161 Milch Galleries. George Ault: Memorial Exhibition. New York: The Galleries, 1950.

Catalogue of an exhibition held at the Milch Galleries, New York, 30 January—18 February 1950. The exhibition included twenty-one oils and nine watercolors, gouches, and drawings. The catalogue contains a brief biographical sketch; New Moon, New York of 1945 is illustrated.

162 Vanderwoude Tananbaum. George Ault: Works on Paper with Related Paintings: 1920's-40's. New York: Vanderwoude Tananbaum, 1983.

Catalogue of an exhibition held at Vanderwoude Tananbaum, New York, 16 November—11 December 1983.

163 _____. George Ault (1881-1948): Paintings & Works on Paper. New York: Vanderwoude Tananbaum, 1988.

Catalogue of an exhibition held at Vanderwoude Tananbaum, New York, 14 April—4 June 1988.

164 Vassar College Art Gallery. Woodstock: An American Art Colony, 1902-1977. Pougkeepsie, N.Y.: The Gallery, 1977.

Catalogue of an exhibition held at the Vassar College Art Gallery, Pougkeepsie, New York, 23 January—4 March 1977. The exhibition included Ault's watercolor Woodstock Nocturne of 1940 (Cat. 57), which is discussed by Matthew Leaycraft. Catalogue essay by guest curator Karal Ann Marling.

165 Whitney Museum of American Art. <u>George Ault: Nocturnes</u>. New York: The Museum, 1973.

Catalogue of an exhibition held at the Whitney Museum of American Art, New York, 7 December 1973—6 January 1974. In his catalogue foreword, John I. H. Baur writes, "Since his death in 1948, George Ault has emerged as one of the most personal and poetic painters of the Precisionist movement." The catalogue contains a biographical note and a checklist of the thirty-eight paintings and drawings in the exhibition, all of which have a nocturnal theme.

166 Woodstock Art Gallery. <u>Memorial Exhibition: George Ault</u>. Woodstock, N.Y.: The Gallery, 1949.

Catalogue of an exhibition sponsored by the Woodstock Artists Association and held at the Woodstock Art Gallery, Woodstock, New York, 9-23 September 1949. The exhibition included sixty-two works (two are illustrated). Catalogue essay by John Ruggles.

167 Woodstock Artists Association (Woodstock, N.Y.) <u>Woodstock's Art Heritage: The Permanent Collection of the Woodstock Artists Association</u>. Woodstock, N.Y.: Overlook, 1987.

This catalogue of the permanent collection of the Woodstock Artists Association, Woodstock, New York, contains four works by Ault (all of which are illustrated): the oils <u>Jane Street, Corner of Hudson</u> of 1931 and <u>The Lake Valley: Autumn</u> of 1919; the watercolor <u>Late November in the Catskills</u> of 1940; and th gouache <u>Mexican Jug and Zinnias</u> of 1939. Sandra S. Phillips provides commentary on the paintings (pp. 50-51). The book includes a historical survey of the Woodstock Artists Association by Tom Wolf.

168 Zabriskie Gallery. <u>George Ault 1891-1948</u>. New York: The Gallery, 1957.

Catalogue of an exhibition held at the Zabriskie Gallery, New York, 28 October—25 November 1957.

169 _____. <u>George C. Ault: Drawings</u>. New York: The Gallery, 1963.

Catalogue of an exhibition held at the Zabriskie Gallery, New York, 6-25 May 1963.

170 _____. <u>George Ault: Watercolors of the 1920s</u>. New York: The Gallery, 1969.

Catalogue of an exhibition held at the Zabriskie Gallery, New York, 11 February—8 March 1969.

III. Articles and Essays

171 Adams, Henry. "George Ault." In <u>American Drawings and Watercolors in the Museum of Art, Carnegie Institute</u>, 158-160. Pittsburgh: Carnegie Institute, Museum of Art ; Distributed by the University of Pittsburgh Press, 1985.

A discussion of Ault centering on his works in the Museum of Art at Carnegie Institute.

172 Genauer, Emily. "Ault Oil Purchased." <u>The Art Digest</u> 23 (15 September 1949) 20.
A brief notice concerning the Cleveland Museum of Art purchasing Ault's <u>Festus Yayple and His Oxen</u> of 1946.

173 Lowengrund, Margaret. "Death of Ault." <u>Art News</u> 23 (1 February 1949) 25.

An obituary.

174 Schwartz, Sanford. "Summer Nights at Russell's Corners: The Art and Life of George Ault." <u>The Atlantic</u> 263 (May 1989) 84, 86-87. Reprinted in <u>Artists and Writers</u>, by Sanford Schwartz, 299-304. New York: Yarrow Press, 1990.

Schwartz sums up Ault's achievement by saying, ". . . when Ault painted artificial light or moonlight, his pictures were classically balanced and unified." Schwartz feels that in the four paintings of Russell's Corners, a Woodstock intersection of three roads, "Ault transcended himself." Schwartz also praises Ault's pencil drawings which he describes as having "a lovely ornamental quality."

IV. Exhibition Reviews

175 Goodrich, Lloyd. "New York Exhibitions." <u>The Arts</u> 9 (June 1926) 347.

Review of the Ault portion of a three-man exhibition, which also included works by Edwin Booth Grossman and Clement Wilenchick, held at J. B. Neumann's New Art Circle, New York, May 1926.

176 "Exhibitions in the New York Galleries: George Ault—Downtown Gallery." <u>The Art News</u> 27 (1 December 1928) 7.

Review of the exhibition "George C. Ault: Recent Work" held at the Downtown Gallery, New York, 19 November—8 December 1928.

177 Goodrich, Lloyd. "Exhibitions in New York." The Arts 14 (December 1928) 332.

 Review. See entry 176.

178 "New York Season." The Art Digest 3 (1 December 1928) 17.

 Review. See entry 176. Contains reprinted excerpts from the New York Herald Tribune and the New York Post.

179 Pemberton, Murdock. "The Art Galleries—Old Men, Some Young Men, and a Few Masters." The New Yorker (8 December 1928) 137-138.

 Review. See entry 176.

180 "George Ault Exhibits in Woodstock." The Art Digest 17 (1 August 1943) 15.

 Review of the exhibition "Oils and Gouaches by George C. Ault" held at the Little Gallery, Woodstock, New York, 26 July—7 August 1943.

181 Lowengrund, Margaret. "George Ault—1891-1948." The Art Digest 23 (15 September 1949) 20.

 Review of the "George Ault: Memorial Exhibition" sponsored by the Woodstock Artists Association and held at the Woodstock Art Gallery, Woodstock, New York, 9-23 September 1949.

182 Robinson, Amy. "Reviews and Previews—Ault of Woodstock." Art News 48 (September 1949) 46.

 Review. See entry 181.

183 Breuning, Margaret. "George Ault Memorial." The Art Digest 24 (1 February 1950) 17.

 Review of the George Ault Memorial Exhibition" held at the Milch Galleries, New York, 30 January—18 February 1950.

184 Munson, Gretchen T. "Reviews and Previews—George Ault." Art News 48 (February 1950) 50.

 Review. See entry 183.

185 Burrey, Suzanne. "In the Galleries—George Ault." Arts 32 (November 1957) 52.

Review of the exhibition "George Ault 1891-1948" held at the Zabriskie Gallery, New York, 28 October—23 November 1957.

186 Munro, Eleanor C. "Reviews and Previews—George C. Ault." Art News 62 (Summer 1963) 13-14.

Review of the exhibition "George C. Ault: Drawings" held at the Zabriskie Gallery, New York, 6-25 May 1963.

187 Brown, Gordon. "In the Galleries—George Ault." Arts Magazine 43 (March 1969) 62.

Review of the exhibition "George Ault: Watercolors of the 1920s" held at the Zabriskie Gallery, New York, 11 February—8 March 1969.

188 Downes, Rackstraw. "Reviews and Previews—George Ault." Art News 68 (April 1969) 8-9.

Review. See entry 187.

189 Brown, Gordon. "Reviews—George Ault." Arts 48 (February 1974) 70.

Review of the exhibition "George Ault: Drawings" held at the Zabriskie Gallery, New York, 4 December 1973—12 January 1974.

190 Derfner, Phyllis. "New York Letter." Art International 18 (20 February 1974) 47-48.

Review. See entry 189.

191 _____. "New York Letter." Art International 18 (20 February 1974) 47-48.

Review of the exhibition "George Ault: Nocturnes" held at the Whitney Museum of American Art, New York, 7 December 1973—6 January 1974.

192 Mellow, James R. "A Successful Escape Into Night." The New York Times (16 December 1973) 25D.

Review. See entry 191.

193 Smith, Roberta. "Reviews—George Ault, The Whitney Museum." Artforum 12 (March 1974) 73-74.

Review. See entry 191.

194 Henry, Gerrit. "New York Reviews—George Ault." <u>Art News</u> 82 (February 1983) 146.

Review of the exhibition "George Ault: Works on Paper with Related Paintings: 1920's-40's" held at Vanderwoude Tananbaum, New York, 16 November—11 December 1983.

195 Klein, Ellen Lee. "Arts Reviews—George Ault." <u>Arts Magazine</u> 57 (February 1983) 30.

Review. See entry 194.

V. Reference Sources

196 "Ault, George Christian [sic]." In <u>The National Cyclopaedia of American Biography</u>, Vol. XL, 458-459. New York: James T. White, 1955.

197 Baigell, Matthew. <u>Dictionary of American Art</u>. New York: Harper & Row, 1982. S.v. "Ault, George."

198 Cummings, Paul. <u>Dictionary of Contemporary American Artists</u>. 5th ed. New York: St. Martin's, 1988. S.v. "Ault, George C."

199 Falk, Peter Hastings, ed. <u>Who Was Who in American Art: Compiled from the Original Thirty-four Volumes of "American Art Annual: Who's Who in Art."</u> Madison, Conn.: Sound View Press, 1985. S.v. "Ault, George Copeland."

200 Fielding, Mantle. <u>Mantle Fielding's Dictionary of American Painters, Sculptors & Engravers</u>. 2d enl. ed. Edited by Glenn B. Opitz. Poughkeepsie, N.Y.: Apollo, 1986. S.v. "Ault, George Copeland."

201 "George Ault (1891-1948)." In <u>American Art Analog</u>. Vol. 3, <u>1874-1930</u>, comp. Michael David Zellman, 887. New York: Chelsea House, in association with American Art Analog, 1986.

A brief biographical sketch accompanied by auction price information for the artist's works.

202 Gilbert, Dorothy B., ed. <u>Who's Who in American Art</u>. Volume IV, <u>For the Years 1940-1947</u>. Washington, D.C.: American Federation of Arts, 1947. S.v. "Ault, George Copeland."

203 Myers, Bernard S., ed. <u>McGraw-Hill Dictionary of Art</u>, Vol. 1. New York: McGraw-Hill, 1969. S.v. "Ault, George Copeland."

204 Osborne, Harold, ed. The Oxford Companion to Twentieth-Century Art. New
York: Oxford University Press, 1981. S.v. "Ault, George."

205 Phaidon Dictionary of Twentieth-Century Art. London ; New York: Phaidon,
1973. S.v. "Ault, George C."

206 Samuels, Peggy and Harold Samuels. The Illustrated Biographical Encyclopedia
of Artists of the American West. New York: Doubleday, 1976. S.v. "Ault,
George C."

207 Vollmer, Hans. Allgemeines Lexikon der bildenden Kunstler des xx. Jahrhunderts,
Vol. 1. Leipzig: E.A. Seemann, 1953-1962. S.v. "Ault, George C."

VI. Archival Sources

208 Archives of American Art. The Card Catalog of the Manuscript Collections of
the Archives of American Art, Vol. 1. Wilmington, Del.: Scholarly Resources,
1980. S.v. "Ault, George C."

209 _____. The Card Catalog of the Manuscript Collections of the Archives of
American Art, Supplement 1981-1984. Wilmington, Del.: Scholarly Resources,
1985. S.v. "Ault, George."

This circulating microfilm collection contains numerous sources on Ault
including the George Ault Papers, 1915-1958; a forty-eight page record book
of sales and gifts of Ault's work, 1913-1980; and material from the Downtown
Gallery Papers, the J. B. Neumann Papers, the Pennsylvania Academy of the
Fine Arts Collection, and Records of the Public Works Art Project.

VII. Annotated Reproductions

Apple Trees, 1933. HIRSCHL/4 (b/w) 88.

_____. JANSS (b/w) 66, 206.

Black Night: Russell's Corners, 1943. PENNSYLVANIA/1 (b/w) 8-9.

Brooklyn Ice House, 1926. LONG ISLAND (c) 36-37.

_____. NEWARK (b/w) 156, 295.

Church Front, Woodstock, 1933. HIRSCHL/4 (b/w) 69.

Composition—Provincetown, 1922. WICHITA/1 (b/w) 33, 37.

Construction Night, ca. 1923. HIRSCHL/2 (c) 9.

_____. METROPOLIS (c) 461, 462, 464, 499.

_____. YALE (b/w) 12-13.

Corn from Iowa, 1940. JANSS (c) 159, 206.

Daffodil, 1931. HIRSCHL/4 (b/w) 93.

Early America, 1927. HIRSCHL/2 (c) 9.

42nd Street, Night (No. 2), 1920. NEUBERGER (b/w) 25-26.
From Brooklyn Heights, 1926. NEWARK (b/w) 157, 295.

Fruit Bowl on Red Oilcloth, 1930. EBSWORTH (c) 46-47, 197.

Houses in Hills, 1922. HIRSCHL/4 (b/w) 74-75.

The Hudson from Riverside Drive, 1920-21. SAN FRANCISCO/2 (b/w) 267.

Jefferson Gate, New York, 1927. LOS ANGELES (b/w) 460.

Little White Flower, 1939. ADLER (c) 23, 30-31.

The Mill Room, 1923. SAN FRANCISCO/1 (c) 220-221.

New Moon, New York, 1945. MOMA/13 (b/w) 228, 520.

Old House, New Moon, 1943. YALE (b/w) 12-13.

The Pianist, 1923. SHELDON (c) 2-3, 208.

Pile Driver, 1929. EBSWORTH (c) 48-49, 197.

The Propeller, 1922. HIRSHHORN (b/w) Pl. 315; p. 660.

Rick's Barn, Woodstock, 1939. COLUMBUS (b/w) 212.

Road to New York, 1939. SHELDON (b/w) 208.

Smoke Stacks, 1925. CARNEGIE (b/w) 159, 246.

The Stairway, 1921. MONTCLAIR (b/w) 130.

Sullivan Street, Abstraction, 1924. METROPOLIS (c) 461, 499.

_____. WALKER (c) 120-121.

Universal Symphony, 1947. EBSWORTH (c) 50-51, 197-198.

Victorian House and Tree, 1927. NEWARK (b/w) 156, 295.

Village Roofs, 1931. MINNESOTA (b/w) 36, 52.

_____. WALKER (b/w) 531.

Woodstock Landscape, 1938. BROOKLYN/1 (b/w) 15.

Young Girl, 1926. MET/3 (b/w) 148-149.

CHAPTER THREE
Peter Blume

Peter Blume was born on 27 October 1906 in Smorgon, Russia. His family moved to the United States in 1911 and settled in Brooklyn, New York. Following high school graduation in 1921, Blume enrolled in art classes at the Educational Alliance Art School, supplemented with study at the Beaux-Arts Institute of Design and the Art Students League. He rented a studio in New York on 13th Street while supporting himself with part-time work. During the late 1920s he also spent time painting in Provincetown, Northhampton, and Gloucester, Massachusetts; Camden, Maine; Exeter, New Hampshire; and Woodstock and Patterson, New York.

Blume's early works reflected the influence of Cubist Purism and occasionally incorporated unlikely combinations of objects. His career received a major boost when his works were shown to Charles Daniel, who invited Blume to join the stable of artists he represented through his Daniel Gallery. These included a number of early American modernists, among them Precisionists like Demuth, Dickinson, Sheeler, and Spencer. Blume's most important Precisionist works were executed in the late 1920s with rural and urban architectural subjects—Winter, New Hampshire and Gloucester: Landscape with Farm Buildings of 1927; White Factory and The Bridge of 1928; and The Boat and The Waterfront of 1929.

Blume's first one-man exhibition at the Daniel Gallery in 1930 featured the premiere of Parade, his first large-scale work. The painting combined Precisionist and Surrealist elements in a highly individualistic manner. He utilized the same basic approach in his next major work, South of Scranton of 1931, which incorporated realistic elements with fantasy images based on his memories of a car trip from Pauling, New York, to Charleston, South Carolina, via Scranton, Pennsylvania. Blume received national attention when the painting won the prestigious First Prize at the 1934 Carnegie International, although its imagery tended to baffle viewers and critics alike. In Light of the World of 1932, Blume again produced a work with enigmatic symbolism and allusions.

In 1931 Blume and his wife Ebie, whom he married the previous year, used the proceeds from his recent Guggenheim Fellowship to finance a trip to Italy, a country which would provide him with a great deal of artistic inspiration. Perhaps Blume's most famous work—and surely his most controversial—was The Eternal City of 1934-37. The painting showed a Roman vista with the Italian fascist dictator Mussolini depicted as a lurid green jack-in-the-box. Its overtly political theme led the jury for the

Sixteenth Biennial Exhibition at the Corcoran Gallery in 1939 to reject the painting, although it was purchased by Alfred Barr for the Museum of Modern Art in 1943. South of Scranton was acquired by the Metropolitan Museum of Art and Light of the World was purchased by the Whitney Museum of American Art. With his three most important canvases installed in New York's top museums, Blume's career was solidly established by the early 1940s. Blume had been involved in the Public Works Art Project during the 1930s and he was subsequently commissioned by the U.S. Treasury Department's Section of Fine Arts for Post Office murals in Rome, Georgia; Geneva, New York; and Canonsburg, Pennsylvania, between 1937 and 1942.

Blume's next major work was The Rock of 1948, which won the Popular Prize at the 1950 Carnegie International. This painting, as well as many of Blume's major canvases from this point onward—Passage to Aetna of 1956, Tasso's Oak of 1960, and From the Metamorphoses of 1979—contain highly-charged, sharply-defined imagery painted with a brilliant palette and replete with allegorical and mythological overtones. Other paintings, however, particularly landscapes and interiors such as The Italian Straw Hat of 1952, Landscape in Bali of 1954, Children in the Tree of 1961, Recollection of the Flood of 1969, The Boulders of Avila of 1976, and the seasons series (Winter of 1964, Summer of 1966, and Autumn of 1984), portray a calmer, more pastoral world.

In addition to his talents as a painter, Blume was also an accomplished draughtsman. He executed two notable series of drawings while he was Artist-in-Residence at the American Academy in Rome during 1956-57 and 1961-62, and another during a Pacific cruise in 1954. He turned his attention to sculpture in 1974 for a series of twenty-seven bronze statues of the goddess Venus.

Blume has carved out a special place for himself in the history of American modernism and he continues to chart a unique artistic course from his home and studio in Sherman, Connecticut.

I. Blume's Writings, Statements, and Interviews

210 Blume, Peter. "After Superrealism." The New Republic 80 (31 October 1934) 338-340.

> Review of James Johnson Sweeney's Plastic Redirections in 20th Century Painting (Chicago: University of Chicago Press, 1934).

211 _____. "The Artist Must Choose." In Artists Against War and Fascism: Papers of the First American Artists' Congress, 98-102. New Brunswick, N.J.: Rutgers University Press, 1986.

> Blume's address delivered to the public session of the First American Artists' Congress on 14 February 1936. Blume argues that the era in which the artist lives apart from society, with a highly specialized set of values and a contempt for the masses as despoilers of culture, must end in the face of the impending fascist threat to liberty.

212 Coates, Robert M. and Peter Blume. "Correspondence." Art Front 1 (May 1935) 7-8.

In a letter to the editors of Art Front, Coates and Blume supply the original answer to a question concerning the social function of a mural posed to Thomas Hart Benton in an interview appearing in an earlier issue of the magazine.

213 Parker, Donald G. and Warren Herendeen. "An Interview with Peter Blume." The Visionary Company 1 (Summer 1981) 56-76.

A lengthy interview of the artist conducted on 25 April 1981 at his home in Sherman, Connecticut. Blume discusses his early life and family background, his association with the Daniel Gallery, the influence of European art and American modernism on his work, and numerous other subjects. The second part of this interview was never published although Frank Anderson Trapp quotes extracts from a manuscript copy in his book Peter Blume (see 239).

214 Blume, Peter. "A Recollection of Hart Crane." The Yale Review 76 (March 1987) 152-156.

Blume's reminiscence of his friendship with Hart Crane centers on the years 1929-1930 when they both lived in the large colonial house owned by Addie Turner in Pawling, New York.

215 "South of Scranton." Carnegie Magazine 8 (October 1934) 155.

In this excerpted transcript of a radio talk, Blume addresses the manner in which he combined diverse impressions of the countryside gathered from an auto trip into the compositional elements of his painting South of Scranton of 1931.

216 "Symposium: The Creative Process." The Art Digest 28 (15 January 1954) 15, 32.

Blume's replies to thirteen questions concerning the creative process.

See also entries 217, 219, 221, 233, 235, 236, 239, 245, 248, 252, 253, 268, 274, and 333-337.

II. Monographs and Exhibition Catalogues

217 Amherst College. Mead Art Museum. Peter Blume: The Italian Drawings. Amherst, Mass.: The Museum, 1985.

Catalogue of an exhibition held at the Mead Art Museum, Amherst College, Amherst, Massachusetts, 1 November—1 December 1985. The thirty-one pen and ink drawings in the exhibition—all of which are illustrated—were executed while Blume was Artist-in-Residence at the American Academy in Rome during 1956-57 and 1961-62. The catalogue includes an essay by Frank Anderson Trapp and a statement by Blume on the drawings.

218 Art Students League of New York. Art Students League: Centennial Decade, 1967-1968, 24. New York: The League, 1967.

Blume was an instructor in the Art Students League of New York during the 1967-68 term when this catalogue of courses was issued. There is a biographical sketch of the artist and Tasso's Oak of 1960 is illustrated.

219 Coe Kerr Gallery. Bronzes About Venus. New York: The Gallery, [1974].

Catalogue of an exhibition of Blume's series of twenty-seven bronze sculptures of Venus held at the Coe Kerr Gallery, New York, 3 December 1974—4 January 1975. The catalogue contains an essay by Gordon Henricks and photographs of ten original wax models, accompanied by Blume's comments on each.

220 Currier Gallery of Art. Peter Blume in Retrospect: 1925 to 1964; Paintings & Drawings. [Manchester, N.H.: The Gallery, 1964.]

Catalogue of a major retrospective exhibition held at the Currier Gallery of Art, Manchester, New Hampshire, 18 April—31 May 1964. The exhibition also featured the premiere of Blume's Winter of 1964. In his catalogue essay, gallery director and exhibition curator Charles E. Buckley stresses Blume's singular place in the history of modern American painting and says, "Over a period of nearly forty years Blume has followed a path which has led him from the precise elegance of his early style deep into a territory that no other American painter has explored." The catalogue contains a checklist of the thirty-one paintings and sixty-three drawings in the exhibition and a biographical note on the artist.

221 Bernard Danenberg Galleries. Peter Blume: "Recollection of the Flood" and Related Works. New York: The Galleries, 1970.

Catalogue of an exhibition held at the Bernard Danenberg Galleries, New York, 30 March—18 April 1970, which includes thirty-five paintings and drawings, all of which are illustrated. The highlight of the exhibition was the premiere of Blume's Recollection of the Flood of 1969 along with numerous composition studies for the painting. The catalogue includes a statement by Blume on the painting.

222 Davidson, Abraham A. The Eccentrics and Other American Visionary Painters, 170-171. New York: E.P. Dutton, 1978.

A discussion of Blume's The Eternal City.

223 Durlacher Brothers. Peter Blume. New York: Durlacher Brothers, 1947.

Catalogue of an exhibition held at Durlacher Brothers, New York, 6 January—1 February 1947. The exhibition featured twenty studies for Quarry of 1942 and seventy-seven other drawings.

224 _____. Peter Blume. New York: Durlacher Brothers, 1949.
Catalogue of an exhibition held at Durlacher Brothers, New York, 3-29 January 1949. The exhibition featured the premiere of The Rock of 1948 plus ten other paintings.

225 _____. Peter Blume. New York: Durlacher Brothers, 1954.

Catalogue of an exhibition held at Durlacher Brothers, New York, 30 November—24 December 1954. The exhibition featured over forty pen and ink drawings rendered during a Pacific cruise in addition to seven paintings.

226 _____. Peter Blume. New York: Durlacher Brothers, 1958.

Catalogue of an exhibition held at Durlacher Brothers, New York, 25 February—22 March 1958.

227 _____. Peter Blume. New York: Durlacher Brothers, 1960.

Catalogue of an exhibition held at Durlacher Brothers, New York, 5 December 1960—28 January 1961. The exhibition featured the premiere of Tasso's Oak of 1960 along with compositional sketches for the painting.

228 _____. Peter Blume. New York: Durlacher Brothers, 1964.

Catalogue of an exhibition held at Durlacher Brothers, New York, 27 October—21 November 1964. The exhibition included two paintings, Children in the Tree of 1961 and Winter of 1964, in addition to fifty-two drawings.

229 Gambone, Robert L. Art and Popular Religion in Evangelical America, 1915-1940, 224-225. Knoxville: University of Tennessee Press, 1989.

An explication of the religious and political imagery in Blume's The Eternal City.

230 Kennedy Galleries. Peter Blume. New York: The Galleries, 1968.

Catalogue of an exhibition held at the Kennedy Galleries, New York, 20 February—9 March 1968. The exhibition included fifty-one paintings and drawings, all of which are illustrated. Catalogue essay by Frank Getlein.

231 Levy, Julien. Memoir of an Art Gallery, 203-204. New York: G.P. Putnam, 1977.

Levy recalls the circumstances surrounding the exhibition of Blume's The Eternal City at his New York gallery in 1937. Levy remarks, "I could sympathize with Blume's violent opinions at that time, but I could never bring myself to feel that propaganda took precedence over aesthetic elements in a painting. I wished very much to talk this matter through with Peter, but his stance was of such serene and stubborn determination that I was never able to do so."

232 Museum of Contempory Art, Chicago. Peter Blume: A Retrospective Exhibition. Chicago: The Museum, 1976.

Catalogue of an exhibition held at the Museum of Contemporary Art, Chicago, 10 January—20 February 1976. Blume's statement on his Recollection of the Flood of 1969 is reprinted from the Bernard Danenberg Gallery catalogue (see 221). A checklist of the twenty-seven paintings, forty-nine drawings and compositional studies, and seven pieces of sculpture, as well as a chronology of Blume's career, are included. Dennis Adrian's catalogue essay is reprinted in his Sight Out of Mind: Essays and Criticism on Art (Ann Arbor, Mich.: UMI Research Press, 1985).

233 Museum of Modern Art (New York, N.Y.) The Artist as Adversary. New York: The Museum, 1971.

Catalogue of an exhibition held at the Museum of Modern Art, New York, 1 July—17 September 1971. The exhibition included Blume's The Eternal City of 1934-37 and four preliminary studies for the painting executed during 1933-34. Two statements by Blume, excerpted from a 1943 MOMA interview, are included (pp. 11-12).

234 New Britain Museum of American Art. Peter Blume: Selected Paintings, Drawings and Sculpture Since 1964. New Britain, Conn.: The Museum, 1982.

Catalogue of an exhibition held at the New Britain Museum of American Art, New Britain, Connecticut, 3 October—14 November 1982. The exhibition featured the premiere of Blume's Crashing Surf of 1982 accompanied by four preliminary studies for the painting. The exhibition also included four other canvases along with numerous preliminary studies for each (Summer of 1966,

Recollection of the Flood of 1967, Boulders of Avila of 1973, and From the Metamorphoses of 1978) and seven pieces of sculpture from the artist's "Bronzes About Venus" series of 1973. The catalogue contains a checklist of the sixty works in the exhibition, a lengthy essay, and a chronology.

235 100 Contemporary American Jewish Painters and Sculptors. New York: YKUF Art Section, 1947. S.v. "Peter Blume."

A biographical entry with an illustration of Parade of 1947 and a statement by the artist under "Credo."

236 Park, Marlene and Gerald E. Markowitz. Democratic Vistas: Post Offices and Public Art in the New Deal. Philadelphia: Temple University Press, 1984. This book includes an extract from Blume's letter to Edward P. Rowan, an administrator with the U.S. Treasury Department's Section of Fine Arts, dated 11 February 1943, concerning the installation of Blume's mural Vineyard in the Post Office in Geneva, New York (p. 26; Color Plate I and Fig. 138). The authors briefly discuss this mural (p. 145), and Blume's other Post Office murals in Rome, Georgia (p. 23) and Canonsburg, Pennsylvania (p. 80; Fig. 67).

237 Rutgers University Art Gallery. Realism and Realities: The Other Side of American Painting, 1940-1960. New Brunswick, N.J.: The Gallery, 1981.

Catalogue of an exhibition held at the Rutgers University Art Gallery, New Brunswick, New Jersey, 17 January—26 March 1982, which includes two works by Blume. Blume's career is discussed by Greta Berman and Jeffrey Wechsler in their catalogue essay (pp. 35-37).

238 Terry Dintenfass, Inc. Peter Blume: "From the Metamorphoses," Recent Paintings and Drawings. New York: Terry Dintenfass, Inc., 1980.

Catalogue of an exhibition held at Terry Dintenfass, Inc., New York, 8-28 March 1980. The exhibition featured the premiere of From the Metamorphoses of 1979 along with two preliminary studies for the painting. Catalogue essay by John Paul Driscoll. The catalogue contains a chronology of Blume's career and a checklist of the sixteen works in the exhibition.

239 Trapp, Frank Anderson. Peter Blume. New York, Rizzoli International, 1987.

Trapp's monograph provides a detailed analysis of Blume's artistic evolution and aesthetic philosophy spanning seven decades, from the artist's early floral still lifes of 1925, Hyacinth and Cyclamen, to Autumn of 1984. Trapp quotes extensively from Blume's interviews and his published and unpublished writings. A good deal of attention is devoted to the critical reaction to Blume's work. Trapp's extensive commentary on The Eternal City of 1934-37 is

particularly noteworthy. The book is abundantly illustrated with color and black and white reproductions of paintings, drawings, and sculpture. A selected bibliography and lists of one-man exhibitions, public collections, and awards and honors, are also included. Malcolm Cowley's foreword is reprinted from The Virginia Quarterly Review (see 252), although this fact is not so noted.

240 University of Texas. Art Museum. Paul Magriel Collection: 100 Years of American Drawing. Austin: The Museum, [1964].

Catalogue of an exhibition of selected American drawings from the collection of Paul Magriel held at the Art Museum of the University of Texas, Austin, 8 November—6 December 1964. The exhibition included Blume's crayon drawing Columbine (not illustrated).

241 Vance, William L. America's Rome. Volume Two, Catholic and Contemporary Rome, 340-342. New Haven, Conn.: Yale University Press, 1989.

A discussion of Blume's The Eternal City.

242 Von Blum, Paul. The Art of Social Conscience, 124. New York: Universe, 1976.

A discussion of Blume's The Eternal City.

243 Whiting, Cecile. Antifascism in American Art, 54-64. New Haven, Conn.: Yale University Press, 1989.

Whiting's book contains an extended commentary on Blume's The Eternal City with reference to its depiction of antifascist themes in the Popular Front era.

III. Articles and Essays

244 Adams, Henry. "Peter Blume." In American Drawings and Watercolors in the Museum of Art, Carnegie Institute, 160-163. Pittsburgh: Carnegie Institute, Museum of Art ; Distributed by the University of Pittsburgh Press, 1985.

A discussion of Blume centering on his works in the Museum of Art at Carnegie Institute.

245 "Art: Carnegie Decides Blume's 'South of Scranton' is Best." News-Week 4 (27 October 1934) 19.

In this article on Blume's South of Scranton winning First Prize in the 1934 Carnegie International, the artist is quoted as saying, "I moved in my mind from Scranton to Bethlehem to Charleston. Things lost their logical connections, as they do in a dream."

246 "Art—'Important Acquisition'." Newsweek 21 (15 March 1943) 72, 74.

A report on the acquisition of Blume's The Eternal City by the Museum of Modern Art.

247 "Art—Mr. Carnegie's Good Money." Time 24 (29 October 1934) 38.

This discussion of Blume's South of Scranton winning First Prize in the 1934 Carnegie International contains comments of critics excerpted from five newspapers (Henry McBride, Douglas Naylor, William Germain Dooley, Margaret Breuning, and Edward Alden Jewell).

248 "Art—Not So Hopeful." Time 53 (17 January 1949) 73-74.

This article contains Blume's comments on The Rock of 1948.

249 "Art—Roman Token." Time 41 (15 March 1943) 38.

A report on the acquisition of Blume's The Eternal City by the Museum of Modern Art.

250 "Awarded the First Prize in Carnegie's Annual Show for South of Scranton." The Art News 33 (20 October 1934) 3.

Notice of Blume's South of Scranton being awarded First Prize at the 1934 Carnegie International.

251 Boswell, Peyton. "Logic Takes a Holiday." The Art Digest 13 (15 April 1939) 3.

In March 1939 Blume submitted The Eternal City to the Sixteenth Biennial Exhibition at the Corcoran Gallery of Art in Washington, D.C. Boswell, editor of The Art Digest, defends the Corcoran jury in their rejection of the painting.

252 Cowley, Malcolm. "Peter Blume: Painting the Phoenix." The Virginia Quarterly Review 61 (Summer 1985) 529-536.

Cowley's reminiscence of his lifelong friendship with Blume, which began in the late autumn of 1928, contains an insightful analysis of the artist's paintings, which Cowley feels are not only visual and architectural, but legendary or mythopoetic as well. Cowley quotes Blume as saying about his work, "I've been painting the phoenix, the Resurrection theme, in various forms." This article is reprinted as the foreword to Frank Anderson Trapp's Peter Blume (see 239).

253 Cowley, Robert. "Blume's Oak." <u>Horizon</u> 3 (July 1961) 70-75.

Cowley's discussion of Blume's <u>Tasso's Oak</u> of 1960 is accompanied by a photograph of the actual tree in Rome that served as Blume's inspiration. A large color reproduction of the painting and a number of comments by the artist are also included.

254 Geldzahler, Henry. "Peter Blume." In <u>American Painting of the Twentieth Century</u>, by Henry Geldzahler, 158-159. New York: Metropolitan Museum of Art ; Greenwich, Conn.: New York Graphic Society, 1965.
A discussion of Blume's <u>South of Scranton</u> of 1931.

255 Godsoe, Robert Ulric. "Peter Blume—A New Vision." <u>Creative Art</u> 11 (September 1932) 10-15.

A general assessment of Blume's work noting its Surrealist qualities, careful organization, and controlled craftmanship.

256 Gray, Cleve. "The Artist in America: Anniversary Album." <u>Art in America</u> 51 (February 1963) 66-67.

Two of Blume's 1961 pen and ink drawings are included in an album of works by ten American artists created in honor of the 50th anniversary of <u>Art in America</u>.

257 Kootz, Samuel M. "Peter Blume." In <u>Modern American Painters</u>, by Samuel M. Kootz, 27-29. New York: Brewer & Warren, 1930.

Kootz gives a critical assessment of Blume's early career with special attention devoted to <u>Parade</u> of 1930. Kootz speaks of Blume's "inventive originality that is almost austere in its devotion to the realization of a full expression of his own experiences." Four works are illustrated on black and white plates.

258 McBride, Henry. "This Year's International." <u>The American Magazine of Art</u> 27 (November 1934) 655-656.

McBride's comments on Blume's <u>South of Scranton</u> of 1931, which he calls "a weak effort at modernism."

259 O'Connor, John. "The People's Choice: <u>The Rock</u> by Peter Blume." <u>Carnegie Magazine</u> 25 (January 1951) 13-15.

Notice of Blume's <u>The Rock</u> of 1948 being awarded the Popular Prize in the 1950 Pittsburgh International. Excerpts from Howard Devree's comments on the painting in the <u>New York Times</u> (9 January 1949) are reprinted.

260 "People in the Arts." Arts 35 (January 1961) 10.

Blume's election to membership in the American Academy of Arts and Letters
is noted.

261 "Peter Blume Tilts with a Paper Dictator." The Art Digest 12 (15 December 1937)
12.

A review of the critical reaction to Blume's The Eternal City.

262 "Recent Paintings: Italian Straw Hat." Wadsworth Atheneum Bulletin 2d ser.,
no. 53 (January 1955) 2.

A discussion of the acquisition of Blume's The Italian Straw Hat of 1952 by the
Wadsworth Atheneum, Hartford, Connecticut.

263 Reed, Judith K. "Honored by the American Academy." The Art Digest 21 (1 June
1947) 11, 22.

A brief notice of Blume's receipt of a grant awarded jointly by the National
Institute of Arts and Letters and the American Academy of Arts and Letters.

264 Riley, Maude. "Modern Museum Buys Eternal City." The Art Digest 17 (15
March 1943) 5, 25.

Notice of the purchase of Blume's The Eternal City by the Museum of Modern
Art.

265 "The Rock—Artist Worked on it for Seven Years." Life 26 (11 April 1949) 108-
109.

A double-page color illustration of Blume's The Rock is accompanied by two
preliminary sketches and some general comments about the work.

266 Saint-Gaudens, Homer. "Consider the International." The Carnegie Magazine
8 (October 1934) 131-141.

This article, written by the Director of Fine Arts for the Carnegie Institute,
includes comments concerning Blume's South of Scranton being awarded First
Prize at the 1934 Carnegie International.

267 Soby, James Thrall. "The Fine Arts—History of a Picture." Saturday Review of
Literature 30 (26 April 1947) 30-33. Reprinted in Modern Art and the New Past,
by James Thrall Soby, 49-53. Norman: University of Oklahoma Press, 1957.

Soby traces the critical reception of Blume's South of Scranton of 1931 and concludes that in the final analysis there is no political, social, or moral "message" in the painting whatsoever.

268 _____. "An Important American Acquisition—Peter Blume's 'Eternal City'." The Bulletin of the Museum of Modern Art 10 (April 1943) 1-6. This detailed analysis of the genesis and iconography of Blume's The Eternal City is accompanied by the artist's comments on the painting.

269 _____. "Peter Blume." In Contemporary Painters, [2d ed.], by James Thrall Soby, 51-55. New York: Museum of Modern Art ; Distributed by Simon & Schuster, 1948.

A general overview of Blume's career, whom Soby calls "one of the major American painters of our century."

270 _____. "Peter Blume." In New Art in America: Fifty Painters of the 20th Century, ed. John I. H. Baur, 203-208. Greenwich, Conn.: New York Graphic Society, in cooperation with Praeger, New York, [1957].

A biographical sketch of Blume accompanied by six illustrations.

271 "Surrealism Wins the People's Vote." The Art Digest 25 (1 January 1949) 8.

Notice of Blume's The Rock of 1949 being awarded the Popular Prize in the 1950 Pittsburgh International; a brief commentary on the painting is included.

272 "Surrealist Work Wins First Prize at Carnegie International." The Art Digest 9 (15 October 1934) 5.

Notice of Blume's South of Scranton being awarded First Prize at the 1934 Carnegie International.

273 "The Talk of the Town—Prizewinner." The New Yorker 10 (3 November 1934) 14-15.

An overview of Blume's early career.

274 Weller, Allen S. "Blume." In Art: USA: Now, Vol. 1, ed. Lee Nordness, 146-149. New York: Viking, 1963.

A brief biographical sketch accompanied by illustrations and a statement by the artist.

IV. Exhibition Reviews

275 Goodrich, Lloyd. "New York Exhibitions." The Arts 9 (June 1926) 286.

Review of Blume's works appearing in an exhibition at the Daniel Gallery, New York.

276 Lozowick, Louis. "In the Midwinter Exhibitions." The Menorah Journal 13 (February 1927) 49-50.

Review of Blume's works appearing in an exhibition at the Daniel Gallery, New York.

277 "Exhibitions in New York: Peter Blume—Daniel Gallery." The Art News 28 (8 February 1930) 15-16.

Review of the exhibition "Paintings by Peter Blume" held at the Daniel Gallery, New York, 22 January—15 February 1930. This was Blume's first one-man show at the Daniel Gallery and it featured the premiere of Parade of 1930.

278 Flint, Ralph. "Around the Galleries." Creative Art 6 (March 1930) supp. 66.

Review. See entry 277.

279 Goodrich, Lloyd. "Around the Galleries—The Daniel Gallery." The Arts 16 (February 1930) 416, 419.

Review. See entry 277.

280 V. N. "Exhibitions." International Studio 95 (March 1930) 74.

Review. See entry 277.

281 "Art—Image of Italy." Time 30 (6 December 1937) 65.

Review of Blume's one-man exhibition at the Julien Levy Gallery, New York, 24 November—14 December 1937, which featured The Eternal City of 1934-37, along with preparatory sketches, related drawings, and watercolors.

282 Burke, Kenneth. "Growth Among the Ruins." The New Republic 93 (15 December 1937) 165-166.

Review. See entry 281.

283 Coates, Robert M. "The Art Galleries: The Bache Collection—Toulouse-Lautrec—and Peter Blume." The New Yorker 13 (4 December 1937) 113.

 Review. See entry 281.

284 Davidson, Martha. "Single Painting: Eternal City." The Art News 36 (27 November 1937) 14.

 Review. See entry 281.

285 Morris, George L. K. "Art Chronicle: Some Personal Letters to Artists Recently Exhibiting in New York. To Peter Blume, Julien Levy Gallery (one picture exhibition)." Partisan Review 4 (March 1938) 40-41.

 Review. See entry 281.

286 Coates, Robert M. "The Art Galleries—Huggermugger from the Louvre." The New Yorker 17 (15 February 1941) 61.

 Coates' review of the exhibition "American Art" held at the Downtown Gallery, New York, contains comments on Blume's The Eternal City.

287 _____. "The Art Galleries—Arthur Dove, Walter Murch, Peter Blume." The New Yorker 22 (18 January 1947) 60-61.

 Review of the exhibition "Peter Blume" held at Durlacher Brothers, New York, 6 January—1 February 1947.

288 Gibbs, Jo. "Unfinished Blume." The Art Digest 21 (15 January 1947) 17.

 Review. See entry 287.

289 "Reviews and Previews—Peter Blume." Art News 45 (January 1947) 42.

 Review. See entry 287.

290 Breuning, Margaret. "Peter Blume Presents His Magnum Opus." The Art Digest 23 (15 January 1949) 13.

 Review of the exhibition "Peter Blume" held at Durlacher Brothers, New York, 3-29 January 1949.

291 Coates, Robert. "The Art Galleries—Blume, Delaunay, Glackens." The New Yorker 24 (15 January 1949) 48-49.

Review. See entry 290.

292 Fremantle, Christopher E. "New York Commentary." The Studio 137 (May 1949) 157.

Review. See entry 290.

293 Hess, Thomas B. "Blume: Obsessed Realist." Art News 47 (January 1949) 22-23.

Review. See entry 290.

294 Coates, Robert M. "The Art Galleries—World Tour." The New Yorker 30 (11 December 1954) 171.

Review of the exhibition "Peter Blume" held at Durlacher Brothers, New York, 30 November—24 December 1954.

295 Newbill, Al. "Fortnight in Review—Peter Blume." Arts Digest 29 (15 December 1954) 20.

Review. See entry 294.

296 Seckler, Dorothy Gees. "Reviews and Previews—Peter Blume." Art News 53 (January 1955) 47.

Review. See entry 294.

297 Ashbery, John. "Reviews and Previews—Peter Blume." Art News 57 (March 1958) 16.

Review of the exhibition "Peter Blume" held at Durlacher Brothers, New York, 25 February—22 March 1958.

298 Breuning, Margaret. "Margaret Breuning Writes." Arts 32 (March 1958) 54.

Review. See entry 297.

299 Coates, Robert M. "The Art Galleries—Peter Blume and Others." The New Yorker 34 (15 March 1958) 128, 131.

Review. See entry 297.

300 Grosser, Maurice. "Art." The Nation 186 (22 March 1958) 264.

Review. See entry 297.

301 Schwartz, Marvin D. "News and Views from New York—Peter Blume Exhibits at Durlacher Brothers." Apollo 67 (April 1958) 144.

Review. See entry 297.

302 Coates, Robert M. "The Art Galleries—Those Nineteen Twenties Again." The New Yorker 36 (21 January 1961) 84, 86.

Review of the exhibition "Peter Blume" held at Durlacher Brothers, New York, 5 December 1960—28 January 1961.

303 Hayes, Richard. "Reviews and Previews—Peter Blume." Art News 59 (January 1961) 16.

Review. See entry 302.

304 Judd, Donald. "In the Galleries—Peter Blume." Arts 35 (January 1961) 56.

Review. See entry 302.

305 Coates, Robert M. "The Art Galleries—Six." The New Yorker 40 (7 November 1964) 169.

Review of the exhibition "Peter Blume in Retrospect, 1925 to 1964: Paintings & Drawings" held at the Currier Gallery of Art, Manchester, New Hampshire, and which later traveled to the Wadsworth Atheneum, Hartford, Connecticut, 9 July—16 August 1964.

306 Campbell, Lawrence. "Reviews and Previews—Peter Blume." Art News 63 (November 1964) 14.

Review of the exhibition "Peter Blume" held at Durlacher Brothers, New York, 27 October—21 November 1964.

307 Raynor, Vivian. "In the Galleries—Peter Blume." Arts Magazine 39 (December 1964) 76.

Review. See entry 306.

308 Downes, Rackstraw. "Reviews and Previews—Peter Blume." Art News 67 (March 1968) 11.

Review of the exhibition "Peter Blume" held at the Kennedy Galleries, New York, 20 February—9 March 1968.

309 Giuliano, Charles. "In the Galleries—Peter Blume." <u>Arts Magazine</u> 42 (March 1968) 60.

Review. See entry 308.

310 Spector, Stephen. "In the Galleries—Peter Blume at Danenberg." <u>Arts Magazine</u> 44 (April 1970) 61.

Review of the exhibition "Peter Blume—<u>Recollection of the Flood</u> and Related Works" held at the Bernard Danenberg Galleries, New York, 30 March—18 April 1970.

311 White, Claire Nicholas. "Reviews and Previews—Peter Blume." <u>Art News</u> 69 (April 1970) 14.

Review. See entry 310.

312 Silverthorne, Jeanne. "Reviews—New York: Peter Blume." <u>Artforum</u> 18 (Summer 1980) 81.

Review of the exhibition "Peter Blume: 'From the Metamorphoses,' Recent Paintings and Drawings" held at Terry Dintenfass, Inc., New York, 8-28 March 1980.

313 Bass, Ruth. "Reviews—New York: Peter Blume." <u>Art News</u> 87 (March 1988) 195.

Review of the exhibition "Peter Blume: Paintings and Drawings" held at Terry Dintenfass, Inc., New York, 1-31 December 1987, which included seventeen paintings and drawings and three pieces of sculpture from the artist's "Bronzes About Venus" series of 1974.

V. Reference Sources

314 Abramson, Glenda, ed. <u>The Blackwell Companion to Jewish Culture from the Eighteenth Century to the Present</u>. Cambridge, Mass.: Basil Blackwell, 1989. S.v. "Blume, Peter," by Kristie A. Jayne.

315 Baigell, Matthew. <u>Dictionary of American Art</u>. New York: Harper & Row, 1982. S.v. "Blume, Peter."

316 Contemporary Artists. 3d ed. Chicago: St. James Press, 1989. S.v. "Blume, Peter."

317 Cummings, Paul. Dictionary of Contemporary American Artists. 5th ed. New York: St. Martin's, 1988. S.v. "Blume, Peter."

318 Current Biography Yearbook 1956. New York: H.W. Wilson, 1957. S.v. "Blume, Peter."

319 Encyclopedia of American Art. New York: E.P. Dutton, 1981. S.v. "Blume, Peter," by Alfred V. Frankenstein.

320 Falk, Peter Hastings, ed. Who Was Who in American Art: Compiled from the Original Thirty-four Volumes of "American Art Annual: Who's Who in Art." Madison, Conn.: Sound View Press, 1985. S.v. "Blume, Peter."

321 Fielding, Mantle. Mantle Fielding's Dictionary of American Painters, Sculptors & Engravers. 2d enl. ed. Edited by Glenn B. Opitz. Poughkeepsie, N.Y.: Apollo, 1986. S.v. "Blume, Peter."

322 International Who's Who, 1990-91. 54th ed. London, England: Europa, 1990. S.v. "Blume, Peter."

323 Myers, Bernard S., ed. McGraw-Hill Dictionary of Art, Vol. 1. New York: McGraw-Hill, 1969. S.v. "Blume, Peter," by Jerome Viola.

324 Osborne, Harold, ed. The Oxford Companion to Twentieth-Century Art. New York: Oxford University Press, 1981. S.v. "Blume, Peter."

325 "Peter Blume (1906-)." In American Art Analog. Vol. 3, 1874-1930, comp. Michael David Zellman, 964. New York: Chelsea House, in association with American Art Analog, 1986.

 A brief biographical sketch accompanied by auction price information for the artist's works.

326 "Peter Blume—Painter." Index of Twentieth Century Artists, 1933-1937, 583-584, 595. New York: Arno Press, 1970.

327 Phaidon Dictionary of Twentieth-Century Art. London ; New York: Phaidon, 1973. S.v. "Blume, Peter."

328 Praeger Encyclopedia of Art, Vol. 1. New York: Praeger, 1971. S.v. "Blume, Peter," by Emily Wasserman.

329 Rosenblatt, Judith Turk, ed. Who's Who in World Jewry: A Biographical Dictionary of Outstanding Jews. Baltimore ; New York: Who's Who in World Jewry, 1987. S.v. "Blume, Peter."

330 Vollmer, Hans. Allgemeines Lexikon der bildenden Kunstler des xx. Jahrhunderts, Vol. 1. Leipzig: E.A. Seemann, 1953-1962. S.v. "Blume, Peter."

331 Who's Who in America, 1990-91, Vol. 1. 46th ed. Wilmette, Ill.: Marquis Who's Who, 1990. S.v. "Blume, Peter."

332 Who's Who in American Art, 1991-92. 19th ed. New York: R.R. Bowker, 1990. S.v. "Blume, Peter."

VI. Archival Sources

333 Brown, Robert F. "Regional Office Reports—New England." Archives of American Art Journal 23, no. 4 (1983) 37.

334 _____. "Regional Office Reports—New England." Archives of American Art Journal 24, no. 2 (1984) 33.

Blume was the subject of an extensive series of interviews with the Archives of American Art during late 1983 and early 1984. Blume's papers will eventually be donated to the AAA. "Throughout the interviews," Brown remarks, "Blume stressed the continuity of purpose and the paramountcy of formal qualities in his work."

335 Archives of American Art. The Card Catalog of the Manuscript Collections of the Archives of American Art, Vol. 1. Wilmington, Del.: Scholarly Resources, 1980. S.v. "Blume, Peter."

This circulating microfilm collection contains numerous sources on Blume including material from the Albert Duveen Papers, the Downtown Gallery Papers, the Whitney Museum Papers (which include a typescript of a paper delivered at the symposium, "Modern Artists on Artists of the Past," Museum of Modern Art, 22 April 1952), and the Records of the Public Works Art Project, in addition to Blume's correspondence with various individuals such as Joseph Hirsch, Louis Lozowick, and Henry Schnakenberg.

336 _____. The Card Catalog of the Oral History Collections of the Archives of American Art. Wilmington, Del.: Scholarly Resources, 1984. S.v. "Blume, Peter."

This oral history collection contains an untranscribed lecture delivered by Blume at the Skowhegan School of Painting and Sculpture, Skowhegan, Maine, on 15 August 1958.

337 Records of the Public Buildings Service (Record Group 121), Case Files Concerning Embellishments of Federal Buildings, 1934-43. National Archives and Records Administration, Washington, D.C.

These files contain approximately seventy-five pages of materials relating to Blume's commission for a Post Office mural in Canonsburg, Pennsylvania, and approximately two hundred pages concerning his commission for a Post Office mural in Rome, Georgia. The National Archives also maintains files of artists' correspondence that house Blume's correspondence relating to his Post Office mural in Geneva, New York.

VII. Annotated Reproductions

Coal Breaker—Scranton, 1930. CUMMINGS (b/w) 114-115.

Crucifixion, 1951. ILLINOIS/53 (b/w) Pl. 107; p. 167.

_____. RANDOLPH-MACON (b/w) 46-47.

Drawing, 1942. MOMA/3 (b/w) 28-29, 64.

Early Spring, 1957. CUMMINGS (b/w) 115.

Elemosina, 1933. MOMA/5 (b/w) 207, 247.

The Eternal City, 1934-37. CANADAY (c) Pl. 132; pp. 26-27.

_____. MOMA/6 (c) 106.

_____. MOMA/13 (b/w) 245, 525.

_____. TIME-LIFE (b/w) 110-111.

Excavation, 1945. ROCKEFELLER/1 (c) 155.

Flowers and Torso, 1927. EBSWORTH (c) 52-53, 198.

_____. MARONEY/2 (c) 20-23, 62-63.

Gloucester: Landscape with Farm Buildings, 1927. MICHENER (c) 41.

Home for Christmas, 1926. COLUMBUS (c) 120-121, 203.

_____. HOWLAND (b/w) 9-10, 12.

Hyacinth, 1920. SAN FRANCISCO/2 (b/w) 275.

Hyacinth, 1926. GOLDSTONE (b/w) 12-13.

Key West Beach, 1940. MOMA/3 (b/w) 28-29, 64.

Landscape (Falling Water), 1938. HIRSCHL/4 (b/w) 99.

Landscape with Cow, 1926. MARONEY/2 (c) 20-23, 66-67.

Landscape with Poppies, 1939. MOMA/3 (b/w) 28, 64.
_____. MOMA/13 (b/w) 245, 525.

Nude, 1957. ROBY (b/w) 32.

Painting of a Nun, 1967. MCNAY (b/w) 50-51.

Parade, 1930. BOSWELL (c) [106]-108.

_____. MOMA/4 (b/w) Pl. 200.

_____. MOMA/5 (b/w) 207, 247.

_____. MOMA/13 (b/w) 244, 525.

The Rock, 1948. CHICAGO (c) 147.

_____. LEAGUE/2 (b/w) 74-75.

Sketch for Landscape and Poppies, 1938. HIRSCHL/4 (b/w) 98.

_____. JANSS (b/w) 62, 207.

South of Scranton, 1931. ELIOT (c) 255, 257-258.

_____. FOREIGN (b/w) 108-109.

_____. WIGHT (b/w) Pl. 33; pp. 31, 98.

Still Life—Cyclamen No. 1, ca. 1925. HOWLAND (b/w) 9, 12.

Study for <u>Parade</u>, 1929. KENNEDY/6 (c) Pl. 25.

_____. NEW YORK/2 (b/w) 70, 82.

Study for <u>South of Scranton (Crow's Nest)</u>, 1930. CARNEGIE (b/w) 162, 251.

_____. MARONEY/3 (b/w) Pl. 12.

Study for <u>The Rock</u>, 1942. SACHS/2 (b/w) 232, 247-248.

<u>Vegetable Dinner</u>, 1927. MARONEY/2 (c) 20-23, 64-65.

<u>Waterfront, Manhattan</u>, 1929. CITYSCAPE (b/w) Pl. 18.

<u>White Boat</u> (<u>The Boat</u>; <u>Showboat</u>), 1929. LEWISOHN/1 (b/w) Pl. 126; p. 299.
_____. LEWISOHN/2 (b/w) 13, 84.

_____. MOMA/13 (b/w) 245, 525.

<u>White Factory</u>, 1928. BARKER (b/w) 66-69.

_____. SHELDON (c) 18-19, 220.

CHAPTER FOUR
Ralston Crawford

Although he was born north of the border in Saint Catharines, Ontario, on 25 September 1906, George Ralston Crawford spent only a short period of time in Canada before his family moved to Buffalo, New York, in 1910. He was the only son of a ship's captain and spent his early years around the docks and wharves of the Great Lakes. After completing secondary school, Crawford moved to New York City in 1926 where he joined the crew of a United Fruit Company vessel bound for Los Angeles via ports in Central and South America. While in Los Angeles he studied commercial art at the Otis Art Institute and worked as an illustrator for the Walt Disney Studios. He moved to Philadelphia in 1927 to enroll at the Pennsylvania Academy of the Fine Arts, where he studied under Hugh Breckenridge and Henry Bainbridge McCarter until 1930. During this time Crawford also attended the lectures of Dr. Albert Coombs Barnes in nearby Merion. The Barnes Foundation's outstanding collection of European art ranges from the Impressionists and Post-Impressionists to the Cubists and Fauves. American modernism is also represented, including Precisionist works by Demuth and Sheeler. In contrast to the more conservative approach taught at the Pennsylvania Academy, which emphasized color and subject matter, Dr. Barnes concentrated on the formal structural qualities in the works of artists such as Cezanne, Picasso, and Matisse. Crawford was able to view another excellent collection of Cubist art in Philadelphia belonging to the Precisionist artist Earl Horter.

Crawford returned to New York in 1931 and married Margaret Stone the following year. They set off on a European sojourn which took them to France, Spain, Italy, and Switzerland. Crawford was particularly impressed with the works of El Greco and Goya he viewed in Spain. The financial problems experienced by the Crawfords upon their return to New York in 1933 eventually led to their move to Exton, Pennsylvania, near Philadelphia, in 1935. Crawford was the subject of a critically acclaimed one-man exhibition at Philadelphia's Boyer Galleries in 1937. His Precisionist works of the 1930s generally depict rural architecture, industrial vistas, or seascapes. His use of simplified geometrical forms, rendered through the arrangement of smooth interlocking planes of single colors, reflect the influence of Synthetic Cubism. Crawford frequently imbued the pictorial elements in these compositions with Surrealist overtones of mystery, incongruity, and suspended time.

Crawford spent five months in early 1938 as Artist-in-Residence at the Research Studios in Maitland, Florida. It was here that he began his career in photography,

concentrating on architectural and industrial subjects. His involvement with lithography also began in the late 1930s. His first color print, <u>Overseas Highway</u>, was produced in 1940. Crawford's oil painting of the same title was featured in the February 1939 issue of <u>Life</u> magazine and was an instant popular success. Although Crawford's paintings of the 1940s retained Precisionist subject matter, they eliminated modeling and perspective in favor of arrangements of extremely flat, sharp-edged color planes. While these works bear a superficial similarity to those of the Abstract Expressionists of the period, Crawford's aesthetic aims and working methods were diametrically opposed to theirs. As Crawford put it, his goal was "selection, elimination, simplification and distortion for the purpose of conveying emotional and intellectual reactions to the thing seen."

Following his divorce from Margaret in 1939, Crawford remained in New York until he accepted visiting art instructor positions at the Cincinnati Art Academy (1940-41), where he met his second wife Peggy Frank, and at the Albright Art School in Buffalo, New York (1942). During World War II he served as a master sergeant in the Visual Presentation Unit of the Weather Division, Headquarters, Army Air Force, Washington, D.C. Following the war, Crawford was commissioned by <u>Fortune</u> to cover Operation Crossroads, the atomic bomb tests conducted on the Bikini Atoll in the Marshall Islands. His paintings and drawings of Test Able, the above ground detonation, were featured in the December 1946 issue of the magazine.

Crawford moved beyond his Precisionist phase in the postwar years and started to work with a vocabulary of abstract geometric forms and linear patterns and grids in complex, rhythmic arrangements. Crawford's photographs frequently served as compositional studies for his paintings following selected modifications such as cropping or enlargement of details. Photography was a serious, independent pursuit for him as well as being a valuable adjunct to the painting process. Between 1950 and the mid-1970s Crawford produced a large body of genre photographs of New Orleans—a city that held a special fascination for him—focusing on the street life, parades, jazz musicians, and cemeteries. He also painted over a dozen canvases devoted to various aspects of the city.

Crawford's involvement with lithography intensified after 1950. Many of his finest works in this medium were produced at the atelier of Georges Sagourin during his visits to Paris. The subjects of Crawford's graphic works frequently reflect the sights he viewed on his travels—postwar ruins in Cologne, bullfights in Spain, fishing villages in southern France, car races in Indianapolis, graveyards in New Orleans, freightyards in Minneapolis, and elevated railways in New York.

Crawford's late work continued to build upon his achievements of the previous decades with his compositions becoming increasingly complex. He began to work seriously with motion pictures as an artistic tool in the mid-1960s, preferring a movie camera to a sketch pad for an assignment at the behest of the Interior Department to document water reclamation sites in the western states. Outside of his work as an artist and a photographer, two activities took up much of Crawford's time later in life. The first was teaching, either as a faculty member or as a visiting artist, at various educational institutions that included the New School for Social Research, Louisiana State University, University of Colorado, University of Kentucky, University of

Minnesota, University of Nebraska, University of Illinois, and Hofstra College. The second activity was world travel, which took him to many parts of the globe, including Europe, Asia, Africa, Canada, Mexico, the Caribbean, and the South Pacific.

Despite a diagnosis of cancer in 1971, Crawford continued to work up to the very end, which came in Houston, Texas, on 27 April 1978. He was buried in the St. Louis Cemetary, New Orleans, after a traditional brass band funeral. Crawford's distinguished and singular achievements in painting, lithography, and photography, clearly established him as the most important of the later Precisionists.

I. Crawford's Writings, Statements, and Interviews

338 Crawford, Ralston. "Art Notes." Maryland Quarterly no. 2 (1944) 83.

> Crawford discusses what he believes to be the challenge confronting contemporary painters, namely, "Is his particular vehicle suitable for documenting a particular situation?" Crawford finds a lack of realism in photographs of World War II and he also expresses concern over the democratic distribution of art works. One of Crawford's pen and ink war drawings is illustrated (p. 54).

339 "Bikini—With Documentary Photographs, Abstract Paintings, and Meteorological Charts Ralston Crawford Here Depicts the New Scale of Destruction." Fortune 34 (December 1946) 156-161.

> In 1946 Crawford was commissioned by Fortune magazine to cover Operation Crossroads on the Bikini Atoll in the Marshall Islands where two atomic bomb tests were conducted (Test Able, the above water test on July 1 which Crawford witnessed, and Test Baker, the underwater test on July 25). In addition to photographs and meteorological charts, two paintings (Test Able and U.S.S. Nevada) are reproduced in color. Crawford states in the article, "But my forms and colors are not direct transcriptions; they refer in paint symbols to the blinding light of the blast, to its colors, and to its devastating character as I experienced them in Bikini lagoon." The paintings and gouaches Crawford executed were featured in a special exhibition at the Downtown Gallery, New York, 3-21 December 1946, and they received a good deal of criticism for their abstract treatment of the subject.

340 "The Collections: Recent Acquisitions: Coal Elevators by Ralston Crawford." Saint Louis Art Museum Bulletin n.s. 14 (January-March 1978) 10-15.

> An edited interview of Crawford conducted by Jack Cowart in New York on 10 August 1977. In addition to discussing his Coal Elevators of 1938, Crawford also comments on his Overseas Highway, his paintings of the Bikini atomic

bomb tests, and his influences and general working methods. "It is sure," Crawford remarks, "that Guglielmi was an influence in my life and a great source of nourishment."

341 Crawford, Ralston. "Comment on Modern Art." Paradise of the Pacific 59 (August 1947) 17-19, 32.

Crawford gives a general statement of his aesthetic philosophy and he notes that the great vital traditions of art in the Orient and the Occident, whether primitive or sophisticated, are not concerned with copying nature, but rather with selective principles, distortion, and abstraction.

342 _____. "Crawford Dissents." The Art Digest 22 (1 April 1948) 32-33.

An open letter from Crawford to James S. Plaut and Nelson W. Aldrich of the Boston Institute of Contemporary Art in which Crawford defends modern art against their charges that it is "dated and academic."

343 _____. "Editors Letters." Art News 40 (1-14 December 1941) 4.

Crawford states that he objects to being classified by specific labels, particularly his characterization as a "New Realist."

344 "A Modern Artist Explains the Relationship Between His Photography and Painting." Modern Photography 13 (September 1949) 74-79, 110.

In this article, Crawford articulates the nature of the relationship between his photography and his painting. "My photography," he states, "follows my painting in a great measure. So it is of a rather abstract variety." Crawford believes that photography serves to extend, magnify, and clarify one's experience in viewing objects, rather than simply substituting for such experience. He has found that shooting a single subject from various angles and distances, as well as enlarging and cropping prints from a single negative, frequently yields illuminating discoveries.

345 Simon, Joan. "New York Today: Some Artists Comment—Ralston Crawford." Art in America 65 (September-October 1977) 80-81.

An interview of Crawford in which he discusses various aspects of the New York art scene.

346 "Symposium: Is the French Avant Garde Overrated?" Art Digest 27 (August 1953) 12.

Crawford offers the opinion that American art, while gaining respect in Europe, has had little appreciable influence on French and European art. On the other

hand, he states that no young artists presently working in Paris have the substance of Cezanne, Picasso, or Gris.

See also entries 017, 074, 347, 353, 354, 361, 362, 364, 375, 379, 386, 390, 393, 454-456, 719, and 1192.

II. Monographs and Exhibition Catalogues

347 Agee, William C. Ralston Crawford. Pasadena, Calif: Twelvetrees Press, 1983.

Agee states in his introductory essay that although Crawford's art historically has been classified as Precisionist, it actually owes more to European modernism than to American sources, particularly Surrealism, Cubism, and Non-Objective painting. Agee notes that Crawford's post-1944 style moved in an abstract direction whose orientation can be placed within the broad forms and strong colors of Synthetic Cubism and was based on a continual process of selection and synthesis, reordering and recombining visual elements. Pictorial complexity dominated Crawford's work by the late 1950s, an era in which Agee feels the artist had reached the peak of his creative powers. Agee also assesses Crawford's work in lithography and photography. Many of the sixty-seven illustrations are juxtaposed with excerpts from the artist's interviews, lectures, statements, and correspondence, both published and unpublished. The book closes with a chronology, a selected bibliography, a list of one-man exhibitions, and a list of collections owning Crawford's work.

348 Boyer Galleries (Philadelphia, Pa.) Exhibition of Paintings: Ralston Crawford. Philadelphia: The Galleries, 1937.

Catalogue of an exhibition of eighteen works held at the Boyer Galleries, Philadelphia, 10-30 March 1937. In his catalogue essay, Ford Madox Ford notes that Crawford's colors ". . . have an infectious gaiety because they are clear and juxtaposed with knowledge the one beside the other. His composition is good, in the sense that the eye is cunningly directed, has no difficulty in finding the place where the gaze should alight."

349 Cincinnati Art Museum. Crawford. Cutler. Cincinnati, Ohio: The Museum, 1949.

Catalogue of an exhibition of paintings by Crawford and sculpture by George Gordon Cutler, held at the Cincinnati Art Museum, 17 February—15 March 1949. Catalogue essay by Philip Rhys Adams.

350 Cincinnati Modern Art Society. Ralston Crawford Lithographs. Cincinnati, Ohio: Contemporary Arts Center; Cincinnati Art Museum, 1956.

Catalogue of an exhibition held at the Contemporary Arts Center, Cincinnati Art Museum, 6 January—17 February 1956. Catalogue foreword by Gustave von Groschwitz.

351　Crawford, Ralston. Music in the Street: Photographs of New Orleans. New Orleans, La.: Historic New Orleans Collection, 1983.
Catalogue of an exhibition sponsored by the Historic New Orleans Collection and the William Ransom Hogan Jazz Archive of Tulane University, New Orleans, Louisiana, 13 April—22 July 1983. Foreword by Stanton Frazar, Director of the Historic New Orleans Collection; catalogue essay, "Music in the Street: New Orleans Musical Folk as Photographed by George Ralston Crawford," by Curtis J. Jerde, Curator of the William Ransom Hogan Jazz Archive; and "Introduction to the Photographs" by John H. Lawrence, Curator of the Historic New Orleans Collection. The catalogue reproduces thirty-three of the sixty-five photographs in the exhibition, which feature New Orleans jazz musicians, dancers, parades, storefronts, funerals and cemetaries, and so forth, taken between the late 1940s and the early 1960s.

352　Creighton University. Fine Arts Gallery. Ralston Crawford: Retrospective Exhibition. Omaha, Neb.: The Gallery, 1968.

Catalogue of an exhibition held at the Creighton University Fine Arts Gallery, Omaha, Nebraska, 23 October—9 December 1968. A checklist of the ninety-two paintings, drawings, and lithographs in the exhibition; a chronology; a bibliography; and a list of public collections owning Crawford's works are included. Catalogue essay by L. E. Lubbers.

353　Downtown Gallery. Ralston Crawford: Paintings of Operation Crossroads at Bikini. New York: The Gallery, 1946.

Catalogue of an exhibition held at the Downtown Gallery, New York, 3-21 December 1946. The exhibition featured eight paintings and selected gouaches of the atomic bomb test on the Bikini Atoll in the Marshall Islands. The catalogue includes a statement by the artist.

354　Freeman, Richard B. The Lithographs of Ralston Crawford. Lexington: University of Kentucky Press, 1962.

Freeman catalogs Crawford's 118 lithographs executed between 1940 and 1960 and provides information on inscriptions; color; paper dimensions; number of prints in edition; artist's proofs; essai proofs; trial proofs; printers; and public collections. Approximately one-third of the lithographs are illustrated, eight in color and thirty-one in black and white. Freeman's introductory essay, "The Lithographs of Ralston Crawford," precedes the catalogue. Crawford's 1961 "Statement on Lithography" is included along with a transcription of a

talk given by the artist in 1953 on the creative process entitled "A Painter's Notes." The book also contains a useful glossary of technical terms and a selected bibliography.

355 _____. Ralston Crawford. University, Ala.: University of Alabama Press, 1953.

Freeman gives an overview of Crawford's career along with providing a chronology, a catalogue of paintings and prints, a list of one-man exhibitions, an indication of Crawford's representation in public collections, a selected bibliography, and a number of reprints of critical writings on the artist. Twenty-nine works are illustrated. "With complete confidence," Freeman writes, "one can say that there are few artists working as seriously, as intelligently, and as effectively as Crawford. He is one of the handful whose work in the past two decades reveals so clearly the logical sequence of growth that has come only by deep thought, by sensitivity to environment, and by the innate poetry and invincibility of his beliefs."

356 Haskell, Barbara. Ralston Crawford. New York: Whitney Museum of American Art, 1985.

Catalogue of a major retrospective exhibition held at the Whitney Museum of American Art, New York, 3 October 1985—2 February 1986. Haskell's extensively documented text outlines and critically assesses Crawford's entire career as a painter, lithographer, and photographer. Haskell points out that while Crawford's work is appropriately classified as Precisionist in terms of its architectural subject matter, stylistic features, and ordered pictorial discipline, Crawford himself belonged to the later generation of artists who developed Abstract Expressionism. Haskell also notes that for Crawford painting was not such a purely objective endeavor as it was for the earlier generation of Precisionists insofar as his work is infused with an emotional intensity and psychological mystery that transcends formalist or thematic interpretations. The catalogue contains 149 illustrations; a checklist of the paintings, drawings, lithographs, and photographs in the exhibition; and a selected exhibition history and bibliography.

357 Heckscher Museum. The Prints of Ralston Crawford. Huntington, N.Y.: The Museum, 1989.

Catalogue of an exhibition held at the Heckscher Museum, Huntington, New York, 29 September—12 November 1989.

358 Helman Gallery. <u>Ralston Crawford</u>. St. Louis, Mo.: The Gallery, 1971.

> Catalogue of an exhibition of eight paintings and selected drawings held at the Helman Gallery, St. Louis, 22 May—25 June 1971. Barbara Rose's catalogue essay, "Ralston Crawford: American Modernist," is a critical overview of the artist's career with a special emphasis on his stylistic development. She notes that while Crawford's energy and dynamism is distinctly American, his formal sources are to be found in European modernism. "His art," Rose concludes, "exemplifies the best values of American painting: dedication to workmanship, personal interpretations of personal experience, controlled energy."

359 Hirschl & Adler Galleries. <u>The Prints of Ralston Crawford</u>. New York: The Galleries, 1985.

> Catalogue of an exhibition of thirty-six prints held at the Hirschl & Adler Galleries, New York, November 1985-January 1986. Catalogue essay by Janet A. Flint.

359a _____. <u>Ralston Crawford and the Sea</u>. New York: The Galleries, 1991.

> Catalogue of an exhibition held at the Hirschl & Adler Galleries, New York, 9 March—20 April 1991. The exhibition included ninety of Crawford's marine paintings, drawings, prints, and photographs, sixty-eight of which are illustrated. Carter Ratcliff's catalogue essay provides background on Crawford's lifelong interest in depicting marine subjects. A selected bibliography is included.

360 Louisiana State University. Art Gallery. <u>Ralston Crawford</u>. Baton Rouge: The Gallery, [1950].

> Catalogue of an exhibition held at the Louisiana State University Art Gallery, Baton Rouge, 24 February—17 March 1950. The catalogue contains a checklist of the nineteen paintings, twelve prints, and fourteen photographs in the exhibition; a chronology; a list of public collections owning Crawford's work; and a bibliography. Twelve works are illustrated. In his introduction, James Johnson Sweeney remarks that Crawford's "gift of selection" in his compositions results in "subtle, delicate tensions" as well as "a quiet, lyric ease."

361 Middendorf/Lane Gallery. <u>Ralston Crawford: Paintings, Watercolors, Prints, and Drawings</u>. Washington, D.C.: The Gallery, 1977.

> Catalogue of an exhibition held at the Middendorf/Lane Gallery, Washington, D.C., December 1977. Russell Lynes' catalogue essay contains statements by the artist.

362 Milwaukee Art Center. <u>Ralston Crawford</u>. [Milwaukee, Wis.: The Center, 1958.]

Catalogue of an exhibition held at the Milwaukee Art Center, Milwaukee, Wisconsin, 6 February—9 March 1958. The catalogue contains an introduction by Edward H. Dwight and eight statements by the artist discussing various aspects of his work and his influences. The Milwaukee Art Center press release, "Ralston Crawford Speaks at Opening of His Exhibition at Milwaukee Art Center," contains brief excerpts from his speech. A checklist of the sixty-one paintings, twelve pen and ink drawings, and thirty-three lithographs is included. Thirty-three works are illustrated (the color lithograph <u>Third Avenue Elevated #4</u> of 1951 is featured on the cover).

363 Nordness Gallery. <u>Ralston Crawford: Oils and Lithographs</u>. New York: The Gallery, 1963.

Catalogue of an exhibition held at the Nordness Gallery, New York, 12-30 March 1963. Catalogue essay by H. H. Arnason. Thirty works are illustrated.

364 Santa Barbara Museum of Art. <u>Ralston Crawford: Paintings</u>. Santa Barbara, Calif.: The Museum, 1946.

Catalogue of an exhibition of twenty-nine paintings held at the Santa Barbara Museum of Art, Santa Barbara, California, 2 April—2 May 1946. Catalogue essay by Donald Bear. A statement by the artist is included.

365 Sheldon Memorial Art Gallery. <u>The Photography of Ralston Crawford</u>. Lincoln, Neb.: The Gallery, 1974.

Catalogue of an exhibition held at the Sheldon Memorial Art Gallery, Lincoln, Nebraska, 15 January—10 February 1974. Forty-nine photographs from the exhibition are illustrated. Crawford's own catalogue of 225 of his photographs, arranged by subject, will be of particular interest to researchers. In his catalogue essay, exhibition organizer Norman A. Geske states that "There is probably no other American artist of our time whose work is so completely integrated, whose achievement in varying media are so equal in quality. To think of Crawford only as a painter is to miss the spare linear brilliance of his drawings and the two-dimensional integrity of his lithographs where color is fused with paper in what must surely be some of the purest prints of our time."

366 University of Kentucky. Art Gallery. <u>Graphics '73: Ralston Crawford</u>. Lexington: The Gallery, 1973.

Catalogue of an exhibition held at the University of Kentucky Art Gallery, Lexington, 11 February—4 March 1973. The exhibition included sixty-one black and white drawings (chiefly pen and ink) and eighteen watercolors, all of

which are illustrated. Richard B. Freeman's catalogue essay discusses Crawford's drawings. The catalogue also includes a chronology, a list of one-man exhibitions, and a checklist of the exhibition.

367 University of Maryland. Art Gallery. Ralston Crawford: Photographs/Art and Process. College Park: The Gallery, 1983.

Catalogue of an exhibition of 152 of Crawford's photographs held at the Art Gallery, University of Maryland, College Park, 22 March—1 May 1983. A preface by Arthur R. Blumenthal precedes Edith A. Tonelli's catalogue essay, "The Process of Art of Ralston Crawford." The catalogue contains fifty-nine reproductions of Crawford's photographs as well as a chronology of Crawford's photographic career.

368 University of Minnesota. University Gallery. Ralston Crawford. [Minneapolis: The Gallery, 1949.]

Catalogue of an exhibition held at the University Gallery, University of Minnesota, Minneapolis, 28 April—20 May 1949. The catalogue includes a checklist of the fifty-five paintings, drawings, prints, and photographs in the exhibition; a chronology; a list of one-man shows; a list of public collections owning the artist's work (prints or drawings); and a selected bibliography. The catalogue features a photograph of Crawford's studio and illustrations of ten works.

369 Whitney Museum of American Art, Fairfield County. Ralston Crawford: Photographs. Stamford, Conn.: The Museum, 1985.

Catalogue of an exhibition held at the Whitney Museum of American Art, Fairfield County, Stamford, Connecticut, 15 November 1985—22 January 1986. The catalogue essay by guest curator Susan Cooke surveys Crawford's entire career as a photographer. A checklist of the 122 photographs in the exhibition is provided (thirteen of which are illustrated).

370 Zabriski Gallery. Ralston Crawford: Paintings, Drawings, Photographs, and Lithographs. New York: The Gallery, 1973.

Catalogue of an exhibition held at the Zabriskie Gallery, New York, 3-30 March 1973. The exhibition featured fifteen paintings, nine pen and ink drawings, and a selection of lithographs and photographs. The catalogue contains an uncredited essay and a chronology.

III. Articles and Essays

371 "Album: Ralston Crawford." Arts Magazine 58 (December 1983) 48-49.

Four black and white reproductions from a Crawford exhibition held at the Robert Miller Gallery, New York, 22 November—30 December 1983.

372 "Buffalo Buys Strong Crawford Canvas." The Art Digest 16 (1 October 1941) 11.

Notice of the purchase of Crawford's Pennsylvania Barn (also called White Barn) of 1936 by the Albright Art Gallery, Buffalo, New York.

373 Crawford, Ralston. "Studies in Black and White." Direction 3 (March 1940) 21.

Photographs of a prison camp in Orlando, Florida.

374 DeWitt, John. "Reclamation Launches Art Program." Reclamation Era: A Water Review Quarterly 56 (February 1970) 5-8.

In the summer of 1969 the Bureau of Reclamation, U.S. Department of the Interior, commissioned a number of artists, selected by Lloyd Goodrich, to paint water resource development sites in the western states for display at visitor's centers. Crawford is pictured with one of the two movie cameras he used to film the Grand Coulee Third Powerplant. He made no preliminary sketches in the field but relied solely on these films as a basis for his paintings and drawings.

375 Dwight, Edward H. "Lithographs by Ralston Crawford." Art in America 43 (October 1955) 40-41.

Dwight feels that the validity and lasting power of Crawford's lithographs executed in Paris in the early 1950s lies in "the essence of something deeply felt and penetratingly seen in nature." Dwight's article contains quotes from his conversations and correspondence with Crawford.

376 Farrell, James J. "The Crossroads of Bikini." Journal of American Culture 10 (Summer 1987) 55-66.

In this article on the United States atomic bomb tests conducted during July 1946 on the Bikini Atoll in the Marshall Islands (Operation Crossroads), Farrell discusses Crawford's paintings and drawings of the event commissioned by Fortune magazine and he remarks on the artist's use of fireball orange colors and jagged lines. "The photographs and paintings of the Bikini tests," Farrell goes on to say, "were also the first instances of the 'atomic sublime,' in which

the color, shape, dynamism, and destructiveness of atomic explosions combined to reproduce an aesthetic response not unlike the response to nineteenth-century landscapes of Albert Bierstadt and Thomas Moran."

377 Fortune 31 (October 1945).

The cover illustration is Air Transport by Crawford.

378 Freeman, Richard B. "Artist at Bikini." Magazine of Art 40 (April 1947) 156-158.

An edited reprint of Freeman's article that originally appeared in the Flint Institute of Arts edition of the Magazine of Art in which Freeman discussed Crawford's "Operation Crossroads" assignment for Fortune magazine. In a postscript to the editor, Freeman defends Crawford's abstract treatment of the subject.

379 _____. "The Prints of Ralston Crawford." Print Review no. 20 (1985) 13-21.

Freeman surveys Crawford's work in lithography from his first print, the color lithograph Overseas Highway of 1940, to his late group of etchings on religious themes executed in Pietrasanta, Italy, in 1976. Numerous prints from the artist's estate are reproduced and selected passages from Crawford's letters to his wife Peggy are reprinted.

380 Frost, Rosamund. "The Air in Abstract." Art News 42 (15-31 January 1944) 20.

Frost reviews Crawford's career and states that his more recent canvases "now represent one of the milestones in American abstract art."

381 Heilpern, John. "Ralston Crawford's Gift of Selection." Aperture no. 92 (Fall 1983) 66-75.

The title of Heilpern's article comes from James Johnson Sweeney's observations on Crawford's "gift of selection" (see 360). Heilpern argues that Crawford's carefully controlled reduction and ordering of the visual elements in his compositions, and their resulting mathematical precision and symmetry, gives his photographs a special sort of emotional intensity. Heilpern also comments on Crawford's choice of subject matter for his photographs, the relationship between his photography and his painting, and the little known silent film shorts he made starting in the 1940s.

382 Jordan, George E. "Ralston Crawford: A Remembrance." The New Orleans Art Review 2 (May-June 1983) 10-11.

383 Koch, Vivienne. "Four War Drawings." New Directions no. 9 (1946) 411-[415].

Koch discusses four of Crawford's war drawings (which are illustrated) and notes his powers of observation, discipline, and control which have produced a symbolic warning of the dangers of atomic warfare.

384 Lawrence, John. "Ralston Crawford: The Photographs." The New Orleans Art Review 2 (May-June 1983) 9-10.

385 "National Affairs—House: Out of the Picture." Newsweek 29 (12 May 1947) 32-33.

Crawford's Plane Production of ca. 1946 was one of seventy-nine modernist oils and thirty-eight watercolors purchased by the Department of State for a projected two-part "Advancing American Art" exhibition slated to make an extensive goodwill tour of Europe and Latin America under the auspices of the Department's newly organized Office of International and Cultural Affairs. The widely publicized controversy generated by the exhibition, however, led to its recall by Secretary George Marshall in 1947. This article contains a partial transcript of an exchange between Assistant Secretary of State William Benton, who organized the exhibition, and Representative Karl Stefan, a Nebraska Republican who was a vocal critic, during hearings before the subcommittee of the House Committee on Appropriations. Stefan took the opportunity to ridicule Benton and a number of the paintings in the exhibition. Crawford's canvas is illustrated sideways in the article over the caption "Which side up? Benton didn't know." For the complete story behind this ill-fated exhibition, which also included works by Guglielmi and Sheeler, see Advancing American Art: Painting, Politics, and Cultural Confrontation at Mid-Century, by Taylor D. Littleton and Maltby Sykes (Tuscaloosa: University of Alabama Press, 1989).

386 Pagano, Grace. Contemporary American Painting: The Encyclopaedia Britannica Collection. New York: Duell, Sloan and Pearce, 1945. S.v. "Ralston Crawford."

A biographical sketch with a statement by Crawford on Whitestone Bridge of 1939, which is illustrated.

387 "Photographs by Ralston Crawford." Paradise of the Pacific 59 (Christmas 1947) 4-5.

388 "Purchase of Prints—Ralston Crawford Colored Lithograph." The Bulletin of the Museum of Fine Arts of Houston, Texas 4 (June 1941) [9].

Notice of the purchase of Crawford's lithograph <u>Overseas Highway</u> by the Museum of Fine Arts, Houston, Texas, and a brief discussion concerning the ways in which it differs from Crawford's oil painting of the same title.

389 "Radar—The Technique." <u>Fortune</u> 32 (October 1945) 138-145, 196, 198, 200.

This article on basic radar principles and their use in navigation, bombing, weather reconnaissance, and airborne search is illustrated by a weather map by Crawford (p. 145); the cover illustration is <u>Radar</u> by Crawford.

390 "Ralston Crawford's Photographs." <u>The Second Line</u> 4 (July-August 1953) 1-12.

Crawford discusses his photographs of New Orleans jazz musicians—twenty of which are illustrated—and states that jazz music and painting both emphasize the importance of individual expression.

391 "Thunder Over the North Atlantic." <u>Fortune</u> 30 (November 1944) 152-160, 197, 199-200, 203-204, 206.

This article on weather forecasting over the North Atlantic by the Eighth Squadron of the Army Air Force's Weather Wing during World War II is illustrated with weather maps by Crawford; the cover illustration is <u>Merchant Marine</u> by Crawford.

392 Watson, Ernest W. "The Art of Ralston Crawford." <u>American Artist</u> 24 (April 1960) 47-51, 64-66.

In his survey and analysis of Crawford's paintings, Watson focuses on the artist's role in securing the validity of abstraction as an art form through his sincerity, the range and depth of his personal experience, his formal training, and the emotional power of his compositions.

393 Weller, Allen S. "Crawford." In <u>Art: USA: Now</u>, Vol. 1, ed. Lee Nordness, 150-153. New York: Viking, 1963.

A brief biographical sketch accompanied by illustrations and a statement by the artist.

IV. Exhibition Reviews

394 "Crawford Simplicity." <u>The Art Digest</u> 11 (1 April 1937) 11.

Two reviews from Philadelphia newspapers are quoted concerning the "Exhibition of Paintings: Ralston Crawford" held at the Boyer Galleries, Philadelphia, 10-30 March 1937.

395 "Crawford's Abstractions." The Art Digest 13 (1 March 1939) 23.

Review of the exhibition "Ralston Crawford: Paintings" held at the Boyer Galleries, New York, 23 February—11 March 1939.

396 Holme, Bryan. "New York—Ralston Crawford (Boyer Gallery)." The Studio 117 (May 1939) 229.

Review. See entry 395.

397 McCausland, Elizabeth. "Gallery Index—Boyer Galleries." Parnassus 11 (March 1939) 34.
Review. See entry 395.

398 "New Exhibitions of the Week—Crawford at Boyer Galleries." Art News 37 (4 March 1939) 21.

Review. See entry 395.

399 "Crawford Exhibits Industry-Inspired Art." The Art Digest 16 (1 June 1942) 10.

A lengthy quote from Richard B. Freeman's catalogue essay for the exhibition "The Work of Ralston Crawford" held at the Flint Institute of Arts, Flint, Michigan, June-July 1942.

400 "What the Artists are Doing: Crawford Solo." Art News 42 (15-31 March 1943) 21.

Review of the exhibition "Paintings by Ralston Crawford" held at the Artist's Gallery, Philadelphia, 5 March—3 April 1943.

401 "Art—Abstractions and Weather." Newsweek 23 (17 January 1944) 91.

Review of the exhibition "Ralston Crawford in Peace and War" held at the Downtown Gallery, New York, 4-29 January 1944.

402 Coates, Robert M. "In the Galleries—Fifty Years Too Soon." The New Yorker 19 (15 January 1944) 54-55.

Review. See entry 401.

403 Holme, Bryan. "New York Commentary." The Studio 128 (July 1944) 28, 30.

Review. See entry 401. This review includes an excerpt of a letter from Colonel N. N. Yates, Chief of the Weather Information Branch, Weather Division of the

Air Corps, to gallery director Edith Gregor Halpert, concerning the paintings and drawings in the exhibition (reprinted from the exhibition catalogue).

404 Riley, Maude. "The Artist and the Meteorologist." The Art Digest 18 (15 January 1944) 9.

Review. See entry 401.

405 Tjader, Harris M. "Recent Work by M/Sgt. Ralston Crawford." Direction 7 (February-March 1944) 25.

Review. See entry 401.

406 "Art—Pat Chaos." Time 48 (9 December 1946) 61.

Review of the exhibition "Ralston Crawford: Paintings of Operation Crossroads at Bikini" held at the Downtown Gallery, New York, 3-21 December, 1946.

407 Coates, Robert M. "In the Galleries—The Artist and the World." The New Yorker 22 (14 December 1946) 70.

Review. See entry 406.

408 Wolf, Ben. "Crawford Interprets the Bikini Blast." The Art Digest 21 (1 December 1946) 10.

Review. See entry 406.

409 "Reviews and Previews—Ralston Crawford." Art News 45 (December 1946) 42.

Review. See entry 406.

410 La Farge, Henry A. "Reviews and Previews—Ralston Crawford." Art News 48 (February 1950) 48-49.

Review of the exhibition "Ralston Crawford: Paintings, Drawings, Photographs" held at the Downtown Gallery, New York, 31 January—18 February 1950.

411 Reed, Judith Kaye. "Ralston Crawford: Plane and Straight." The Art Digest 24 (15 February 1950) 14.

Review. See entry 410.

412 Porter, Fairfield. "Reviews and Previews—Ralston Crawford." Art News 53 (December 1954) 49-50.

Review of the exhibition "Recent Works by Ralston Crawford" held at the Grace Borgenicht Gallery, New York, 8 November—4 December 1954.

413 Rosenblum, Robert. "Fortnight in Review—Ralston Crawford." Arts Digest 29 (15 November 1954) 23-24.

Review. See entry 412.

414 B.G. "In the Galleries—Ralston Crawford." Arts 30 (November 1955) 50.

Review of the exhibition "Ralston Crawford Lithographs Made in Paris" held at the Weyhe Gallery, New York, 17 October—10 November 1955.

415 J.K.H. "Reviews and Previews—Ralston Crawford." Art News 54 (December 1955) 56.

Review. See entry 414.

416 Munro, Eleanor C. "Reviews and Previews—Ralston Crawford." Art News 55 (December 1956) 12.

Review of the exhibition "Ralston Crawford" held at the Grace Borgenicht Gallery, New York, 19 November—8 December 1956.

417 Pollet, Elizabeth. "In the Galleries—Ralston Crawford." Arts 31 (December 1956) 64.

Review. See entry 416.

418 Campbell, Lawrence. "Reviews and Previews—Ralston Crawford." Art News 57 (November 1958) 52.

Review of the exhibition "Ralston Crawford" held at the Grace Borgenicht Gallery, New York, 28 October—15 November 1958.

419 Sawin, Martica. "In the Galleries—Ralston Crawford." Arts 33 (November 1958) 57.

Review. See entry 418.

420 Peterson, Valerie. "Reviews and Previews—Ralston Crawford." Art News 60 (October 1961) 13.

Review of the exhibition "Ralston Crawford: Retrospective of Lithographs" held at the Nordness Gallery, New York, 3-21 October 1961.

421 Tillman, Sidney. "New York Exhibitions: In the Galleries—Ralston Crawford." Arts Magazine 36 (October 1961) 39-40.

 Review. See entry 420.

422 Beck, James H. "Reviews and Previews—Ralston Crawford." Art News 62 (May 1963) 12.

 Review of the exhibition "Ralston Crawford: Oils and Lithographs" held at the Nordness Gallery, New York, 12-30 March 1963.

423 Tillman, Sidney. "New York Exhibitions: In the Galleries—Ralston Crawford." Arts Magazine 37 (May-June 1963) 103.

 Review. See entry 422.

424 Atirnomis. "New York Galleries—Ralston Crawford." Arts Magazine 45 (May 1971) 62.

 Review of the exhibition "Ralston Crawford: Recent Paintings, Plus Selected Major Oils, Gouaches, and Drawings from the 1930s to the 1960s" held at the Nordness Gallery, New York, 17 April—7 May 1971.

425 Channin, Richard. "Reviews and Previews—Ralston Crawford." Art News 70 (Summer 1971) 12.

 Review. See entry 424.

426 Atirnomis. "New York Galleries—Ralston Crawford." Arts Magazine 45 (May 1971) 62.

 Review of the exhibition "Ralston Crawford" held at the Zabriskie Gallery, New York, 27 April—15 May 1971.

427 Campbell, Lawrence. "Reviews and Previews—Ralston Crawford." Art News 70 (May 1971) 12.

 Review. See entry 426.

428 Lanes, Jerrold. "New York—Ralston Crawford." Artforum 9 (June 1971) 88-89.

 Review. See entry 426.

429 Frank, Peter. "Reviews and Previews—Ralston Crawford." Art News 72 (May 1973) 83.

Review of the exhibition "Ralston Crawford: Paintings, Drawings, Photographs, and Lithographs" held at the Zabriskie Gallery, New York, 3-30 March 1973.

430 Masheck, Joseph. "Reviews—Ralston Crawford." Artforum 11 (June 1973) 77-78.

Review. See entry 429.

431 Eisenman, Stephen. "Ralston Crawford." Arts Magazine 58 (December 1983) 4.

Review of the exhibition "Ralston Crawford: Photographs/Art and Process" held at the Art Gallery, University of Maryland, College Park, 22 March—1 May 1983 and which traveled to the Frederick S. Wight Gallery, University of California at Los Angeles, 27 September—13 November 1983.

432 Gallati, Barbara. "Arts Reviews—Ralston Crawford." Arts Magazine 58 (March 1984) 37-38.

Review of the exhibition "Ralston Crawford: A Selection of Important Paintings from the Years 1945 to 1975" held at the Robert Miller Gallery, New York, 22 November—30 December 1983.

433 Danto, Arthur C. "Art—Ralston Crawford." The Nation 241 (7 December 1985) 625-629. Reprinted in The State of the Art, by Arthur C. Danto, 140-145. New York: Prentice-Hall, 1987.

Review of the exhibition "Ralston Crawford" held at the Whitney Museum of American Art, New York, 3 October 1985—2 February 1986.

434 Stretch, Bonnie Barrett. "Reticent Romantic." Art News 85 (April 1986) 117-121.

Review. See entry 433.

435 Tillyard, Virginia. "Exhibition Reviews: New York—Ralston Crawford at the Whitney." The Burlington Magazine 128 (February 1986) 175-176.

Review. See entry 433.

436 Mahoney, Robert. "Arts Reviews—Ralston Crawford." Arts Magazine 62 (March 1988) 106-107.

Review of the exhibition "Ralston Crawford (1906-1978): An Exhibition of Abstract Works in Painting, Photographs and Drawings" held at the Robert Miller Gallery, New York, 1 December 1987—2 January 1988.

437 Tillyard, Virginia. "Exhibition Reviews: Chicago and New York—O'Keeffe, Davis, Crawford." The Burlington Magazine 130 (March 1988) 260.

Review. See entry 436.

438 Grimes, Nancy. "Reviews: New York—Ralston Crawford." ArtNews 90 (Summer 1991) 151-152.

Review of the exhibition "Ralston Crawford and the Sea" held at the Hirschl & Adler Galleries, New York, 9 March—20 April 1991.

V. Book Reviews

439 Galloway, John C. "Book Reviews." The Art Journal 22 (Summer 1963) 276.

Review of Richard B. Freeman's The Lithographs of Ralston Crawford (Lexington: University of Kentucky Press, 1962).

VI. Reference Sources

440 Baigell, Matthew. Dictionary of American Art. New York: Harper & Row, 1982. S.v. "Crawford, Ralston."

441 Cummings, Paul. Dictionary of Contemporary American Artists. 5th ed. New York: St. Martin's, 1988. S.v. "Crawford, Ralston."

442 Encyclopedia of American Art. New York: E.P. Dutton, 1981. S.v. "Crawford, Ralston," by Alfred V. Frankenstein.

443 Falk, Peter Hastings, ed. Who Was Who in American Art: Compiled from the Original Thirty-four Volumes of "American Art Annual: Who's Who in Art." Madison, Conn.: Sound View Press, 1985. S.v. "Crawford, Ralston."

444 Fielding, Mantle. Mantle Fielding's Dictionary of American Painters, Sculptors & Engravers. 2d enl. ed. Edited by Glenn B. Opitz. Poughkeepsie, N.Y.: Apollo, 1986. S.v. "Crawford, Ralston."

445 Marks, Claude. World Artists, 1950-1980. New York: H.W. Wilson, 1984. S.v. "Crawford, Ralston."

446 Myers, Bernard S. <u>McGraw-Hill Dictionary of Art</u>, Vol. 2. New York: McGraw-Hill, 1969. S.v. "Crawford, Ralston."

447 Osborne, Harold, ed. <u>The Oxford Companion to Twentieth-Century Art</u>. New York: Oxford University Press, 1981. S.v. "Crawford, Ralston."

448 <u>Phaidon Dictionary of Twentieth-Century Art</u>. London ; New York: Phaidon, 1973. S.v. "Crawford, Ralston."

449 "Ralston Crawford (1906-1978)." In <u>American Art Analog</u>. Vol. 3, <u>1874-1930</u>, comp. Michael David Zellman, 968. New York: Chelsea House, in association with American Art Analog, 1986.

A brief biographical sketch accompanied by auction price information for the artist's works.

450 Vollmer, Hans. <u>Allgemeines Lexikon der bildenden Kunstler des xx. Jahrhunderts</u>, Vol. 1. Leipzig: E.A. Seemann, 1953-1962. S.v. "Crawford, Ralston."

451 <u>Who Was Who in America</u>. Vol. 7, <u>1977-1981</u>. Chicago: Marquis Who's Who, 1981. S.v. "Crawford, Ralston."

452 <u>Who's Who in American Art, 1978</u>. New York: Bowker, 1978. S.v. "Crawford, Ralston."

VII. Theses

453 Frank, Peter. "Ralston Crawford." M.A. thesis, Columbia University, 1974.

VIII. Archival Sources

454 Archives of American Art. <u>The Card Catalog of the Manuscript Collections of the Archives of American Art</u>, Vol. 3. Wilmington, Del.: Scholarly Resources, 1980. S.v. "Crawford, Ralston."

455 _____. <u>The Card Catalog of the Manuscript Collections of the Archives of American Art, Supplement 1981-1984</u>. Wilmington, Del.: Scholarly Resources, 1985. S.v. "Crawford, Ralston."

This circulating microfilm collection contains numerous sources on Crawford including material from the Albert Duveen Papers, the American Artists Group, Inc., Papers, the Downtown Gallery Papers, and the Records of the Public Works Art Project, in addition to Crawford's correspondence with various individuals such as Julien Levi, A. Hyatt Mayor, and Edgar P. Richardson.

456 _____. The Card Catalog of the Oral History Collections of the Archives of
 American Art. Wilmington, Del.: Scholarly Resources, 1984. S.v. "Crawford,
 Ralston."

 This oral history collection contains a 1968 interview of Ilya Bolotowsky which
 includes the artist's reminisences about Crawford.

457 William Ransom Hogan Jazz Archive. Tulane University, New Orleans,
 Louisiana.
 This archive contains approximately eight hundred of Crawford's photographs
 of various New Orleans subjects such as jazz musicians, dancers, parades,
 funeral processions and cemetaries, and so forth. The archive also houses tape
 recorded talks Crawford gave to a class conducted by former curator Richard
 B. Allen.

IX. Annotated Reproductions

At the Dock #2, 1941-42. NEUBERGER (b/w) 112-114.

Boat and Grain Elevators No. 2, 1941-42. PHILLIPS/2 (b/w) Pl. 319.

Bomber, 1944. ILLNOIS/49 (b/w) Pl. 60; [biographical note].

Box Car, n.d. PHILLIPS/2 (b/w) Pl. 320.

Box Cars, Minneapolis II, 1961. WHITNEY/2 (b/w) Pl. 49; p. 15.

Buffalo Grain Elevators, 1937. NATIONAL (c) 134-135, 234.

Buildings, 1936. MUNSON (c) 152-153.

Cold Spring Harbor, 1931. LONG ISLAND (c) 28.

Cologne Landscape, No. 6, 1951. MET/4 (c) 41.

Easthampton Bridge (Bridge at Easthampton), 1940. SHELDON (b/w) 233-234.

Electrification, 1936. HIRSHHORN (b/w) Pl. 462; p. 675.

First Avenue No. 4, 1968. COLUMBUS (b/w) 222.

Fishing Boat No. 1, n.d. TWEED (b/w) 120-121.

From the Bridge, 1942. MOMA/1 (b/w) 91, 149.

Fuel Tanks, Wisconsin [photograph], n.d. GRUBER (b/w) Pl. 180; p. 259.

The Glass No. 1, 1954. PHILLIPS/2 (b/w) Pl. 321.

Grain Elevators from the Bridge, 1942. GINGOLD (b/w) 44-45.

_____. JANIS (b/w) 64.

Grain Elevators, Minneapolis, 1949. FOREIGN (b/w) 96-97.

Grey Street, 1940. PRINTS/3 (b/w) Pl. 14; p. 114.

Maitland Bridge No. 2, 1938. LANE (c) Pl. 90; p. 175.

Mountain Bird Maru, 1947-49. TOLEDO (b/w) 37, 210.

Nacelles Under Contruction, 1946. CORPORATE (c) 98-99.

New Orleans No. 3, 1953. LANE (c) Pl. 90, p. 175.

New Orleans No. 5, 1953-54. SHELDON (c) 30-31, 234.

New Orleans No. 7, 1954-56. LANE (c) Pl. 92; p. 175.

Overseas Highway, 1939. BOSWELL (c) 115-116, [126].

_____. THYSSEN (c) 70-73.

Overseas Highway, 1942. PRINTS/5 (b/w) 46, 239-240.

Plane Production, ca. 1946. LITTLETON (c) 90-91.

Port Clyde #1, 1965. FLINT (b/w) Pl. 28.

Shaw's Propellors, 1954. NEWARK (b/w) 196, 311.

Steel Foundry, Coatsville, 1937. HIRSCHL/2 (c) 20.

Theatre Roof, 1937. HIRSCHL/2 (c) 21.

Third Avenue El, 1949. WALKER (c) 166-167.

Third Avenue Elevated #3, 1952. PHILLIPS/2 (b/w) Pl. 322.

Third Avenue Elevated #4, 1952. ACTON (c) 188-189, 257-258.

Torn Signs #2, 1967-68. HIRSHHORN (b/w) Pl. 835; p. 675.

Untitled, ca. 1949-51. WHITNEY/5 (b/w) Pl. 55; pp. 122-123.

Ventilator with Porthole, 1935. SHELDON (b/w) 233.

Vertical Building, 1934. SAN FRANCISCO/2 (b/w) 289.

White Barn, 1936. ALBRIGHT-KNOX/2 (b/w) 548.

Whitestone Bridge, 1939. ROCHESTER (b/w) 232.

CHAPTER FIVE
Charles Demuth

One of several Precisionists native to Pennsylvania, Charles Henry Buckius Demuth was born on 8 November 1883 in Lancaster. His early artistic education began in Philadelphia, first at the Drexel Institute of Art, Science, and Industry, from October 1901 to June 1905, and concurrently at the Pennsylvania School of Industrial Art during the summer of 1904 and the Pennsylvania Academy of Fine Arts from April 1905 to February 1910. Although Demuth studied under William Merritt Chase at the Pennsylvania Academy, he was more influenced there by Henry Bainbridge McCarter and Hugh Breckenridge. It was also in Philadelphia where Demuth met and formed a lifelong friendship with William Carlos Williams.

During Demuth's five-month trip to Europe in 1907-08 he viewed a wide range of modernist European art. On his next European visit in December of 1912 he met Marsden Hartley. It was through Hartley that Demuth met Gertrude Stein, whose Paris salon served as a gathering place for many leading artists and intellectuals. Demuth attended classes in Paris at the Academie Moderne, supplemented with independent study at the Academie Colarossi and the Academie Julian.

Upon his return to America in the spring of 1914, Demuth divided his time between Lancaster and New York, with summers spent in Provincetown in the company of Hartley, Stuart Davis, Eugene O'Neill, and other artists and writers. In 1915 he rented an apartment in Greenwich Village on Washington Square South. Being somewhat of a dandified bon-vivant, Demuth enjoyed frequenting Village cafes, Broadway vaudeville theatres, and Harlem nightclubs, often in the company of Hartley, Marcel Duchamp, or Edward Fisk. He executed a large number of watercolors depicting scenes from the circus, vaudeville, male Turkish baths (he was a homosexual), and other spots of New York nightlife. He was given the first of eight one-man exhibitions at the Daniel Gallery during October and November of 1914 (the last took place during November and December of 1923).

Demuth's strong literary interests led him to illustrate the works of a number of authors including Watteau, Pater, Balzac, Zola, Wedekind, Poe, James, and McAlmon. During this period he also produced a large body of floral watercolors which showcased his considerable talents as a colorist.

A decisive turning point in Demuth's artistic evolution took place during his stay in Bermuda from late 1916 to early 1917 in the company of Hartley and the French Cubist Albert Gleizes. Demuth's Bermuda landscapes reflected an increasing

appropriation of the formal Cubist vocabulary, which included linear precision, geometric simplification, dynamic angles, faceted planes, shallow space, and a multiplicity of viewpoints. His final trip to Europe in 1921 convinced Demuth that he needed to seek his identity as an American artist despite the difficulties inherent in championing modernism in a less than receptive cultural environment. It was also on this trip that he became ill with a malady that was later to be diagnosed as diabetes and one which would increasingly take its toll on his artistic activities over the remainder of his life.

Although Demuth continued to paint watercolor still lifes throughout the 1920s, he turned his attention early in the decade to architectural and industrial subjects in Pennsylvania, chiefly in Lancaster, executed in oil or tempera. These paintings were influenced both by William Carlos Williams' emphasis on indigenous local subject matter and by the interest displayed by Dada artists in machines and the modern urban landscape. While Demuth did not view industrialization with hostility, his ambivalence towards it was sometimes reflected in the titles he gave to these Precisionist works. Incense of a New Church of 1921, for example, shows a factory with bellowing smokestacks.

Demuth's fondness for ambiguity, witty riddles, veiled allusions, and symbolism was not confined to his Precisionist works such as Nospmas. M. Egiap Nospas. M. and My Egypt (which depicts grain elevators in Lancaster), but it also extended to his series of poster portraits of the 1920s. These works do not portray physical likenesses, but instead utilize physical objects, words, and word fragments to convey an idea of the character and personality of their subjects, who were Demuth's friends from artistic and literary circles. The best known of these poster portraits is of William Carlos Williams, I Saw the Figure 5 in Gold (sometimes called simply The Figure 5 in Gold) of 1928, which was inspired by Williams' poem "The Great Figure."

Demuth continued to produce Precisionist works until the early 1930s, when failing health began to severely limit his activities. His final works were watercolors of beach scenes in Provincetown painted during the summer of 1934. He died in Lancaster on 25 October 1935 from complications stemming from his diabetes. Demuth ranks with Winslow Homer and John Marin as one of America's finest watercolorists. Among those he influenced were some of the major Pop artists of the 1960s, including Robert Indiana and Jasper Johns.

I. Demuth's Writings, Statements, and Interviews

458 Demuth, Charles. "Aaron Eshleman." Historical Papers and Addresses of the Lancaster County Historical Society 16 (October 1912) 247-250.

A biographical essay on a nineteenth-century Lancaster, Pennsylvania, artist.

459 _____. "The Azure Adder." The Glebe 1 (December 1913) 5-31.

Demuth's first dramatic work is a comic parody dealing with the so-called little magazines of the era.

460 _____. "Between Four and Five." Camera Work no. 47 (July 1914) 32. Reprinted in Camera Work: A Critical Anthology, ed. Jonathan Green, 291. Millerton, N.Y.: Aperture, 1973.

A response to Alfred Stieglitz's question "What is 291?"

461 _____. "Filling a Page: A Pantomime with Words." The Rouge 1 (April 1915) 13-14.

462 _____. "For Richard Mutt." The Blind Man no. 2 (May 1917) 6. Reprinted in Charles Demuth: Behind a Laughing Mask, by Emily Farnham, 105. Norman: University of Oklahoma Press, 1971.

This issue of The Blind Man, edited by Marcel Duchamp, is devoted to Duchamp's Fountain, a 1917 Readymade consisting of a porcelain urinal inscribed "R. MUTT/1917" in black paint on the lower left front.

463 _____. "Can a Photograph Have the Significance of Art?" MSS. 4 (December 1922) 4.

464 Georgia O'Keeffe Paintings, 1926. Foreword by Charles Demuth. New York: The Intimate Gallery, 1927. Reprinted in The Philadelphia Museum Bulletin 40 (May 1945) 78, and in Charles Demuth: Behind a Laughing Mask, by Emily Farnham, 164. Norman: University of Oklahoma Press, 1971.

465 Peggy Bacon Exhibition. Foreword by Charles Demuth. New York: The Intimate Gallery, 1928.

466 Georgia O'Keeffe Paintings, 1928. Foreword by Charles Demuth. New York: The Intimate Gallery, 1929. Reprinted in The Philadelphia Museum Bulletin 40 (May 1945) 78, and in Charles Demuth: Behind a Laughing Mask, by Emily Farnham, 165. Norman: University of Oklahoma Press, 1971.

467 Demuth, Charles. "Confessions: Replies to a Questionnaire." The Little Review 12 (May 1929) 30-31.

468 _____. "Across a Greco is Written." Creative Art 5 (September 1929) 629-634. Reprinted in Twentieth-Century Artists on Art, ed. Dore Ashton, 100-101. New York: Pantheon, 1985.

In this essay Demuth expresses his admiration for El Greco, Blake, Rubens, Watteau, and Beardsley. He states that he sees little value in attempting to write about his own paintings.

469 _____. "Lighthouses and Fog." In <u>America and Alfred Stieglitz</u>, ed. Waldo Frank, Lewis Mumford, Dorothy Norman, Paul Rosenfeld, and Harold Rugg, 246. New York: The Literary Guild, 1934. Reprinted in <u>Charles Demuth: Behind a Laughing Mask</u>, by Emily Farnham, 156. Norman: University of Oklahoma Press, 1971.

Demuth's reflections on Alfred Stieglitz.

470 _____. "Fantastic Lovers: A Pantomime After Paul Verlaine." Reprinted in <u>Charles Demuth</u>, by Barbara Haskell, 42-44. New York: Whitney Museum of American Art, in association with H.N. Abrams, 1987.

Unpublished MS of a pantomime from the Richard Weyand scrapbooks.

471 _____. "In Black and White." Reprinted in <u>Charles Demuth</u>, by Barbara Haskell, 44-45. New York: Whitney Museum of American Art, in association with H.N. Abrams, 1987.

Unpublished MS of a short story from the Richard Weyand scrapbooks.

472 _____. "In the Fields." Reprinted in "Charles Demuth: His Life, Psychology, and Works," by Emily Farnham, 924-925. Ph.D. diss., Ohio State University, 1959.

Unpublished poem from the Richard Weyand scrapbooks.

473 _____. "Untitled." Reprinted in <u>Charles Demuth</u>, by Barbara Haskell, 45-46. New York: Whitney Museum of American Art, in association with H.N. Abrams, 1987.

Unpublished MS of a short story from the Richard Weyand scrapbooks.

474 _____. "The Voyage Was Almost Over." Reprinted in <u>Charles Demuth</u>, by Barbara Haskell, 46-47. New York: Whitney Museum of American Art, in association with H.N. Abrams, 1987.

Unpublished MS of a short story from the Richard Weyand scrapbooks.

475 _____. "'You Must Come Over,' A Painting, A Play." Reprinted in <u>Charles Demuth</u>, by Barbara Haskell, 41-42. New York: Whitney Museum of American Art, in association with H.N. Abrams, 1987. Unpublished MS of a play from the Richard Weyand scrapbooks.

476 _____. "Drei Texts des Malers Charles Demuth." Du pt. 2 (1988) 4-6, 8, 10.

German translations of three unpublished works: "Untitled," "The Journey Came to an End," and a dialogue, "Piece for Two People." Translations by Marc Keller.

See also 485, 506, 515, 643, and 647-654.

II. Monographs and Exhibition Catalogues

477 Adams, Henry. "The Beal Collection of Watercolors by Charles Demuth". Carnegie Magazine 56 (November-December 1983) 21-28.

Catalogue of an exhibition held at the Museum of Art, Carnegie Institute, Pittsburgh, Pennsylvania, 23 November 1983—22 January 1984. Exhibition curator Henry Adams gives a brief overview of Demuth's career in addition to annotating the twelve watercolors in the collection of Mrs. James H. Beal, which range from the early Bartender at the Brevoort of ca. 1912 to the artist's last self-portrait, The Artist on the Beach (at Provincetown) of 1934.

478 Akron Art Institute. Paintings by Charles Demuth, 1883-1935. [Akron, Ohio: The Institute, 1968].

Catalogue of an exhibition held at the Akron Art Institute, Akron, Ohio, 16 April—12 May 1968. The catalogue essay is a reprint of Andrew Carnduff Ritchie's essay featured in the catalogue for the 1950 Demuth retrospective at the Museum of Modern Art (see 493). A checklist of the ninety-five works in the exhibition is included.

479 Andrew Crispo Gallery. Ten Americans: Avery, Burchfield, Demuth, Dove, Homer, Hopper, Marin, Prendergast, Sargent, Wyeth. New York: The Gallery, [1974].

Catalogue of an exhibition of watercolors held at the Andrew Crispo Gallery, New York, 16 May—30 June 1974. A statement by Demuth is included along with a brief stylistic analysis by Larry Curry and reproductions of seventeen Demuth watercolors.

480 Cooper, Emmanuel. The Sexual Perspective: Homosexuality and Art in the Last 100 Years in the West, 113-120. London ; New York: Routledge and Kegan Paul, 1986.

Cooper discusses Demuth's homosexuality in the context of the artist's relationship with his mother and his use of metaphor, symbolism, and ambiguity in his art.

481 A Collection of Watercolors and Drawings by Charles Demuth. New York: Sotheby Parke Bernet, 1976.

Catalogue of a Sotheby Parke Bernet sale (Public Sale no. 3913), 28 October 1976, that contained fifty-five Demuth works including watercolors, drawings, and sketchbook pages from the estate of Richard W. C. Weyand. For an analysis of the works in this sale, see the article "Auctions—Glimpsing the 'Hidden' Demuth," by Sanford Schwartz (see 550).

482 Eight American Masters of Watercolor: Winslow Homer, John Singer Sargent, Maurice B. Prendergast, John Marin, Arthur G. Dove, Charles Demuth, Charles E. Burchfield, Andrew Wyeth. New York: Praeger, [1968].

Catalogue of an exhibition held at the Los Angeles County Museum of Art, 23 April—16 June 1968, which contains a brief overview of Demuth's career by Larry Curry and reproductions of eight Demuth watercolors.

483 Eiseman, Alvord L. Charles Demuth. New York: Watson-Guptill, 1982.

Eiseman begins his book with a chronology and a twenty-one page overview of Demuth's career. This is followed by forty annotated color illustrations from Demuth's early watercolor Spring Clouds of ca. 1899 to his late watercolor Man and Woman, Provincetown of 1934. Eiseman's bibliography contains a number of errors and should be used with caution.

484 Fahlman, Betsy. Pennsylvania Modern: Charles Demuth of Lancaster. Philadelphia: Philadelphia Museum of Art, 1983.

Catalogue of an exhibition held at the Philadelphia Museum of Art, 16 July—11 September 1983. Fahlman's biographical essay focuses on Demuth's Lancaster roots. Each of the thirty-eight works in the exhibition is illustrated and annotated in detail. The catalogue also contains a selected bibliography.

485 Farnham, Emily. Charles Demuth: Behind a Laughing Mask. Norman: University of Oklahoma Press, 1971.

Farnham's biography of Demuth is largely based upon her three volume 1959 doctoral dissertation (see 643). Of particular interest is the detailed background she provides on his family history, student days in Philadelphia, and his four European sojourns. Throughout the text she intersperses transcriptions of Demuth's correspondence with various individuals such as Alfred Stieglitz and William Carlos Williams. In an epilogue Farnham discusses Demuth's influence on American art. A chronology, catalogue of works mentioned in the text, and a bibliography are included.

486 Fisher-Wirth, Ann W. <u>William Carlos Williams and Autobiography: The Woods of his Own Nature</u>, 107-114. University Park: Pennsylvania State University Press, 1989.

Fisher-Wirth analyzes "The Crimson Cyclamen," Williams' memorial poem to Demuth published in <u>Adam & Eve & The City</u> (1936), in terms of what it reveals about their relationship.

487 Gallatin, A. E. <u>American Water-Colourists</u>, 22-23. New York: E.P. Dutton, 1922.

Gallatin briefly discusses Demuth and he offers the opinion that "In the rendering of flowers no other American has equalled him." Three Demuth watercolors are illustrated (Plates 24-26).

488 _____. <u>Charles Demuth</u>. New York: William Edwin Rudge, 1927.

This was the first monograph published on Demuth. In his preface, Gallatin discusses the increasing recognition given the artist by public museums. Gallatin's essay is a stylistic analysis of the watercolors (vaudeville subjects, floral pieces, Bermuda landscapes, still lifes, and so forth) and architectural subjects in tempera and oil, which Gallatin feels are notable for their "precision of execution" and "intelligent use of the investigations of Cubism." Regarding Demuth's literary illustrations, Gallatin states, "His line is extremely sensitive and nervous, and the washes of delicate and alluring colour play an important part in organizing the design." The book contains twenty-seven black and white reproductions.

489 Hartley, Marsden. <u>Adventures in the Arts</u>, 100-101. New York: Boni & Liveright, 1921.

A brief assessment of Demuth as a watercolorist.

490 Haskell, Barbara. <u>Charles Demuth</u>. New York: Whitney Museum of American Art, in association with H.N. Abrams, 1987.

Haskell's book was published in conjunction with the major retrospective exhibition "Charles Demuth" held at the Whitney Museum of American Art, New York, 15 October 1987—17 January 1988. Haskell's extensively documented text discusses all phases of Demuth's career including his literary efforts. In her discussion of Precisionism, Haskell notes that while Demuth did not view industrialization with hostility, he did have far more ambivalent feelings towards it than did the other Precisionists such as Lozowick and Sheeler. She discusses Demuth's use of enigmatic titles, words and word fragments as compositional elements, and ray lines to suggest the passage of

time in these Precisionist works. In addition to numerous black and white illustrations, the book contains 116 color reproductions. Marilyn Kushner provides an exhibition history and a selected bibliography to conclude the book. The Whitney Museum's separately published checklist of the works in the exhibition is not included despite its being listed in the table of contents.

491 Mellquist, Jerome. The Emergence of an American Art, 336-340. New York: Scribner's, 1942.

Mellquist assesses Demuth's achievement, noting that the artist "prized deftness, versatility, innuendo," and concludes that he "triumphed by elegance."

492 Murrell, William. Charles Demuth. New York: Whitney Museum of American Art, 1931.

Murrell's book was the second monograph published on Demuth. Murrell feels that although Demuth's art reflects no social concerns, he nevertheless developed a wide range of interests as the result of the fineness of his perceptions and, in addition, he evolved an unusual flexibility of method and approach through the peculiar quality of his aesthetic curiosity.

493 Museum of Modern Art (New York, N.Y.) Charles Demuth. New York: The Museum, 1950.

Catalogue of a retrospective exhibition held at the Museum of Modern Art, New York, 7 March—11 June 1950. The inclusion of a number of heretofore undisplayed works—the Nana illustrations, for example—showed for the first time Demuth's extraordinary versatility. Andrew Carnduff Ritchie's catalog essay raised Demuth scholarship to a new level of excellence. Ritchie offers astute insights into Demuth's early works, flower pieces, figure pieces (vaudeville and book illustrations), landscapes, and poster portraits. "A Tribute to the Artist," by Marcel Duchamp, precedes the catalogue section. The catalogue concludes with a four-page annotated bibliography.

494 Norton, Thomas E., ed. Homage to Charles Demuth: Still Life Painter of Lancaster. Ephrata, Pa.: Science Press, 1978.

As its title implies, the focus of this anthology is on Demuth's still lifes. A general biographical sketch by Norton opens the book. This is followed by "Demuth's Lancaster," by Gerald S. Lestz, a Lancaster newspaperman and local historian, who discusses the Lancaster tradition of farmers' markets where Demuth and his mother picked out fresh produce for his still life compositions. Alvord L. Eiseman, in his essay "Charles Demuth—a Still Life Painter in The American Tradition," states that Demuth was one of America's major still life painters. Eiseman notes that Demuth did not seek out new styles, techniques,

or formulas, but instead constantly sought to refine his own unique aesthetic vision which involved the desire to eliminate all but the most essential compositional elements. The book also contains abridged versions of previously published material by Sherman E. Lee and Marsden Hartley. The numerous color illustrations throughout the book, taken from transparencies in Sotheby's photography department, are of superb quality. Also of interest are five photographs of Demuth by Dorothy Norman from her personal collection.

495 Pennsylvania Historical and Museum Commission. Charles Demuth of Lancaster. Harrisburg, Pa.: William Penn Memorial Museum, 1966.

Catalogue of a retrospective exhibition held at the William Penn Memorial Museum, Harrisburg, Pennsylvania, 24 September—6 November 1966. An essay by Emily Genauer precedes a checklist of the 151 works in the exhibition, thirteen of which are illustrated.

496 Solomon R. Guggenheim Museum. Twentieth-Century American Drawing: Three Avant-Garde Generations. New York: Solomon R. Guggenheim Foundation, 1976.

Catalogue of an exhibition held at the Solomon R. Guggenheim Museum, New York, which includes six drawings and watercolors by Demuth. In her catalogue essay, Diane Waldman discusses Dada's influence on Precisionism in addition to offering comments on the Demuth works in the exhibition (pp. 15-16). The catalogue contains a biographical note plus a brief bibliography on Demuth (pp. 115-116).

497 Steinman, Lisa M. Made in America: Science, Technology, and American Modernist Poets, 109-110. New Haven, Conn.: Yale University Press, 1987.

Steinman analyzes "The Crimsom Cyclamen," William Carlos Williams' memorial poem to Demuth published in Adam & Eve & The City (1936).

498 Stieglitz Circle: Demuth, Dove, Hartley, Marin, O'Keeffe, Weber. [S.l. : s.n.], 1958.

Catalogue of an exhibition held at the Pomona College Galleries, Claremont, California, 11 October—15 November 1958. Included are a checklist of the twelve Demuth works in the exhibition; quotes from Demuth, James Thrall Soby, and Marcel Duchamp; and a general chronology of the Stieglitz circle. In his foreword, gallery director Peter Selz remarks on "the elegant and detached refinement of Demuth's water colors with their crystalline coherence of once fragmented structure."

499 Turner, Elizabeth Hutton. American Artists in Paris, 1919-1929, 75-78, 167. Ann Arbor, Mich.: UMI Research Press, 1988.

Turner discusses Demuth's 1921 visit to Paris and his relationship with Gertrude Stein.

500 University of California, Santa Barbara. Art Galleries. Charles Demuth: The Mechanical Encrusted on the Living. [Santa Barbara, Calif.: The Galleries, 1971.]

Catalogue of a major retrospective exhibition held at the Art Galleries, University of California, Santa Barbara, 5 October—14 November 1971. David Gebhard's catalogue essay reviews Demuth's critical reception during the 1920s. Phyllis Plous' essay is a general overview of the artist's career. The catalogue contains a checklist of the 192 works in the exhibition, a chronology, and a bibliography.

501 University of Minnesota. University Gallery. 5 Painters. [Minneapolis, Minn.: The Gallery, 1930.]

Catalogue of an exhibition held at the University Gallery, University of Minnesota, Minneapolis, which includes five works by Demuth. In the catalogue foreword, exhibition curator Ruth Lawrence states, "In Demuth's work there is an apparent, intelligent search for natural forms, proportion, balance, spacial values which are the basis of the work done by the best cubist painters. He nevertheless paints with recognizable forms."

502 Washburn Gallery. Charles Demuth (1883-1935): The Early Years—Works from 1909 to 1917. New York: The Gallery, 1975.

Catalogue of an exhibition of seven of Demuth's early watercolor landscapes, floral pieces, and figure studies, held at the Washburn Gallery, New York, 4 February—1 March 1975. The catalogue contains reprinted statements by Marcel Duchamp, Sherman Lee, and Andrew C. Ritchie, in addition to a black and white illustration of each work.

503 Watercolors and Paintings by Charles Demuth: Part One of the Collection Belonging to the Estate of the Late Richard W. C. Weyand, Lancaster, Pennsylvania. New York: Parke-Bernet Galleries, 1957.

Catalogue of a Parke-Bernet Gallery sale (Public Sale no. 1772), 16 October 1957, that included eighty-three Demuth works, mainly watercolors.

504 Watercolors and Paintings by Charles Demuth: Part Two of the Collection Belonging to the Estate of the Late Richard W. C. Weyand, Lancaster, Pennsylvania. New York: Parke-Bernet Galleries, 1958.

Catalogue of a Parke-Bernet Gallery sale (Public Sale no. 1804), 5 February 1958, that included eighty-six Demuth works.

505 Weinhardt, Carl J. Robert Indiana, 107-113. New York: H.N. Abrams, 1990.

Weinhardt discusses the influence of Demuth's 1928 poster portrait I Saw the Figure 5 in Gold on four of Indiana's paintings of 1963: The Demuth American Dream #5, The Figure Five, The Small Demuth Diamond Five, and X-5.

506 Whitney Museum of American Art. Charles Demuth Memorial Exhibition. New York: The Museum, 1937.

Catalogue of the "Charles Demuth Memorial Exhibition" held at the Whitney Museum of American Art, New York, 15 December 1937—16 January 1938. Henry McBride's catalogue essay, "Charles Demuth—Artist," precedes a biographical note and a checklist of the 122 works in the exhibition. McBride conjectures that the serenity of Demuth's floral watercolors stems from the cloistered security he felt in his Lancaster garden. The execution of his earlier figure paintings demanded a great deal of him and he suffered from the effects of diabetes for most of his adult life. When McBride paid one of his last visits to Demuth in Lancaster, he inquired why Demuth didn't return to figurative pieces and the artist replied, "I simply haven't the strength."

507 _____. A History of American Watercolor Painting. New York: The Museum, [1942].

Catalogue of an exhibition held at the Whitney Museum of American Art, New York, 27 January—25 February 1942. The catalogue contains a checklist of the Demuth watercolors in the exhibition (nos. 192-201), but no illustrations.

508 Williams, William Carlos. The Autobiography of William Carlos Williams. New York: Random House, 1951.

Williams and Demuth were both students at the same time in Philadelphia—Demuth at the Drexel Institute and Williams at the University of Pennsylvania. As Williams recalls it, "I met Charles Demuth over a dish of prunes at Mrs. Chain's boarding house on Locust Street and formed a lifelong friendship on the spot with dear Charlie, now long since dead." Williams' autobiography contains numerous other reminiscences about his relationship with Demuth.

III. Articles and Essays

509 Aiken, Edward A. "'I Saw the Figure 5 in Gold': Charles Demuth's Emblematic Portrait of William Carlos Williams." Art Journal 46 (Fall 1987) 178-184.

Aiken presents a wide-ranging analysis of Demuth's paintings with references to Williams' poetry and prose (including The Great American Novel and Spring and All); the cinema; poster and billboard art; Futurist aesthetics; and the philosophy of Henri Bergson.

510 Allara, Pamela. "Charles Demuth: Always a Seeker." Arts Magazine 50 (June 1976) 86-89.

Allara contends that Demuth's most obviously autobiographical literary illustration is A Prince of Court Painters (After Watteau) of 1918. Based upon Walter Pater's fictional re-creation of the personality of Antoine Watteau in his Imaginary Portraits, Demuth identified with Pater's description of Watteau's personal and artistic alienation. Demuth inscribed a quotation from Pater in the lower right corner of the illustration which encapsulates his feelings about pioneering European modernism at a time when it was neither widely accepted nor appreciated in America: "He was always a seeker after something in the world that is there in no satisfying measure, or not at all." This article is based on material from Allara's doctoral dissertation (see 639).

511 Breslin, James E. "William Carlos Williams and Charles Demuth: Cross-Fertilization in the Arts." Journal of Modern Literature 6 (April 1977) 248-263.

Breslin explores the artistic affinities the painter and the poet shared through two sets of comparisons. First, a comparison of Demuth's Tuberoses of 1922 and Williams' "The Pot of Flowers," originally published in Secession (January 1923) and dedicated to Demuth; second, a comparison of Demuth's I Saw the Figure 5 in Gold of 1928 and Williams' "The Great Figure," published in Sour Grapes (1920). Williams and Demuth created a dynamism, Breslin argues, through placing before their respective audiences both a real world of hard, literal objects and at the same time an autonomous, self-referential, and multidirectional world of the imagination.

512 Burgard, Timothy Anglin. "Charles Demuth's Longhi on Broadway: Homage to Eugene O'Neill." Arts Magazine 58 (January 1988) 110-113.

Burgard conjectures that Demuth's poster portrait of Eugene O'Neill has three distinct levels of meaning. First, it is ostensibly a "portrait" of the unseen subject; second, it is a portrait of friendship; and third, it is an allegory of art and the creative life in America. Burgard also offers an iconographical analysis of various elements in the painting including the green bottle, the spoon, the masks, and the words and word fragments. He finds precedents for this painting in Demuth's earlier studies for poster portraits of Marsden Hartley and Wallace Stevens.

513 Champa, Kermit. "'Charlie Was Like That'." Artforum 12 (March 1974) 54-59.

The title of Champa's article is quoted from an observation of William Carlos Williams: "In my painting of Orchids which Charlie did—the one called Pink Lady Slippers [1918] he was interested in the similarities between the forms of the flowers and the phallic symbol, the male genitals. Charlie was like that." Champa presents an analysis of Demuth's sexuality both through a consideration of the French tradition of "decadence" exemplified by Joris-Karl Huysman's novel A Rebours (which Demuth is known to have read and recommended to friends), and through examining the Freudian connotations of Marcel Duchamp's Fountain, a Readymade of 1917, and The Bride Stripped Bare by Her Bachelors, Even (the Large Glass) of 1915-23.

514 Cooper, Helen A. "The Watercolors of Charles Demuth." Antiques 83 (January 1988) 258-265.

This general analysis of Demuth's watercolors is accompanied by twelve color illustrations.

515 Craven, Thomas. "Charles Demuth." Shadowland 7 (December 1922) 11, 78.

Craven assesses Demuth's work and states that although it is refined, fragile, and decorative in the sense of lacking solidity and depth, he nevertheless finds it "valid and beautiful," and while Demuth is sometimes capricious, Craven feels that he is always "sane and intelligible." When Craven asked Demuth for an opinion on his art, he replied, "With few exceptions, artists think of themselves too constantly as 'artists,' or men of genius—we should always be children or fools."

516 Davidson, Abraham A. "Charles Demuth—Stylistic Development." Bulletin of Rhode Island School of Design: Museum Notes 54 (March 1968) 9-16.

Davidson discusses two early Demuth flower pieces (morning glories) acquired by the Museum of Art, Rhode Island School of Design. Both paintings are entitled Flowers and were executed between 1908 and 1910 in an Art Nouveau style.

517 _____. "Cubism and the Early American Modernist." Art Journal 26 (Winter 1966/67) 122-129, 165.

Davidson's survey of the influence of Cubism on early American modernism includes a discussion of Demuth's End of the Parade of 1920. Davidson notes that Demuth's use of Futurist converging lines of force serve simply as a decorative Cubist device and convey no sense of dynamic action. Davidson contrasts Demuth's painting with Leger's The City of 1919 and observes that

Demuth does not paint a shimmering play of light but instead gives us a silent, pristine, motionless industrial scene as contrasted with Leger's sooty depiction of rhythmic activity.

518 _____. "Demuth's Poster Portraits." Artforum 24 (November 1978) 54-57.

Davidson analyses the symbolism and allusions in a number of Demuth's poster portraits in addition to showing how the selection and placement of objects in these paintings convey the presence and personality of the individual subjects.

519 _____. "The Poster Portraits of Charles Demuth." Auction 3 (September 1969) 28-31.

520 Deak, Gloria-Gilda. "Charles Demuth" In Kennedy Galleries Profiles of American Artists, 2d ed., 70-71. New York: Kennedy Galleries, 1984.

A biographical essay.

521 "Death of Demuth." The Art Digest 10 (1 November 1935) 8.

An obituary.

522 Doyle, J. Ray. "Technical Page." American Artist 51 (September 1987) 32, 90-91.

Doyle examines some of Demuth's distinctive watercolor techniques including blotting and puddling.

523 Dunlap, Ben. "A Garden Canvas." Organic Gardening 35 (May 1988) 80-83.

Dunlap reports on the 1984 restoration of the garden in the Demuth family's Lancaster home which was sponsored by the Demuth Foundation. Many of Demuth's floral watercolors feature flowers from the original garden.

524 Fahlman, Betsy. "Charles Demuth's Paintings of Lancaster Architecture: New Discoveries and Observations." Arts Magazine 61 (March 1987) 24-29.

Fahlman documents specific sites that served as a basis for Demuth's paintings of Lancaster architecture which have not heretofore been identified, or which she feels have been identified incorrectly by art historians. To this end she juxtaposes the paintings in question with photographs of the actual sites in Lancaster and concludes that Demuth intended for his sources to be recognizable because, despite his European influences, a strong regional sense of place was of fundamental importance to him.

525 _____. "Modern as Metal and Mirror: The Work of Robert Evans Locher."
Arts Magazine 59 (April 1985) 108-113.

Fahlman's article will be useful for those researching the life and career of
Robert E. Locher, a Lancaster, Pennsylvania, decorative artist and interior
designer, who was a lifelong homosexual associate of Demuth.

526 Faison, S. Lane. "Fact and Art in Charles Demuth." Magazine of Art 43 (April
1950) 123-128.

Faison was the first critic to systematically compare a select group of Demuth's
architectural paintings of Lancaster with the actual historical sites through the
juxtaposition of photographs and paintings. This same basic approach was later
used by Betsy Fahlman (see 524).

527 Farnham, Emily. "Charles Demuth's Bermuda Landscapes." Art Journal 25
(Winter 1965/66) 130-137.

Fahlman analyses Demuth's Bermuda landscapes and architectural paintings of
1917 in terms of the influence of Cezanne and with reference to Demuth's
appropriation of numerous Cubist devices. She feels the only Futurist influence
in these works is the use of ray lines. Fahlman contends that Demuth's Bermuda
paintings were significant insofar as they signaled a move away from his
romantic, fluid, humanistic approach (exemplified by his literary illustrations)
to a more classical, abstract, and static style.

528 Geldzahler, Henry. "Charles Demuth." In American Painting in the Twentieth
Century, by Henry Geldzahler, 133-138. New York: Metropolitan Museum of
Art ; Greenwich, Conn.: Distributed by New York Graphic Society, 1965.

Geldzahler discusses a number of Demuth's paintings including I Saw the
Figure 5 in Gold of 1928; he provides a more extended discussion of this
painting in his article "Numbers in Time: Two American Paintings" (see 529).

529 _____. "Numbers in Time: Two American Paintings." The Metropolitan
Museum of Art Bulletin 23 (April 1965) 295-299.

Geldzahler compares and contrasts Demuth's I Saw the Figure 5 in Gold of
1928 with Jasper Johns' The Black Figure 5 of 1960.

530 Gustafson, Eleanor H. "Museum Accessions." Antiques 138 (November 1990)
918, 922.

A discussion of Demuth's From the Garden of the Chateau of 1921, which was acquired by the Fine Arts Museums of San Francisco in 1990, the first Demuth oil to enter a public collection on the West Coast.

531 Halter, Peter. "Soothing the Savage Beast: William Carlos Williams' and Charles Demuth's Urban Landscapes." In Modes of Interpretation: Essays Presented to Ernst Leisi on the Occasion of His 65th Birthday, ed. Richard J. Watts and Urs Weidman, 71-91. Tubingen: Gunter Narr, 1984.

Halter's point of reference in analyzing the relationship between Williams and Demuth is what he perceives to be their common aesthetic viewpoint. Demuth achieved an ironic detachment, ambiguity, and ambivalence both through the titles he gave to his urban landscapes and through juxtaposing industrial subject matter with contrasting elements that are difficult to reconcile—the natural and the industrial, the organic and the mechanistic, the sublime and the banal, the religious and the secular, the idealistic and the vitalistic. Williams, too, brought such contrasting realms together in his urban poetry in order to create a sense of tension and irony in the reader. Halter argues that both Williams and Demuth used this approach with the intent of prompting their respective audiences into a more critical and complex analysis of their value systems.

532 Hartley, Marsden. "Farewell, Charles, an Outline in Portraiture of Charles Demuth—Painter." In The New Caravan, ed. Alfred Kreymborg, Lewis Mumford, and Paul Rosenfeld, 552-562. New York: W.W. Norton, 1936. Reprinted in Marsden Hartley, On Art, ed. Gail R. Scott, 91-102. New York: Horizon Press, 1982.

Scott's transcription of Hartley's tribute is from the original typescript copy in the Beinecke Rare Book and Manuscript Library at Yale University and it therefore differs at some points with the version published in The New Caravan. Hartley wrote of his friend, "Charles loved the language of paint with the fervour of an ardent linguist, and this side of his work alone is thoroughly achieved."

533 Ischar, Doug. "Endangered Alibis." Afterimage 17 (May 1990) 8-11.

Ischar's review of the controversial 1990 traveling exhibition of Robert Mappelthorpe's photographs contains a comparison of the way in which Demuth and Mappelthorpe integrated their homosexuality into their respective crafts.

534 Kootz, Samuel M. "Charles Demuth." In Modern American Painters, by Samuel M. Kootz, 30-33. New York: Brewer & Warren, 1930.

Kootz gives a critical assessment of Demuth's early career saying that the artist's works "exhibit as intelligent a search for natural forms, balance, measure, spatial values as the best of the Cubist abstractions." Five works are illustrated on black and white plates.

535 Koskovich, Gerard. "A Gay American Modernist: Homosexuality in the Life and Art of Charles Demuth." The Advocate (25 June 1985) 50-52.

An analysis of Demuth's homosexuality that appeared in a major publication for gay men. Koskovich notes that Harlem, a place frequented by Demuth while in New York, was a focal point for the homosexual subculture during this period.

536 Lane, James W. "Charles Demuth." In Masters of Modern Art, by James W. Lane, 85-92. Boston: Chapman & Grimes, 1936.

Lane discusses Demuth's mastery of still lifes and architectural subjects. He writes, "A true 'Immaculate' in precision, refinement of line, and selective ability, Demuth had the inner feeling, a splendid detachment, that fused his art into an emotionally moving whole and kept it from being—what the art of some of the other 'Immaculates' has become—soul-less." This is an expanded version of his article "Charles Demuth" that appeared in the March 1936 issue of Parnassus.

537 Lee, Sherman, E. "The Illustrative and Landscape Watercolors of Charles Demuth." The Art Quarterly 5 (Spring 1942) 158-174.

Lee presents a detailed stylistic analysis of Demuth's watercolors including the narrative illustrations, circus series, flower still lifes, beach scenes, and landscapes from Bermuda, Provincetown, and Lancaster. Lee concludes that "Demuth's early contribution lay in his ability to invest the vibrant color and outward forms of Expressionism with the tortured subtleties of a sensitive and sophisticated mind." Lee feels that Demuth ranks with Picasso, Braque, Nolde, and Toulouse-Lautrec as a master of watercolor painting.

538 Levi, Julian E. "Charles Demuth." Living American Art Bulletin (March 1939) 1-3.

539 Levy, Herbert S. "Charles Demuth of Lancaster." Journal of the Lancaster County Historical Society 68 (5 March 1965) 41-62.

Levy's biographical portrait of Demuth draws upon the recollections of the artist's friends and acquaintances including Helen Henderson, Rita Wellman, Henry McBride, George Biddle, and Marcel Duchamp.

540 Malone, Mrs. John E. "Charles Demuth." <u>Papers of the Lancaster County Historical Society</u> 52, no. 1 (1948) 1-[15].

Malone's biographical essay—prepared with the assistance of a number of Demuth's friends and associates including Robert E. Locher and Richard W. C. Weyand—utilizes archival material and is particularly informative about Demuth's family background and early life.

541 Marling, Karal Ann. "<u>My Egypt</u>: The Irony of the American Dream." <u>Winterthur Portfolio</u> 15 (Spring 1980) 25-29.

In this article Marling explores the genesis, iconography, and significance of Demuth's <u>My Egypt</u> of 1927. Marling conjectures that the painting was "a culminating reprise of themes, methods, and relationships pieced together in a biographical context haunted by the shadow of death." Marling notes that Demuth's ironic wit lets a grain elevator serve as a line of demarcation between the rural agrarian past and the industrialized present. In the author's opinion, <u>My Egypt</u> is both a personal autobiographical statement and at the same time the embodiment of a national myth.

542 McBride, Henry. "Charles Demuth, Artist." <u>Magazine of Art</u> 31 (January 1938) 21-23, 58.

A reprint of McBride's 1937 essay for the catalogue <u>Charles Demuth Memorial Exhibition</u> (see 506).

543 _____. "Water-Colours of Charles Demuth." <u>Creative Art</u> 5 (September 1929) 634-635.

A general assessment of Demuth's watercolors with some specific remarks on the <u>Nana</u> illustrations.

544 Neal, Kenneth. "Charles Demuth." In <u>American Drawings and Watercolors in the Museum of Art, Carnegie Institute</u>, 151-154. Pittsburgh: Carnegie Institute, Museum of Art ; Distributed by the University of Pittsburgh Press, 1985.

A discussion of Demuth centering on his works in the Museum of Art at Carnegie Institute.

545 North, Michael. "The Sign of Five: Williams' 'The Great Figure' and its Background." <u>Criticism</u> 30 (Summer 1988) 325-348.

North discusses Williams' poem "The Great Figure" in terms of the Cubist-inspired alphanumeric symbols in Demuth's <u>I Saw the Figure 5 in Gold</u> of 1928 and Marsden Hartley's <u>Portrait of Berlin</u> of 1921. North argues that Demuth's

painting, far from illustrating the visual clarity of the poem, actually serves to heighten the ironic tension and visual ambiguity between representation and object, sign and referent.

546 Norton, Thomas E. "The N'th Whoopee of Sight." Portfolio 1 (August-September 1979) 20-27.

A general overview of Demuth's career accompanied by eight color illustrations.

547 "Obituary, Charles Demuth." The Art News 34 (2 November 1935) 12.

548 Rosenfeld, Paul. "American Art." The Dial 71 (December 1921) 649-670.

This article contains a general assessment of Demuth's work (pp. 662-663), which Rosenfeld criticizes for its daintiness and feminine refinement.

549 Sayre, Henry M. "The Artist's Model: American Art and the Question of Looking like Gertrude Stein." In Gertrude Stein and the Making of Literature, ed. Shirley Neuman and Ira B. Nadel, 24. Boston: Northeastern University Press, 1988.

Sayre's essay contains a brief explication of the pun involved in Demuth's poster portrait of Gertrude Stein, Love, Love, Love (Homage to Gertrude Stein) of ca. 1928.

550 Schwartz, Sanford. "Auctions—Glimpsing the 'Hidden' Demuth." Art in America 64 (September-October 1976) 102-103.

Schwartz discusses the Demuth works appearing in the October 1976 Sotheby Parke Bernet auction (see 481).

551 Shorto, Sylvia. "Charles Demuth in Bermuda." Heritage Magazine (1986) [Cover title: Bermuda Heritage '86: Inspirations] 100-107.

Shorto, Curator for the Bermuda National Trust, gives an overview of Demuth's Bermuda landscapes of 1917 with a number of observations on the architecture of St. George's as it relates to this series of paintings.

552 Smith, Jacob Getlar. "The Watercolors of Charles Demuth." American Artist 19 (May 1955) 26-31, 73.

Smith remarks on Demuth's fondness for vignettes, soft edges, unfinished areas of white, and opulent subtle tones.

553 Soby, James Thrall. "Charles Demuth." In New Art in America: Fifty Painters of the 20th Century, ed. John I. H. Baur, 50-55. Greenwich, Conn.: New York Graphic Society, in cooperation with Praeger, New York, [1957].

This biographical sketch of Demuth is accompanied by six illustrations.

554 _____. "Three American Watercolorists: I. Charles Demuth." In Contemporary Painters, [2d ed.], 9-15. New York: Museum of Modern Art ; Distributed by Simon & Schuster, 1948.

A general stylistic analysis of Demuth's watercolors.

555 Sweeney, John L. "The Demuth Pictures." The Kenyon Review 5 (Autumn 1943) 522-532.

Sweeney analyzes the compositional motifs and symbolism in Demuth's three illustrations for Henry James' The Beast in the Jungle. Sweeney advances the thesis that when the series is properly viewed as a triptych, "Demuth's pictures are not static, isolated representations. Symbol, form, color, and rhythm of arrangement carry the observer's eye back and forth from the center of the series in much the same way that James's echo of image and oblique interaction of phrases carry the reader backward and forward through the incidents, transitions, and recapitulations of his narrative." Sweeney is careful to point out, however, that while James welcomed illustrations of his work, he insisted that they be published separately and independently so as not to interfere with the relationship between author and reader.

556 Van Vechten, Carl. "Pastiches et Pistache: Charles Demuth and Florine Stettheimer." The Reviewer 2 (February 1922) 269-270.

One of a number of puritanical critics of Demuth, Van Vechten refers to the artist as a "perverse genius."

557 "Water-Color—A Weapon of Wit." Current Opinion 66 (January 1919) 52-53.

Critics from three New York newspapers are quoted discussing Demuth's watercolors. One is of the opinion that Demuth's work contains a "liberal quota" of modernism which is "just enough to suggest the present, but not enough to destroy the older more traditional representational values."

558 Watson, Forbes. "Charles Demuth." The Arts 3 (January 1923) 78. Reprinted in Readings in American Art, 1900-1975, ed. Barbara Rose, 82-83. New York: Praeger, 1975.

Watson, editor of The Arts, gives a general assessment of Demuth and finds watercolor to be the medium in which he has produced his finest work. Watson writes, "Fantasy, the light touch, the art quality (aesthetic), the whimsical, the ironic, the delicate (never the sweet), the biting—Charles Demuth."

559 Weinberg, Jonathan. "Demuth and Difference." Art in America 76 (April 1988) 188-194, 221, 223.

Weinberg takes up the theme of Demuth's homosexuality with reference to the 1987 Demuth retrospective held at the Whitney Museum of American Art, which was the first to mount some of the artist's more overtly erotic watercolors. Weinberg notes that Demuth was one of the few twentieth-century American artists to deliberately pursue several completely separate modes of painting simultaneously, each aimed at a different audience. Weinberg argues that in order to fully understand the relationship between Demuth's sexuality and his art, we must first move beyond his personal biography to a consideration of the cultural history of homosexuality and gender in America during the post-World War I era.

560 _____. "'Some Unknown Thing': The Illustrations of Charles Demuth." Arts Magazine 61 (December 1986) 14-21.

Until recently the homosexual aspects of Demuth's life and work have received relatively little serious attention from art historians. The starting point for Weinberg's article is a line from Demuth's unfinished story, "The Voyage was Almost Over," that reads, "The hate against some unknown Thing filled his soul." Weinberg argues that this troublesome "unknown Thing" was Demuth's homosexuality. It is his thesis that Demuth explored the relationship between sexuality, power, and death, as well as the alienating effect of sexual life-styles outside society's norms, through his illustrations for the works of various authors. These included Zola's Nana, James' The Turn of the Screw and The Beast in the Jungle, Balzac's The Girl with the Golden Eyes, Poe's The Masque of the Red Death, McAlmon's Distinguished Air, and Wedekind's Lulu Plays.

561 Weinberg-Staber, Margit. "Charles Demuth (1883-1935): ein amerikanischer Modernist." Du, pt. 2 (1988) 12-57.

This essay covers Demuth's entire career and emphasizes the European influences on his art. Text in German; summary in English under "A Selective Summary of the Contents."

562 Wellman, Rita. "Pen Portraits—Charles Demuth: Artist." Creative Art 9 (December 1931) 483-484.

Wellman presents a personal reminiscence of her student days with Demuth at the Pennsylvania Academy of the Fine Arts in Philadelphia in addition to other observations on the artist.

563 Wick, Peter Ames. "Some Recent Acquisitions." Bulletin. Museum of Fine Arts, Boston 60, no. 322 (1962) 151.

Wick discusses the acquisition of Demuth's The Purple Pup of 1918 by the Museum of Fine Arts, Boston.

IV. Exhibition Reviews

564 McBride, Henry. "Demuth's First Exhibition." In The Flow of Art: Essays and Criticisms of Henry McBride, ed. Daniel Catton Rich, 67-70. New York: Atheneum, 1975.

Review of the exhibition "Watercolors by Charles Demuth" held at the Daniel Gallery, New York, October-November 1914. Reprinted from The Sun, 1 November 1914. This was Demuth's first exhibition at the Daniel Gallery.

565 "Charles Demuth and Edward Fiske are Showing in the Daniel Galleries." Fine Arts Journal 35 (December 1917) 52-54.

Review of the exhibition "Watercolors by Charles Demuth and Oils by Edward Fiske" held at the Daniel Gallery, New York, November-December 1917. This was Demuth's fourth exhibition at the Daniel Gallery.

566 Wright, Willard Huntington. "Modern Art: Four Exhibitions of the New Style of Painting." International Studio 60 (January 1918) 97-98.

Review. See entry 565.

567 Field, Hamilton Easter. "Comment on the Arts." The Arts 1 (January 1921) 29-31.

Review of the exhibition "Paintings by Charles Demuth" held at the Daniel Gallery, New York, December 1920. This was Demuth's sixth exhibition at the Daniel Gallery.

568 McBride, Henry. "Modern Art." The Dial 70 (February 1921) 234-236.

Review. See entry 567.

569 Watson, Forbes. "At the Galleries." Arts & Decoration 14 (January 1921) 230.

Review. See entry 567.

570 Strand, Paul. "American Watercolors at the Brooklyn Museum." The Arts 2 (20 January 1922) 148-152.

Review of the exhibition "Watercolor Paintings by American Artists" held at the Brooklyn Museum, 7 November—18 December 1921. Strand notes that "Demuth has yet to disentangle himself from the sophistication of contemporary French influence."

571 McBride, Henry. "Modern Art." The Dial 74 (February 1923) 217-219.

Review of the exhibition "Recent Paintings by Charles Demuth" held at the Daniel Gallery, New York, December 1922. This was Demuth's seventh exhibition at the Daniel Gallery.

572 Cortissoz, Royal. "291." In Personalities in Art, by Royal Cortissoz, 419-422. New York: Scribner's, 1925.

Review of the exhibition "Alfred Stieglitz Presents Seven Americans; 159 Paintings, Photographs & Things Recent & Never before Publicly Shown by Arthur G. Dove, Marsden Hartley, John Marin, Charles Demuth, Paul Strand, Georgia O'Keeffe, Alfred Stieglitz" held at the Anderson Galleries, New York, 9-28 March 1925. (Reprinted, with modifications, from the The New York Herald Tribune, 15 March 1925.)

573 Fulton, Deough. "Cabbages and Kings." International Studio 81 (May 1925) 144-147.

Review. See entry 572.

574 Read, Helen Appleton. "New York Exhibitions: Seven Americans." The Arts 7 (April 1925) 229, 231.

Review. See entry 572.

575 "Exhibitions in the New York Galleries: Charles Demuth—Intimate Gallery." The Art News 24 (10 April 1926) 7.

Review of the exhibition "Recent Paintings by Charles Demuth" held at The Intimate Gallery, New York, 5 April—2 May 1926.

576 Kalonyme, Louis. "The Art Makers: Charles Demuth, the Magician of Water Colors Leads Art Season of Old Favorites and New Contenders." Arts & Decoration 26 (December 1926) 63.

Review. See entry 575.

577 McBride, Henry. "Demuth." In The Flow of Art: Essays and Criticisms of Henry McBride, ed. Daniel Catton Rich, 217-219. New York: Atheneum, 1975.

Review (reprinted from The New York Sun, 10 April 1926). See entry 575.

578 "Exhibitions in the New York Galleries: Charles Demuth—Intimate Gallery." The Art News 27 (4 May 1929) 14.

Review of the exhibition "Charles Demuth: Five Paintings" held at The Intimate Gallery, New York, 29 April—18 May 1929.

579 "New York Season." The Art Digest (1 May 1929) 17-18.

Review. See entry 578.

580 "Exhibitions in New York: Charles Demuth—An American Place." The Art News 29 (18 April 1931) 10.

Review of the exhibition "Paintings by Charles Demuth" held at An American Place, New York, April 1931.

581 Hagen, Anglea E. "Around the Galleries—Demuth Watercolors and Oils at 'An American Place'." Creative Art 8 (June 1931) 441-443.

Review. See entry 580.

582 Rosenfeld, Paul. "Art—Charles Demuth." The Nation 133 (7 October 1931) 371-373.

Review. See entry 580.

583 Schnakenberg, Henry E. "Exhibitions—Charles Demuth." The Arts 17 (May 1931) 581.

Review. See entry 580.

584 Davidson, Martha. "Demuth, Architecture of Painting—The Whitney's Complete Show Permits a New Appraisal." The Art News 36 (18 December 1937) 7-8.

Review of the "Charles Demuth Memorial Exhibition" held at the Whitney Museum of American Art, New York, 15 December 1937—16 January 1938.

585 Lane, James W. "Notes from New York." Apollo 27 (February 1938) 96-97.

Review. See entry 584.

586 McBride, Henry. "Demuth Memorial Exhibition." In The Flow of Art: Essays and Criticisms of Henry McBride, ed. Daniel Catton Rich, 354-357. New York: Atheneum, 1975.

Review (reprinted from The New York Sun, 18 December 1937). See entry 584.

587 Morris, George L. K. "Art Chronicle: Some Personal Letters to American Artists Recently Exhibiting in New York. To Charles Demuth, Whitney Museum." Partisan Review 4 (March 1938) 38-39.

Review. See entry 584.

588 Rosenfeld, Paul. "Art—The Demuth Memorial Show." The Nation 146 (8 January 1938) 50, 52.

Review. See entry 584.

589 "Whitney Holds Memorial to Charles Demuth." The Art Digest 12 (1 January 1938) 5.

Review. See entry 584.

590 Davidson, Martha. "New Exhibitions of the Week." The Art News 37 (4 March 1939) 17.

Review of the exhibition "Demuth Oils and Water-Colors, in the White Room" held at An American Place, New York, 29 December 1938—18 January 1939.

591 "Art News of America: A Demuth Show in Washington." Art News 41 (15-31 May, 1942) 7.

Review of the exhibition "Charles Demuth: Exhibition of Water Colors and Oil Paintings" held at the Phillips Memorial Gallery, Washington, D.C., 3-25 May 1942.

592 Breuning, Margaret. "Demuth's Fastidious Taste and Magic Craft." The Art Digest 24 (15 March 1950) 17.

Review of the exhibition "Charles Demuth" held at the Museum of Modern Art, New York, 7 March—11 June 1950.

593 Coates, Robert M. "The Art Galleries—Charles Demuth." The New Yorker 26 (18 March 1950) 57-59.

Review. See entry 592.

594 McBride, Henry. "Demuth—Phantoms from Literature." Art News 49 (March 1950) 18-21.

Review. See entry 592.

595 Krasne, Belle. "Fifty-Seventh Street in Review—Demuth Moves Downtown." The Art Digest 24 (1 July 1950) 19.

Review of the exhibition "Charles Demuth—Oils and Watercolors" held at the Downtown Gallery, New York, 6-28 July 1950.

596 Seckler, Dorothy. "Reviews and Previews—Demuth." Art News 49 (September 1950) 48.

Review. See entry 595.

597 Breuning, Margaret. "Fifty-Seventh Street in Review—Charles Demuth." The Art Digest 25 (15 March 1951) 22.

Review of "Exhibition of Portraits by Florine Stettheimer and Watercolors by Charles Demuth" held at Durlacher Brothers, New York, 27 February—24 March 1951.

598 McBride, Henry. "Nicholson, Stettheimer, Demuth." Art News 50 (March 1951) 51.

Review. See entry 597.

599 Breuning, Margaret. "Fortnight in Review—Charles Demuth/Arthur Dove." The Art Digest 28 (15 April 1954) 20.

Review of the exhibition "Demuth—Watercolor Retrospective" held at the Downtown Gallery, New York, 6 April—1 May 1954.

600 Guest, Barbara. "Reviews and Previews—Charles Demuth, Arthur Dove." <u>Art News</u> 53 (April 1954) 43.

Review. See entry 599.

601 Musterberg, Hugo. "In the Galleries—Charles Demuth." <u>Arts Magazine</u> 32 (May 1958) 62.

Review of the exhibition "Charles Demuth: 30 Paintings" held at the Downtown Gallery, New York, 20 May—7 June 1958.

602 Porter, Fairfield. "Reviews and Previews—Charles Demuth." <u>Art News</u> 57 (May 1958) 13-14.

Review. See entry 601.

603 Seldis, Henry J. "The Stieglitz Circle Show at Pomona College." <u>Art in America</u> 46 (Winter 1958/59) 62-65.

Review of the exhibition "Stieglitz Circle: Demuth, Dove, Hartley, Marin, O'Keeffe, Weber" held at the Pomona College Galleries, Claremont, California, 11 October—15 November 1958.

604 Eiseman, Alvord L. "A Charles Demuth Retrospective Exhibition." <u>Art Journal</u> 31 (Spring 1972) 283-286.

Review of the exhibition "Charles Demuth: The Mechanical Encrusted on the Living" held at the Art Galleries of the University of California, Santa Barbara, 5 October—14 November 1971.

605 Derfner, Phyllis. "New York Letter." <u>Art International</u> 19 (20 April 1975) 59.

Review of the exhibition "Charles Demuth (1883-1935): The Early Years— Works from 1909 to 1917" held at the Washburn Gallery, New York, 4 February—1 March 1975.

606 Tannenbaum, Judith. "Charles Demuth." <u>Arts Magazine</u> 49 (April 1975) 16.

Review. See entry 605.

607 Weisman, Julian. "New York Reviews—Charles Demuth." <u>Art News</u> 74 (April 1975) 94, 96.

Review. See entry 605.

608 Fort, Ilene Susan. "Charles Demuth." Arts Magazine 56 (September 1981) 26-27.

Review of the exhibition "Charles Demuth: Watercolors and Drawings" held at the Salander-O'Reilly Galleries, New York, 30 April—30 May 1981.

609 Fort, Ilene Susan. "Arts Reviews—Charles Demuth." Arts Magazine 57 (December 1982) 37.

Review of the exhibition "Charles Demuth: Important Watercolors and Drawings" held at the Salander-O'Reilly Galleries, New York, 15 September—30 October 1982.

610 Agee, William C. "Demuth at the Whitney." The New Criterion 6 (June 1988) 41-48.

Review of the exhibition "Charles Demuth" held at the Whitney Museum of American Art, New York, 15 October 1987—17 January 1988.

611 Danto, Arthur C. "Art—Charles Demuth." The Nation 246 (23 January 1988) 101-104. Reprinted in Encounters and Reflections: Art in the Historical Present, by Arthur C. Danto, 158-163. New York: Farrar, Straus and Giroux, 1990.

Review. See entry 610.

612 Dean, Andrea O. "He Was an Acrobat on the Leading Edge of Jazz Age Art." Smithsonian 18 (November 1987) 58-64, 66-67.

Review. See entry 610.

613 Fahlman, Betsy. "The Charles Demuth Retrospective at the Whitney Museum." Arts Magazine 62 (March 1988) 52-54.

Review. See entry 610.

614 Heartney, Eleanor. "Poet of the Smokestack and Flower." Art News 87 (March 1988) 202.

Review. See entry 610.

615 Hughes, Robert. "Art—Demuth Amid the Silos." Time 130 (7 December 1987) 91.

Review. See entry 610.

616 Stevens, Mark. "Art—The Poet and the Engineer." Newsweek 111 (4 January 1988) 55.

Review. See entry 610.

V. Book Reviews

617 Eiseman, Alvord L. "Book Reviews." Art Journal 32 (Fall, 1972) 116.

Review of Emily Farnham's Charles Demuth: Behind a Laughing Mask (Norman: University of Oklahoma Press, 1971).

618 Reich, Sheldon. "Book Reviews." The Art Bulletin 54 (June 1972) 228-229.

Review. See entry 617. A reply to this review by Farnham, with a rejoinder by Reich, appears in The Art Bulletin 55 (March 1973) 164.

619 Agee, William C. "Demuth at the Whitney." The New Criterion 6 (June 1988) 41-48.

This review of the 1987 Demuth retrospective at the Whitney Museum of American Art also includes a review of Barbara Haskell's Charles Demuth (New York: Whitney Museum of American Art, in association with H.N. Abrams, 1987).

620 Fahlman, Betsy. "The Charles Demuth Retrospective at the Whitney Museum." Arts Magazine 62 (March 1988) 52-54.

Review. See entry 619.

VI. Reference Sources

621 Baigell, Matthew. Dictionary of American Art. New York: Harper & Row, 1982. S.v. "Demuth, Charles."

622 "Charles Demuth (1883-1935)." In American Art Analog. Vol. 3, 1874-1930, comp. Michael David Zellman, 832. New York: Chelsea House, in association with American Art Analog, 1986.

A brief biographical sketch accompanied by general auction price information for the artist's works.

623 "Charles Demuth—Painter." Index of Twentieth Century Artists, 1933-1937, 430-433, 443, 445. New York: Arno Press, 1970.

624 Cummings, Paul. <u>Dictionary of Contemporary American Artists</u>. 5th ed. New York: St. Martin's, 1988. S.v. "Demuth, Charles."

625 Dynes, Wayne R., ed. <u>Encyclopedia of Homosexuality</u>, Vol. 1. New York: Garland, 1990. S.v. "Demuth, Charles," by Wayne R. Dynes.

626 <u>Encyclopedia of American Art</u>. New York: E.P. Dutton, 1981. S.v. "Demuth, Charles," by David W. Scott.

627 Falk, Peter Hastings, ed. <u>Who Was Who in American Art: Compiled from the Original Thirty-four Volumes of "American Art Annual: Who's Who in Art."</u> Madison, Conn.: Sound View Press, 1985. S.v. "Demuth, Charles (Henry)."

628 Fielding, Mantle. <u>Mantle Fielding's Dictionary of American Painters, Sculptors & Engravers</u>. 2d enl. ed. Edited by Glenn B. Opitz. Poughkeepsie, N.Y.: Apollo, 1986. S.v. "Demuth, Charles."

629 <u>The Larousse Dictionary of Painters</u>. New York: Larousse, 1976. S.v. "Demuth, Charles," by Daniel Robbins.

630 Myers, Bernard S., ed. <u>McGraw-Hill Dictionary of Art</u>, Vol. 2. New York: McGraw-Hill, 1969. S.v. "Demuth, Charles," by Robert Reiff.

631 Osborne, Harold, ed. <u>The Oxford Companion to Twentieth-Century Art</u>. New York: Oxford University Press, 1981. S.v. "Demuth, Charles."

632 <u>Phaidon Dictionary of Twentieth-Century Art</u>. London ; New York: Phaidon, 1973. S.v. "Demuth, Charles."

633 <u>Praeger Encyclopedia of Art</u>, Vol. 2. New York: Praeger, 1971. S.v. "Demuth, Charles," by John Ashbery.

634 Starr, Harris E., ed. <u>Dictionary of American Biography</u>, Vol. 11, supp. 1. New York: Scribner's 1944. S.v. "Demuth, Charles," by William Murrell.

635 Vinson, James, ed. <u>International Dictionary of Art and Artists</u>. Volume 1, <u>Artists</u>. Chicago: St. James Press, 1990. S.v. "Demuth, Charles," by Percy North.

636 Vollmer, Hans. <u>Allgemeines Lexikon der bildenden Kunstler des xx. Jahrhunderts</u>, Vol. 1. Leipzig: E.A. Seemann, 1953-1962. S.v. "Demuth, Charles."

637 <u>Who Was Who in America</u>. Vol. 4, <u>1961-1968</u>. Chicago: Marquis Who's Who, 1968. S.v. "Demuth, Charles."

638 Woodbridge, Margaret. "Demuth, Charles." In A Gertrude Stein Companion: Content with the Example, ed. Bruce Kellner, 178-179. Westport, Conn.: Greenwood Press, 1988.

VII. Dissertations and Theses

639 Allara, Pamela Edwards. "The Water-color Illustrations of Charles Demuth." Ph.D. diss., Johns Hopkins University, 1970.

Demuth's literary illustrations for various nineteenth-century fictional works are the subject of Allara's dissertation. She begins with an overview of Demuth's career with special attention given to his literary interests and influences. The main body of her study is devoted to discussions of Demuth's illustrations for the works of Zola, Balzac, Poe, Pater, Wedekind, Henry James, and Robert McAlmon. Allara considers why Demuth chose these particular authors' works and scenes to illustrate; the ways in which he explores their methods and interprets their messages; and how closely he adheres to the actual texts in his illustrations. She also discusses the critical reception contemporary art critics gave to these works. Allara concludes that Demuth captured the true essence of the spirit of European fin-de-siecle better than any other American artist.

640 Brenner, Isabel. "Charles Demuth: The Poster Portraits." M.A. thesis, Hunter College, City University of New York, 1974.

641 Davidson, Abraham Aba. "Some Early American Cubists, Futurists, and Surrealists: Their Paintings, Their Writings, and Their Critics." Ph.D. diss., Columbia University, 1965.

Davidson analyzes a number of Demuth's works in terms of his appropriation of Cubist devices such as ray lines and wedge shapes (pp. 62-66, 77-81, 95-99); his Dada influences (pp. 123-127); and the Surrealist overtones of his poster portraits (pp. 134-138).

642 Eiseman, Alvord L. "A Study of the Development of an Artist: Charles Demuth." 2 vol. Ph.D. diss., New York University, 1976.

Eiseman's dissertation deals with the effects Demuth's artistic education and peer relationships had on his artistic development, particularly as a colorist. Eiseman analyzes nearly three hundred works going back to Demuth's childhood drawings. The final chapter is an overview of the critical response to Demuth focusing on the years 1916-1933.

643 Farnham, Emily Edna. "Charles Demuth: His Life, Psychology, and Works." 3 vol. Ph.D. diss., Ohio State University, 1959.

The first part of Farnham's dissertation is a detailed biography; the second part consists of a lengthy attempt to psychoanalyze Demuth; and the third part contains a stylistic comparison of Demuth's works with those of Marin, Feininger, Sheeler, Stella, Duchamp, and Hartley, plus a catalogue raisonne of 747 paintings and 327 drawings. This is followed by a chronology; a list of 160 exhibitions in which Demuth's works were shown; a selection of the artist's published and unpublished writings and correspondence; replies to questionnaires sent by Farnham to various individuals including Marcel Duchamp, Henry McBride, and William Carlos Williams; transcriptions of interviews Farnham conducted with, among others, Robert Locher, Richard Weyand, Stuart Davis, Marcel Duchamp, Henry McBride, Carl Van Vechten, Edith Gregor Halpert, William Carlos Williams, Charles Daniel, and Christopher Demuth; and a bibliography.

644 Hale, Eunice Mylonas. "Charles Demuth: His Study of the Figure." 2 vol. Ph.D. diss., New York University, 1974.

Hale begins her dissertation with an examination of Demuth's artistic education at the Drexel Institute, with its emphasis on the English tradition of illustration, and the Pennsylvania Academy of the Fine Arts, with its emphasis on the French tradition. Hale then considers two other traditions and their influence on Demuth's figurative work throughout his career, namely, the realistic treatment of the urban scene as exemplified by "The Eight," and the more private and imaginative approach as exemplified by Whistler. Hale devotes the remainder of her dissertation to an examination of Demuth's treatment of the figure in his literary illustrations, his early large watercolors, his poster portraits of the 1920s, and his late watercolors of the 1930s.

645 Herrman, Robert Louis. "Stylistic Development of Charles Demuth's Art." M.A. thesis, Ohio State University, 1949.

646 Lee, Sherman E. "A Critical Survey of American Watercolor Painting." Ph.D. diss., Western Reserve University, 1941.

Chapter Nine is an analysis of Demuth's watercolor paintings. An article based upon this chapter was published in the Spring 1942 issue of The Art Quarterly (see 537).

VIII. Archival Sources

647 Alfred Stieglitz Collection. Collection of American Literature, Beinecke Rare Book and Manuscript Library, Yale University, New Haven, Connecticut.

The collection contains twenty-four letters and one undated note from Demuth to Alfred Stieglitz and two letters from Stieglitz to Demuth.

648 Archives of American Art. The Card Catalog of the Manuscript Collections of the Archives of American Art, Vol. 3. Wilmington, Del.: Scholarly Resources, 1980. S.v. "Demuth, Charles."

649 _____. The Card Catalog of the Manuscript Collections of the Archives of American Art, Supplement 1981-1984. Wilmington, Del.: Scholarly Resources, 1985. S.v. "Demuth, Charles."

This circulating microfilm collection contains numerous sources on Demuth including material from the Downtown Gallery Papers, the Pennsylvania Academy of the Fine Arts Collection, and the Whitney Museum Papers; photographs of Demuth's childhood sketchbook; plus Demuth's correspondence with various individuals such as Albert Gallatin, Marsden Hartley, Robert Locher, Henry McBride, Georgia O'Keeffe, Charles and Katherine Sheeler, Florine Stettheimer, and William Carlos Williams.

650 Baldwin, Neil and Steven L. Meyers. The Manuscripts and Letters of William Carlos Williams in the Poetry Collection of the Lockwood Memorial Library, State University of New York at Buffalo: A Descriptive Catalog. Boston: G.K. Hall, 1978.

Entries F143-146 catalog three hand-written letters and one telegram from Demuth to Williams; entry F1188 catalogs a typewritten letter from Demuth to Sibley Watson.

651 Eugene O'Neill Collection. American Literature Collection, Beinecke Rare Book and Manuscript Library, Yale University, New Haven, Connecticut.

The collection contains seven items of correspondence from Demuth to O'Neill.

652 Gallup, Donald. "Carl Van Vechten—17 June 1880 : 17 June 1980—A Centenary Exhibition of Some of His Gifts to Yale." The Yale University Library Gazette 55 (October 1980) 70.

Catalogue of an exhibition held at the Beinecke Rare Book and Manuscript Library and the Sterling Memorial Library, Yale University, New Haven, Connecticut, 17 June—30 September 1980. The exhibition included a letter from Demuth, dated 26 March 1922, concerning an article by Van Vechten on Demuth's floral watercolors: "The article was very sympathetic; and unlike most did not rest on the words 'Beauty' and 'Art,'—thanks."

653 Gertrude Stein Collection. Collection of American Literature, Beinecke Rare Book and Manuscript Library, Yale University, New Haven, Connecticut.

The collection contains two letters and several undated notes from Demuth to Gertrude Stein.

654 William Carlos Williams Collection. American Literature Collection, Beinecke Rare Book and Manuscript Library, Yale University, New Haven, Connecticut.

The collection contains one item of correspondence from Williams to Demuth.

IX. Annotated Reproductions

Acrobats, 1919. MOMA/13 (b/w) 226, 535.

_____. SACHS/2 (b/w) 220, 250.

Acrobats—Balancing Act, 1916. HIGH (b/w) 83, 185.

African Daisies, 1925. MURDOCK (b/w) 43.

After Sir Christopher Wren, ca. 1920. HIRSCHL (b/w) 27.

Amaryllis, n.d. ANDERSON (c) 64-65.

And the Home of the Brave, 1931. CHICAGO (c) 137.

Apples, 1925. ROCKEFELLER/2 (b/w) 224, 227.

Apples and Pears, ca. 1929. BENJAMIN (b/w) 29, 87.

Apples (Still Life; Apples, No. 1), ca. 1925. SHELDON (b/w) 241.

Architecture, 1918. CARNEGIE (c) 151, 261.

Arthur G. Dove, 1924. YALE (b/w) 38-39.

The Artist on the Beach (at Provincetown), 1934. CARNEGIE (b/w) 153, 261.

"At a House in Harley Street," 1918. MOMA/13 (b/w) 227, 535.

Aucassin and Nicolette, 1921. HOWLAND (b/w) 24, 29.

_____. STIEGLITZ/2 (c) 58-59.

Backdrop of East Lynne, 1919. SHELDON (c) 44-45, 241.

Bathers, 1924. GOLDSTONE (b/w) 20-21.

Bathers, 1934. TANNAHILL (b/w) 63, 69, 80.

Bathers on a Raft, 1916. MEAD (b/w) 66.

Bathing Beach, ca. 1916. KENNEDY/4 (b/w) Pl. 6.

The Bay, Provincetown, ca. 1914. TOLEDO (b/w) 40, 184.

Beach Scene, 1934. BRADLEY (b/w) 40.

Beach Study No. 3, Provincetown, 1934. HOOD (c) 137.

Bermuda, 1917. ARENSBERG (b/w) Pl. 44.

Bermuda Landscape, 1916. HOWLAND (b/w) 19, 21.

Bermuda No. 1, Tree and House, ca. 1917. MET/2 (c) 31-32, 187.

Bermuda No. 2 (The Schooner), 1917. MET/2 (c) 188-189.

Bermuda: Trees and Houses, 1917. HIRSCHL/2 (c) 25.

_____. HIRSCHL/4 (c) 64-65.

Bicycle Act, Vaudeville, 1916. BALTIMORE (b/w) 110-111.

Blue Plums, 1924. ROCKEFELLER/2 (b/w) 224-225.

Bouquet, ca. 1923. ROCKEFELLER/1 (c) 135.

Bowl of Oranges, 1925. COLUMBUS (c) 108-109, 201.

Buildings, 1918. MICHENER (b/w) 80-81.

Buildings, ca. 1930-31. MARONEY/1 (c) 18, 50-51.

Buildings Abstraction—Lancaster, 1931. DETROIT/1 (b/w) 175.

_____. HERITAGE (b/w) Pl. 42.

Caberet Interior (Purple Pup with Carl van Vechten), ca. 1918. HALPERT (c) 80.

_____. KENNEDY/5 (c) Pl. 8.

California Tomatoes, ca. 1925. COLUMBUS (b/w) 226.

Charles Duncan, 1925. YALE (b/w) 38-39.

Church in Provincetown, No. 2, 1919. THYSSEN (c) 86-89.

Cineraria, 1923. CARTER/1 (c) [frontispiece].

The Circus, 1917. COLUMBUS (c) 104-105, 199-200.

_____. HOOPES (c) 133, 148-149, 196.

_____. HOWLAND (b/w) 20, 21-22.

_____. STIEGLITZ/2 (c) 50-51.

The Circus, 1917. HIRSHHORN (b/w) Pl. 264; pp. 682-683.

Circus, 1919. MOMA/4 (b/w) Pl. 215.

Circus Rider, 1916. MURDOCK (b/w) 44.

Columbia, 1919. FLAG (b/w) 52.

_____. HOWLAND (b/w) 22, 25.

_____. STIEGLITZ/2 (c) 52-53.

Corn and Peaches, 1929. MOMA/13 (b/w) 227, 535.

Cottage Window, ca. 1919. COLUMBUS (b/w) 225.

Cucumbers and White Daisies, ca. 1924. KENNEDY/5 (c) Pl. 9.

_____. KENNEDY/7 (c) Pl. 20.

Cyclamen, 1905. PENNSYLVANIA/2 (c) 2, 11, 94.

Cyclamen, 1918. JANSS (c) 74, 211.

Cyclamen, 1920. MET/2 (c) 190.

Daffodils, 1928. HALPERT (c) 23.

_____. PENNSYLVANIA/2 (b/w) 1, 38, 94.

Dancing, 1912. BOSTON/1 (b/w) 134-135.

Dancing Sailors, 1918. MOMA/13 (b/w) 226, 535.

Distinguished Air, 1930. WHITNEY/5 (b/w) Pl. 22; p. 113.

The Drinkers, 1915. HOWLAND (b/w) 18, 21.

_____. STIEGLITZ/2 (c) 46-47.

Dunes, 1915. HOWLAND (b/w) 18, 21.

Early Houses, Provincetown, 1918. MOMA/13 (b/w) 226, 535.

Eggplant, ca. 1921. PHILLIPS (b/w) Pl. 412.

Eggplant and Green Pepper, 1925. BOHAN (c) 11-12.

Eggplant and Pears, 1925. BOSTON/3 (c) Pl. 93.

Eggplant and Summer Squash, ca. 1927. HOOPES (c) 135, 148-149, 196.

Eight O'Clock, 1917. MOMA/13 (b/w) 226, 535.

Eight O'Clock (Evening), 1917. WADSWORTH (c) 50, 75.

Eight O'Clock (Morning #2), 1917. WADSWORTH (c) 51, 75.

End of the Parade, Coatsville, Pa., 1920. METROPOLIS (c) 458, 522.

Erdgeist, ca. 1918. HALPERT (c) 115.

Figures on the Beach, Glocester, 1918. HIGH (b/w) 83, 185.

_____. KENNEDY/6 (c) Pl. 6.

_____. KENNEDY/7 (c) Pl. 18.

Flour Mill (Factory), 1921. HIRSHHORN (c) Pl. 357; pp. 682-683.

_____. WASHINGTON (c) 148-149.

Flowers, 1915. KENNEDY/3 (b/w) Pl. 4.

_____. MOMA/13 (b/w) 226, 535.

Flowers, ca. 1915. TANNAHILL (b/w) 61, 69, 80.

Flowers, 1918. MET/2 (c) 190.

Flowers, 1919. HOWLAND (c) Pl. 26; p. 23.

_____. STEIGLITZ/2 (c) 54-55.

Flowers in Purple Vase, ca. 1915. GOLDSTONE (b/w) 19.

From the Garden of the Chateau, 1921. DALLAS/2 (c) [frontispiece]; pp. 124-125.

_____. HIRSCHL/3 (c) [frontispiece]; Pl. 59.

From the Kitchen Garden, 1925. MCNAY (b/w) 90-91.

Fruit and Flower, ca. 1928. EBSWORTH (c) 76-77, 201-202.

_____. MARONEY/3 (c) Pl. 6.

Fruit and Sunflowers, ca. 1924. HARVARD/2 (b/w) 261.

Fruit No. 1, 1922. HOWLAND (b/w) 32, 34.

Gloucester (Mackerel 35 cents a pound), 1919. RHODE ISLAND/2 (b/w) 53-55.

Golden Swan, sometimes called "Hell Hole," 1919. PARIS-NEW YORK (b/w) 347, 676.

Grapes and Turnips, 1926. CARNEGIE (c) 153, 261.

The Green Dancer, 1916. PHILADELPHIA/1 (b/w) 510-511.

_____. PHILADELPHIA/2 (b/w) 95.

Hibiscus, 1933. MARONEY/3 (c) Pl. 7.

The High Tower, 1916. NEUBERGER (b/w) 121-123.

House and Trees, 1916. KENNEDY/6 (b/w) Pl. 5.

Houses, 1918. HOWLAND (b/w) 22, 25.

Housetops, 1918. HOWLAND (b/w) 22, 25.

_____. KUSHNER (c) 33, 56.

I Saw the Figure 5 in Gold, 1928. VINSON (b/w) 936-937.

In the Province, 1920. GERDTS (c) 268-270.

In the Province #7, 1920. CARTER/1 (c) 88-89.

In Vaudeville, 1916. KENNEDY/2 (c) Pl. 7.

_____. KENNEDY/7 (c) Pl. 17.

In Vaudeville: Bicycle Rider, 1919. CORCORAN/2 (b/w) 100-101.

In Vaudeville: Dancer with Chorus, 1918. PHILADELPHIA/1 (b/w) 510-511.

In Vaudeville: Soldier and Girlfriend, 1915. KUSHNER (c) 33-34, 57.

In Vaudeville: Two Acrobats #2, 1916. MARONEY/2 (c) Pl. 9.

Incense of a New Church, 1921. HOWLAND (b/w) 24, 28.

_____. METROPOLIS (c) 461, 462, 522.

_____. PARIS-NEW YORK (b/w) 340, 676.

_____. PHILADELPHIA/1 (b/w) 524-525.

_____. STIEGLITZ/2 (c) 60-61.

John Marin, 1925. YALE (b/w) 38-39.

Kiss Me Over the Fence, 1929. KUSHNER (c) 34, 58.

Lancaster, 1920. ARENSBERG (b/w) Pl. 45.

Lancaster, 1921. ALBRIGHT-KNOX/1 (c) 92-93.

_____. ALBRIGHT-KNOX/2 (b/w) 506-507.

Large Dome-Shaped Steeple, n.d. HIRSCHL/2 (b/w) 28-29.

Lily, 1923. HARVARD/1 (b/w) Pl. 135.

_____. HOOPES (b/w) 148-149, 165, 196.

Longhi on Broadway, 1927. LANE (c) Pl. 56; p. 169.

Love, Love, Love (Homage to Gertrude Stein), ca. 1928. HALPERT (c) 47.

_____. THYSSEN (c) 90-93.

Magnolias, ca. 1922. MEAD (b/w) 67.

Man and Woman, 1934. FORT WORTH (b/w) 21.

Man and Sailors, ca. 1932. KENNEDY/6 (c) Pl. 7.

Men on Beach with Dog, 1916. HIRSCHL/5 (b/w) 9.

Modern Conveniences, 1921. COLUMBUS (c) 106-107, 200-201.

_____. HOWLAND (b/w) 23-24, 27.

_____. STIEGLITZ/2 (c) 62/63.

Monument, Bermuda, 1917. PHILLIPS/1 (b/w) Pl. CXXV; pp. 64, 96.

_____. PHILLIPS/2 (b/w) Pl. 413.

My Egypt, 1927. MOMA/2 (b/w) Pl. 23; p. 28.

_____. MOMA/12 (b/w) 17, 19.

_____. WIGHT (c) Pl. 7; pp. 29, 46.

My Egypt, Study #1, ca. 1927. HIRSCHL/2 (b/w) 30.

Nana, Seated Left, and Satin at Laure's Restaurant, 1916. MOMA/13 (b/w) 227, 535.

Negro Jazz Band, 1916. KUSHNER (c) 34, 59.

New England Landscape #8 (Mt. Monadmock, N.H.), ca. 1912-16. MISSOURI (c) 55, 89.

Nospmas. M. Egiap Nospmas. M., 1921. MUNSON (c) 126-127.

The Nut, Pre-Volstead Days, 1916. HOWLAND (b/w) 19, 21.

_____. STIEGLITZ/2 (c) 48-49.

Old Houses, 1917. LOS ANGELES (b/w) 450-452.

On Stage, 1915. KENNEDY/2 (c) Pl. 6.

_____. KENNEDY/5 (c) Pl. 7.

On That Street (Sand Street, Brooklyn), 1932. KENNEDY/2 (c) Pl. 9.

_____. KENNEDY/7 (c) Pl. 21.

Oranges, Bananas, Zinnia, ca. 1925. HIRSCHL/3 (c) Pl. 60.

Paquebot Paris, ca. 1921. HOWLAND (b/w) 31, 33.

_____. STIEGLITZ/2 (c) 64-65.

Peach Blossoms, ca. 1915. HIGH (c) 82-83, 185.

Pepper and Tomatoes, ca. 1927-28. FRAAD (b/w) 100-101.

Pink Dress, 1934. SPRINGFIELD (b/w) 65.

Pink Magnolias, 1933. HIRSCHL/3 (c) Pl. 61.

Plums, 1925. HAYES (c) 79, 130.

Poppies, ca. 1915. HOWLAND (b/w) 18, 21.

Poppies, 1926. HOOPES (b/w) 148-149, 166, 196.

_____. SANTA BARBARA (b/w) Pl. 79.

The Primrose, 1916-17. THYSSEN (c) 84-85.

Red and Yellow Tulips, 1933. THYSSEN (c) 94-95.

Red Chimneys, 1918. JANIS (b/w) 37.

_____. PHILLIPS/1 (b/w) Pl. CXXIV; pp. 64, 96.

_____. PHILLIPS/2 (b/w) Pl. 414.

Red Cyclamen, 1928. MARONEY/3 (c) Pl. 5.

Red Poppies, 1929. HALPERT (c) 21.

Red State and the Gray Church (Red and Gray Buildings), 1919. CRANBROOK (c)
 52-53.

Resting on the Beach, 1916. KENNEDY/7 (c) Pl. 16.

Rise of the Prism, 1919. MURDOCK (b/w) 45.

Roof and Steeple #2, 1921. HIRSCHL/2 (b/w) 26.

Roofer, ca. 1910. HALPERT (b/w) 117.

Roofs and Gables, ca. 1918. CURRIER (b/w) 93.

Roofs and Steeple, 1921. BROOKLYN/1 (b/w) 28.

_____. HOOPES (c) 134, 148-149, 196.

Rooftops and Fantasy, 1918. BOHAN (c) 10-11.

Rooftops and Trees, 1918. CORCORAN/1 (c) 56, 58-60.

Roses, ca. 1920. KENNEDY/8 (b/w) Pl. 30.

Rue du Singe Qui Peche, 1921. HIRSCHL/2 (b/w) 28-29.

_____. METROPOLIS (c) 363, 522.

Sailor, Soldier and Policeman, 1916. HIRSHHORN (b/w) Pl. 265; pp. 682-683.

Spring, ca. 1921. HIRSCHL/1 (c) 95.

Squash and Zinnias, ca. 1916. HALPERT (c) 17.

Squash and Zinnias, ca. 1923-24. MARONEY/1 (c) 17-18, 48-49.

Squashes #2, 1929. MARONEY/3 (c) Pl. 8.

Stairs, Provincetown, 1920. MOMA/8 (c) 142-143.

_____. MOMA/13 (b/w) 227, 535.

Still Life, 1921. MOMA/10 (b/w) 16-17.

_____. MOMA/12 (b/w) 16, 17.

_____. DETROIT/2 (c) 170-171.

Still Life—Apples and Bananas, 1925. TANNAHILL (b/w) 61-62, 66, 69.

Still Life—Egg Plant, n.d. PHILLIPS/1 (b/w) Pl. CXXIV; pp. 64, 96.

Still Life (Egg Plant and Squash), ca. 1927. WADSWORTH 52, 75.

Still Life No. 1, ca. 1922. HOWLAND (b/w) 30, 33.

_____. STIEGLITZ/2 (c) 66-67.

Still Life No. 2, 1922. HOWLAND (b/w) 32, 33.

Still Life No. 3, 1922. HOWLAND (b/w) 32, 33-34.

Still Life No. 3 (Magnolias), ca. 1917. KENNEDY/1 (c) Pl. 16; [biographical note].

Still Life—Peaches, ca. 1925-26. BROOKLYN/1 (c) [frontispiece]; p. 28

_____. BROOKLYN/2 (b/w) Pl. 41.

Still Life with Geranium, 1923. HALPERT (b/w) 119.

Still Life with Spoon, 1927. GEORGIA/1 (b/w) Pl. 9.

Strolling, 1912. MARONEY/1 (c) 46-47.

_____. MOMA/13 (b/w) 226, 535.

Study of a House with Color Notes, n.d. HIRSCHL/2 (b/w) 28-29.

Sun Bathing, Provincetown, 1934. GEORGIA/2 (b/w) 152-153.

Three Acrobats, 1916. CARTER/1 (c) 88-89.

Three Lilies (Study of Three Flowers), 1926. EBSWORTH (c) 78-79, 202.

Three Male Bathers, 1917. BROOKLYN/1 (b/w) 28.

Tiger Lilies, 1920. PENNSYLVANIA/2 (b/w) 1, 39, 94.

Tomatoes, Peppers, and Zinnias, ca. 1927. NEWARK (c) 40, 314.

The Tower, 1920. HOWLAND (b/w) 23, 26.

_____. STIEGLITZ/2 (c) 56-57.

Tree Trunk No. 1, 1916. JANSS (b/w) 68, 211.

Trees, ca. 1917. HOWLAND (b/w) 19, 22.

Trees, ca. 1919. YORK/2 (c) Pl. 25.

Trees, ca. 1920. HALPERT (b/w) 106.

Trees and Barn, 1917. TANNAHILL (b/w) 61, 69, 80.

Trees and Rooftop, 1916. HOUSTON/2 (c) 63, 107.

Two Figures, 1917. MICHIGAN/2 (b/w) 174-175.

Valentine, 1913. MARONEY/3 (c) [front cover]; Pl. 13.

Vaudeville, ca. 1915. NEUBERGER (b/w) 122-123.

Vaudeville, 1917. MOMA/13 (b/w) 226, 535.

Vaudeville—Bicycle Act, ca. 1915. KENNEDY/3 (c) Pl. 6.

Vaudeville—Bird Woman, 1917. KENNEDY/2 (c) Pl. 8.

_____. KENNEDY/7 (c) Pl. 19.

Vaudeville Dancers, 1918. MOMA/13 (b/w) 226, 535.

Vaudeville—"Many Brave Hearts are Asleep in the Deep," 1916. HIRSHHORN (c)
Pl. 358; pp. 682-683.

Vaudeville Musicians, 1917. MOMA/13 (b/w) 226, 535.

Watercolor for Henry James, The Turn of the Screw, 1912. ARTIST & BOOK (b/w)
57-58.

_____. LEWISOHN/1 (b/w) Pl. 127; pp. 292, 296.

White Architecture, 1917. LANE (c) Pl. 55; p. 169.

Yellow Iris, 1921. AMHERST (c) [back cover]; p. 56.

Zinnia and Snapdragons, ca. 1921. HOWLAND (b/w) 24, 30.

Zinnia Bouquet, 1925. PENNSYLVANIA/2 (c) 2, 11, 94.

Zinnias, 1915. ROCHESTER (b/w) 229.

Zinnias, 1926. KUSHNER (c) 34, 60.

Zinnias, 1933. THYSSEN (c) 96-97.

Zinnias and a Blue Dish with Lemons, 1924. GOLDSTONE (b/w) 20.

_____. NEW YORK/1 (c) 34-35.

CHAPTER SIX
Preston Dickinson

William Preston Dickinson was born on 9 September 1889 in New York City. By 1906, when he began classes at the Art Students League, the Dickinson family was living in Suffern, New York. Henry Barby, an art patron who frequented the Daniel Gallery, paid Dickinson's art school tuition and later financed the artist's trip to Europe in late 1910 or early 1911. Dickinson continued his studies in Paris at the Ecole des Beaux-Arts and the Academie Julian. His works were included in two Parisian exhibitions in 1912. Dickinson's Cafe Scene with a Portrait of Charles Demuth indicates that he knew his fellow Precisionist in Paris.

Dickinson returned to America in September 1914, following the outbreak of World War I, and lived with his family in the Bronx. His works were soon shown at the Daniel Gallery in group exhibitions, including his series of paintings and drawings of the Harlem River and farms in the Catskills. Dickinson's works of this period reveal that he had appropriated the Precisionist idiom as early as 1915. His compositions show a strong interest in geometrical abstraction and lyrical dynamism; an expert eye for pattern, texture, and tone; and a highly personal and expressive use of brilliant colors, undoubtedly influenced by his admiration of the Post-Impressionists and the Fauves.

Dickinson's industrial scenes executed around 1920 feature dynamic angles, dramatic light effects, and an expressive handling of his materials. He again turned to depicting the Harlem River in the early 1920s, frequently employing watercolor, gouache, or pastel. Critics of the period noted an Oriental influence on Dickinson's work and it is known that he studied the paintings of the Japanese ukiyo-e masters. Around this time Dickinson also began an extensive series of still lifes and interior scenes. His works were becoming a regular feature of New York exhibitions and he was given his first one-man show at the Daniel Gallery in 1923.

Dickinson spent the summer of 1924 in Omaha, Nebraska, where he produced a series of drawings of the Peters Mills granaries and factory complex. These works pre-date the treatment of grain elevators by other Precisionists—Demuth's My Egypt of 1927, Sheeler's American Landscape of 1930, and Lozowick's Granaries of Democracy (Omaha, Nebraska) of 1943—and they also reflect the greater realism that Dickinson was beginning to employ in both his still lifes and his landscapes.

During 1925 and 1926 Dickinson was in Quebec, Canada, where he painted a number of landscapes and street scenes in rich colors with decorative surface effects.

Later in the decade, as his reputation as an important American modernist was becoming firmly established, his works began to enter a number of public and private collections.

In June of 1930 Dickinson and his friend, fellow painter Oronzo Gasparo, went to Spain in search of an inexpensive place to live and paint. Finding himself short of money by autumn, Dickinson attempted to return home, but he was stricken with double pneumonia and hospitalized. He died three days later on 25 November 1930 in Irun, Spain, where he is buried. Dickinson was one of the earliest American modernists—and arguably the first Precisionist—to utilize industrial subjects in his works and to render them with elements of both realism and abstraction.

I. Monographs and Exhibition Catalogues

655 Cloudman, Ruth. <u>Preston Dickinson 1889-1930</u>. Lincoln: Nebraska Art Association, 1979.

Catalogue of a major retrospective exhibition held at the Sheldon Memorial Art Gallery, Lincoln, Nebraska, 4 September—7 October 1979. Cloudman's lengthy catalogue essay traces Dickinson's career and provides commentary on his artistic evolution and critical reception. She discusses numerous individual paintings and drawings in her essay in addition to annotating the seventy-one catalogue entries, all of which are illustrated. The catalogue also contains a selected bibliography and an exhibition history.

656 Daniel Gallery. <u>Paintings by Preston Dickinson</u>. New York: The Gallery, 1924.

Catalogue of an exhibition held at the Daniel Gallery, New York, April-May 1924.

657 _____. <u>Recent Pastels by Preston Dickinson</u>. New York: The Gallery, 1927.

Catalogue of an exhibition held at the Daniel Gallery, New York, 10 February—5 March 1927.

658 Downtown Gallery. <u>Preston Dickinson: 13 Pastels</u>. New York: The Gallery, 1938.

Catalogue of an exhibition held at the Downtown Gallery, New York, 5-23 April 1938.

659 Hackley Art Gallery. <u>Exhibition of Works by Preston Dickinson, Edwin James Smith and Oronzo Gasparo</u>. Muskegon, Mich.: The Gallery, 1933.

Catalogue of an exhibition held at the Hackley Art Gallery, Muskegon, Michigan, April-May 1933.

660 M. Knoedler & Co. <u>Preston Dickinson</u>. New York: M. Knoedler & Co., 1943.

Catalogue of an exhibition held at M. Knoedler & Co., New York, 7-27 February 1943. The exhibition featured twenty-seven works executed between 1910 and 1929 (including seventeen still lifes) purchased from the Daniel Gallery. Foreword by Duncan Phillips.

661 Phillips Memorial Gallery. <u>Memorial Exhibition of Preston Dickinson</u>. Washington, D.C.: The Gallery, 1931.

Catalogue of an exhibition held at the Phillips Memorial Gallery, Washington, D.C., February 1931.

662 Smith College. Museum of Art. <u>Water Color Sketches and Drawings by the Late Preston Dickinson</u>. Northampton, Mass.: The Museum, 1934.

Catalogue of an exhibition held at the Museum of Art, Smith College, Northampton, Massachusetts, 19 February—12 March 1934.

663 Zabriskie Gallery. <u>Preston Dickinson (1889-1930)</u>. New York: The Galleries, 1974.

Catalogue of an exhibition held at the Zabriskie Gallery, New York, 15 January—2 February 1974. Catalogue foreword by Beth Urdang.

II. Articles and Essays

664 Bouche, Louis. "Preston Dickinson." <u>Living American Art Bulletin</u> (October 1939) 2-4.

665 "Cincinnati Acquires a Dickinson Pastel." <u>The Art Digest</u> 6 (15 November 1931) 12.

A brief notice of the acquisition of Dickinson's pastel <u>View of Quebec</u> of 1926 by the Cincinnati Art Museum.

666 Deak, Gloria Gilda. "Preston Dickinson." In <u>Kennedy Galleries Profiles of American Artists</u>, 2d ed., 74-75. New York: Kennedy Galleries, 1984.

A biographical essay.

667 Craven, Thomas Jewell. "Preston Dickinson." <u>Shadowland</u> 6 (November 1921) 11, 68.

Craven gives a critical assessment of Dickinson's work with some interesting remarks on the artist's Persian influences. Although he finds that Dickinson's compositions tend to be disjointed despite well-conceived individual parts, Craven concludes, "His art is high strung and brilliant. His most sober studies bear evidence of his close contact with American life, and are stamped with nervous energy. His struggles for composed expression are often too apparent, but he is still young and his work is steadily growing more robust and sustained. He is unquestionably one of the finest colorists, and his landscapes executed in an original spectrum scale are both distinguished and exciting."

668 Grafly, Dorothy. "Philadelphia Notes." The American Magazine of Art 17 (December 1926) 652.

Notice of Demuth winning the gold medal, and Dickinson the bronze, in the watercolor competition during the Sesquicentennial exposition.

669 Kootz, Samuel M. "Preston Dickinson." Creative Art 8 (May 1931) 338-341.

Kootz criticizes Dickinson's work for lacking an overall vision in addition to being too superficial, brittle, and metallic.

670 _____. "Preston Dickinson." In Modern American Painters, by Samuel M. Kootz, 34-35. New York: Brewer & Warren, 1930.

Kootz gives a critical assessment of Dickinson's career and says that the artist is "sharply intelligent" and a "master technician" who constructs his pictures in "brilliant intellectual order." Five works are illustrated on black and white plates.

671 "Omaha." The Art News 23 (18 October 1924) 7.

A brief notice of Dickinson's artistic activities in Omaha, Nebraska, during the summer of 1924.

672 Pemberton, Murdock. "Critique—Art." The New Yorker 1 (19 September 1925) 21.

In discussing Dickinson's pastel still life Hospitality, shown at the Daniel Gallery, Pemberton says, "It is a marvelous picture, we should imagine perfect. Yet it is so beautifully handled that you have the feeling of it being brittle. Perhaps some of the charm of Dickinson is lost when you stop to consider such things as technique and the time he spends in his organizations."

673 "Preston Dickinson." The Art News 29 (20 December 1930) 56.

An obituary.

674 "Preston Dickinson, 1889-1930." Smith College Museum of Art. Bulletin no. 15 (June 1934) 14.

A brief notice of the museum's acquisition of a portfolio of Dickinson's drawings, watercolors, and oils, a gift of a close friend of the artist, Mrs. Janet Munro Curtis.

675 Watson, Forbes. "Preston Dickinson." The Arts 5 (May 1924) 284-288.

Watson gives a brief assessment of Dickinson's work and writes of the artist's "clear-cut individuality," his "lucid and inventive mind capable of great concentration," and his "compact, intentional, and logical" compositions.

III. Exhibition Reviews

676 Brook, Alexander. "The Exhibitions—Preston Dickinson." The Arts 3 (April 1923) 274-276.

Review of the exhibition "Paintings and Drawings by Preston Dickinson" held at the Daniel Gallery, New York, February-March 1923. This was Dickinson's first one-man exhibition at the Daniel Gallery.

677 Craven, Thomas. "American Month in the Galleries." The Arts 11 (March 1927) 152-153.

Review of the exhibition "Recent Pastels by Preston Dickinson" held at the Daniel Gallery, New York, 10 February—5 March 1927.

678 Lowe, Jeanette. "New Exhibitions of the Week—Subtle and Accomplished Pastels by P. Dickinson." The Art News 36 (16 April 1938) 15.

Review of the exhibtion "Preston Dickinson: 13 Pastels" held at the Downtown Gallery, New York, 5-23 April 1938.

679 "Reviving a Memory." The Art Digest 12 (15 April 1938) 20.

Review. See entry 678.

680 Comstock, Helen. "The Connoisseur in America—Daniel Collection Acquired by M. Knoedler & Co." The Connoisseur 61 (July 1943) 132.

Review of the exhibition "Preston Dickinson" held at M. Knoedler & Co., New York, 8-27 February 1943.

681 "The Passing Shows." Art News 42 (15-28 February 1943) 24.

Review. See entry 680.

682 Riley, Maude. "Dickinson Surveyed." The Art Digest 17 (15 February 1943) 19.

Review. See entry 680.

683 Frank, Peter. "Reviews and Previews—Preston Dickinson." Art News 73 (March 1974) 105.

Review of the exhibition "Preston Dickinson (1889-1930)" held at the Zabriskie Gallery, New York, 15 January—2 February 1974.

684 "Art Across North America—Outstanding Exhibition: Golden Boy." Apollo 111 (May 1980) 401-402.

Review of the exhibition "Preston Dickinson 1889-1930" held at the Sheldon Memorial Art Gallery, Lincoln, Nebraska, 4 September—7 October 1979.

685 "Museen und Gallerien—Preston Dickinson (1889-1930) First Retrospective." Pantheon 38 (April-June 1980) 136.

Review. See entry 684.

IV. Reference Sources

686 Baigell, Matthew. Dictionary of American Art. New York: Harper & Row, 1982. S.v. "Dickinson, Preston."

687 Encyclopedia of American Art. New York: E.P. Dutton, 1981. S.v. "Dickinson, Preston," by Alfred V. Frankenstein.

688 Falk, Peter Hastings, ed. Who Was Who in American Art: Compiled from the Original Thirty-four Volumes of "American Art Annual: Who's Who in Art." Madison, Conn.: Sound View Press, 1985. S.v. "Dickinson, Preston."

689 Fielding, Mantle. Mantle Fielding's Dictionary of American Painters, Sculptors & Engravers. 2d enl. ed. Edited by Glenn B. Opitz. Pougkeepsie, N.Y.: Apollo, 1986. S.v. "Dickinson, Preston."

690 Myers, Bernard S., ed. McGraw-Hill Dictionary of Art, Vol. 2. S.v. "Dickinson, Preston," by Jerome Viola.

691 Osborne, Harold, ed. The Oxford Companion to Twentieth-Century Art. New York: Oxford University Press, 1981. S.v. "Dickinson, Preston."

692 Phaidon Dictionary of Twentieth-Century Art. London ; New York: Phaidon, 1973. S.v. "Dickinson, Preston."

693 "Preston Dickinson (1891 [sic]-1930)." In American Art Analog. Vol. 3, 1874-1930, comp. Michael David Zellman, 886. New York: Chelsea House, in association with American Art Analog, 1986.

 A brief biographical sketch accompanied by auction price information for the artist's works.

694 "Preston Dickinson—Painter." Index of Twentieth Century Artists, 1933-1937. 510-511, 525. New York: Arno Press, 1970.

695 Praeger Encyclopedia of Art, Vol. 2. New York: Praeger, 1971. S.v. "Dickinson, Preston," by Emily Wasserman.

696 Starr, Harris E., ed. Dictionary of American Biography, Vol. 11, supp. 1. New York: Scribner's, 1944. S.v. "Dickinson, Preston," by William M. Milliken.

697 Vollmer, Hans. Allgemeines Lexikon der bildenden Kunstler des xx. Jahrhunderts, Vol. 1. Leipzig: E.A. Seeman, 1953-1962. S.v. "Dickinson, Preston."

V. Dissertations

698 Rubenfeld, Richard Lee. "Preston Dickinson: An American Modernist, with a Catalogue of Selected Works." 2 vol. Ph.D. diss., Ohio State University, 1985.

 The first volume of Rubenfeld's dissertation consists of a detailed biography of Dickinson and a lengthy analysis of the stylistic and thematic aspects of his art, with special attention devoted to the historical context in which he worked. Rubenfeld points out that although Dickinson made an important contribution to Precisionism, and there is always an element of that style in his oeuvre, the Precisionist emphasis varies in its importance from work to work. Dickinson also experimented with more painterly and coloristic styles inspired by the Post-Impressionists, the Fauves, and the Japanese ukiyo-e masters. The second volume consists of an extensively annotated catalogue encompassing 183 of Dickinson's works, a list of exhibitions in which his works were shown, and a bibliography.

VI. Archival Sources

699 Archives of American Art. The Card Catalog of the Manuscript Collections of
the Archives of American Art, Vol. 3. Wilmington, Del.: Scholarly Resources,
1980. S.v. "Dickinson, Preston."

700 _____. The Card Catalog of the Manuscript Collections of the Archives of
American Art, Supplement 1981-1984. Wilmington, Del.: Scholarly Resources,
1985. S.v. "Dickinson, Preston."

This circulating microfilm collection contains a number of sources on Dickinson
including material from the Downtown Gallery Papers, the Pennsylvania
Academy of the Fine Arts Collection, the Forbes Watson Papers, and the
Macbeth Gallery Papers.

VII. Annotated Reproductions

The Absinthe Drinker, ca. 1921. KENNEDY/8 (b/w) [back cover].

Along the Harlem River, 1922. SHELDON (b/w) 242.

Along the River, n.d. PHILLIPS/2 (b/w) Pl. 429.

The Artist's Table, n.d. EBSWORTH (c) 80-81, 202.

The Black House, ca. 1923. HOWLAND (b/w) 36, 39.

_____. KUSHNER (c) 34, 61.

The Bridge, ca. 1922-23. NEWARK (b/w) 160, 315.

Bridge over Harlem River, n.d. BENJAMIN (b/w) 24, 87-88.

Cubistic Interior, n.d. GEORGIA/1 (b/w) Pl. 11.

Decanter and Bottles, 1925. PHILLIPS/2 (b/w) Pl. 430.

Factories, 1920. NEWARK (b/w) 160, 315.

Factories, 1924. HOWLAND (b/w) 37, 39.

Factory, ca. 1920. COLUMBUS (c) 96-97, 196-197.

Factory, ca. 1921. HIRSCHL/2 (b/w) 30-31.

Factory in Winter, n.d. HALPERT (b/w) 128.

Fort George Hill, 1915. MUNSON (c) 118-119.

Garden in Winter, ca. 1922. EBSWORTH (c) 82-83, 202.

Grain Elevators, 1924. HOWLAND (b/w) 38, 39.

Grain Elevators and Architectural Theme: A Double-Sided Drawing, 1924. HALPERT
 (b/w) 27.

Harlem River, n.d. HAYES (c) 78, 130-131.

_____. MOMA/13 (b/w) 229, 536.

Hillside, 1919. HOOPES (b/w) 149, 167, 196.

_____. HOWLAND (b/w) 34, 35.

Hospitality, ca. 1926. HOWLAND (b/w) 40, 41.

Industrial Landscape (The Suburbs ; Modern Industry), ca. 1918-22. HOOD (c) 134-
 135.

Landscape, n.d. HOWLAND (b/w) 34, 35.

Landscape with Bridge, 1922. MOMA/12 (b/w) 20-21.

Locomotive, 1922. KUSHNER (c) 34, 62.

Maine Landscape, ca. 1917-21. LOS ANGELES (b/w) 276-277.

My House, n.d. PHILLIPS/2 (b/w) Pl. 431.

Nebraska Grain Elevators, 1924. HIRSCHL/4 (c) 70.

Old Quarter, Quebec, 1927. PHILLIPS/2 (b/w) Pl. 432.

_____. WIGHT (b/w) Pl. 8; pp. 29, 48.

Plums on a Plate, 1926. MOMA/2 (b/w) Pl. 26; p. 28.

_____. MOMA/4 (b/w) Pl. 119.

_____. MOMA/13 (b/w) 229, 536.

Port Jefferson, Long Island, ca. 1920. LONG ISLAND (c) 34-35.

Snow Scene, Catskills, n.d. SHELDON (b/w) 243.

Spanish Landscape, 1930. TOLEDO (b/w) 41, 191.

Still Life, n.d. CLEVELAND (b/w) 190.

Still Life, n.d. MET/1 (c) 138-139.

Still Life, ca. 1924. ALBRIGHT/KNOX/1 (c) 94-95.

Still Life, ca. 1924. PENNSYLVANIA/1 (b/w) 38.

Still Life, 1924. LEAGUE/1 (b/w) 94-95.

Still Life, 1925. HIRSCHL/4 (c) 95.

Still Life, 1928. MOMA/12 (b/w) 21, 23.

Still Life No. 1, ca. 1924. HOWLAND (c) Pl. 54; P. 39.

Still Life No. 2 (Still Life with Vegetables), n.d. HOWLAND (b/w) 36, 39.

Still Life with Candle, 1930. YORK/2 (c) Pl. 32.

Still Life with Compote, ca. 1922. HALPERT (b/w) 114.

_____. MCDONOUGH (b/w) 27, 111.

Still Life with Demijohn, 1930. LEAGUE/2 (b/w) 56-57.

_____. MCDONOUGH (b/w) 27, 111.

_____. WALKER (b/w) 536.

Still Life with Knife, 1924. WADSWORTH (c) 56, 76.

Still Life with Navajo Blanket, 1928. HIRSHHORN (c) Pl. 382; p. 684.

Still Life with Pipe and Books, 1920. NEUBERGER (b/w) 125-126.

Still Life with Round Plate (Still Life with Knife) ca. 1924. SHELDON (b/w) 242.

Still Life with Yellow Green Chair, 1928. COLUMBUS (c) 98-99, 197-198.

_____. HOWLAND (b/w) 36, 40.

Street in Quebec, n.d. PHILLIPS/1 (b/w) Pl. CXXXII; pp. 74-75, 97.

_____. PHILLIPS/2 (b/w) Pl. 433.

Street in Quebec, 1926. BROOKLYN/1 (b/w) 28.

Suburbs, 1916. GOLDSTONE (b/w) 23.

Symphonie Domestique, Americaine, ca. 1922-23. AMHERST (b/w) 60.

_____. MEAD (b/w) 68.

Washington Bridge, 1922. NEWARK (b/w) 160, 315.

The Water Gate, 1922. MET/1 (c) 138-139.

Winter, Harlem River, n.d. PHILLIPS/1 (b/w) Pl. CXXXII; pp. 74-75, 97.

_____. PHILLIPS/2 (b/w) Pl. 434.

Woman Bathing, n.d. HOWLAND (b/w) 34, 35.

Women at Pool, 1916. JANSS (b/w) 123, 211.

CHAPTER SEVEN
O. Louis Guglielmi

Osvaldo Luigi Guglielmi was born in Cairo, Egypt, on 9 April 1906 to parents of Italian descent. His father was a touring concert violinist and violist. Guglielmi lived with his mother in Milan, Italy, and Geneva, Switzerland, until the family emigrated to the United States in 1914 and settled in New York City. His early artistic education took place during night classes at the National Academy of Design from 1920 to 1922 while he was still a high school student, and then on a full-time basis from 1923 to 1925 after he dropped out of school. He also studied sculpture at the Beaux Arts Institute from 1921 to 1923.

Guglielmi was a guest artist at the Yaddo Colony in Saratoga Springs, New York, during the summer of 1928. By 1930 he had rented a working studio in West 23rd Street in New York. He considered 1932 to be his starting point as a serious painter after spending the summer as a Fellow of the MacDowell Colony. He was to spend eleven such summers at the Colony between 1932 and 1949. In 1934 he joined the easel painting division of the Public Works Art Project.

Guglielmi's works from the mid-1930s to the early 1940s are Precisionist insofar as they depict urban or industrial scenes in a modified Cubist style. However, he populated compositions such as South Street Stoop of 1935 and View in Chambers Street of 1936 with somber, isolated individuals surrounded by an aura of melancholy and alienation. In other works like The Various Spring of 1937 and Mental Geography of 1938, Guglielmi employed symbolism, enigmatic imagery, poetic metaphors, and incongruous combinations of objects. Satire appeared in Sisters of Charity of 1936, while a more straightforward depiction of the problems of the underclass is found in The Relief Blues of 1937. Death is a recurrent theme of many of Guglielmi's works of this period such as Funeral at Woodford of 1932, The Tenements of 1939 (which shows caskets lying in the street), and Terror in Brooklyn of 1941.

Guglielmi placed nine of his canvases with Jacques Seligman's gallery in 1934, although he was later represented by the Downtown Gallery, which gave him his first one-man show in 1938. This critically acclaimed exhibition established Guglielmi as a leading figure in the social Surrealist movement. Guglielmi was influenced by the Metaphysical School of Carlo Carra and Giorgio de Chirico as well as by European Surrealists like Rene Magritte. His appropriation of the Surrealist idiom, however, was not centered on a private dream world, but was utilized instead to convey social

commentary both on the economic problems of impoverished urban dwellers during the Great Depression and on the impending threat of war.

Guglielmi's career was interrupted by his army service from 1943 to 1945, but he again resumed work following his discharge and was given his second one-man show at the Downtown Gallery in 1948. While some of his postwar paintings continue to show the influence of de Chirico, Guglielmi was beginning to move in the more abstract direction taken by his friends Ralston Crawford and Stuart Davis. By the time Guglielmi accepted teaching appointments at Louisiana State University in the early 1950s, he was working with a vocabulary of flat planar elements in complex, semi-abstract arrangements. His social Surrealist period had ended and he was now preoccupied with formal compositional problems involving color, pattern, and geometrical simplification. Guglielmi's late works, like his circus series of 1953-56, became quite abstract and experimental, as if he were attempting to capture the energy of the Abstract Expressionists in a more calculated and controlled manner.

After returning from a very brief trip to Italy in the spring of 1956, Guglielmi purchased a home in Amagansett, New York. He died of a sudden heart attack on 3 September 1956, leaving behind his wife and a twelve-year old son. In addition to being one of the more individualistic and eclectic Precisionists, Guglielmi ranks with James Guy and Walter Quirt as one of the premiere social Surrealists.

I. Guglielmi's Writings, Statements, and Interviews

701 Bel Ami International Art Competition, 23. Hollywood, Calif.: Lowe-Lewin, 1946.

A statement by Guglielmi on The Temptation of St. Anthony of 1946.

702 Boswell, Peyton. "Peyton Boswell Comments: Name Calling." The Art Digest 16 (15 December 1941) 3.

Boswell prints and offers comments on edited version of Guglielmi's response to Walter Quirt's criticism of Salvador Dali in his article, "Dali a Fascist?" The Art Digest 16 (1 December 1941) 6, 14.

703 Guglielmi, O. Louis. "After the Locusts." In Art for the Millions: Essays from the 1930s by Artists and Administrators of the WPA Federal Art Project, ed. Francis V. O'Connor, 112-115. Greenwich, Conn.: New York Graphic Society, 1973.

Guglielmi states that the paintings he produced under the auspices of the Public Works Art Project were both autobiographical and a reflection of the social environment of the lower class sections of New York. He speaks in favor of government patronage of the arts on a permanent basis "free from the offensive stigma of relief." Guglielmi offers comments on two canvases of 1936, Hague Street (Spring Comes to Hague Street) and Wedding in South Street.

704 _____. "I Hope to Sing Again." Magazine of Art 37 (May 1944) 173-177.

In this autobiographical essay, written during his army service in World War II, Guglielmi discusses his artistic development and two of his canvases, The Bridge of 1943 and Mental Geography of 1938. "It has been said," Guglielmi writes, "that my work requires program notes. There may be some truth in that assertation. The mystification arises in the use I make of fantasy in an otherwise orderly and objective representation."

705 _____. "Letters to the Editor." Life 22 (31 March 1947) 9.

Guglielmi's responses to Winthrop Sargeant's article, "Why Artists Are Going Abstract: The Case of Stuart Davis," in the 17 February 1947 issue of Life, and to a letter to the editor by Aaron Bohrod (an artist who covered World War II for the magazine) in the 10 March 1947 issue.

706 _____. Richmond Times-Dispatch Magazine (Richmond, Va.), (2 July 1950).

Contains a statement by Guglielmi on Fourth of July of 1948.

See also entries 708, 715, 718, 721, 724, and 759-760.

II. Monographs and Exhibition Catalogues

707 Baker, John. O. Louis Guglielmi: A Retrospective Exhibition. New Brunswick, N.J.: Rutgers University Art Gallery, Rutgers, The State University of New Jersey, 1980.

Catalogue of a major retrospective exhibition held at the Rutgers University Art Gallery, New Brunswick, New Jersey, 2 November—21 December 1980. In his catalogue essay, which is virtually a monograph, John Baker provides an analysis of Guglielmi's entire career along with comments on all the works in the exhibition, focusing on the artist's stylistic development and the visual metaphors and symbolism in his work. The catalogue contains a chronology and a selected bibliography. In addition to four color plates, there are 125 black and white illustrations.

708 Bethers, Ray. How Paintings Happen. New York: W.W. Norton, 1951.

Bethers offers brief analyses of Mental Geography of 1938 (p. 40) and Obsolete Structure of 1947, accompanied by a photograph of the original site upon which the latter painting was based (pp. 84-85). Statements by Guglielmi on both paintings are included.

709 Downtown Gallery. <u>O. Louis Guglielmi</u>. New York: The Gallery, 1938.

Catalogue of an exhibition held at the Downtown Gallery, New York, 15 November—3 December 1938. This was the artist's first one-man exhibition.

710 _____. <u>O. Louis Guglielmi</u>. New York: The Gallery, 1948.

Catalogue of an exhibition held at the Downtown Gallery, New York, 2-20 March 1948.

711 _____. <u>Guglielmi: Exhibition of New Paintings</u>. New York: The Gallery, 1951.

Catalogue of an exhibition of thirteen works held at the Downtown Gallery, New York, 20 November—8 December 1951.

712 _____. <u>Guglielmi: Exhibition of Paintings 1931 to 1954</u>. New York: The Gallery, 1967.

Catalogue of an exhibition of twenty-eight works held at the Downtown Gallery, New York, 7-25 November 1967.

713 Genauer, Emily. <u>Best of Art</u>, 34-36. Garden City, N.Y.: Doubleday, 1948.

Genauer discusses Guglielmi's <u>The Temptation of St. Anthony</u> of 1946, which is illustrated.

714 Louisiana State University. Foster Hall Art Gallery. <u>Paintings by Louis Guglielmi</u>. Baton Rouge, La.: The Gallery, 1952.

Catalogue of an exhibition of fifteen works held at the Foster Hall Art Gallery, Louisiana State University, Baton Rouge, 11-30 March 1952.

715 Museum of Modern Art (New York, N.Y.) <u>American Realists and Magic Realists</u>. New York: The Museum, 1943.

Catalogue of an exhibition held at the Museum of Modern Art, New York, which includes fifteen works by Guglielmi (two are illustrated). The catalogue contains an autobiographical sketch by Guglielmi and a statement on his influences and aesthetic philosophy (pp. 38-39).

716 Nordness Gallery. <u>O. Louis Guglielmi: Memorial Exhibition</u>. New York: The Gallery, 1958.

Catalogue of an exhibition of twenty-three paintings executed between 1930 and 1956 held at the Nordness Gallery, New York, 14 October—1 November 1958. In addition to a checklist of the works in the exhibition, the catalogue also contains a reprint of Guglielmi's statement from American Realists and Magic Realists; biographical notes; and listings of one-man exhibitions, awards, publications, and museum representation. In his "An Appreciation of Guglielmi," Stuart Davis writes, "He was a student of all contemporary styles of art, literature and music, and his personal choice of direction had this sound critical base of understanding. Guglielmi is one of the few American artists who is explicit as an individual in his work. I feel fortunate to have had his friendship, and grateful for the courage it gave me."

717 _____. O. Louis Guglielmi: The Complete Precisionist (Distinguished Exhibitions of American Art Number Ten). New York: The Gallery, 1961.

Catalogue of an exhibition held at the Nordness Gallery, New York, 31 January—18 February 1961. The statements and supplementary material that appeared in the gallery's catalogue of its 1958 Guglielmi memorial exhibition are reprinted (see 716). The catalogue contains a checklist of the thirty paintings in the exhibition (all of which are illustrated), with a reference to additional unlisted selected drawings.

718 Pagano, Grace. Contemporary American Painting: The Encyclopaedia Britannica Collection. New York: Duell, Sloan, and Pearce, 1945. S.v. "Louis Guglielmi."

A biographical sketch with a statement by Guglielmi on Odyssey for Moderns of 1943, which is illustrated.

719 Photography: Bonge, Dwight, Guglielmi, Siskind, White. Introduction by Ralston Crawford. Hempstead, N.Y.: Hofstra College, 1961.

Catalogue of an exhibition held at the gallery of Walt Whitman Hall, Hofstra College, Hempstead, New York, 27 February—10 March 1961. The exhibition included five photographs by Guglielmi (Shadow on New Orleans Tomb is illustrated). In his introduction, Crawford said of the exhibition, "I like it because it enlarges by experience; because it has, to one extent or another, an unexpected quality." The dates of this exhibition have been incorrectly cited in other sources; the correct dates have been supplied courtesy of the Hofstra University Archives, Joan and Donald E. Axinn Library.

720 Seven Decades of MacDowell Artists. New York: MacDowell Colony, 1976.

Catalogue of an exhibition held at the James Yu Gallery, New York, 24-28 October 1976. The exhibition featured works of artists and sculptors who had either been awarded the MacDowell Medal or had been Fellows at the

MacDowell Colony. Guglielmi spent seven summers as a Fellow starting in 1932. His <u>Deserted Bridge with Figure</u> of 1934 is illustrated and accompanied by a biographical sketch.

721 University of Illinois—Urbana. College of Fine and Applied Arts. <u>University of Illinois Exhibition of Contemporary American Painting</u>. Urbana: University of Illinois Press, 1951.

Catalogue of an exhibition held at the Galleries of the College of Fine and Applied Arts, University of Illinois, Urbana, 4 March—15 April 1951, which includes Guglielmi's <u>Night Windows</u> of 1948. The biographical note on Guglielmi contains a statement by the artist on the painting (pp. 183-184).

722 Washburn Gallery. <u>O. Louis Guglielmi</u>. New York: The Gallery, 1988.

Catalogue of six works executed between 1946 and 1954 held at the Washburn Gallery, New York, 11 May—10 June 1988. The catalogue contains reprints of statements by Guglielmi and Stuart Davis and a color reproduction of each work.

III. Articles and Essays

723 Baker, John. "O. Louis Guglielmi: A Reconsideration." <u>Archives of American Art Journal</u> 15, no. 2 (1975) 15-20.

Baker gives a more extended analysis of Guglielmi's career in his 1980 catalogue essay for <u>O. Louis Guglielmi: A Retrospective Exhibition</u> (see 707).

724 O'Connor, John. "Painting in the United States, 1945." <u>Carnegie Magazine</u> 19 (November 1945) 144-145.

Notice of Guglielmi's <u>The River</u> of 1942 being awarded the Third Honorable Mention, with a prize of $200, in the exhibition "Painting in the United States, 1945" held at the Carnegie Institute, Pittsburgh, Pennsylvania. A statement by the artist is included.

725 "Old Age." <u>Fortune</u> 34 (December 1946) 122-125, 243-244, 247-248.

This portrait of Ward Manor, a Hudson River home for the aged owned by the Community Service Society of New York, is illustrated with two paintings and three drawings by Guglielmi.

726 Salpeter, Harry. "About O. Louis Guglielmi: A Note on an Artist Who is Not as Well-Known as He Should Be." <u>Coronet</u> 1 (March 1937) 182-183.

Salpeter gives a brief overview of Guglielmi's career. In comparing Guglielmi's Memory of the Charles River with Blume's South of Scranton, he observes that Guglielmi "subordinated document to paint and message to design." Guglielmi's Persistent Sea No. 2 of 1935 is illustrated in color.

727 "Your Money Bought These Paintings: They are part of a collection of modern American art purchased by the State Department for exhibition abroad." Look 11 (18 February 1947) 80-81.

Guglielmi's The Tenements of 1939 is pictured with other paintings selected for the Department of State's "Advancing American Art" exhibition (see 002).

IV. Exhibition Reviews

728 "Arts—Wave of One-Man Shows." Newsweek 12 (28 November 1938) 25.

Review of the exhibition "O. Louis Guglielmi" held at the Downtown Gallery, New York, 15 November—3 December 1938. This was the artist's first one-man show.

729 "Guglielmi's 'First'." The Art Digest 13 (15 November 1938) 20.

Review. See entry 728.

730 Lowe, Jeanette. "New Exhibitions of the Week—A First New York Show of Guglielmi, Satirist of the American Scene." The Art News 37 (26 November 1938) 13.

Review. See entry 728.

731 "Rational Grotesqueries." Time 32 (5 December 1938) 38.

Review. See entry 728.

732 Coates, Robert M. "The Art Galleries—Latter Day Impressionist." The New Yorker 24 (13 March 1948) 62-63.

Review of the exhibition "O. Louis Guglielmi" held at the Downtown Gallery, New York, 2-20 March 1948.

733 Reed, Judith Kaye. "Presenting Guglielmi in Solo Exhibition." The Art Digest 22 (1 March 1948) 16.

Review. See entry 732.

734 "Reviews and Previews—Louis Guglielmi." Art News 47 (March 1948) 44.

 Review. See entry 732.

735 Breuning, Margaret. "Fifty-Seventh Street in Review—Louis Guglielmi." The Art Digest 26 (1 December 1951) 19.

 Review of "Guglielmi: Exhibition of New Paintings" held at the Downtown Gallery, New York, 20 November—8 December 1951.

736 Goodnough, Robert. "Reviews and Previews—Louis Guglielmi." Art News 50 (December 1951) 47.

 Review. See entry 735.

737 Campbell, Lawrence. "Reviews and Previews—Louis Guglielmi." Art News 57 (October 1958) 14.

 Review of the exhibition "O. Louis Guglielmi: Memorial Exhibition" held at the Nordness Gallery, New York, 14 October—1 November 1958.

738 Coates, Robert M. "The Art Galleries—All American." The New Yorker 34 (25 October 1958) 158.

 Review. See entry 737.

739 Ventura, Anita. "In the Galleries—Louis Guglielmi Memorial." Arts 33 (October 1958) 54.

 Review. See entry 737.

740 Campbell, Lawrence. "Reviews and Previews—Louis Guglielmi." Art News 59 (February 1961) 13.

 Review of the exhibition "O. Louis Guglielmi: The Complete Precisionist" held at the Nordness Gallery, New York, 31 January—18 February 1961.

741 Coates, Robert M. "The Art Galleries—Backward, O Time." The New Yorker 37 (18 February 1961) 114, 117.

 Review. See entry 740.

742 De Mott, Helen. "In the Galleries—O. Louis Guglielmi." Arts 35 (February 1961) 54.

Review. See entry 740.

743 Preston, Stuart. "Current and Forthcoming Exhibitions—New York." Burlington Magazine 103 (March 1961) 119.

Review. See entry 740.

744 Campbell, Lawrence. "Reviews and Previews—O. Louis Guglielmi." Art News 61 (Summer 1962) 58.

Review of the exhibition "O. Louis Guglielmi" held at the Nordness Gallery, New York, May 1962.

745 Calas, Nicholas. "In the Galleries—Louis Guglielmi." Arts Magazine 42 (December 1967-January 1968) 58.

Review of the "O. Louis Guglielmi (1906-1956): Retrospective Exhibition" held at the Downtown Gallery, New York, 7-25 November 1967.

746 Campbell, Lawrence. "Reviews and Previews—O. Louis Guglielmi." Art News 66 (November 1967) 18, 20.

Review. See entry 745.

747 _____. "Reviews and Previews—O. Louis Guglielmi." Art News 71 (March 1972) 16.

Review of the exhibition "Miklos Suba & O. Louis Guglielmi" held at the Robert Schoelkopf Gallery, New York, 19 February—9 March 1972.

748 Conrad, Peter. "Antitheses of Abstraction." The Times Literary Supplement (19 June 1981) 696.

Review of the exhibition "O. Louis Guglielmi: A Retrospective Exhibition" held at the Rutgers University Art Gallery, New Brunswick, New Jersey, 2 November—21 December 1980 and which traveled, on a reduced scale, to the Whitney Museum of American Art, New York, 6 May—5 July 1981.

V. Reference Sources

749 Baigell, Matthew. Dictionary of American Art. New York: Harper & Row, 1982. S.v. "Guglielmi, O. Louis."

750 Cummings, Paul. Dictionary of Contemporary American Artists. 5th ed. New York: St. Martin's, 1988. S.v. "Guglielmi, O. Louis."

751 Encyclopedia of American Art. New York: E.P. Dutton, 1981. S.v. "Guglielmi, O. Louis," by Alfred V. Frankenstein.

752 Falk, Peter Hastings, ed. Who Was Who in American Art: Compiled from the Original Thirty-four Volumes of "American Art Annual: Who's Who in Art." Madison, Conn.: Sound View Press, 1985. S.v. "Guglielmi, Louis O. [sic]."

753 Gilbert, Dorothy B., ed. Who's Who in American Art. New York: Bowker, 1956. S.v. "Guglielmi, Louis."

754 Myers, Bernard S., ed. McGraw-Hill Dictionary of Art, Vol. 3. New York: McGraw-Hill, 1969. S.v. "Guglielmi, O. Louis."

755 "O. Louis Guglielmi (1906-1956)." In American Art Analog. Vol. 3, 1874-1930, comp. Michael David Zellman, 967. New York: Chelsea House, in association with American Art Analog, 1986.

 A brief biographical sketch accompanied by auction price information for the artist's works.

756 Phaidon Dictionary of Twentieth-Century Art. London ; New York: Phaidon, 1973. S.v. "Guglielmi, O. Louis."

757 Vollmer, Hans. Allgemeines Lexikon der bildenden Kunstler des xx. Jahrhunderts, Vol. 2. Leipzig: E.A. Seemann, 1953-1962. S.v. "Guglielmi, Louis."

758 Who Was Who in America. Vol. 3, 1951-1960. Chicago: Marquis Who's Who, 1963. S.v. "Guglielmi, Louis O. [sic]."

VI. Archival Sources

759 Archives of American Art. The Card Catalog of the Manuscript Collections of the Archives of American Art, Vol. 4. Wilmington, Del.: Scholarly Resources, 1980. S.v. "Guglielmi, O. Louis" and "Guglielmi, Louis."

760 _____. The Card Catalog of the Manuscript Collections of the Archives of American Art, Supplement 1981-1984. Wilmington, Del.: Scholarly Resources, 1985. S.v. "Guglielmi, Louis."

This circulating microfilm collection contains numerous sources on Guglielmi including the correspondence and scrapbook of the artist, 1934-1959, and

material from the Downtown Gallery Papers, records of the Alan Gallery, and Records of the Public Works Art Project.

VII. Annotated Reproductions

A Connecticut Autumn, 1937. WASHINGTON (c) 174-175.

Deserted Bridge with Figure, 1934. GINGOLD (b/w) 108-109.

_____. WHITNEY/4 (b/w) 44.

Elements of a Street, 1947. CRANBROOK (b/w) 68-69.

From Manhattan, 1950. NEUBERGER (b/w) 250-251, 254.

Funeral at Woodford, 1932. MICHENER (b/w) 143.

Hague Street, 1936. NEWARK (b/w) 164, 327.

Interior and Facade Number 2, 1954. WHITNEY/2 (b/w) Pl. 23; p. 16.

_____. WHITNEY/5 (b/w) Pl. 23; p. 16.

The Land of Canaan, 1934. EBSWORTH (c) 102-103, 206.

_____. HALPERT (b/w) 81.

Mental Geography, 1938. EBSWORTH (c) 104-105, 206-207.

_____. HALPERT (b/w) 137.

_____. MOMA/4 (b/w) Pl. 201.

A Muted Street, ca. 1942. HALPERT (b/w) 152.

New York 21, 1949. ILLINOIS/50 (b/w) Pl. 7; p. 178.

Night Windows, 1948. ILLINOIS/51 (b/w) Pl. 14; pp. 183-184.

One Third of a Nation, n.d. ACA (b/w) 34.

Phoenix, 1935. SHELDON (c) 74-75, 261.

_____. WICHITA/2 (b/w) 37, 58.

The Relief Blues, ca. 1937. ACA (b/w) 35.

_____. BOSTON/4 (c) [front cover]; p. 53.

South Street Stoop, 1935. SPENCER (b/w) 111.

Street, 1939. SAN FRANCISCO/2 (b/w) 309.

Subway Exit, 1946. LITTLETON (c) [front cover]; pp. 124-125.

The Temptation of St. Anthony, 1946. ILLINOIS/49 (b/w) Pl. 72; [biographical note].

The Tenements, 1939. GEORGIA/1 (b/w) Pl. 17.

Terror in Brooklyn, 1941. JANIS (b/w) 111.

_____. MOMA/3 (b/w) 38-39, 65.

The Various Spring, 1937. WHITNEY/4 (b/w) 44.

View in Chambers Street, 1936. FOREIGN (b/w) 104-105.

_____. NEWARK (b/w) 164, 327.

War News, 1942. MOMA/3 (b/w) 38, 65.

Wedding in South Street, 1936. MOMA/10 (b/w) Pl. 79; p. 145.

_____. MOMA/13 (b/w) 244, 547.

Louis Lozowick

Louis Lozowick's career was distinguished by being devoted primarily to lithography. He was born on 10 December 1892 in the small Ukrainian village of Ludvinovka. He studied art at the Kiev Art School for a short period before joining his brother in the United States in 1906. After completing high school in Newark, New Jersey, Lozowick continued to study art at the National Academy of Design from 1912 to 1915. In the fall of 1915 he entered Ohio State University to study liberal arts under a special three-year program, graduating with Phi Beta Kappa honors in 1918. Following a brief stint in the army, he embarked on a cross-country trip that took him to a number of major cities, including Pittsburgh, Chicago, Minneapolis, and Seattle.

Lozowick became an American citizen shortly before leaving for Europe in 1919. During his stay in Paris, Lozowick met Fernand Leger and was particularly impressed with the French artist's series of ink drawings of machines. Lozowick was also involved with various activities of the Parisian Dadaists. Moving on to Berlin in 1920, Lozowick became a member of the avant-garde artistic community, exhibited with the Novembergruppe, and viewed the works of Theo Van Doesberg, Laszlo Moholy-Nagy, and a number of the Russian Constructivists, among them El Lissitsky and Naum Gabo. On a trip to Moscow in 1922, Lozowick met Vladamir Tatlin, Alexander Rodchenko, Kasimir Malevich, and other leading Russian artists. Lozowick's interest in stage design was sparked after viewing Liubov Popova's theatre sets for V. E. Meyerhold's The Magnificient Cuckhold.

During his stay in Europe, Lozowick executed a series of paintings—and his earliest recorded lithographs—which focused on the urban architecture of the American cities he visited on his 1919 trip. He began an important series of ink drawings around 1922, known collectively as his Machine Ornaments, which featured sharply-drawn, two-dimensional geometric and mechanical designs. This series reflects the Constructivists' admiration for the aesthetics of technological subject matter and it also incorporates some of Dada's whimsy. Although Lozowick was somewhat less political and ideological than the Constructivists, he did share their interest in the utilitarian applications of artistic endeavors.

Lozowick continued to work on his Machine Ornaments upon his return to New York in 1924 and this series—along with his paintings of American cities—were the subject of a critically acclaimed one-man exhibition at J. B. Neumann's New Art Circle in 1926. Carl Zigrosser, director of the Weyhe Gallery, encouraged Lozowick's use

of lithography and he gave Lozowick his first one-man exhibition devoted exclusively to this medium in 1929.

Lozowick was a prolific writer, particularly during the 1920s and 1930s, when he contributed art and theatre reviews, profiles of contemporary Jewish artists and sculptors, and theoretical essays, to a wide range of publications that included Broom, The Little Review, The Nation, The Menorah Journal, and Theatre Arts Monthly. His lectures on Russian art for Societe Anonyme were published in 1925. His essay, "The Americanization of Art," written for the 1927 Machine Age Exposition Catalogue, was one of the earliest expressions of the Precisionist aesthetic to appear in print. Lozowick was also involved in various applied design projects during the 1920s that included stage sets for Marion Gerling's production of Georg Kaiser's Gas, fashion show backdrops for Lord & Taylor, textile designs, book jackets, posters, and art work for the socialist periodical New Masses (where he was the art director and later served on the executive board).

During the 1930s, as the Great Depression deepened, Lozowick began to have doubts about the optimistic promise of American technology in the face of the scenes of economic despair he saw in New York. This growing political awareness led him to join leftist organizations like the American Artists' Congress and the John Reed Club. He also contributed articles to periodicals such as Art Front and New Masses in which he criticized what he perceived to be the failings of capitalism and he exhorted artists to adopt a socialist stance in support of the proletariat. Lozowick's lithographs of this period, while still incorporating Precisionist subject matter (factories, bridges, construction sites, power stations, quarries, and so forth), began to be less abstract in their composition and the human figure started to come to the forefront in scenes of social realism showing urban laborers, union strikers, and the unemployed. During the last half of the decade Lozowick worked for the Graphic Arts Division of the Public Works Art Project and he was also commissioned by the Treasury Relief Art Project to execute two murals for the General Post Office in Manhattan.

Lozowick and his wife Adele, whom he married in 1931, moved to South Orange, New Jersey, in 1944 following the birth of their son. Lozowick continued to utilize Precisionist subject matter in his lithographs throughout his career, but starting in the mid-1950s he increasingly turned to depicting the sights he viewed on his extensive world travels, which took him to the Soviet Union, Europe, Israel, Africa, India, Southeast Asia, South America, Mexico, and Canada. The Whitney Museum of American Art presented a major retrospective of his lithographs one year before his death, which came in South Orange on 9 September 1973. In addition to his notable accomplishments as a lithographer, which included developing a number of innovative techniques, Lozowick was also one of the most articulate exponents of the Precisionist aesthetic.

I. Lozowick's Writings, Statements, and Interviews

761 Lozowick, Louis. "Tentative Attitudes." Sansculotte 1 (January 1917) 14.

In this early student essay, Lozowick laments the fact that art has become a privilege of the few and no longer has any important function to perform as a distinct social institution. He therefore concludes that art "is doomed to inevitable extinction."

762 _____. "The Russian Dadaists." The Little Review 7 (September-December 1920) 72-73.

A brief discussion of Russian Dada writers including Vasili Gniedov and Alexander Krutchenich.

763 _____. "Numa Patlagean: The Artist of Spiritual Synthesis." The Union Bulletin 11 (May 1921) 6, 22, 26.

764 _____. "Ephram Mikhael: A French Poet." The Union Bulletin 11 (August-September 1921) 8, 17.

765 _____. "Camille Pissaro: The Great Impressionistic Artist." The Union Bulletin 11 (October 1921) 8, 22.

766 _____. "Ivan Goll: An Expressionist Poet." The Union Bulletin 11 (November 1921) 15-16.

767 _____. "Neantisme." La Vie des Lettres et des Arts 8 (February 1922) 67.

A French language Dada manifesto, the title meaning "nothingism".

768 _____. "A Note on the New Russian Poetry." Broom 1 (February 1922) 306-311.

In his survey of Russian poetry in the early post-revolutionary years, Lozowick states that it is still in a state of preparation, fermentation, and incubation—wavering between capitalist reality and Communist visions—and therefore has not yet found its full expression.

769 _____. "The Poet in Architecture: A Study of the Work and Ideas of Erich Mendelsohn." The Union Bulletin 12 (April-May 1922) 7, 19.

770 _____. "Russian Berlin." Broom 3 (August 1922) 78-79.

A Dada-inspired celebration of the Russian poet Sergey Yessenin.

771 _____. "Tatlin's Monument to the Third International." Broom 3 (October 1922) 232-234.

Lozowick makes a theoretical distinction in this article between composition and construction. The former has a backward-looking emphasis on ornamentation, decoration, romanticism, and prettiness, whereas the latter has a forward-looking emphasis on the strength, clarity, and simplicity of the methods and materials utilized in industrial technology.

772 _____. "Max Lieberman." The Union Bulletin 13 (January 1923) 14-15.

773 _____. "Max Reinhardt." The Union Bulletin 13 (February 1923) 16-17, 31.

774 _____. "A Note on Modern Russian Art." Broom 4 (February 1923) 200-204.

Lozowick surveys the new Russian art movements in the early post-revolutionary era—including Cubism, Suprematism, and Constructivism—in addition to discussing contemporary Russian critics.

775 _____. "Jewish Artists of the Season." The Menorah Journal 10 (June 1924) 282-285.

An omnibus exhibition review of the Independent Show; Maurice Becker (Whitney Studio Club); Abraham Walkowitz (Kraushaar's Gallery); A.S. Baylinson (Little Book Store); the Russian Exhibition (Grand Central Palace); Feder and Mondzian (New Gallery); Leon Kroll and Maurice Stern (Anderson Galleries); El Lissitsky (Societe Anonyme); Marc Chagall (Montross Gallery); Jacques Lipchitz (Societe Anonyme); Epstein (Scott and Fowles Gallery); William Gropper (96th and Lexington Avenue Library); and Max Weber (J. B. Neumann's Print Room).

776 _____. "Marc Chagall." The Menorah Journal 10 (August-September 1924) 343-346.

Lozowick discusses what he feels to be the two decisive factors in Chagall's artistic development, namely, his life in Vitebsk and his training in Paris. Lozowick notes that although Chagall's weird imagery and whimsical color give the impression that his art is without tradition or precedent, it is in fact historically and biographically conditioned. The article is followed by a portfolio of six Chagall paintings.

777 _____. "A Jewish Art School." The Menorah Journal 10 (November-December 1924) 465-466.

Review of an exhibition of ten year's work of the Educational Alliance Art School held at the Anderson Galleries, New York, 22 October-1 November 1924. The review is followed by two photographs of classes at the school and a number of student works.

778 _____. Modern Russian Art. New York: Museum of Modern Art, Societe Anonyme, 1925.

Lozowick surveys Russian art in the mid-1920s and discusses the first modernist schools such as the Bubnovy Valet (the "Jack of Diamonds"), the Cubists, the Suprematists, the Constructivists, and the Expressionists. Lozowick also remarks on the Russian art critics of the period.

779 _____. "Dorthea Dreier." The Little Review 11 (Spring 1925) 33-34.

Review of Dreier's "Memorial Exhibition" held at the Brooklyn Museum, 14 April—14 May 1925.

780 _____. "Ferdinand Leger." The Nation 121 (16 December 1925) 712.

Lozowick, an admirer of Leger, surveys the artist's career and observes that his work "is charged with the rhythm of the present mechanical world."

781 _____. "The Art of Nathan Altman." The Menorah Journal 12 (February 1926) 61-64.

Lozowick discusses the various phases of Altman's career from his early years in Paris to his later Constructivist works. Nine works of Altman are illustrated following the article, including paintings, sculpture, and stage settings.

782 _____. "Marc Chagall." The Nation 122 (17 March 1926) 294-295.

In his overview of Chagall's career, Lozowick notes that the artist's paintings are autobiographic and contain sudden shifts between the real and the symbolic.

783 _____. "Eliezer Lissitsky." The Menorah Journal 12 (April-May 1926) 175-176.

Lissitsky's copies of the mural decorations of the self-taught painter Segall at the Mohilev synagogue are illustrated and discussed.

784 _____. "Some Artists of Last Season." The Menorah Journal 12 (August-September 1926) 401-405.

An omnibus exhibition review of Marc Chagall (Reinhardt Galleries); Maurice Sterne (Scott and Fowles); Samuel Halpert (Kraushaar's); Feiga Blumberg (Neumann's); Hugo Gellert (Neumann's); Louis Lozowick (Neumann's); William Meyerowitz (Civic Club); Theresa Bernstein (Civic Club); Moise Kisling (New Gallery); Naum Gabo and Antoine Pevsner (Little Review Gallery); David Sternberg (Little Review Gallery); and the International

Theatre Exposition (Steinway Hall). The reviews are preceded by reproductions of seven works from the various exhibitions.

785 _____. "'Gas': A Theatrical Experiment." The Little Review 11 (Winter 1926) 58-60.

Lozowick discusses the associative, plastic, and functional aspects of his stage settings for Marion Gering's production of George Kaiser's Gas, performed at the Kenneth Sawyer Goodman Theatre, Chicago, Illinois, during January and February of 1926.

786 _____. "Modern Art: Genesis or Exodus?" The Nation 123 (22 December 1926) 672.

Review of the "International Exhibition of Modern Art: Assembled by Societe Anonyme" held at the Brooklyn Museum, 19 November 1926—9 January 1927.

787 _____. In the Midwinter Exhibitions." The Menorah Journal 13 (February 1927) 49-50.

An omnibus exhibition review of the International Exhibition of Modern Art (Brooklyn Museum and Anderson Galleries); Amadeo Modigliani (New Gallery); Jules Pascin (New Gallery, Reinhardt Gallery, Whitney Studio Club); I. Kostini (Jewish Art Center); Sol Wilson (Babcock Galleries); Max Brand (New Art Circle); Louis Ribak and Ben Shann (Jewish Art Center); Levinson (New Art Circle); Mark Schwartz (New Art Circle); S. Simkovitch (Art Patrons of America); and Peter Blume (Daniel Gallery). The reviews are preceded by reproductions of eight works from these various exhibitions.

788 _____. "The Americanization of Art." The Little Review 12, supp., "Machine Age Exposition Catalogue," (May 1927) 18-19. Reprinted in The Prints of Louis Lozowick: A Catalogue Raisonne, by Janet Flint, 18-19. New York: Hudson Hills Press, 1982.

Lozowick's celebrated essay is one of the most articulate and concise expressions of the Precisionist aesthetic. In the face of allegations that this country lacks a strong cultural tradition, Lozowick urges artists to call upon their original creative vision and controlled craftsmanship to extol the American industrial landscape by exploiting the subject matter and plastic possibilities inherent in the rigid geometry of the modern American city.

789 _____. "Eugene Zak." The Menorah Journal 13 (June 1927) 283-286.

A biographical sketch of the Polish-French artist who died in 1926. Lozowick analyzes a number of his works, nine of which are illustrated following the article.

790 _____. "Russia's Jewish Theatres." Theatre Arts Monthly 11 (June 1927) 419-422.

An overview of Jewish theatre in Russia illustrated with five costumes and one stage setting.

791 _____. "Books." The Arts 12 (August 1927) 115-116.

Review of Nach-Expressionismus by Franz Roh (Leipzig: Klinkhardt & Biermann, 1925). Roh's book was at the time the principal published source for the German Neue Sachlichkeit movement which, as Lozowick notes, emphasized "clarity and precision" as aspects of the depiction of the "factual and tangible objects of the visual world."

792 _____. "Marc Chagall." Young Israel 20 (March 1928) 3-4.

793 _____. "The Moscow Jewish State Theatre." The Menorah Journal 14 (May 1928) 478-482.

An overview of various performances of the Moscow Jewish State Theatre which was founded by A. M. Granovsky in Leningrad. The article is followed by eight photographs.

794 _____. "Moise Kisling." Young Israel 20 (June 1928) 7.

795 _____. "Alexandra Exter's Marionettes." Theatre Arts Monthly 12 (July 1928) 514-519.

An examination of Exter's marionettes, which Lozowick feels strike a middle ground between extreme realism and extreme abstraction. Five photographs of her marionettes are included.

796 _____. "Letters from Abroad—Jewish Artists in Paris." The Menorah Journal 15 (July 1928) 62-67.

Lozowick discusses the art of Soutine, Chagall, Kisling, Grunewald, Kars, Iser, Pascin, Mandzain, Kremegne, Marcovssis, Muter, Halika, Orloff, and others.

797 _____. "Moise Kisling." The Menorah Journal 15 (September 1928) 227-230.

A biographical sketch of the Polish-French artist and an overview of his artistic development. The article is preceded by reproductions of eight of Kisling's works.

798 _____. "Modern Art in Germany." The Nation 127 (7 November 1928) 494.

Review of Bauhaus Bucher (Munich: Albert Langen Verlag, 1926-1928).

799 _____. "Jacques Lipchitz." The Menorah Journal 15 (January 1929) 46-48.

An overview of the work of the Russian-French sculptor followed by illustrations of eight of his works.

800 _____. "Tairov." Theatre 1 (January 1929) 9-11.

801 _____. "A Century of French Painting." The Nation 128 (2 January 1929) 24, 26.

Review of the exhibition "A Century of French Painting" held at M. Knoedler & Co., New York.

802 _____. "A Decade of Soviet Art." The Menorah Journal 16 (March 1929) 243-248.

Lozowick discusses the contributions of a number of Jewish artists to Russian art following the October revolution, including Sternberg and Altman in Moscow; Chagall and Lissitsky in Vitebsk; and Tchaikov and Rybbak in Kiev.

803 _____. "Honore Daumier, 1808-1879." The Nation 128 (24 April 1929) 505-506.

Lozowick assesses Daumier's work both as a great caricaturist and propagandist, and as a distinguished artist.

804 _____. "Numa Patlagean." The Menorah Journal 16 (May 1929) 420.

Lozowick's discussion of the work of the Russian sculptor is followed by illustrations of eight of his works.

805 _____. "Chagall's Circus." Theatre Arts Monthly 13 (August 1929) 593-601.

Lozowick analyzes Marc Chagall's circus series of seventy-five gouaches and comments on the artist's affinity with the theatre. Four works from the series are illustrated.

806 _____. "The Soviet Cinema: Eisenstein and Pudovkin." Theatre Arts Monthly 13 (September 1929) 664-675.

Lozowick discusses the films of Sergei Eisenstein and Vsevolod Pudovkin and remarks on their similarities vis-a-vis conception and ideology.

807 _____. "The Theatre is for the Actor: An Iconoclast's Methods in Moscow." Theatre Guild Magazine 7 (October 1929) 34-35.

808 _____. "El Lissitsky." transition 18 (November 1929) 285-286.

Lozowick places Lissitsky in the context of a Jewish artist, a Constructivist, an architect, and a political activist. Lissitsky's Project for a Public Rostrum is illustrated.

809 _____. "Lithographs." Forum 83 (February 1930) 88, 92, 93.

810 _____. "Lithography: Abstraction and Realism." Space 1 (March 1930) 31-33.

Lozowick counsels graphic artists to strike a middle ground between ornamental abstraction and photographic realism. This is one of Lozowick's most important theoretical essays.

811 _____. "Theatre Chronicle—V. E. Meyerhold and His Theatre." The Hound & Horn 4 (October-December 1930) 95-105.

This overview of Meyerhold's career since the revolution is accompanied by four photographs of his stage productions.

812 _____. "What Should Revolutionary Artists Do Now?" New Masses 6 (December 1930) 21.

Lozowick's letter to the editor is in response to criticism raised in an earlier letter by Vern Jessup in New Masses (October 1930) concerning the proper role of a revolutionary artist in bourgeois society.

813 Freeman, Joseph, Joshua Kunitz, and Louis Lozowick. Voices of October: Art and Literature in Soviet Russia. New York: Vanguard Press, 1930.

Chapter III is "The Soviet Theatre" by Lozowick and Freeman; Chapter V is "Soviet Painting and Architecture" by Lozowick.

814 Lozowick, Louis. "Art in the Service of the Proletariat." Literature of the World Revolution 4 (1931) 126-127.

Lozowick finds America to be unhospitable to revolutionary artists in their quest to expose the class character of bourgeois art and to represent the class of proletarians in their struggle to overthrow the capitalist system and establish a new socialist society.

815 _____. "William Gropper." The Nation 134 (10 February 1932) 176-177.

Review of Gropper's exhibition at the John Reed Club, New York.

816 _____. "The Artist in Soviet Russia." The Nation 135 (13 July 1932) 35-36.

Lozowick discusses the ways in which Russian artists participate in a wide range of activities in a socialist society.

817 _____. "Travel—New World in Central Asia." The Menorah Journal 20 (July 1932) 167-173.

An account of Lozowick's travels in central Asia with an international group of writers under the auspices of the Soviet government to make studies of local conditions vis-a-vis collectivization, industrialization, and so forth. Lozowick concentrates specifically on the Jewish populations in these regions and generally writes favorable reports on their circumstances as they attempt to adjust to post-revolutionary life.

818 _____. "Hazardous Sport in Tajikistan." Travel 61 (September 1933) 14-17, 38.

Lozowick's travelogue includes a description of "Buzkashak," or the sport of goat-ripping, among the Tajik in the Soviet Republic of Tajikistan. Several of Lozowick's illustrations accompany the article.

819 _____. "The Theatre of Turkestan: Old Forms Serve New Needs." Theatre Arts Monthly 17 (November 1933) 885-890.

Lozowick discusses the changing nature of the dramatic arts of the Tajiks since the revolution and provides four of his own drawings to illustrate the article. He writes, "Westerners often associate industry and the machine only with grime, drudgery, regimentation, exploitation. To the Tajiks the machine is still a wonder-worker held in awe for its superhuman feats; a factor of liberation rather than enslavement."

820 _____. "John Reed Club Show." New Masses 10 (2 January 1934) 27.

Review of the second annual John Reed Club exhibition, "Revolutionary Front—1934." Lozowick's lithograph Strike Scene of 1934 was included in the exhibition.

821 _____. "Aspects of Soviet Art." New Masses 14 (January 1935) 16-19.

Lozowick discusses various Soviet groups that were organized around 1922 to 1924 in response to the perceived failings of modernism. These groups include New Society of Painters (Noj), Existence, Society of Easel Painters (Ost), Association of Artists of Revolutionary Russia, (Akhrr), and their eventual union into the Federation of Soviet Artists.

822 _____. "The Independent Art Show." The Daily Worker (19 April 1935) 5.

823 _____. "The Status of the Artist in the U.S.S.R." In Artists Against War and Fascism: Papers of the First American Artists' Congress, 162-165. New Brunswick, N.J.: Rutgers University Press, 1986.

Lozowick's address delivered to the second closed session of the First American Artists' Congress on 15 February 1936. Lozowick states that the role of the artist in the U.S.S.R. is bound up with a planned policy inseparable from all other social and economic planning.

824 _____. "Lithography." In America Today: A Book of 100 Prints Chosen and Exhibited by the American Artists' Congress, 10. New York: Equinox Cooperative Press, 1936. Reprinted in Artists Against War and Fascism: Papers of the First American Artists' Congress, 286-287. New Brunswick, N.J.: Rutgers University Press, 1986.

Lozowick urges graphic artists to focus on contemporary issues in their work. Lozowick's Lynching of 1936 is illustrated (Pl. 98).

825 _____. "William Gropper." New Masses 18 (18 February 1936) 28.

Review of an exhibition of Gropper's paintings held at the A.C.A. Gallery, New York, which Lozowick praises for their "revolutionary conviction."

826 _____. "Soview Gypsy Theatre." Theatre Arts Monthly 20 (April 1936) 282-287.

An examination of the Soviet gypsy theatre collective in terms of its new social status and cultural autonomy won as a result of the revolution. Six photographs of actors and stage productions are included.

827 _____. "Toward a Revolutionary Art." Art Front 2 (July-August 1936) 12-14.

Lozowick argues that revolutionary art is in the vanguard of a process of historical evolution because it encompasses the broad social, cultural, and economic transformations which are decisive in the ongoing class struggle taking place in capitalist society. He counsels bourgeois artists to seek a Marxist-Leninist approach to art and to adopt the perspective of historical materialism.

828 A.C.A. Gallery. William Gropper. Introduction by Louis Lozowick. New York: The Gallery, 1937.

829 Lozowick, Louis. "Review and Comment—American Artist." New Masses 29 (11 October 1938) 25-26.

Review of Constance Rourke's Charles Sheeler: Artist in the American Tradition (New York: Harcourt, Brace, 1938).

830 _____. "Revolutionary Artist." New Masses 30 (31 January 1939) 22-23.

Review of Charles Poore's Goya (New York: Scribner's, 1938).

831 _____. "Hitler Calls It Art." New Masses 40 (29 July 1941) 26-28.

Lozowick discusses the Weltanschauung of Nazi art in the context of the exhibition opened by Hitler at the Haus der Deutschen Kunst. In Lozowick's opinion, Nazi art ". . . adds up to a system of permanent militarization, subordination of women to the triple virtues of Kinder, Kirche, and Kuche, the total regimentation of youth, unity between exploiter and exploited. Nazi art is mask and costume over a face cruel and ugly, and a body vengeful, fearsome, but not invincible."

832 _____. "What, Then, Is Jewish Art?" The Menorah Journal 25 (January-March 1947) 103-110.

Review of Franz Lansberger's A History of Jewish Art (Cincinnati, Ohio: Union of American Hebrew Congregations, 1946).

833 _____. "The Jew in American Plastic Art." In 100 Contemporary American Jewish Painters and Sculptors, ix-xv. New York: YKUF Art Section, 1947.

A general history of American Jewish artists and sculptors since the Colonial period.

834 _____. "Soviet Art." In Understanding the Russians: A Study of Soviet Life and Culture, ed. Bernard J. Stern and Samuel Smith, 143-145. New York: Barnes and Noble, 1947.

A survey of twentieth-century Soviet art with an emphasis on its social and political aspects.

835 A Treasury of Drawings from Pre-history to the Present. New York: Lear Publishers, 1948.

This selection of eighty-three drawings is introduced by Lozowick's survey of historical periods and styles, which concludes with his comments on social art.

836 Lozowick, Louis. "When the U.S.S.R. Was Radical." Art News 61 (December 1962) 47, 67-68.

Review of Camilla Gray's The Great Experiment: Russian Art, 1863-1922 (New York: H.N. Abrams, 1962).

837 Encyclopedia Americana, Vol. 24. International ed. New York: Americana Corporation, 1966. S.v. "Russian Art," by Louis Lozowick.

838 Lozowick, Louis. "Lithography." New Jersey Music and Arts (January 1971) 20-21.

839 _____. "Moscow Theatre, 1920s." Russian History 8, no. 1-2 (1981) 140-144.

This essay, published in a special issue on "Twentieth Century Russian and Ukrainian Stage Design," edited by John E. Bowlt, is an extract from an unpublished manuscript of Lozowick's memoirs.

840 _____. William Gropper. Foreword by Milton W. Brown. Philadelphia: Art Alliance Press, 1983.

Lozowick's biography of William Gropper (1897-1977), the American painter and lithographer best known for his satirical social and political cartoons appearing in radical periodicals. The book is divided into two parts-- "The Pictorial Satirist" and "The Painter." In addition to numerous black and white illustrations, the book contains seventeen color reproductions, a chronology, a list of major exhibitions, and a bibliography.

See also entries 094, 151, 335, 858, 862, 864, 887, and 931-936.

II. Monographs and Exhibition Catalogues

841 <u>Artists for Victory: An Exhibition Catalog</u>. Washington, D.C.: Library of Congress, 1983.

Catalogue of a graphic arts exhibition held at the Library of Congress, Washington, D.C., 2 February—31 July 1983, which includes Lozowick's lithograph <u>Granaries of Democracy</u> of 1943. This exhibition re-created the October 1943 exhibition "America in the War," which was sponsored by Artists for Victory and shown simultaneously in twenty-six museums and galleries across the United States. A biographical sketch of Lozowick is provided by Ellen G. Landau (pp. 66-67).

842 Associated American Artists. <u>Louis Lozowick's New York</u>. New York: Associated American Artists, 1976.

Catalogue of an exhibition of nearly one hundred prints and preliminary drawings of New York held at Associated American Artists, New York, 5-31 January 1976. Catalogue introduction by Sylvan Cole, Jr. Lozowick's long association with AAA extended from 1935 until his death in 1973.

843 _____. <u>The Prints of Louis Lozowick</u>. New York: Associated American Artists, 1982.

Catalogue of an exhibition held at Associated American Artists, New York, 1-24 November 1982. The exhibition was held in conjunction with the publication of Janet Flint's <u>The Prints of Louis Lozowick: A Catalogue Raisonne</u>. The catalogue contains a checklist of the eighty-three prints in the exhibition, an introduction by Sylvan Cole, Jr., a chronology, and a partial list of permanent collections owning the artist's work.

844 _____. <u>The Prints of Louis Lozowick</u>. New York: Associated American Artists, 1990.

Catalogue of an exhibition held at Associated American Artists, New York, 3-27 October 1990. Catalogue introduction by Robert P. Conway. A priced checklist of the seventy-nine prints in the exhibition is included.

845 Flint, Janet. <u>The Prints of Louis Lozowick: A Catalogue Raisonne</u>. Foreword by Alfred P. Maurice. New York: Hudson Hills Press, 1982.

This important catalogue raisonne contains 301 prints, chiefly lithographs, with some examples of Lozowick's work in other media such as drypoint, woodcut, and silkscreen. Each print is illustrated (sixteen in color) and accompanied by the title; date of execution; medium; dimensions; edition; printer; public

collections and Adele Lozowick's collection; monogram; and descriptive notes. Flint provides a critical essay on Lozowick's career and an introduction to the catalogue. The book also includes a chronology, an exhibition history, and a selected bibliography.

846 Galerie Zak. Exposition de Dessins et gravures de Louis Lozowick. Paris: The Galerie, 1928.

Catalogue of an exhibition at the Galerie Zak, Paris, France, 11-25 July 1928. Catalogue introduction by Valdemar Georges.

847 Gallerie Alfred Heller. Louis Lozowick, New York: Ausstellung. Berlin: The Gallerie, 1923.

Catalogue of an exhibition held at the Gallerie Alfred Heller, Berlin, Germany, 1 August—1 September 1923. Catalogue essay by Fred Antoine Angermayer.

848 Hirschl & Adler Galleries. Louis Lozowick (1892-1973): Works in the Precisionist Manner. New York: The Galleries, 1980.

Catalogue of an exhibition held at the Hirschl & Adler Galleries, New York, 16 February—15 March 1980, which includes twenty paintings, eleven drawings, and twelve lithographs. In addition to five black and white illustrations, three oil paintings are illustrated in color: Urban Geometry of 1925-27, Blast Furnace (Pittsburgh Landscape) of 1925-27, and Steel Valley of 1942. The catalogue contains an introduction by Richard T. York and a chronology.

849 _____. Lithographs of Louis Lozowick (1892-1973). New York: The Galleries, 1986.

Catalogue of an exhibition held at the Hirschl & Adler Galleries, New York, 25 September—25 October 1986, which includes forty lithographs and eight paintings and drawings. Janet Flint's catalogue introduction is reprinted from her book The Prints of Louis Lozowick: A Catalogue Raisonne (New York: Hudson Hills Press, 1982).

850 _____. Lithographs by Louis Lozowick. New York: The Galleries, [1990].

Catalogue of an exhibition held at the Hirschl & Adler Galleries, New York, 3 March—14 April 1990. Introduction by Janet A. Flint.

851 Kampf, Avram. Jewish Experience in the Art of the Twentieth Century, 62, 65-71. South Hadley, Mass.: Bergin & Garvey, 1984.

Kampf surveys Lozowick's career in the context of twentieth-century Jewish art and social realism. Among Lozowick's works that he discusses is Autobiographic of 1967.

852 Long Beach Museum of Art. Louis Lozowick: American Precisionist Retrospective. Long Beach, Ca.: The Museum, 1978.

Catalogue of an exhibition held at the Long Beach Museum of Art, Long Beach, California, 26 February—7 May 1978. A catalogue essay by John Bowlt precedes a checklist of the 105 works in the exhibition, over half of which are illustrated.

853 McCabe, Cynthia Jaffee. The Golden Door: Artist-Immigrants of America, 1876-1976. Washington, D.C.: Published for the Hirshhorn Museum and Sculpture Garden by the Smithsonian Institution Press, 1976.

Catalogue of an exhibition held at the Hirshhorn Museum and Sculpture Garden, Smithsonian Institution, Washington, D.C., 20 May—20 October 1976, which includes Lozowick's oil painting Minneapolis of 1926-27 and his Machine Ornament #2 of 1927. The catalogue contains a biographical sketch of Lozowick (pp. 140-143) and a selected bibliography (p. 420). Introduction to the catalogue, "The Immigrant's Vision," by Daniel J. Boorstin; catalogue essay, "A Century of Artist-Immigrants," by Cynthia Jaffee McCabe. A detailed chronology spanning the period 1876-1976 is provided.

854 Museum of Fine Arts, Boston. An Exhibition of Lithographs: 527 Examples by 312 Different Artists from 1799 to 1937. Boston: The Museum, [1937].

Catalogue of an exhibition held at the Museum of Fine Arts, Boston, 7 October—31 December 1937, which includes Lozowick's Still Life No. 2 of 1929 (not illustrated).

855 New York City WPA Art: Then 1934-1943 and ... Now 1960-1977. [New York]: NYC WPA Artists, [1977].

Catalogue of an exhibition of former WPA artists held at the Parsons School of Design, New York, November 1977. Each artist is represented by one early work executed under the auspices of the WPA and one later work. Included are Lozowick's Relic of 1939 and Interior of 1973. The catalogue contains a biographical sketch of the artist (p. 58) in addition to general essays and statements by Norman Barr, Audrey McMahon, Emily Genauer, and Greta Berman.

856 Newark Public Library. Louis Lozowick: Graphic Retrospective. Newark, N.J.: The Library, 1969.

Catalogue of an exhibition held at the Newark Public Library, Newark, New Jersey, 28 February—28 March 1969. Catalogue essay by David Schapiro.

857 _____. Louis Lozowick: Lithographs and Drawings. Newark, N.J.: The Library, [1972].

Catalogue of an exhibition held at the Newark Public Library, Newark, New Jersey, 20 December 1972—31 January 1973. A checklist of the seven drawings and fifty-four lithographs is included in addition to brief biographical information on the artist. Catalogue essay by Susan G. Solomon.

858 100 Contemporary American Jewish Painters and Sculptors. New York: YKUF Art Section, 1947. S.v. "Louis Lozowick."

A biographical entry with an illustration of Pneumatic Drill of 1934 and a statement by the artist under "Credo."

859 Original Etchings, Lithographs and Woodcuts Published by American Artists Group, Inc. New York: American Artists Group, 1937.

Included in this book of graphic works published by the American Artists Group are two of Lozowick's lithographs—Oil Country of 1936 and Distant Manhattan of 1937—in addition to a biographical sketch of the artist (p. 35).

860 Rashell, Jacob. Jewish Artists in America, 76-81. New York: Vantage Press, 1967.

Rashell gives an overview and general assessment of Lozowick's career.

861 Richard York Gallery. Louis Lozowick: Lithographs. New York: The Gallery, 1991.

Catalogue of an exhibition held at the Richard York Gallery, New York, 15 March—20 April 1991. Twenty-seven lithographs are included in the checklist (two are illustrated).

862 Robert Hull Fleming Museum. Abstraction and Realism, 1923-1943: Paintings, Drawings, and Lithographs of Louis Lozowick. Burlington, Vt.: The Museum, 1971.

Catalogue of an exhibition held at the Robert Hull Fleming Museum, University of Vermont, Burlington, Vermont, 14 March—18 April 1971. William C. Lipke's catalogue essay contains material from his interview with the artist on 11 January 1971. The catalogue contains a checklist of the fifty-two oils,

lithographs, and drawings in the exhibition (six of which are illustrated) and a chronology of the artist's career.

863 Santa Clara University. de Saisset Museum. The Artist and the Machine, 1910-1940. Santa Clara, Calif.: The Museum, 1986.

Catalogue of an exhibition held at the de Saisset Museum, Santa Clara University, 28 January—16 March 1986, which includes five lithographs by Lozowick. Catalogue essay by Georgianna M. Lagoria.

864 Seton Hall University. Department of Art and Music. Louis Lozowick (1892-1973). South Orange, N.J.: The Department, [1973].

Catalogue of an exhibition held at the Student Art Center Gallery, Seton Hall University, South Orange, New Jersey, 14 October—11 November 1973. The catalogue opens with an introduction by Barbara Wahl Kaufman and a section of lengthy transcribed excerpts from two taped interviews of Lozowick in 1973 which are rearranged chronologically and accompanied by a running chronology in the margins. Lozowick also provided a statement on his colored ink drawing Autobiographic of 1967. The catalogue includes a checklist of the thirteen oils, twelve drawings, and forty-two lithographs in the exhibition; a selected bibliography; and a photograph of the artist taken eleven days before his death. Twenty-two works are illustrated in black and white.

865 Smithsonian Institution. National Collection of Fine Arts. Louis Lozowick: Drawings and Lithographs. Washington, D.C.: Smithsonian Institution, National Collection of Fine Arts, 1975.

Catalogue of an exhibition held at the National Collection of Fine Arts, Smithsonian Institution, Washington, D.C., 12 September—23 November 1975.

866 _____. The Prints of Louis Lozowick. Washington, D.C.: Smithsonian Institution Press, 1982.

Catalogue of an exhibition of seventy prints held at the National Museum of American Art, Smithsonian Institution, 5 November 1982—10 April 1983. The catalogue introduction and chronology are reprinted from Janet Flint's The Prints of Louis Lozowick: A Catalogue Raisonne (New York: Hudson Hills Press, 1982).

867 Weyhe Gallery. Illustrated Catalogue of Lithographs, Engravings, and Etchings Published by the Weyhe Gallery. New York: The Gallery, 1928.

This catalogue contains a biographical note on Lozowick and a listing of four lithographs (three of which are illustrated): New York; Under the Elevated; Waterfront, New York; and Whitehall Building (entries 150-153).

868 _____. Lithographs by Louis Lozowick. New York: The Gallery, 1929.

Catalogue of an exhibition held at the Weyhe Gallery, New York, 28 October— 9 November 1929. This was Lozowick's first one-man exhibition devoted exclusively to his lithographs.

869 _____. Paintings, Drawings, and Lithographs by Louis Lozowick. New York: The Gallery, 1931.

Catalogue of an exhibition held at the Weyhe Gallery, New York, 23 March— 4 April 1931.

870 _____. Paintings and Lithographs by Louis Lozowick. New York: The Gallery, 1936.

Catalogue of an exhibition held at the Weyhe Gallery, New York, 6-18 April 1936.

871 Whitney Museum of American Art. Louis Lozowick: Lithographs. New York: The Museum, 1972.

Catalogue of an exhibition held at the Whitney Museum of American Art, New York, 21 November 1972—1 January 1973. Catalogue introduction by Elke M. Solomon. A selected exhibition history is provided.

872 Whitney Museum of American Art at Equitable Center. City Life: New York in the 1930s; Prints from the Permanent Collection of the Whitney Museum of American Art. New York: The Museum, 1986.

Catalogue of an exhibition held at the Whitney Museum of American Art at Equitable Center, New York, 16 April—6 June 1987. The exhibition included four of Lozowick's lithographs from the 1930s (two of which are illustrated). Kathleen Monaghan provides a biographical sketch of Lozowick and comments on Clouds Above Manhattan of 1935 (p. 25). Catalogue essay, "City Life Revisited: Printmaking in New York in the 1930s," by Edith Tonelli.

III. Articles and Essays

873 Adams, Henry. "Louis Lozowick." In American Drawings and Watercolors in the Museum of Art, Carnegie Institute, 188-191. Pittsburgh: Carnegie Institute, Museum of Art ; Distributed by the University of Pittsburgh Press, 1985.

A discussion of Lozowick centering on his works in the Museum of Art at Carnegie Institute.

874 Dreier, Katherine S. "Louis Lozowick." In <u>Collection of the Societe Anonyme: Museum of Modern Art 1920</u>, 182-183. New Haven, Conn.: Published for the Associates in Fine Arts by Yale University Art Gallery, 1950.

Dreier provides a brief biographical sketch, a list of exhibitions, and a bibliography. Lozowick's <u>City Shapes</u> of 1950 is illustrated.

875 Gaer, Yossef. "Louis Lozowick: An Artist Who Presents the Soul of America." <u>B'nai B'rith Magazine</u> 41 (June 1927) 378-379.

Gaer discusses Lozowick's series of paintings of American cities and his <u>Machine Ornaments</u>.

876 Garfield, John M. "Louis Lozowick." <u>Das Zelt</u> 1, no. 9 (1924) 330-331.

877 Hanley, F. "'La vie boheme' is 'la vie de machine' in America." <u>The American Hebrew</u> (15 January 1926) 323.

878 Kainen, Jacob. "Prints of the Thirties: Reflections on the Federal Art Project." In <u>Artist's Proof: The Annual of Prints and Printmaking</u>, Vol. 11, 34-41. New York: Pratt Graphics Center, in association with New York Graphic Society, Greenwich, Conn., 1971. Reprinted in <u>Art in Public Places in the United States</u>, comp. Emma Lila Fundaburk and Thomas G. Davenport, 100-101. Bowling Green, Ohio: Bowling Green University Popular Press, 1975.

In his survey of printmaking in the 1930s, Kainen discusses the Graphics Arts Division of the WPA Federal Art Project with which Lozowick was associated starting in 1935. Lozowick's lithograph <u>Relic</u> of 1939 is illustrated.

879 "Lozowick, American, Wins $1,000 Cleveland Print Club Prize." <u>The Art Digest</u> 5 (1 April 1931) 19.

Lozowick's lithograph <u>City on a Rock</u> of 1931 won the first prize of $1,000 in the International Competitive Print Exhibition held under the auspices of the Print Club of Cleveland, 18 March—15 April 1931.

880 Marquardt, Virginia Hagelstein. "Louis Lozowick: From 'Machine Ornaments' to Applied Design, 1923-1930." <u>Journal of Decorative and Propaganda Arts</u> no. 8 (Spring 1988) 40-57.

Marquardt focuses on Lozowick's interest in applied design as a reflection of the contemporary industrial environment during the 1920s. She discusses the

European influences on his series of <u>Machine Ornaments</u>, particularly that of Fernand Leger, Laszlo Moholy-Nagy, El Lissitsky, and Theo Van Doesburg, whose work he admired during his European sojourn of 1919 to 1923. Soon after Lozowick's return to New York he began to apply mechanically-based decorative designs to a wide variety of utilitarian projects including theatre backdrops, fashion window displays, advertisements, posters, and book and magazine covers. Marquardt's article is extensively documented and illustrated with numerous examples of Lozowick's work.

881 _____. "<u>New Masses</u> and John Reed Club Artists, 1926-1936: Evolution of Ideology, Subject Matter, and Style." <u>The Journal of Decorative and Propaganda Arts</u> 12 (Spring 1989) 56-75.

Marquardt analyzes the ideology of artists associated with the socialist periodical <u>New Masses</u>, and its related organization of artists, the John Reed Club, in terms of the style and subject matter of their illustrations. Lozowick was artistic director and a member of the editorial board of the former and a charter member of the latter. Marquardt discusses his activities at various points in her article and provides reproductions of three of his illustrations for the periodical (figs. 5-7).

882 Marquardt, Virginia Hagelstein and Sylvan Cole. "American Artists School's Print Series of 1936." <u>Print Quarterly</u> 6 (December 1989) 413-421.

Marquardt and Cole give an overview of the American Artists School which opened on 1 February 1936. Lozowick was a member of the board of control and an instructor in lithography. His <u>Five Year Plan Comes to a Caucasian Village</u> of 1932—part of the school's "Second Edition First Annual Print Series"—is illustrated and briefly discussed.

883 Potamkin, Harry Alan. "Louis Lozowick." <u>Young Israel</u> 26 (January 1934) 3-4.

884 Rich, Louis. "Souls of Our Cities: A Painter's Interpretation of the Expression of Civilization Through Machinery." <u>The New York Times Magazine</u> (17 February 1924) 3.

A discussion of Lozowick's series of paintings of American cities. "To Lozowick," Rich writes, "there is a tremendous story in the American city, told not in words or written records, but in terms of structure, movement, color, mass. He paints the city not as it appears to the eye, but as it affects the imagination."

885 Rothschild, Lincoln. "Louis Lozowick (1893 [sic]-1973)." The Pragmatist in Art 7 (Fall 1973) 3.

An obituary.

886 Rub, Timothy F. "American Architectural Prints." Print Review 18 (1984) 6-19.

Rub surveys the theme of architecture in American prints and he observes, "No other printmaker would abstract architecture to the degree that Lozowick did in his series of American Cities, made in 1925-26." He also discusses Lozowick's Through Brooklyn Bridge Cables of 1938.

887 Singer, Esther Forman. "The Lithography of Louis Lozowick." American Artist 37 (November 1973) 36-41, 78-79.

Singer's survey of Lozowick's working methods and technical innovations in lithography contains a number of statements by the artist. Seven individual lithographs are illustrated and accompanied by caption comments.

888 Von Dietrich, Redigiert. "Louis Lozowick." Farbe und Form 8 (January 1923) 4-5.

889 Wolf, Robert L. "Loony: A Modern Movie." The Nation 121 (9 September 1925) 270-276.

This screenplay for a silent movie is accompanied by four illustrations by Lozowick.

890 Zabel, Barbara. "Louis Lozowick and Urban Optimism of the 1920s." Archives of American Art Journal 14, no. 2 (1974) 17-21.

Zabel gives an overview of Lozowick's urban works of the 1920s and discusses his attitude at the time that technology was a beneficial and liberating force in society. She also summarizes Lozowick's various European influences such as De Stijl, Purism, the Bauhaus, and Constructivism.

891 _____. "The Precisionist-Constructivist Nexus: Louis Lozowick in Berlin." Arts Magazine 56 (October 1981) 123-127.

Zabel discusses the influence Russian Constructivism exerted on Lozowick during his stay in Berlin in the early 1920s. She points out that Lozowick's art and ideology are far less political and idealistic than those of Russians such as El Lissitsky, Liubov Popova, and Vladimir Tatlin. It is Zabel's contention that Lozowick's contact with Berlin Dada artists resulted in his appropriation of the machine as a subject in a much more witty and whimsical manner than is to be

found in the work of the Constructivists. This cross-fertilization of seemingly antithetical aesthetic viewpoints was not uncommon during this period in Berlin. Zabel concludes that Lozowick, better than any other Precisionist, assimilated the ideologies of a number of post-war European art movements and adapted them to distinctly American subject matter.

IV. Exhibition Reviews

892 "Exhibitions in New York." The Art News 26 (23 January 1926) 7.

Review of the exhibition "Paintings and Drawings by Louis Lozowick" held in the Print Room of J. B. Neumann's New Art Circle, New York, 18 January— 4 February 1926.

893 Goodrich, Lloyd. "New York Exhibitions—Sheeler and Lozowick." The Arts 9 (February 1926) 102-103.

Review. See entry 892.

894 Wolf, Robert. "Art—Louis Lozowick." The Nation 122 (17 February 1926) 186.

Review. See entry 892.

895 "Exhibitions—American Printmakers, The Downtown Gallery." The Art News 29 (20 December 1930) 59.

Review of the fourth annual exhibition of the American Printmakers held at the Downtown Gallery, New York, 7-26 December 1930. The reviewer writes, "Louis Lozowick is probably the most effective lithographer in the group and it is obvious that he has a rarely communicating feeling for the stone [sic]."

896 Campbell, Lawrence. "Reviews and Previews—Louis Lozowick." Art News 59 (January 1961) 13.

Review of the exhibition "Louis Lozowick: Precisionist Paintings 1923-28" held at the Zabriskie Gallery, New York, 2-21 January 1961.

897 Judd, Donald. "In the Galleries—Louis Lozowick." Arts 35 (January 1961) 55.

Review. See entry 896.

898 Campbell, Lawrence. "Reviews and Previews—Louis Lozowick." Art News 70 (April 1971) 16.

Review of the Lozowick portion of the exhibition "Three Contemporary Artists: Drawings 1920-1950" held at the Zabriskie Gallery, New York, 23 January—6 March 1971.

899 Williams, Ruthann. "Louis Lozowick at the Whitney Museum." New Jersey Music and Arts 28 (November 1972) 25-30.

Review of the exhibition "Louis Lozowick: Lithographs" held at the Whitney Museum of American Art, New York, 21 November 1972—1 January 1973.

900 Smith, Roberta Pancoast. "Reviews—Galleries: Louis Lozowick." Arts Magazine 47 (February 1973) 76-77.

Review. See entry 899.

901 Schwartz, Sanford. "New York Letter." Art International 17 (April 1973) 50-51.

Review of the exhibition "Louis Lozowick: Paintings & Lithographs" held at the Dain Gallery, New York, 2-31 January 1973.

902 Shirley, David L. "Reviews and Previews—Louis Lozowick." Art News 72 (February 1973) 83.

Review. See entry 901.

903 Smith, Roberta Pancoast. "Reviews—Galleries: Louis Lozowick." Arts Magazine 47 (February 1973) 76-77.

Review. See entry 901.

904 Frackman, Noel. "Arts Reviews—Louis Lozowick's New York." Arts Magazine 50 (March 1976) 19-20.

Review of the exhibition "Louis Lozowick's New York" held at Associated American Artists, New York, 5-31 January 1976.

905 Frank, Peter. "New York Reviews—Louis Lozowick's New York." Art News 75 (March 1976) 138.

Review. See entry 904.

906 "Art Across North America: A Precisionist from the Ukraine." Apollo 111 (May 1980) 402.

Review of the exhibition "Louis Lozowick (1892-1973): Works in the Precisionist Manner" held at the Hirschl & Adler Galleries, 16 February—15 March 1980.

907 Galassi, Susan Grace. "Arts Reviews—Louis Lozowick." Arts Magazine 54 (May 1980) 28-29.

Review. See entry 906.

908 Goodman, Helen. "Louis Lozowick." Arts Magazine 57 (January 1983) 12.

Review of the exhibition "The Prints of Louis Lozowick" held at Associated American Artists, New York, 1-14 November 1982.

909 Bond, Constance. "Down & Out at the NMAA." Smithsonian 13 (January 1983) 133.

Review of the exhibition "The Prints of Louis Lozowick" held at the National Museum of American Art, Smithsonian Institution, Washington, D.C., 5 November 1982—10 April 1983.

910 Yau, John. "Review of Exhibitions: Louis Lozowick at Summit." Art in America 71 (September 1983) 174.

Review of a Lozowick exhibition held at Summit Gallery, Ltd., New York.

911 Bass, Ruth. "New York Reviews—Louis Lozowick." Art News 84 (Summer 1985) 123.

Review of the exhibition "Louis Lozowick: Urban Images" held at Vanderwoude Tananbaum, New York, 20 February—30 March 1985.

912 Klein, Ellen Lee. "Arts Reviews—Louis Lozowick." Arts Magazine 59 (May 1985) 45.

Review. See entry 911.

V. Reference Sources

913 Abramson, Glenda, ed. The Blackwell Companion to Jewish Culture from the Eighteenth Century to the Present. Cambridge, Mass.: Basil Blackwell, 1989. S.v. "Lozowick, Louis," by Barbara Gilbert.

914 Baigell, Matthew. Dictionary of American Art. New York: Harper & Row, 1982. S.v. "Lozowick, Louis."

915 <u>Contemporary Authors</u>, Vol. 107. Detroit: Gale, 1983. S.v. "Lozowick, Louis."

916 Cummings, Paul. <u>Dictionary of Contemporary American Artists</u>. 5th ed. New York: St. Martin's, 1988. S.v. "Lozowick, Louis."

917 <u>Current Biography Yearbook 1942</u>. New York: H.W. Wilson, 1943. S.v. "Lozowick, Louis."

918 Falk, Peter Hastings, ed. <u>Who Was Who in American Art: Compiled from the Original Thirty-four Volumes of American Art Annual: Who's Who in Art</u>." Madison, Conn.: Sound View Press, 1985. S.v. "Lozowick, Louis."

919 Fielding, Mantle. <u>Mantle Fielding's Dictionary of American Painters, Sculptors & Engravers</u>. 2d enl. ed. Edited by Glenn B. Opitz. Pougkeepsie, N.Y.: Apollo, 1986. S.v. "Lozowick, Louis."

920 Karpman, I. J. Carmin, ed. <u>Who's Who in World Jewry: A Biographical Dictionary of Outstanding Jews</u>. New York: Who's Who in World Jewry ; Pitman Publishing, 1972. S.v. "Lozowick, Louis."

921 Landman, Isaac, ed. <u>Universal Jewish Encyclopedia</u>. New York: Universal Jewish Encyclopedia, 1942. S.v. "Lozowick, Louis," by William Gropper.

922 "Louis Lozowick—Graver and Illustrator." <u>Index of Twentieth Century Artists, 1934-1937</u>, 571-573, 578-579. New York, Arno Press, 1970.

923 Reimann, Bruno. "Louis Lozowick." In <u>Jahrbuch der Jungen Kunst</u>, ed. Georg Biermann, 312-315. Leipzig: Klinkhardt & Biermann, 1923.

924 Vollmer, Hans. <u>Allgemeines Lexikon der bildenden Kunstler des xx. Jahrhunderts</u>, Vol. 3. Leipzig: E.A. Seeman, 1953-1962. S.v. "Lozowick, Louis."

925 <u>Who Was Who in America</u>. Vol. 6, <u>1974-1976</u>. Chicago: Marquis Who's Who, 1976. S.v. "Lozowick, Louis."

926 <u>Who's Who in American Art, 1973</u>. New York: Jaques Cattell Press ; R.R. Bowker, 1973. S.v. "Lozowick, Louis."

927 <u>Who's Who in American Jewry</u>. New York: National News Association, 1938. S.v. "Lozowick, Louis."

VI. Dissertations and Theses

928 Joffe, Harriette N. "Louis Lozowick: The Creative Artist as Social Critic." M.A. thesis, City College of New York, 1981.

929 Marquardt, Virginia Carol Hagelstein. "Louis Lozowick: Development from Machine Aesthetic to Social Realism, 1922-1936." Ph.D. diss., University of Maryland, 1983.

In her study of Lozowick's early career, Marquardt analyzes the sources, implications, and continuity of the artist's aesthetic, formal, and thematic development. She examines in considerable depth Lozowick's machine aesthetic which was influenced by his association with a wide range of European, Russian, and American writers and artists during the period from 1920 to 1923. In addition, she documents Lozowick's subsequent commitment to social realism that grew out of his involvement with radical artists and writers of the publication New Masses, the John Reed Club, and the American Artists' Congress, beginning in the late 1920s. Marquardt's dissertation includes a selected bibliography and 126 illustrations.

930 Zabel, Barbara Beth. "Louis Lozowick and Technological Optimism of the 1920s." Ph.D. diss., University of Virginia, 1978.

Zabel's dissertation focuses on Lozowick's career in the 1920s and his interest in technology, the machine motif, and the urban landscape. She presents detailed discussions of his American, Russian, and European influences. Her final chapter deals with his rejection of technological optimism late in the decade and his subsequent move away from abstraction toward an urban realism that reflected his growing social and political concerns. Her dissertation contains seventy-six illustrations and a selected bibliography.

VII. Archival Sources

931 Archives of American Art. The Card Catalog of the Manuscript Collections of the Archives of American Art, Vol. 6. Wilmington, Del.: Scholarly Resources, 1980. S.v. "Lozowick, Louis."

932 _____. The Card Catalog of the Manuscript Collections of the Archives of American Art, Supplement 1981-1984. Wilmington, Del.: Scholarly Resources, 1985. S.v. "Lozowick, Louis."

This circulating microfilm collection contains numerous sources on Lozowick including the Louis Lozowick Papers (which contain the artist's unpublished autobiography, "Survivor from a Dead Age," and an unpublished manuscript, "Machine Ornament," orginally scheduled to appear in The Little Review); material from the American Artists Group, Inc., Papers, the Cleveland Print Club Papers, and the J. B. Neumann Papers; and various items of business and personal correspondence.

933 _____. The Card Catalog of the Oral History Collections of the Archives of American Art. Wilmington, Del.: Scholarly Resources, 1984. S.v. "Lozowick, Louis."

This oral history collection contains a transcribed interview of Lozowick conducted by William C. Lipke on 11 January 1970.

934 Harold A. Loeb Papers. Princeton University Libraries, Princeton, New Jersey.

The collection contains one letter from Loeb to Lozowick, dated 1922, and four letters from Lozowick to Loeb, dated 1921-23.

935 Louis Lozowick Papers. George Arents Research Library for Special Collections, E. S. Bird Library, Syracuse University, Syracuse, New York.

The Louis Lozowick Papers comprise eight series: Printed Material; Catalogues and Invitations to Exhibits; Correspondence; Memorabilia; Miscellaneous; Photographs of the Work; Writings (published and unpublished); and Posters and Photographs.

936 Societe Anonyme Collection. Katherine S. Dreier Papers. Collection of American Literature, Beinecke Rare Book and Manuscript Library, Yale University, New Haven, Connecticut.

The collection contains several items of correspondence between Dreier and Lozowick (presently uncataloged).

VIII. Annotated Reproductions

Bridge, 1960. ROBY (b/w) 95.

Bridge in Shadow (Williamsburg Bridge), 1930. PRINTS/1 (b/w) Pl. 69.

_____. WERTHAM (b/w) 77.

Brooklyn Bridge, 1930. CITYSCAPE (b/w) front cover.

_____. PRINTS/3 (b/w) Pl. 39; p. 120.

_____. PRINTS/4 (b/w) Pl. 92.

Checkerboard (Under the Elevated), 1927-28. WERTHAM (b/w) 76.

Chicago, ca. 1923. HIRSCHL/2 (c) 53.

City Shapes, 1922-23. DREIER (b/w) 423-425.

_____. YALE (b/w) 93.

Composition with Red Circles, 1927. CARNEGIE (c) 189, 285.

_____. HIRSCHL/4 (c) 108.

Derricks and Men, 1942-44. HIRSCHL/4 (b/w) 72.

Design for the August 1928 cover of New Masses, 1928. NELSON (b/w) 226-227.

Design for the frontispiece and jacket of Unrest: The Rebel Poet's Anthology for 1930, 1930. NELSON (c) 28, 183-184, 311.

Design in Wire, 1949. BARO (b/w) 76.

Doorway Into Street, 1929. CITYSCAPE (b/w) Pl. 91.

_____. WERTHAM (b/w) 76.

57th Street (Rubber Center), 1929. WERTHAM (b/w) 77.

High Voltage, 1929-30. HIRSCHL/1 (b/w) 96.

High Voltage—Cos Cob, 1929. WERTHAM (b/w) 77.

Machine Ornament, ca. 1925-26. DREIER (b/w) 423-425.

Machine Ornament, ca. 1925-27. WHITNEY/1 34, 37.

Machine Ornament #4, ca. 1926-27. ADLER (b/w) 22, 110-111.

Madison Avenue, 1929. HIRSCHL/2 (b/w) 52.

Mid-air, 1931. MOMA/3 (b/w) 47, 66.

Minneapolis, 1925. HIRSCHL/2 (b/w) 50.

Minneapolis, 1926-27. HIRSHHORN (b/w) Pl. 324; p. 715.

_____. PRINTS/1 (b/w) Pl. 67.

New York, ca. 1923. WHITNEY/5 (b/w) Pl. 14; p. 111.

New York, ca. 1925. METROPOLIS (b/w) 453, 568.

_____. WERTHAM (b/w) 76.

_____. WHITNEY/3 (b/w) n.p.; p. 83.

New York, 1925-26. WALKER (c) 326-327.

Nuns on Wall Street, 1946. PRINTS/5 (b/w) 129, 249.

Open Air Barber, 1939. MICHIGAN/1 (b/w) 108-109.

Pittsburgh, 1922-23. METROPOLIS (c) 453, 568.

_____. WHITNEY/4 (b/w) 59.

Pneumatic Drill, 1935. ACA (b/w) 45.

Relic, 1949. Newark (b/w) 201, 348.

Saucon, 1930. HIRSCHL/3 (b/w) 72.

Seattle, 1926-27. CITYSCAPE (b/w) Pl. 90.

Smoke Stack, 1929. ADLER (b/w) 22, 112-113.

Still Life, n.d. SHELDON (b/w) 298.

Still Life, No. 2, 1929. MOMA/3 (b/w) 47, 66.

Subway Construction, 1931. WHITNEY/3 (b/w) n.p.; p. 83.

Tanks #1, 1929. WERTHAM (b/w) 77.

Tanks #3, 1930. PRINTS/3 (b/w) Pl. 40; p. 120.

_____. RHODE ISLAND/4 (b/w) 30.

Traffic, 1930. PRINTS/4 (b/w) Pl. 93.

Urban Geometry, ca. 1925-27. HIRSCHL/2 (c) 51.

White Tanks, 1930. WERTHAM (b/w) 77.

Whitehall Building, 1927-28. HIRSCHL/2 (b/w) 54.

————————. WERTHAM (b/w) 76.

<u>Williamsburg Bridge</u>, 1945. JANSS (b/w) Pl. 215; p. 218.

Morton L. Schamberg

Morton Livingston Schamberg enjoyed the briefest career of any of the Precisionists, yet his contribution was highly significant and, until recently, relatively unheralded. Schamberg was born in Philadelphia on 15 October 1881. After graduating from Philadelphia's Central High School, he attended the School of Fine Arts at the University of Pennsylvania, graduating with a Bachelor of Architecture degree in 1903. From 1903 to 1906 he studied under William Merritt Chase at the Pennsylvania Academy of the Fine Arts. Along with fellow student Charles Sheeler, Schamberg visited Europe with Chase's student groups in the summers of 1904 and 1905, where he was introduced to the English, Dutch, and Spanish masters. In the fall of 1908 Schamberg made another trip to Europe and joined Sheeler in Italy, where they viewed a wide range of Italian Renaissance masterworks. Moving on to Paris, they saw works of Cezanne, Van Gogh, Picasso, Matisse, and Derain. After Sheeler returned home, Schamberg stayed on in Europe to travel and paint. Upon his return in mid-1909, he and Sheeler rented working studios in the same downtown Philadelphia building and a rural Bucks County farmhouse for use as a weekend and summer retreat.

Schamberg's early landscapes were influenced both by Cezanne's compositional structure and by the expressive use of color employed by the Post-Impressionists and the Fauves. He also painted a number of portraits between 1908 and 1912, often using his friend Fanette Reider as his model. These portraits tended to be on a larger scale than his landscapes. Many of these early works were included in Schamberg's first one-man exhibition, which was held in early 1910 at the McClees Galleries in Philadelphia. Around 1912 Schamberg took up photography as a means of support, specializing first in portraits and later turning to urban architecture. He was also active during this time in promoting modernist art in Philadelphia through organizing exhibitions and by writing an article for the Philadelphia Inquirer in January of 1913 on the upcoming Armory Show.

Schamberg exhibited five works in the Armory Show, an exhibition that was important insofar as it determined the Cubist orientation of his work from early 1913 through 1915. Schamberg's series of paintings known as his Figures of 1913 (sometimes called Geometrical Abstractions) showed that he had fully assimilated the Cubist principles of color abstraction in the manner of Orphists and Synchromists such as Gleizes, Villon, Metzinger, Picabia, and Delaunay. Schamberg's landscapes of this period took on a more relaxed, open, and abstract character than his earlier works.

Schamberg's reputation as an important Precisionist rests on his series of machinist paintings and pastels of 1916. Certainly he drew inspiration for the machine as a subject from the works of Picabia and Duchamp that he viewed in the collection of Walter Conrad Arensberg, yet his treatment of machines in works like The Telephone, The Well, and Camera Flashlight lack the characteristic biting irony and mockery of those Dada artists. The only work of Schamberg's that evinces such an attitude is the plumbing assemblage God of ca. 1916, which was heavily influenced, if not the outright sole creation, of the Dada personality Baroness Elsa von Freytag Loringhoven (some art historians feel that Schamberg only photographed the object despite its being credited to him).

Schamberg's machine pastels of 1916, thirty of which were discovered in the early 1980s, derive their inspiration from the printing and textile machines that Schamberg viewed in trade catalogues. Schamberg's skilled and expressive use of this difficult medium shows him to be a master of hue and texture. His final works were watercolors executed in 1918, the last of which was Bowl of Flowers.

Schamberg was a pacifist and the turmoil of World War I caused him a great deal of intellectual and emotional distress. He succumbed to the influenza epidemic of 1918 on October 13 and was buried two days later on what would have been his thirty-seventh birthday. Schamberg was the first Precisionist to systematically exploit the machine motif and he ranks as one of America's most important Cubists.

I. Schamberg's Writings

937 McClees Galleries. Philadelphia's First Exhibition of Advanced Modern Art. Philadelphia: The Galleries, 1916.

Catalogue of an exhibition held at the McClees Galleries, Philadelphia, 17 May—15 June 1916. Preface by Schamberg.

938 Schamberg, Morton. "Post-Impressionism Exhibit Awaited." Philadelphia Inquirer (19 January 1913) sec. 2, p. 3. Reprinted in Morton Livingston Schamberg, by Ben Wolf, 26-28. Philadelphia: University of Pennsylvania Press, 1963.

In this article, written as a prelude to the Armory Show, Schamberg discusses Post-Impressionist painting and he alludes to a fourth dimension in works of art.

939 _____. "Cubist Analyzes Cubist Paintings." Philadelphia Press (14 March 1913).

See also entry 985.

II. Monographs and Exhibition Catalogues

940 Brown, Milton W. The Story of the Armory Show, 2d ed., 314. [Washington, D.C.]: Joseph H. Hirshhorn Foundation ; New York: Abbeville, 1988.

A list of the five works Schamberg exhibited at the Armory Show ("International Exhibition of Modern Art") held at the Armory of the Sixty-ninth Regiment, New York, 17 February—15 March 1913. Brown has revised and updated the original catalogue listings—in terms of titles, media, dated, lenders, prices listed, buyers and prices paid, present collections, added works, and supplementary notes—through utilizing documentary sources in the Kuhn Papers, the MacRae Papers, and the sales books of Walter Pach. Brown also provides an extract from a letter, dated 23 August 1912, from Schamberg to Pach informing him of the exhibition (pp. 63-64).

941 Dallas Museum for Contemporary Arts. American Genius in Review, No. 1. Dallas, Tex.: The Museum, 1960.

Catalogue of an exhibition held at the Dallas Museum for Contemporary Arts, 11 May—19 June 1960. The exhibition included the works of five American artists. Schamberg was represented by eight oils and one watercolor, four of which are illustrated in black and white. Catalogue introduction by Douglas MacAgy, who also provides a biographical sketch of Schamberg accompanied by a photograph of the artist.

942 Henderson, Linda Dalrymple. The Fourth Dimension and Non-Euclidian Geometry in Modern Art, 173-175. Princeton, N.J.: Princeton University Press, 1983.

Henderson briefly discusses Schamberg's views on the fourth dimension in art and she notes that he "made a notable contribution to American theorizing on higher dimensions in art."

943 Federal Reserve System. Morton Livingston Schamberg: Color and Evolution of His Paintings. Washington, D.C.: Federal Reserve System, 1984.

Catalogue of an exhibition held at the gallery of the Marriner S. Eccles Federal Reserve Board Building, Washington, D.C., 11 April—30 May 1984. This exhibition was a scaled-down version of the exhibition held at the Salander O'Reilly Galleries in 1982. The catalogue contains a reprint of William C. Agee's essay (see 946) and a checklist of forty-three works.

944 McClees Galleries. Exhibition of Paintings by Morton Livingston Schamberg. Philadelphia: The Galleries, 1910.

Catalogue of an exhibition held at the McClees Galleries, Philadelphia, 31 January— 5 February 1910, which lists fifty-four works executed between 1905 and 1910.

945 Pennsylvania Academy of the Fine Arts. Paintings by Morton L. Schamberg. Philadelphia: The Academy, 1963.

Catalogue of an exhibition held at the Pennsylvania Academy of the Fine Arts, Philadelphia, 21 November—24 December 1963.

946 Salander-O'Reilly Galleries. Morton Livingston Schamberg (1881-1918). New York: The Galleries, 1982.

Catalogue of an exhibition held at the Salander-O'Reilly Galleries, New York, 3 November—31 December 1982. There are sixty works in the exhibition checklist with four additional works in a supplementary list. The catalogue contains small black and white reproductions of each work. Sixteen of these are also illustrated on color plates. The catalogue essay by William C. Agee is identical to his Arts Magazine article (see 950).

947 _____. Morton Livingston Schamberg (1881-1918): The Machine Pastels. New York: The Galleries, 1986.

Catalogue of an exhibition held at the Salander-O'Reilly Galleries, New York, 4 January—1 February 1986. The exhibition featured thirty pastels executed in 1916 and discovered in 1982-83. In his catalogue essay, William C. Agee discusses the machine images in these works and Schamberg's remarkable mastery of pastel as a medium. Agee writes, "The magnitude of Schamberg's achievement makes his early death all the more grevious. Yet his achievement should not be seen as anything less than complete in itself; few artists reach these heights." Each pastel is illustrated on a color plate.

948 Wolf, Ben. Morton Livingston Schamberg. Philadelphia: University of Pennsylvania Press, 1963.

Wolf, who presents a detailed biography of Schamberg in this monograph, emphasizes the artist's profound understanding of form and composition and his remarkable color sense. Important reviews by Walter Pach and Henry McBride of the 1919 Schamberg retrospective exhibition held at M. Knoedler & Co. are reprinted, as are several items of the artist's correspondence. The second half of the book contains a catalogue of fifty-one paintings, fifteen photographs, and one assemblage, accompanied by Wolf's critical comments. Each work is illustrated (one in color). The book concludes with a brief selected bibliography.

III. Articles and Essays

949 Adams, Henry. "Morton Livingston Schamberg." In <u>American Drawings and Watercolors in the Museum of Art, Carnegie Institute</u>, 184-187. Pittsburgh: Carnegie Institute, Museum of Art; Distributed by the University of Pittsburgh Press, 1985.

A discussion of Schamberg centering on his works in the Museum of Art at Carnegie Institute.

950 Agee, William C. "Morton Livingston Schamberg (1881-1918): Color and the Evolution of His Painting." <u>Arts Magazine</u> 57 (November 1982) 108-119.

Agee presents a detailed stylistic analysis and critical assessment of Schamberg's brief career, concentrating on his Cubist and Dada influences, his development of the machine motif, and his talents as a colorist. Agee points out that not only was Schamberg clearly the first Precisionist artist, but he was also an important American Cubist in the period from 1913 through 1915.

951 _____. "Morton Livingston Schamberg: Notes on the Sources of His Machine Images." In <u>New York Dada</u>, edited by Rudolf E. Kuenzli, 66-80. New York: Willis Locker & Owens, 1986.

Agee feels that Schamberg's series of machine images executed in 1916 are "among the most compelling Dada-related works done by any American artist." Focusing on thirty newly discovered pastels in this series, Agee traces their inspiration to textile knitting machines. He points out that Schamberg explored a unique aspect of Dada, one that was independent of the irony and mockery found in the works of Duchamp and Picabia.

952 Coke, Van Deren. "The Cubist Photographs of Paul Strand and Morton Schamberg." In <u>One Hundred Years of Photographic History: Essays in Honor of Beaumont Newhall</u>, edited by Van Deren Coke, 36-42. Albuquerque: University of New Mexico Press, 1975.

Coke discusses the influence exerted on Schamberg's photography both by Dada artists like Duchamp and Picabia, and by Schamberg's background in architecture. Coke points out that Schamberg successfully captured the Cubist sense of interlocking shapes in his photographs through his effective use of light and shadow to emphasize linear elements and to break up static masses.

953 Hamilton, George Heard. "Morton L. Schamberg, 1882-1918." In <u>Collection of the Societe Anonyme: Museum of Modern Art 1920</u>, 43-44. New Haven, Conn.: Published for the Associates in Fine Arts by Yale University Art Gallery, 1950.

A brief biographical sketch, a list of exhibitions, and a bibliography. Schamberg's Machine of 1916 is illustrated.

954 "Morton L. Schamberg." In The Collection of Alfred Stieglitz: Fifty Pioneers of Modern Photography, 426-427. New York: Metropolitan Museum of Art ; Viking Press, 1978.

Schamberg's Portrait Study of 1917 is illustrated and annotated. A chronology, a list of selected photography exhibitions, and a bibliography are provided.

955 Powell, Earl A. "Morton Schamberg: The Machine as Icon." Arts Magazine 51 (May 1977) 122-123.

Powell argues that Schamberg's mechanical abstractions of 1916, while having Cubist and pre-Dada sources, nevertheless transcend purely modernist formal concerns. Powell feels that these paintings are conservative symbolic statements of a machine aesthetic, rooted in traditional American painting and completely lacking Dada's humor and irony. Powell points to Stielgitz's periodical 291 as being particularly important in establishing the new imperatives of modernism and the myth of the machine.

956 Reiss, Robert. "'My Baroness': Elsa von Freytag-Loringhoven." In New York Dada, edited by Rudolf E. Kuenzli, 81-101. New York: Willis Locker & Owens, 1986.

In his essay on the Baroness Elsa von Freytag-Loringhoven, Reiss discusses the speculation that the assemblage God of ca. 1916, which has generally been credited to Schamberg, may have been the noncollaborative, unitary creation of the Baroness and only photographed by Schamberg (p. 88).

957 Wolf, Ben. "Rediscovery—Morton L. Schamberg." Art in America 52 (February 1964) 76-80.

A general overview of Schamberg's career. Seven black and white illustrations accompany the article.

IV. Exhibition Reviews

958 McBride, Henry. "Posthumous Paintings by Schamberg." New York Sun (25 May 1919). Reprinted in Morton Livingston Schamberg, by Ben Wolf, 34-35. Philadelphia: University of Pennsylvania Press, 1963.

Review of the exhibition "Paintings and Drawings by Morton L. Schamberg" held at M. Knoedler & Co., New York, 10-24 May 1919.

959 Pach, Walter. "The Schamberg Exhibition." The Dial 66 (17 May 1919) 505-506. Reprinted in Morton Livingston Schamberg, by Ben Wolf, 36-38. Philadelphia: University of Pennsylvania Press, 1963.

Review. See entry 958.

960 MacAgy, Douglas. "5 Rediscovered from the Lost Generation." Arts News 59 (Summer 1960) 39-41.

Review of the exhibition "American Genius in Review, No. 1" held at the Dallas Museum for Contemporary Arts, 11 May—19 June 1960, which included nine works by Schamberg.

961 Campbell, Lawrence. "Reviews and Previews—Morton Livingston Schamberg." Art News 62 (January 1964) 14.

Review of the exhibition "Morton L. Schamberg (1881-1918)" held at the Zabriskie Gallery, New York, 6-25 January 1964.

962 Raynor, Vivian. "In the Galleries—Morton Schamberg." Arts Magazine 38 (March 1964) 61-62.

Review. See entry 961.

963 Ballerini, Judith. "Venus and the Stocking Machines." Art in America 71 (April 1983) 154-159.

Review of the exhibition "Morton Livingston Schamberg (1881-1918)" held at the Salander-O'Reilly Galleries, New York, 3 November—31 December 1982.

964 Cohen, Ronny. "New York Reviews—Morton Livingston Schamberg." Art News 82 (February 1983) 143.

Review. See entry 963.

965 Fort, Ilene Susan. "Art Reviews—Morton Livingston Schamberg." Arts Magazine 57 (January 1983) 35.

Review. See entry 963.

966 Klein, Ellen Lee. "Arts Reviews—Morton Livingston Schamberg." Arts Magazine 57 (January 1983) 32.

Review. See entry 963.

967 Kramer, Hilton. "The Morton Schamberg Retrospective." The New Criterion 1 (April 1983) 50-54. Reprinted in The Revenge of the Philistines: Art and Culture, 1972-1984, by Hilton Kramer, 127-132. New York: Free Press, 1985.

 Review. See entry 963.

968 Scott, Wilford. "Morton L. Schamberg." Arts Magazine 57 (January 1983) 9.

 Review. See entry 963.

969 Spike, John T. "Exhibition Reviews—New York." The Burlington Magazine 125 (April 1983) 247-248.

 Review. See entry 963.

970 Bass, Ruth. "New York Reviews—Morton Livingston Schamberg." Art News 85 (April 1986) 160-161.

 Review of the exhibition "Morton Livingston Schamberg (1881-1918): The Machine Pastels" held at the Salander-O'Reilly Galleries, New York, 4 January—1 February 1986.

971 Klein, Ellen Lee. "Arts Reviews—Morton Livingston Schamberg." Arts Magazine 60 (March 1986) 127-128.

 Review. See entry 970.

972 Loughery, John. "Arts Reviews—Morton Livingston Schamberg." Arts Magazine 60 (March 1986) 132.

 Review. See entry 970.

V. Reference Sources

973 Baigell, Matthew. Dictionary of American Art. New York: Harper & Row, 1982. S.v. "Schamberg, Morton Livingston."

974 Encyclopedia of American Art. New York: E.P. Dutton, 1981. S.v. "Schamberg, Morton Livingston," by David W. Scott.

975 Falk, Peter Hastings, ed. Who Was Who in American Art: Compiled from the Original Thirty-four Volumes of American Art Annual: Who's Who in Art." Madison, Conn.: Sound View Press, 1985. S.v. "Schamberg, Morton L(ivingston)."

976 Fielding, Mantle. <u>Mantle Fielding's Dictionary of American Painters, Sculptors & Engravers</u>. 2d enl. ed. Edited by Glenn B. Opitz. Pougkeepsie, N.Y.: Apollo, 1986. S.v. "Schamberg, Morton L."

977 "Morton Livingston Schamberg (1881-1918)." In <u>American Art Analog</u>. Vol. 3, <u>1874-1930</u>, comp. Michael David Zellman, 814. New York: Chelsea House, in association with American Art Analog, 1986.

 A brief biographical sketch.

978 Myers, Bernard S., ed. <u>McGraw-Hill Dictionary of Art</u>, Vol. 5. New York: McGraw-Hill, 1969. S.v. "Schamberg, Morton."

979 Osborne, Harold, ed. <u>The Oxford Companion to Twentieth-Century Art</u>. New York: Oxford University Press, 1981. S.v. "Schamberg, Morton Livingstone [sic]."

980 <u>Phaidon Dictionary of Twentieth-Century Art</u>. London ; New York: Phaidon, 1973. S.v. "Schamberg, Morton Livingstone [sic]."

981 <u>Praeger Encyclopedia of Art</u>, Vol. 5. New York: Praeger, 1971. S.v. "Schamberg, Morton Livingston," by Emily Wasserman.

VI. Dissertations and Theses

982 Lampe, Mary Margaret. "Morton Schamberg's Role in Precisionism." M.A. thesis, North Texas State University, 1987.

 Lampe's thesis focuses on Schamberg as an originator of Precisionism and as a promoter of modernism. She traces the artist's influences to the Armory Show, the Stieglitz and Arensberg circles, European artists in New York, contemporary photography, scientific and technical advances, architecture, and literature. Seventy-five illustrations and a bibliography are included.

983 Scott, Wilford Wildes. "The Artistic Vanguard in Philadelphia: 1905-1920." Ph.D. diss., University of Delaware, 1983.

 Chapters Four, Five, and Six of Scott's dissertation contain discussions of Schamberg's role in the development and promotion of modernist art in pre-World War I Philadelphia.

VII. Archival Sources

984 Alfred Stieglitz Collection. Collection of American Literature, Beinecke Rare Book and Manuscript Library, Yale University, New Haven, Connecticut.

This collection contains one item of correspondence from Stielgitz to Schamberg, dated 14 December 1916.

985 Archives of American Art. <u>The Card Catalog of the Manuscript Collections of the Archives of American Art</u>, Vol. 9. Wilmington, Del.: Scholarly Resources, 1980. S.v. "Schamberg, Morton Livingston."

This circulating microfilm collection contains one item of correspondence between Schamberg and William Macbeth, dated 19 November 1909.

VIII. Annotated Reproductions

<u>Abstraction</u>, 1916. MOMA/1 (b/w) 60, 155.

<u>City Rooftops</u>, [photograph], 1916. EASTMAN/2 (b/w) 234-235, 454.

<u>Composition</u>, ca. 1915-16. CARNEGIE (c) 185, 299.

_____. HIRSCHL/4 (b/w) 101.

<u>Composition</u>, 1916. HOWLAND (b/w) 95, 97.

_____. KUSHNER (c) 38, 84.

<u>Composition</u> [two versions], 1916. CARTER/1 (c) 87.

<u>Figure</u> (<u>Geometrical Patterns</u>), 1914. PHILADELPHIA/1 (b/w) 498-499.

<u>Figure B</u> (<u>Geometrical Patterns</u>), 1913. CARTER/1 (c) 86-87.

<u>Fruitbowl</u>, 1917. PILAVIN (b/w) 7-9.

_____. RHODE ISLAND/2 (b/w) 49-51.

<u>Geometric Patterns</u>, 1913. SYNCHROMISM (b/w) 28-29, 53.

<u>Geometric Patterns</u> (<u>Abstract Figure</u>), 1913. SAN DIEGO (c) 89, 96.

<u>God</u> [assemblage], 1917-18. HULTEN (b/w) 101.

_____. PARIS-NEW YORK (b/w) 351, 716.

_____. PHILADELPHIA/1 (b/w) 515-516.

<u>Landscape</u>, 1913. QUINN/2 (b/w) 138.

Landscape, ca. 1916. ARENSBERG (b/w) Pl. 184.

Landscape, Bridge, ca. 1915. PARIS-NEW YORK (b/w) 325, 716.

Landscape (Lake Placid), 1911. HIGH (b/w) 157, 185.

Machine, 1916. DREIER (c) Pl. 41; pp. 585-587.

_____. MOMA/1 (b/w) 61, 155.

_____. YALE (b/w) 122-123.

Machine Forms, 1916. NEUBERGER (b/w) 406-407, 412.

Mechanical Abstraction, 1916. PARIS-NEW YORK (b/w) 353, 716.

_____. PHILADELPHIA/1 (b/w) 505-506.

Mechanical Abstraction [two versions], 1916. ARENSBERG (b/w) Pl. 185, 186.

Painting V (Mechanical Abstraction), 1916. WHITNEY/4 (b/w) 88.

Paris Cafe, 1908-09. WHITNEY/4 (b/w) 88.

Portrait of Fanette Reider, ca. 1912. HIGH (c) 156-157, 189.

The Regatta, 1907. SHELDON (b/w) 335.

Rooftops [photograph], 1917. PHILADELPHIA/1 (b/w) 514-515.

Self-Portrait [photograph], 1912-1915. TRAVIS (b/w) 99, 172.

Studio Interior, ca. 1912. HIGH (b/w) 157, 185.

Study of a Girl, ca. 1909-11. PARIS-NEW YORK (b/w) 224, 716.

Telephone, 1916. COLUMBUS (c) 90-91, 195.

_____. HOWLAND (b/w) 95, 98.

_____. QUINN/2 (b/w) 139.

Untitled, 1916. HULTEN (b/w) 100.

_____. PARIS-NEW YORK (b/w) 353, 716.

Untitled (cityscape) [photograph], 1916. TRAVIS (b/w) 97, 173.

Untitled [photograph], 1917. FORD (b/w) 9, 11-12.

Untitled (rooftops) [photograph], 1917. NEW VISION (b/w) Pl. 4.

The Well, 1916. QUINN/1 (b/w) 25, 183.

Charles Sheeler

Perhaps the artist who best represents the quintessential Precisionist, Charles R. Sheeler, Jr., was born in Philadelphia on 16 July 1883. After completing secondary school, he enrolled in the School of Industrial Design in Philadelphia, where he studied applied design from 1900 to 1903. He entered the Pennsylvania Academy of the Fine Arts in 1903 to pursue further studies. Sheeler and fellow student Morton Schamberg accompanied William Merritt Chase, the academy's most influential teacher, on student tours of Europe during the summers of 1904 and 1905, where they became acquainted with the works of the English, Dutch, and Spanish masters. Sheeler visited Europe again in late 1908, this time in the company of his parents. They were later joined by Schamberg in Italy. Of all the Italian Renaissance art he viewed, Sheeler was the most impressed by Piero della Francesca's architectonic compositions. Moving on to Paris, Sheeler was introduced to the works of artists such as Cezanne, Picasso, Braque, and Matisse.

Upon their return to America in 1910, Sheeler and Schamberg rented working studios in a downtown Philadelphia building and an eighteenth-century farmhouse in rural Bucks County, near Doylestown, for use as a summer and weekend retreat. Sheeler's photographs of this farmhouse, taken around 1917, garnered him critical acclaim and served as models for later paintings. This rural experience also sparked his lifelong interest in Shaker architecture, furniture, and domestic artifacts.

Sheeler's paintings during this early period were chiefly still lifes and landscapes, heavily influenced by Cezanne. They were shown in a number of important exhibitions, including the 1913 Armory Show and the 1914 Forum Exhibition. Sheeler began his career in commercial photography around 1912 as a means of generating supplemental income, specializing in architectural subjects. He moved to New York in 1919 and married his first wife Katherine in 1923. The Mexican artist and dealer Marius de Zayas took Sheeler on as an associate of his Modern Gallery and featured Sheeler's paintings and photographs in his exhibitions. Sheeler also received support in New York from Alfred Stieglitz, although the two later had an acrimonious falling out. One of Sheeler's early patrons was the wealthy connoisseur Walter Conrad Arensberg, whose New York apartment served as a gathering place for many avant-garde artists and writers. It was here that Sheeler met Marcel Duchamp, who reinforced Sheeler's intellectual approach to art and also expressed admiration for Sheeler's Dada-inspired Self-Portrait of 1923.

Around 1920 Sheeler began a series of photographs and paintings of New York skyscrapers. The New York skyline also served as the focus of a seven-minute silent film, Manhatta, produced by Sheeler and Paul Strand in 1921. Sheeler began a close association with the Whitney Studio Club and its director, Juliana Force, after moving into an apartment above their galleries in 1923. At the invitation of Edward Steichen, Sheeler joined the staff of Conde Nast in 1926 and worked for the firm until mid-1929. Approximately sixty of his photographic portraits appeared in Vanity Fair and over sixty appeared in Vogue.

Sheeler's increasing disenchantment with living in Manhattan led to his move to South Salem, New York, in 1927. That same year he was commissioned by the Ford Motor Company to photograph their River Rouge Plant near Dearborn, Michigan. His series of thirty-two photographs were internationally acclaimed and they served as the basis for two of his most famous paintings, American Landscape of 1930 and Classic Landscape of 1931. While in Europe in 1929 to view the German exhibition, "Film und Foto," Sheeler visited France where he took a series of photographs of the Chartres Cathedral which exemplify his rigorous formal approach.

Sheeler felt that his painting Upper Deck of 1929, a view of the electrical engines and ventilator stacks of the steamer S. S. Majestic, marked an important turning point in his career. Utilizing his earlier photograph of the subject as a blueprint, Sheeler struck a balance between realism and abstraction through isolating a selected area of the ship's structural design and capturing it in a way that eliminated all unnecessary details. Sheeler effaced the painting process through utilizing the Precisionist technique of applying smooth, precisely-defined areas of unmodulated pigment with a minimum of visible brushwork. As he stated in an interview, "I just don't want to see any more than is absolutely necessary of the physical materials that go into a picture."

In 1931 Sheeler entered into an agreement with Edith Gregor Halpert's Downtown Gallery to be his exclusive representative. At Halpert's instigation, Sheeler terminated his commercial work in photography to concentrate on his paintings, which Halpert promoted and marketed very successfully. In 1932 he and Katherine moved to Ridgefield, Connecticut, where she died the following year. Sheeler painted relatively few industrial scenes during the latter half of the 1930s, turning instead to subjects involving vernacular architecture and domestic interiors in Pennsylvania and Williamsburg, Virginia.

Three important personal and professional events occurred in 1939. First, Sheeler was commissioned by Fortune to paint a series of six canvases on the theme of industrial power. These were featured in the magazine's December 1940 issue and they were also the subject of a one-man exhibition at the Downtown Gallery. Second, he was given a major retrospective exhibition at the Museum of Modern Art which included his paintings, drawings, and photographs. The catalogue foreword was written by his close friend, William Carlos Williams, who influenced his attitudes about seeking universality in local indigenous subject matter. Both the Fortune commission and the MOMA retrospective served to greatly enhance Sheeler's reputation. Third, Sheeler remarried and moved with his new wife Musya from Connecticut to Irving-on-Hudson, New York.

Sheeler's paintings of the 1940s alternated between photographic realism and a tendency toward abstraction. Later in the decade he experimented with different styles, including magic realism, with varying degrees of success. He was invited to serve as Artist-in-Residence at the Addison Gallery of American Art in 1946 and at the Currier Gallery of Art in 1948. His paintings of this period included a series of New England industrial vistas. Sheeler's work in photography was rewarded by his appointment as the Senior Research Fellow in Photography at the Metropolitan Museum of Art from 1942 to 1945.

In the early 1950s Sheeler returned to a favorite subject, the New York skyscraper, for a series of paintings and photographs. During this decade he moved away from precisely describing the subjects of his paintings to rendering them with greater abstraction, often generating compositional designs through manipulating overlapping photographic images. He also made use of preliminary studies executed in tempera on Plexiglas in addition to adopting a more brilliant palatte. He made a number of paintings and photographs during two trips to California, the first in 1954 to view a retrospective of his works at the UCLA Art Gallery, and the second in 1956 to visit his friend, fellow photographer Ansel Adams. In 1959 Sheeler suffered a stroke which ended his career as a painter, although he continued with his photography on a limited basis during the early 1960s. He died of a second stroke on 7 May 1965. Sheeler virtually defined the Precisionist idiom and he was one of the few American artists to enjoy distinguished careers in both painting and photography.

I. Sheeler's Writings, Statements, and Interviews

986 Sheeler, Charles. "Can a Photograph Have the Significance of Art?" MSS. 4 (December 1922) 3.

987 _____. "Recent Photographs by Alfred Stieglitz." The Arts 3 (May 1923) 345.

Review of a Stieglitz photography exhibition at the Anderson Galleries, New York.

988 _____. "Books." The Arts 5 (May 1924) 293.

Review of Victor O. Freeburg's Pictorial Beauty on the Screen (New York: Macmillan, 1924).

989 _____. "Notes on an Exhibition of Greek Art." The Arts 7 (March 1925) 153.

Review of an exhibition of Greek sculpture at the Whitney Studio Galleries, New York.

990 Weston, Edward. Edward Weston. Foreword by Charles Sheeler. New York: E. Weyhe, 1932.

991 Sheeler, Charles. "To the Editor." The Art News 43 (September 1944) 22-23.

Sheeler's comments concerning "The Fur-lined Museum," a controversial article by Emily Genauer in Harper's (July 1944) which was highly critical of the Museum of Modern Art and its director Alfred H. Barr, Jr.

992 _____. "In a Handful of Pebbles." Briarcliff Quarterly 3 (October 1946) 204.

Sheeler writes of his friend William Carlos Williams, "In a handful of pebbles or a few leaves William Carlos Williams can find an equivalent for the wonders of the firmament. This capacity for observing the neglected close at hand is one of the fundamental reasons for my admiration of the creative writing of Williams through the years. Subject-matter for him is seldom more than an arm's length from his centre of gravity. In the newborn child he finds the seedling of all living forms." This issue also contains Sheeler's photograph of Williams at the time of the Dial Award to the poet, age 43 (facing page 161).

993 "Interview: Charles Sheeler Talks with Martin Friedman." Archives of American Art Journal 16, no. 4 (1976) 15-19.

A partial transcription of the interview Friedman conducted with Sheeler at the artist's home on 18 June 1959. The complete interview is in the oral history collection of the Archives of American Art (see 1188) and was used as resource material by Friedman for his book Charles Sheeler (see 1002). Sheeler discusses various aspects of his career including his artistic development and the choice of subject matter for his paintings.

See also entries 015, 017, 050, 056, 074, 993a, 998, 1001, 1013, 1015, 1020-1023, 1041, 1070, 1074, 1093, 1115, and 1185-1189.

II. Monographs and Exhibition Catalogues

993a Adams, Ansel. Ansel Adams: Letters and Images, 1916-1984, ed. Mary Street Alinder and Andrea Gray Stillman. Boston: Little, Brown, 1988.

This book contains two letters from Sheeler to Adams, dated 9 January 1953 (pp. 229-230) and 1 August 1956 (p. 240); and one letter from Adams to Sheeler and his wife Musya dated 30 December 1956 (pp. 241-242).

994 Allentown Art Museum. Charles Sheeler: Retrospective Exhibition. Allentown, Pa.: The Museum, 1961.

Catalogue of an exhibition held at the Allentown Art Museum, Allentown, Pennsylvania, 17 November—31 December 1961. Catalogue essay by Richard

Hirsch. A checklist of the fifty paintings, drawings, and graphic works in the exhibition is included; seven works are illustrated.

995 Arts Council of Great Britain. Painter as Photographer: An Arts Council Touring Exhibition. London, England: The Council, 1982.

Catalogue of a traveling exhibition sponsored by the Arts Council of Great Britain in 1982. The exhibition featured the photographs of twenty-five nineteenth- and twentieth-century painters, including Sheeler, who is represented by a photograph from his River Rouge series. Catalogue essay and biographical notes by Marina Vaizey.

996 Brown, Milton W. The Story of the Armory Show, 316. 2d ed. [Washington, D.C.]: Joseph H. Hirshhorn Foundation ; New York: Abbeville, 1988.

A list of Sheeler's works exhibited in the Armory Show ("International Exhibition of Modern Art") held at the Armory of the Sixty-ninth Regiment, New York, 17 February—15 March 1913. Brown has revised and updated the original catalogue listings—in terms of titles, media, dates, lenders, prices listed, buyers and prices paid, present collections, added works, and supplementary notes—through utilizing documentary sources in the Kuhn Papers, the MacRae Papers, and the sales books of Walter Pach. Sheeler's Landscape of 1913 is illustrated (Color Plate 18).

997 Cedar Rapids Art Center. Charles Sheeler: A Retrospective Exhibition. Cedar Rapids, Iowa: The Center, [1967].

Catalogue of an exhibition held at the Cedar Rapids Art Center, Cedar Rapids, Iowa, 25 October—26 November 1967. Catalogue essay by Donn L. Young. A checklist of the twenty-seven paintings and drawings and nine photographs in the exhibition, biographical notes, and a selected bibliography are included.

998 Charles Sheeler. Washington, D.C.: Published for the National Collection of Fine Arts by the Smithsonian Institution Press, 1968.

Catalogue of a major retrospective exhibition held at the National Collection of Fine Arts, Smithsonian Institution, Washington, D.C., 10 October—24 November 1968. The 170 paintings, drawings, and photographs are listed chronologically in a timetable by subject matter and are accompanied by biographical notes. Martin Friedman's catalogue essay, "The Art of Charles Sheeler: Americana in a Vacuum," documents the artist's influences, stylistic development, and interest in American historical themes, both urban and rural. Bartlett Hayes' "Reminiscence" is a biographical essay. An abridgement of Charles Millard's essay on Sheeler's photography that originally appeared in Contemporary Photographer (see 1071) is reprinted, as are two of Sheeler's

early reviews originally appearing in The Arts (see 987 and 989). Particularly noteworthy is the transcription of Sheeler's so-called "Black Book," a bound notebook in which he recorded his aesthetic theories for the use of researchers and friends. The catalogue also includes an exhibition list with related references and a selected bibliography. All but eleven of the works in the exhibition are illustrated.

999 Coke, Van Deren. The Painter and the Photograph: from Delacroix to Warhol, rev. and enl. ed., 213-219. Albuquerque: University of New Mexico Press, 1972.

Coke discusses the relationship between Sheeler's paintings and his photographs, noting that the intensity and lack of subtlety in many of the artist's late paintings is due, in part, to the influence of the dyes used in Kodachrome film.

1000 Detroit Institute of Arts. The Rouge: The Image of Industry in the Art of Charles Sheeler and Diego Rivera. Detroit: The Institute, 1978.

Catalogue of an exhibition held at the Detroit Institute of Arts, 15 August—1 October 1978. The catalogue contains thirty-six annotated reproductions of Sheeler's paintings, lithographs, drawings, and photographs depicting various aspects of Ford's River Rouge automobile plant in Dearborn, Michigan. Catalogue essay by Mary Jane Jacob.

1001 The Forum Exhibition of Modern American Painters. New York: M. Kennerley, 1916.

Catalogue of an exhibition sponsored by Willard Huntington Wright and held at the Anderson Galleries, New York, 13-25 March 1916, which included nine works by Sheeler. The catalogue includes Wright's essay, "What is Modern Painting?," in addition to six separate forewords authored by Christian Brinton, Robert Henri, W. H. de B. Nelson, Alfred Stieglitz, John Weichsel, and Wright. Sheeler's "Explanatory Note" is accompanied by an illustration of his Landscape No. 8.

1002 Friedman, Martin. Charles Sheeler. New York: Watson-Guptill, 1975.

Friedman outlines and assesses Sheeler's career, both as an artist and as a photographer, beginning in 1900 when Sheeler became a student of applied design at the School of Industrial Art in Philadelphia. Of particular note are Friedman's discussions of the influence of photography on Sheeler's paintings and the tension between realism and abstraction that developed later in his career. Friedman intersperses his biographical narrative with stylistic analyses of numerous paintings, drawings, and photographs. In writing this book, Friedman drew upon his 1959 interview with the artist (see 1188), his 1968

catalogue essay for the National Collection of Fine Arts retrospective (see 998), and the files of the Downtown Gallery. In addition to forty-eight color plates, over one hundred works are reproduced in black and white. A chronology, exhibition history, and bibliography are included.

1003 Gallatin, A. E. Gaston Lachaise: Sixteen Reproductions in Collotype of the Sculptor's Work. New York: E.P. Dutton, 1924.

Gallatin's monograph includes sixteen photographs of Lachaise's sculpture by Sheeler.

1004 Institute of Modern Art (Boston, Mass.) Ten Americans: Benton, Brook, Curry, Hopper, James, Levine, Marsh, Sheeler, Watkins, Wood. Boston: The Institute, 1943.

Catalogue of an exhibition held at the Institute of Modern Art, Boston, 20 October—21 November 1943, which includes three works by Sheeler and a biographical sketch of the artist.

1005 James Maroney, Inc. The Elite and Popular Appeal of the Art of Charles Sheeler. New York: James Maroney, Inc., 1986.

Catalogue of an exhibition held at James Maroney, Inc., New York, April 1986, which includes three works by Demuth and fifteen by Sheeler. Maroney states that the catalogue ". . . is illustrated by pertinent works in various media intending to show that the content of Sheeler's still-life compositions is transposed easily by the artist into the forms of his so-called industrial subjects, and that the difference between the two modes, today regarded as fundamental, is a schism bred of Sheeler's patronage as it is perceived by his audience, and not one of his own purposeful, creative intent."

1006 Lucic, Karen. Charles Sheeler and the Cult of the Machine. Cambridge, Mass.: Harvard University Press, 1991.

Through a close examination of the Machine Age iconography in Sheeler's paintings, photographs, and the film Manhatta, Lucic contends that while Sheeler's depictions of American industry are less ironic than those of Demuth, they are equally provocative, ambivalent, and disturbing. It is Lucic's thesis that Sheeler sought to create a signature machine aesthetic distinctly his own, yet at the same time he attempted to convey self-effacement, anonymity, and detachment both in his artistic persona and in his urban, industrial, technological, and even preindustrial subjects. Lucic feels that the somber, solitary, and impersonal world portrayed in Sheeler's paintings reveals his anxiety about the loss of artistic creativity in the face of the increasingly mechanized aspects of

image-making. The book contains seventy illustrations (twenty in color) and a bibliography.

1007 Marx, Leo. <u>The Machine in the Garden: Technology and the Pastoral Ideal in America</u>, 355-356. New York: Oxford University Press, 1964.

Marx analyzes Sheeler's <u>American Landscape</u> of 1930, a painting which he feels represents the industrial landscape pastoralized.

1008 Massachusetts Institute of Technology. Charles Hayden Memorial Library. New Gallery. <u>Charles Sheeler: A Retrospective Exhibition from the William H. Lane Foundation, Leominster, Massachusetts</u>. Cambridge, Mass.: The Gallery, 1959.

Catalogue of an exhibition held at the New Gallery, Charles Hayden Memorial Library, Massachusetts Institute of Technology, Cambridge, 5 January—22 February 1959. A checklist of the forty works in the exhibition (four of which are illustrated), a chronology, and a list of public collections owning Sheeler's works are included. The catalogue reprints William Carlos Williams' foreword to <u>Charles Sheeler: A Retrospective Exhibition</u> (see 1020).

1009 Metropolitan Museum of Art (New York, N.Y.) <u>Egyptian Statues</u>. New York: The Museum, 1945.

Photographs by Sheeler; text by Nora E. Scott.

1010 _____. <u>Egyptian Statuettes</u>. New York: The Museum, 1946.

Photographs by Sheeler; text by Nora E. Scott.

1011 _____. <u>The Great King, King of Assyria: Assyrian Reliefs in the Metropolitan Museum of Art</u>. New York: The Museum, 1945

Photographs by Sheeler; text by Nora E. Scott.

1012 Modern Gallery. <u>Exhibition of African Negro Sculpture</u>. New York: The Gallery, 1918.

Catalogue of an exhibition held at Marius de Zayas' Modern Gallery, New York, 21 January—9 February 1918. The catalogue contains a portfolio of twenty sepia-toned photographs by Sheeler.

1013 Museum of Modern Art (New York, N.Y.) <u>Charles Sheeler: Paintings, Drawings, Photographs</u>. New York: The Museum, 1939.

Catalogue of an exhibition held at the Museum of Modern Art, New York, 4 October—1 November 1939. William Carlos Williams provides an introduction to the catalogue. Sheeler's "A Brief Note on the Exhibition" documents the artist's belief that his Upper Deck of 1929 marked a decisive turning point in his artistic development. A checklist of the 196 paintings, drawings, lithographs, photographs, and industrial designs is included in addition to a chronology and a bibliography. A considerably expanded version of Williams' catalogue introduction appears in A Recognizable Image: William Carlos Williams on Art and Artists, edited with an introduction and notes by Bram Dijkstra (New York: New Directions, 1978).

1014 Pennsylvania State University. Museum of Art. Charles Sheeler: The Works on Paper. University Park: The Museum, 1974.

Catalogue of an exhibition held at the Museum of Art, Pennsylvania State University, University Park, 10 February—24 March 1974. The exhibition consisted of sixty-two works including lithographs, serigraphs, and works executed in tempera, ink, watercolor, conte crayon, colored crayon, charcoal, chalk, and pencil. Catalogue essay by John P. Driscoll.

1015 Rourke, Constance. Charles Sheeler: Artist in the American Tradition. New York: Harcourt, Brace, and Company, 1938.

Rourke's book, the first monograph on Sheeler, contains a biographical narrative interspersed with lengthy quotations from Sheeler's unpublished autobiography. Rourke analyzes a large number of Sheeler's works in terms of craftsmanship, color, light, form, design, and so forth. She is particularly concerned to trace Sheeler's artistic influences, both American and European, and his interest in indigenous historical traditions and subject matter from Shaker domestic artifacts to the modern industrial landscape.

1016 Sheeler, Charles. Charles Sheeler: Photographer at the Metropolitan Museum of Art. New York: Metropolitan Museum of Art, 1982.

A portfolio of nine platinum prints in a limited edition of 250 from Sheeler's work as a photographic consultant for the Metropolitan Museum of Art from 1942 to 1945.

1017 Stebbins, Theodore E., Jr. and Norman Keyes, Jr. Charles Sheeler: The Photographs. Boston: Little, Brown, 1987.

Catalogue of the photography half of the exhibition, "Charles Sheeler: Paintings, Drawings, Photographs," held at the Museum of Fine Arts, Boston, 13 October 1987—3 January 1988. The authors' extensively documented catalogue essay provides a chronological overview and critical assessment of Sheeler's entire

career as a photographer, including a discussion of the 1921 film Manhatta. The ninety photographs in the exhibition—all but one of which is from the Lane Collection—are reproduced. A bibliography on Sheeler's photography, which contains references to archival sources, is also included.

1018 Terry Dintenfass, Inc. Charles Sheeler (1883-1965), Classic Themes: Paintings, Drawings and Photographs. New York: Terry Dintenfass, Inc., 1980.

Catalogue of an exhibition held at Terry Dintenfass, Inc., New York, 10-30 May 1980. Catalogue essay by guest curator John Driscoll. A checklist of the forty-six works in the exhibition is included.

1019 Troyen, Carol and Erica E. Hirshler. Charles Sheeler: Paintings and Drawings. Boston: Little, Brown, 1987.

Catalogue of the painting and drawing half of the exhibition, "Charles Sheeler: Paintings, Drawings, Photographs," held at the Museum of Fine Arts, Boston, 13 October 1987—3 January 1988. Troyen's extensively documented catalogue essay provides a chronological overview and critical assessment of Sheeler's entire career, including a discussion of the relationship between his photography and his paintings. Each of the eighty-seven works in the exhibition is illustrated and discussed in lengthy scholarly annotations by Troyen and Hirshler. Illustrations of related paintings and photographs by Sheeler are frequently juxtaposed with the catalogue illustrations for comparative purposes. A bibliography, which contains references to archival sources, and a chronology are also included.

1020 University of California at Los Angeles. Art Galleries. Charles Sheeler: A Retrospective Exhibition. Los Angeles: The Galleries, 1954.

Catalogue of an exhibition held at the Art Galleries of the University of California at Los Angeles, October 1954. The catalogue contains a foreword by William Carlos Williams, an introductory appreciation by Bartlett H. Hayes, Jr., and a catalogue essay by Frederick S. Wight. Wight's essay is a lengthy assessment of Sheeler's entire career as both an artist and a photographer, and contains biographical details, critical assessments, and numerous statements by Sheeler, many of which are drawn from Wight's own conversations with the artist. The contributions of Wight and Williams are reprinted in Art in America (see 1094 and 1096); Williams' piece is also reprinted in A Recognizable Image: William Carlos Williams on Art and Artists, edited with an introduction and notes by Bram Dijkstra (New York: New Directions, 1978).

1021 University of Illinois—Urbana. College of Fine and Applied Arts. Contemporary American Painting and Sculpture. Urbana: University of Illinois, College of Fine and Applied Arts, 1955.

Catalogue of an exhibition held at the Galleries of the College of Fine and Applied Arts, University of Illinois, Urbana, 27 February—3 April 1955, which includes Sheeler's Midwest of 1954. The biographical note on Sheeler contains a statement by the artist on the painting (p. 241).

1022 _____. Contemporary American Painting and Sculpture. Urbana: University of Illinois Press, 1957.

Catalogue of an exhibition held at the Galleries of the College of Fine and Applied Arts, University of Illinois, Urbana, 3 March—7 April 1957, which includes Sheeler's San Francisco of 1957. The biographical note on Sheeler contains a statement by the artist on the painting (p. 247).

1023 _____. Contemporary American Painting and Sculpture. Urbana: University of Illinois Press, 1959.

Catalogue of an exhibition held at the Galleries of the College of Fine and Applied Arts, University of Illisois, Urbana, 1 March—5 April 1959, which includes Sheeler's Composition Around Red of 1956. The biographical note on Sheeler contains a statement by the artist on the painting (p. 270).

1024 University of Iowa. Department of Art. The Quest of Charles Sheeler: 83 Works Honoring His 80th Year. Iowa City: University of Iowa, 1963.

Catalogue of an exhibition held at the University of Iowa, Iowa City, Iowa, 17 March—14 April 1963. Lillian Dochterman's catalogue essay gives a succinct critical overview of Sheeler's entire career in addition to providing commentary on the individual works in the exhibition, which range from the early Plums on a Plate of ca. 1910 to the late tempera study Sun, Rocks and Trees of 1959. The essay is followed by three important appendixes ("Sheeler's Cubist milleu 1910-1918," "Origins of Cubist-Realist style," and "Photography as a stylistic influence"). The catalogue also includes a checklist of the eighty-three works in the exhibition plus a chronology and a selected list of Sheeler's exhibitions. Three works are illustrated in color and twenty-six in black and white.

1025 Whitney Museum of American Art. Charles Sheeler: A Concentration of Works from the Permanent Collection of the Whitney Museum of American Art. New York: The Museum, 1980.

Catalogue of an exhibition held at the Whitney Museum of American Art, New York, 15 October—7 December 1980, which included twenty-one paintings, drawings, and photographs. The lengthy catalogue essay by Patterson Sims contains sections devoted to an introductory biographical sketch; Chrysanthemums of 1912; the documentary photographs of art; Pertaining to Yachts and Yachting of ca. 1922; Bucks County Barn [photograph] of 1915 and

Bucks County Barn of 1923; the still lifes; the River Rouge series; Interior, Bucks County Barn of 1932; and the later works. A chronology and a selected bibliography are included.

1026 _____. The Museum and Its Friends: Eighteen Living American Artists Selected by the Friends of the Whitney Museum. New York: The Museum, 1959.

Catalogue of an exhibition held at the Whitney Museum of American Art, New York, 5 March—12 April 1959, which includes six works by Sheeler. The catalogue contains a photograph of the artist, a reproduction of Aerial Gyrations, a brief biographical sketch, and a statement by Sheeler reprinted from Constance Rourke's Charles Sheeler: Artist in the American Tradition.

1027 Williams, William Carlos. The Autobiography of William Carlos Williams. New York: Random House, 1951.

Williams and Sheeler first met in August of 1924 at the home of literary critic Kenneth Burke and subsequently became lifelong friends. Williams makes a number of references to his relationship with Sheeler, Sheeler's first wife Katherine, and Sheeler's second wife Musya, at various places in his autobiography.

1028 Yale University. Art Gallery. Charles Sheeler: American Interiors. New Haven, Conn.: The Gallery, 1987.

Catalogue of an exhibition held at the Yale University Art Gallery, New Haven, Connecticut, 1 April—31 May 1987. The fifty-five items in the exhibition included paintings; drawings; photographs; a wide range of vernacular Americana including furniture, glass, and ceramics that Sheeler owned and portrayed in his works; and examples of Sheeler's industrial design prototypes in silver, glass, and textiles. Each item is illustrated and annotated by exhibition organizer Susan Fillin-Yeh and her students. In her catalogue essay, Fillen-Yeh discusses the important role American material culture, particularly that of the Shakers, played in Sheeler's art and the way in which he attempted to tie the vernacular tradition of artifact production to modern aesthetic and cultural concerns.

III. Articles and Essays

1029 Abbott, Jere. "Burchfield and Sheeler for U.S. Collection at Smith College." The Art News 39 (14 December 1940) 12, 17.

The acquisition of Sheeler's Rolling Power of 1939 by the Smith College Museum of Art, Northampton, Massachusetts, is noted.

1030 Adams, Henry. "Charles Sheeler." In American Drawings and Watercolors in the Museum of Art, Carnegie Institute, 164-167. Pittsburgh: Carnegie Institute, Museum of Art ; Distributed by the University of Pittsburgh Press, 1985.

A discussion of Sheeler centering on his works in the Museum of Art at Carnegie Institute.

1031 Ames, Winslow. "A Portrait of American Industry." Worcester Art Museum Annual 2 (1936-1937) 96-98.

Ames analyzes Sheeler's City Interior of 1936 and comments on the colors, light source, perspective, brushwork, and the artist's general treatment of his subject, which Ames feels is rather shy and reticient, although he does not use these terms pejoratively.

1032 Andrews, Faith and Edward D. Andrews. "Sheeler and the Shakers." Art in America 53 (February 1965) 90-95.

Edward Deming Andrews and his wife Faith Andrews, acknowledged authorities on the Shakers, set forth the thesis that Sheeler's interest in Shaker architecture, furniture, and artifacts stemmed from his appreciation of its simplicity, refinement of line, and grace of form. They also note that Sheeler admired the technical precision and economy of Shaker craftsmen.

1033 Beaton, Cecil and Gail Buckland. "Charles Sheeler." In The Magic Image: The Genius of Photography, 172. New York: Viking, 1989.

A biographical sketch and an overview of Sheeler's photographic career.

1034 Belser, Wendy W. "Charles Sheeler: Photographer of Art." The Print Collector's Newsletter 13 (March-April 1982) 16-17.

Sheeler was a photography consultant for the Metropolitan Museum of Art from July 1942 until July 1945, during which time he made several hundred photographs of the museum and its collection. Belser reviews this body of work and the limited edition portfolio published in 1982 (see 1016).

1035 Boorsch, Dorthea Dietrich. "Charles Sheeler, Wings." Yale University Art Gallery Bulletin 37 (Spring 1980) 13-15.

An analysis of Sheeler's painting Wings of 1949, an almost pure abstraction of sailboats in motion, with reference to Sheeler's other depictions of the sailing theme.

1036 Brace, Ernest. "Charles Sheeler." Creative Art 11 (October 1932) 96-104.

Brace argues against critics who find Sheeler's work unemotional by postulating that Sheeler's emotions are bound up in the precision and clarity of his depiction of geometrical forms. Brace also notes the mathematical exactitude in Sheeler's color, form, and design.

1037 Brichta, Vivian. "Portfolio—Charles Sheeler: A Precisionist at Work." American History Illustrated 18 (January 1984) 32-39.

This overview of Sheeler's career is accompanied by eleven illustrations of the artist's paintings, drawings, and photographs.

1038 "Charles Sheeler." In The Collection of Alfred Stieglitz: Fifty Pioneers of Modern Photography, 437-440. New York: Metropolitan Museum of Art ; Viking Press, 1978.

The four Sheeler photographs in the Stieglitz collection are annotated and accompanied by a chronology, a list of selected photography exhibitions and collections, and a bibliography.

1039 Cohen, George Michael. "Charles Sheeler." American Artist 23 (January 1959) 32-37.

Cohen feels that Sheeler changed to more intense colors in the late 1950s in order to heighten the mood, tension, and abstract effects of his compositions.

1040 Craven, George M. "Sheeler at Seventy-Five." College Art Journal 18 (Winter 1959) 136-143.

Craven discusses the relationship between Sheeler's painting and his photography.

1041 Craven, Thomas. "Charles Sheeler." Shadowland 8 (March 1923) 11, 71.

Craven feels that although Sheeler's photography has undeniably influenced his painting, it is the artist's imaginative power of simplifying and reordering pictorial elements, resulting in what Craven calls a "linear precision," that gives his compositions artistic merit. Sheeler remarked to Craven that he aimed to give his work "The absolute beauty we are accustomed to associate with objects suspended in a vacuum."

1042 Davies, Karen. "Charles Sheeler in Doylestown and the Image of Rural Architecture." Arts Magazine 59 (March 1985) 135-139.

Davies documents Sheeler's interest in the vernacular architecture of Doylestown, Pennsylvania, in rural Bucks County through a discussion of the Jonathan Worthington House. Sheeler leased the house from local resident and pioneer anthropologist Henry Chapman Mercer for a number of years starting around 1910. He regularly shared it with Morton Schamberg as a summer and weekend residence until the latter's death in 1918, after which time his visits became less frequent. The numerous photographic studies Sheeler made of the house later served as a frame of reference for at least ten paintings and drawings executed in the 1930s. Davies also discusses the artist's many drawings of Bucks County barns. She notes that Sheeler would return to Bucks County imagery throughout his career during times of personal loss or stylistic transformation.

1043 De Zayas, Marius. "Negro Art." The Arts 3 (March 1923) 199-205.

De Zayas' article includes eight photographs of African sculpture by Sheeler.

1044 Deak, Gloria-Gilda. "Charles Sheeler." In Kennedy Galleries Profiles of American Artists, 2d ed., 220-221. New York: Kennedy Galleries, 1984.

A biographical essay.

1045 Driscoll, John. "Charles Sheeler's Early Work: Five Rediscovered Paintings." The Art Bulletin 62 (March 1980) 124-133.

Driscoll discusses five early paintings by Sheeler dating from 1910 to 1914 that became known only after Mrs. Sheeler personally delivered them to New York art dealer Terry Dintenfass. Peaches in a White Bowl of 1910 and Dahlias: Flowers in a Vase of 1912 were previously unrecorded. The other three works dated 1914: Abstraction: Tree Form, Landscape No. 1, and Landscape No. 6. Utilizing the artist's statements and previously known paintings of this period, Driscoll traces the significance of these five works for Sheeler's early artistic development and he notes the influence of Cezanne, Matisse, and Cubism, which stemmed from Sheeler's European sojourn of 1908-09 and his participation in the Armory Show of 1913.

1046 Esterow, Milton. "Beaumont Newhall: Photographic Memories." Art News 88 (April 1989) 168-173.

This interview of photography historian Newhall includes some interesting and amusing reminisences about Sheeler, whom Newhall calls "a delightful person" (pp. 171-172).

1047 Fillin-Yeh, Susan. "Charles Sheeler: Industry, Fashion, and the Vanguard." Arts Magazine 54 (February 1980) 154-158.

It is Fillin-Yeh's contention that Sheeler's work in the realm of commercial advertising, fashion, and portrait photography in the 1920s for magazines such as <u>Vanity Fair</u> and <u>Vogue</u>, as well as his association with men like Matthew Josephson, Edward Steichen, and Vaughn Flannery, played a key role in setting the artist's paintings and drawings apart from those of his fellow Precisionists insofar as his compositions show more identifiable details and put their subject matter on display by showing adjacent angles. She notes that this latter device has the effect of leading the viewer's eye from the center of the composition outward towards the edges.

1048 _____. "Charles Sheeler's American Interiors." <u>Antiques</u> 131 (April 1987) 828-837.

Fillin-Yeh documents Sheeler's interest in Shaker furniture and domestic artifacts, early American textiles and rugs, and so forth, which were often featured in his paintings, drawings, and photographs of the interiors of his various residences. She explores this subject in greater depth in her catalogue essay in <u>Charles Sheeler: American Interiors</u> (see 1028).

1049 _____. "Charles Sheeler's 1923 'Self-Portrait'." <u>Arts Magazine</u> 52 (January 1978) 106-109.

Fillen-Yeh finds Sheeler's <u>Self-Portrait</u> of 1923 significant for a number of reasons: first, the prominence Sheeler gives the telephone in his composition not only represents the first explicit machine reference in his work, but it also embodies his definition of beauty; second, the telephone represents Sheeler's theory concerning the artist's depersonalized role in communicating with his audience; third, the painting clearly expresses Sheeler's machine aesthetic; and fourth, the Dada overtones in the painting owe a great deal to Sheeler's contacts through the Arensberg and Stieglitz circles with Picabia, de Zayas, and Duchamp, with the latter's <u>The Bride Stripped Bare by Her Bachelors Even</u> (the <u>Large Glass</u> of 1917-23) being particularly influential.

1050 _____. "Charles Sheeler's <u>Rolling Power</u>." In <u>The Railroad in American Art: Representations of Technological Change</u>, ed. Susan Danly and Leo Marx, 147-163. Cambridge, Mass.: MIT Press, 1988.

Fillin-Yeh discusses Sheeler's painting <u>Rolling Power</u> of 1939 in a number of different contexts: as part of the portfolio depicting the theme of power commissioned by <u>Fortune</u> magazine; as influenced by Alfred Stieglitz and Paul Strand's close-up photography; as exemplifying Sheeler's aesthetic of idealizing machinery and remaining faithful to appearances despite evoking ambiguous and equivocal responses in the viewer; and as differing from traditional nineteenth- and twentieth-century representations of the railroad in painting

and photography insofar as Sheeler's image is a close-up, a side view, static, and abstracted from any larger context.

1051 _____. "Charles Sheeler's Upper Deck." Arts Magazine 53 (January 1979) 90-94.

Fillin-Yeh presents a detailed analysis of the genesis and significance of Sheeler's Upper Deck of 1929. This painting, based upon a photographic study, was carefully crafted by Sheeler to eliminate any element that might interfere with the artist's efficient communication with the viewer and signaled Sheeler's commitment to a version of realism which he defined as machine-based optical realism. Sheeler utilized the composition's exaggerated diagonal and its mirror imagery in order to express a vision of the machine as a logical and coherent whole. Fillin-Yeh feels that Sheeler's predilection for intellectualized and impersonal art was reinforced by his contacts with the Arensberg circle, with Duchamp's influence being especially noticable in this painting. She also points out that Upper Deck was the first work Sheeler completed after his visit to Ford's River Rouge plant and the first work he executed in a machinist style with an industrial theme.

1052 "5 Painters." American Artist 9 (February 1945) 15.

The section of this article devoted to Sheeler contains a lengthy quote from Jerome Mellquist's The Emergence of an American Art which is critical of Sheeler's "emotional anemia." Sheeler's Connecticut Farms Buildings is illustrated.

1053 "Fogg Museum Acquires Unusual Sheeler." The Art Digest 9 (15 January 1935) 6.

The acquisition of Sheeler's Feline Felicity of 1934 by the Fogg Art Museum, Harvard University, is noted; comments on the drawing are included.

1054 Froman, Robert. "Charles Sheeler: 'Super-Realist' with a Paintbrush." Pageant 3 (June 1947) 65-73.

1055 Geldzahler, Henry. "Charles Sheeler." In American Painting of the Twentieth Century, by Henry Geldzahler, 138-140. New York: Metropolitan Museum of Art ; Greenwich, Conn.: New York Graphic Society, 1965.

Geldzahler discusses Sheeler's Water of 1945 and Golden Gate of 1955.

1056 Hammen, Scott. "Sheeler and Strand's 'Manhatta': A Neglected Masterpiece." Afterimage 6 (January 1979) 6-7.

Hammen analyzes Sheeler's and Paul Strand's film <u>Manhatta</u> of 1921 and points out that critics who call the film "static" fail to appreciate the movement of the crowds, the ferry, the smoke, and so forth. Because of the high-angle cinematography the crowds are reduced to the visual equivalent of ants, a factor that Hammen feels gives <u>Manhatta</u> a majestic yet threatening quality.

1057 Heller, Nancy and Julia Williams. "Portrait of America: The American Land and Its People as Celebrated by Eight American Painters. Charles Sheeler: American Industry as Landscape." <u>American Artist</u> 40 (January 1976) 58-63, 102-103.

A general overview of the highlights of Sheeler's career.

1058 Hirshler, Erica E. "The 'New New York' and the Park Row Building: American Artists View an Icon of the Modern Age." <u>The American Art Journal</u> 21, no. 4 (1989) 26-45.

Hirshler's article includes a discussion of Sheeler's photographs of the Park Row Building in New York City as well as his paintings and drawings modeled on these photographic studies. Six full-page illustrations of Sheeler's works are included.

1059 Horak, Jan-Christopher. "Modernist Perspectives and Romantic Desire: <u>Manhatta</u>." <u>Afterimage</u> 15 (November 1987) 8-15. Reprinted, in modified form, in <u>Paul Strand: Essays on His Life and Work</u>, ed. Maren Stange, 55-71. New York: Aperture, 1990.

Horak attempts to contextualize Sheeler's and Paul Strand's film <u>Manhatta</u> of 1921 in terms of the history of its production and distribution. Horak analyzes the film's oscillation between modernism and a Whitmanesque romanticism. He also provides a general overview of the early American amateur avant-garde film movement.

1060 Jacobs, Lewis. "Precursors and Prototypes (1894-1922)." In <u>The Documentary Tradition from Nanook to Woodstock</u>, ed. Lewis Jacobs, 6-7. New York: Hopkinson and Blake, 1971.

In his discussion of Sheeler's and Paul Strand's film <u>Manhatta</u> of 1921, Jacobs notes its influence on subsequent European documentaries, particularly Rene Clair's <u>The Eiffel Tower</u> (1927), Walker Ruttman's <u>Berlin</u> (1927), George Lacombe's <u>La Zone</u> (1927) and Joris Iven's <u>The Bridge</u> (1927) and <u>Rain</u> (1929).

1061 Jolas, Eugene. "The Industrial Mythos." <u>transition</u> no. 18 (November 1929) 123-[130].

Jolas, editor of transition, introduces a selection of six Sheeler photographs of Ford's River Rouge plant by stating, "His camera gives us the finest imaginative possibilities through light and dark arrangements which approach the abstract and crystal purity of poetry."

1062 Kellogg, Florence Loeb. "Order in the Machine Age." Survey Graphic 20 (March 1932) 589-591.

Kellogg reproduces the three 1931 conte crayon drawings Sheeler made of Ford's River Rouge plant (Ballet Mechanique, Smokestacks, and Industrial Architecture), and offers a brief commentary.

1063 Keyes, Norman. "The Photographs of Charles Sheeler." Antiques 133 (March 1988) 678-691.

In addition to analyzing Sheeler's photographs of Shaker architecture, furniture, and domestic artifacts—as well as the artist's paintings modeled on these photographic studies—Keyes discusses the influence of Marius de Zayas' theory of the role of photography in the age of modern art on Sheeler's formative years, a theory which saw photography as being a direct, precise, and unbiased statement based upon objective reality.

1064 Kootz, Samuel M. "Charles Sheeler." In Modern American Painting, by Samuel M. Kootz, 50-52. New York: Brewer & Warren, 1930.

Kootz gives a critical assessment of Sheeler's early career. Kootz was one of the first critics to point out the problems inherent in Sheeler's "camera-like synthesis," saying that the artist's "new realism" has led him "to the edge of a bloodless and attenuated subterfuge for humanity." Five works are illustrated on black and white plates.

1065 _____. "Ford Plant Photos of Charles Sheeler." Creative Art 8 (April 1931) 264-267.

Kootz notes that Sheeler's objective attitude gives his photographs a calm, detached, precise, and ordered pictorial expression.

1066 Lucic, Karen. "Charles Sheeler: American Interiors." Arts Magazine 61 (May 1987) 44-47.

Lucic offers a lengthy critique of Susan Fillin-Yeh's catalogue essay in Charles Sheeler: American Interiors (see 1028). Fillin-Yeh implies that there existed an authentic, inherent connection between the Shakers and modernist design as well as between the vernacular craft tradition and modern methods of industrial production. Lucic contends that Fillin-Yeh's arguments are vague and her

conclusions overdrawn. Lucic argues these historical antecedents, far from being natural and necessary, were purely contingent and posited by Sheeler in an artificial, albeit sincere, attempt to assuage his distress over the generally held perception that American art was marginal and provincial as compared with parallel European achievements.

1067 _____. "Charles Sheeler and Henry Ford: A Craft Heritage for the Machine Age." Bulletin of the Detroit Institute of Arts 65, no. 1 (1989) 36-47.

It is Lucic's contention that both Sheeler and Ford had a common interest in utilizing various aspects of America's nineteenth-century handcraft tradition as an idealized historical antecedent of the country's twentieth-century mass production industrialization—Sheeler through his depiction of Shaker themes and Ford through his craft displays at Greenfield Village. Lucic argues that while Ford's interest in the past was aimed at justifying his present exploitation of the machine, Sheeler's interest was aimed at creating a future American machine aesthetic to rival the one found in Europe.

1068 "Manhattan—'The Proud and Passionate City.' Two American Artists Interpret the Spirit of Modern New York Photographically in Terms of Line and Mass." Vanity Fair 18 (April 1922) 51.

Five stills from Sheeler's and Paul Strand's 1921 film Manhatta are illustrated and accompanied by caption comments.

1069 Marling, William. "The Dynamics of Vision in William Carlos Williams and Charles Sheeler." In Self, Sign, and Symbol, ed. Mark Neuman and Michael Payne, 130-143. [Bucknell Review 30, no. 2 (1987).] Lewisburg, Pa.: Bucknell University Press, 1987.

In order to explicate the aesthetic viewpoint shared by Williams and Sheeler, Marling posits "visual editing" as a common element, which he defines as an acquired way of seeing found in the meditative tradition of Eastern philosophy. Marling argues that Sheeler concentrated on the primacy of form in his compositions and Williams emphasized visual shapes in his early poetry. Marling feels that both men created clearly defined "edges" in their respective works. He notes that Williams eventually moved beyond this aesthetic approach, whereas Sheeler adhered to it throughout his career.

1070 McCoy, Garnet. "Charles Sheeler—Some Early Documents and a Reminiscence." Journal of the Archives of American Art 5 (April 1965) 1-4.

McCoy assesses the impact of Sheeler's third European trip in 1908-09 through an examination of the artist's correspondence with William Macbeth of the Macbeth Gallery, New York. McCoy also transcribes excerpts from an

interview with Sheeler conducted by Bartlett Cowdrey at the artist's home on 9 December 1958.

1071 Millard, Charles W. "Charles Sheeler: American Photographer." Contemporary Photographer 6, no. 1 (1967).

Millard's essay is a lengthy and important overview and critical appraisal of Sheeler's entire career as a photographer. Millard feels that Sheeler's undeserved lack of recognition as a major twentieth-century photographer stems from a number of reasons: his relative isolation from other photographers; his revolutionary, yet visually undramatic, innovations in "straight" photography eventually becoming commonplace; and his increasing use of photographs as consciously manipulated preparatory studies for his paintings. Millard points out that Sheeler's photography shares more affinities with Cubism than that of any other major figure and, agreeing with many critics, argues that Sheeler was overall a more successful photographer than a painter.

1072 Nemser, Rebecca. "Charles Sheeler: Master of the Industrial Sublime." Technology Review 91 (April 1988) 42-51.

An overview of Sheeler's paintings and photographs of urban and industrial subject matter.

1073 Noverr, Douglas A. "The Midwestern Industrial Landscapes of Charles Sheeler and Philip Evergood." Journal of American Culture 10 (Spring 1987) 15-25.

In the first half of his article Noverr discusses Sheeler's American Landscape of 1930, River Rouge Plant of 1932, and City Interior of 1936.

1074 Pagano, Grace. Contemporary American Painting: The Encyclopaedia Britannica Collection. New York: Duell, Sloan and Pearce, 1945. S.v. "Charles Sheeler."

A biographical sketch with a statement by Sheeler on Winter Window of 1941, which is illustrated.

1075 Parker, Robert Allerton. "The Art of the Camera: An Experimental 'Movie'." Arts and Decoration 15 (October 1921) 369, 414-415.

A review of Sheeler's and Paul Strand's film Manhatta of 1921, which Parker hails as "a turning point in the art of the camera.".

1076 _____. "The Classical Vision of Charles Sheeler." International Studio 84 (May 1926) 68-72.

Parker discusses Sheeler in terms of the disciplined, intellectual, and balanced art of the classical tradition. "Dispensing with ornamentation and irrelevant embellishment," Parker writes, "Charles Sheeler seeks to disengage, with a precision that at times seems almost surgical, the essential forms of his object."

1077 "People in the Arts—Charles Sheeler." Arts Magazine 36 (May-June 1962) 10.

Notice of the American Academy of Arts and Letters conferring its Award of Merit Medal and a $1,000 prize to Sheeler.

1078 "Photographs of New York by Charles Sheeler." Cahiers d'Art 2, no. 4-5 (1927) 130-132.

Four photographs of New York skyscrapers by Sheeler.

1079 "Precision's Reward." Time 79 (1 June 1962) 65.

Notice of the American Academy of Arts and Letters conferring its Award of Merit Medal and a $1,000 prize to Sheeler.

1080 Ricciotti, Dominic. "City Railways/Modernist Visions." In The Railroad in American Art: Representations of Technological Change, ed. Susan Danly and Leo Marx, 127-146. Cambridge, Mass.: MIT Press, 1988.

Ricciotti's essay includes a discussion of Sheeler's Church Street El of 1920 and American Landscape of 1930. Ricciotti feels that unlike Weber and Stella, whose railroad paintings he also discusses, Sheeler attempted to assimilate European modernism to a more traditional, indigenous realism and he thereby retained ties to the classic American landscape tradition.

1081 _____. "Symbols and Monuments: Images of the Skyscraper in American Art." Landscape 25, no. 2 (1981) 22-29.

Ricciotti describes Sheeler's approach to depicting the skyscraper as "functionalist" insofar as it emphasizes rational structural systems over excessive ornamentation and adherence to architectural historicism. Ricciotti discusses Sheeler's Offices of 1922 in this context.

1082 Richardson, E. P. "Three American Painters: Sheeler—Hopper—Burchfield." Perspectives USA no. 16 (Summer 1956) 111-119.

In his assessment of Sheeler's work Richardson states, "I do not think I underestimate Sheeler's art—both in paint and in photography—when I say its influence on popular taste was more important than the art itself. His work itself

was, and is, disciplined, cold, well constructed as a beautiful machine. But its influence is everywhere in the taste of the industrial designers of our age."

1083 Sheeler, Charles. "Power: A Portfolio by Charles Sheeler." Fortune 22 (December 1940) 73-83.

A series of six paintings commissioned by Fortune magazine depicting the theme of power are reproduced in color and accompanied by editorial commentary: Primitive Power, Yankee Clipper, Rolling Power, Suspended Power, Steam Turbine, and Conversation—Sky and Earth.

1084 "Sheeler Canvas Becomes Goodwill Gesture." The Art Digest 13 (1 September 1939) 9.

The gift of Sheeler's Clapboards of 1936 to the Pennsylvania Academy of the Fine Arts is noted.

1085 "Sheeler Paints Power." The Art Digest 15 (1 December 1940) 8.

A discussion of Sheeler's "Power" portfolio commissioned by Fortune magazine (see 1083).

1086 Sweet, Frederick A. "Three American Paintings." Bulletin of the Art Institute of Chicago 39 (January 1945) 5-7.

Sweet briefly discusses Sheeler's painting The Artist Looks at Nature of 1943, which was acquired by the Art Institute of Chicago as a gift from the Society for Contemporary American Art in 1944.

1087 "Telecast." The Bulletin of the Museum of Modern Art 8 (November 1940) 18.

Notice of a two-part NBC television program covering the 1939 Sheeler retrospective exhibition at the Museum of Modern Art. This program, in which Sheeler participated, was the first American telecast of a one-man art exhibition.

1088 Troyen, Carol. "The Open Window and the Empty Chair: Charles Sheeler's View of New York." The American Art Journal 18, no. 2 (1986) 24-41.

Troyen points out that Sheeler's depiction of his own studio in View of New York of 1931 is similar to the ironic treatment he gives the same subject in other works such as Self-Portrait of 1923 and two other paintings from 1931, Cactus and Tulips. She conjectures that this vivid yet enegmatic composition, with its empty chair, covered camera, and undefined view of New York, represents Sheeler's ambivalent feelings at the time concerning his decision, made at the instigation of his dealer, Edith Gregor Halpert, to curtail his career in commercial

photography in order to devote more time to his painting. The open window becomes for Sheeler, as it has for other artists, a symbol of uncertainty about the future.

1089 Walker, Richard W. "The Art Market—A Sheeler Comes Out of the Closet." Art News 82 (October 1983) 22.

Notice of the discovery of Sheeler's Connecticut Barns (a previously unknown Precisionist work executed when Sheeler worked for the Public Works Art Project) by the General Services Administration in an Interior Department office closet. Because the artist's name was misspelled "Scheeler" on official records, it was only recently learned that he was employed by the program from 5 February—21 March 1934 and earned an average of $30.60 per week for a total of $221.85. The painting, which measures thirty-two by thirty-four inches, is presently housed in the National Museum of American Art in Washington, D.C.

1090 Watson, Forbes. "Charles Sheeler." The Arts 3 (May 1923) 334-344.

In an early critical assessment of Sheeler's work, Watson notes that the artist depicts natural forms in abstract terms yet still retains an objective point of reference for the viewer.

1091 Weaver, Mike. "Precisonist Poetry." In William Carlos Williams: The American Background, by Mike Weaver, 53-64. Cambridge, England: Cambridge University Press, 1971.

Weaver discusses the influence of photography on Precisionism with special reference to Sheeler.

1092 Webb, Virginia-Lee. "Art as Information: The African Portfolios of Charles Sheeler and Walker Evans." African Arts 24 (January 1991) 56-63, 103-104.

Webb discusses Sheeler's portfolio of twenty photographs contained in the catalogue for the "Exhibition of African Negro Sculpture" held at Marius de Zayas' Modern Gallery, New York, 21 January—9 February 1918 (see 1012). She compares Sheeler's photographs with those taken by Walker Evans for the 1935 portfolio African Negro Art. The article features nineteen illustrations.

1093 Weller, Allen S. "Sheeler." In Art: USA: Now, Vol. 1, ed. Lee Nordness, 26-29. New York: Viking Press, 1963.

A brief biographical sketch accompanied by illustrations and a statement by the artist.

1094 Wight, Frederick S. "Charles Sheeler." <u>Art in America</u> 42 (October 1954) 180-213.

A reprint of Wight's catalogue essay from <u>Charles Sheeler: A Retrospective Exhibition</u> (see 1020).

1095 _____. "Charles Sheeler." In <u>New Art in America: Fifty Painters of the 20th Century</u>, ed. John I. H. Baur, 97-102. Greenwich, Conn.: New York Graphic Society, in cooperation with Praeger, [1957].

A biographical sketch of Sheeler accompanied by six illustrations.

1096 Williams, William Carlos. "Postscript by a Poet." <u>Art in America</u> 42 (October 1954) 214-215.

A reprint of Williams' foreword to <u>Charles Sheeler: A Retrospective Exhibition</u> (see 1020).

IV. Exhibition Reviews

1097 De Zayes, Marius. "How, When, and Why Modern Art Came to New York." Introduction and notes by Francis M. Naumann. <u>Arts Magazine</u> 54 (April 1980) 104-105.

Four reviews of Sheeler's one-man exhibition "Paintings and Photographs by Charles Sheeler" held at the Modern Gallery, New York, 3-15 December 1917, are reprinted: <u>New York Sun</u> (10 December 1917); <u>American Art News</u> (15 December 1917); <u>New York Evening World</u> (9 December 1917); and <u>New York American</u> (25 December 1917). De Zayas remarks, "It was Charles Sheeler who proved that cubism exists in nature and that photography can record it."

1098 "Charles Sheeler at De Zayas." <u>American Art News</u> 18 (21 February 1920) 3.

Review of Sheeler's one-man exhibition "Paintings and Photographs by Charles Sheeler" held at Marius de Zayas' Modern Gallery, New York, 16-28 February 1920.

1099 McBride, Henry. "Charles Sheeler's Bucks County Barns." In <u>The Flow of Art: Essays and Criticisms of Henry McBride</u>, ed. Daniel Catton Rich, 155-156. New York: Atheneum, 1975.

Review (reprinted from <u>The Sun and New York Herald</u>, 22 February 1920). See entry 1098.

1100 "Paintings and Drawings by Sheeler." <u>American Art News</u> 20 (1 April 1922) 6.

Review of Sheeler's one-man exhibition at the Daniel Gallery, New York, April 1922.

1101 Watson, Forbes. "Comments—The Whitney Galleries." <u>The Arts</u> 5 (March 1924) 169.

Review of the "Exhibition of Selected Works by Charles Sheeler" held at the Whitney Studio Galleries, New York, 1-31 March 1924. Watson also comments on an exhibition, organized by Sheeler at the Whitney Studio Club, New York, of works by Picasso, Braque, Duchamp, and De Zayas.

1102 Poore, Dudley. "Current Exhibitions—Charles Sheeler." <u>The Arts</u> 7 (February 1925) 115.

Review of a Sheeler exhibition held in the Print Room of J. B. Neumann's New Art Circle, New York.

1103 "Exhibitions in New York: Charles Sheeler—New Art Circle." <u>The Art News</u> 26 (23 January 1926) 7.

Review of a Sheeler exhibition held at J. B. Neumann's New Art Circle, New York, 18 January—4 February 1926.

1104 Goodrich, Lloyd. "New York Exhibitions—Sheeler and Lozowick." <u>The Arts</u> 9 (February 1926) 102-103.

Review. See entry 1103.

1105 "Exhibitions in New York: Charles Sheeler—Downtown Gallery." <u>The Art News</u> 30 (21 November 1931) 8.

Review of the exhibition "Charles Sheeler: Recent Paintings" held at the Downtown Gallery, New York, 18 November—7 December 1931.

1106 Coates, Robert M. "The Art Galleries—A Sheeler Retrospective." <u>The New Yorker</u> 15 (14 October 1939) 56.

Review of the exhibition "Charles Sheeler: Paintings, Drawings and Photographs" held at the Museum of Modern Art, New York, 4 October—1 November 1939.

1107 Devree, Howard. "Exhibition Reviews—Sheeler Complete." Magazine of Art 32 (November 1939) 644-645.

Review. See entry 1106.

1108 Lane, James W. "Of Sheeler's Immaculatism: The Modern Museum's One-Man Show." The Art News 38 (7 October 1939) 10.

Review. See entry 1106.

1109 "Modern Museum Enshrines Charles Sheeler." The Art Digest 14 (15 October 1939) 5-6.

Review. See entry 1106.

1110 Brown, Milton. "Sheeler and Power." Parnassus 13 (January 1941) 46.

Review of the exhibition "Charles Sheeler: Power. Six Original Paintings Commissioned for Reproduction in the December 1940 Issue of Fortune" held at the Downtown Gallery, New York, 2-21 December 1940.

1111 Lowe, Jeanette. "Sheeler's Symbols of the Machine Age." The Art News 39 (7 December 1940) 11.

Review. See entry 1110.

1112 Gibbs, Jo. "Cross-Section of Sheeler's Classic Precision." The Art Digest (1 March 1946) 9.

Review of "Exhibition of Recent Paintings by Charles Sheeler" held at the Downtown Gallery, New York, 5-23 March 1946.

1113 "Machine Age, Philadelphia Style." Time 47 (18 March 1946) 65.

Review. See entry 1112.

1114 McBride, Henry. "Charles Sheeler." In The Flow of Art: Essays and Criticisms of Henry McBride, ed. Daniel Catton Rich, 406-408. New York: Atheneum, 1975.

Review (reprinted from The New York Sun, 13 April 1946). See entry 1112.

1115 "Sheeler—1946." Art News 45 (March 1946) 30-31.

 Review (five brief statements by the artist are included). See entry 1112.

1116 Preston, Stuart. "5 Stars for February—Charles Sheeler." Art News 47 (February 1949) 15-16.

 Review of the exhibition "Charles Sheeler" held at the Downtown Gallery, New York, 25 January—12 February 1949.

1117 Reed, Judith K. "The Disciplined Art of Charles Sheeler." The Art Digest 23 (1 February 1949) 13.

 Review. See entry 1116.

1118 Krasne, Belle. "Fifty-Seventh Street in Review—Charles Sheeler." The Art Digest 25 (15 March 1951) 16.

 Review of the exhibition "Paintings, 1949-1951, by Charles Sheeler" held at the Downtown Gallery, New York, 13-31 March 1951.

1119 Seckler, Dorothy. "Reviews and Previews—Charles Sheeler." Art News 50 (April 1951) 44.

 Review. See entry 1118.

1120 Chanin, A. L. "Charles Sheeler: Purist Brush and Camera Eye." Art News 54 (Summer 1955) 40-41, 70-71.

 Review of "Charles Sheeler: A Retrospective Exhibition" held at the Art Galleries, University of California at Los Angeles, October 1954.

1121 Goodall, Donald. "San Diego." Arts Digest 29 (15 January 1955) 14-15.

 Review of "Charles Sheeler: A Retrospective" held at the Art Galleries, University of California at Los Angeles, October 1954, and which traveled to the San Diego Fine Arts Gallery.

1122 Coates, Robert M. "The Art Galleries: Gauguin and Sheeler." The New Yorker 32 (14 April 1956) 112.

 Review of the exhibition "Sheeler: From the Collection of the William H. Lane Foundation" held at the Downtown Gallery, New York, 3-28 April 1956.

1123 Campbell, Lawrence. "Reviews and Previews—Charles Sheeler." Art News 57 (April 1958) 13.

Review of the exhibition "Sheeler: Recent Paintings" held at the Downtown Gallery, New York, 25 March—19 April 1958.

1124 Coates, Robert M. "The Art Galleries—Seurat, Albers, Sheeler." The New Yorker 34 (15 April 1958) 91-93.

Review. See entry 1123.

1125 Browne, Rosalind. "Yasuo Kuniyoshi and Charles Sheeler." Art News 63 (January 1965) 13.

Review of the exhibition "Charles Sheeler: Exhibition, Tempera on Glass" held at the Downtown Gallery, New York, 4-23 January 1965.

1126 Raynor, Vivian. "Yasuo Kuniyoshi, Charles Sheeler." Arts Magazine 39 (February 1965) 63.

Review. See entry 1125.

1127 Brown, Gordon. "In the Galleries—Charles Sheeler." Arts Magazine 40 (June 1966) 47.

Review of the exhibition "Sheeler (1883-1965)" held at the Downtown Gallery, New York, 3-27 May 1966.

1128 Waldman, Diane. "Reviews and Previews—Charles Sheeler." Art News 65 (Summer 1966) 16.

Review. See entry 1127.

1129 "Art Across the U.S.A.—Charles Sheeler in the Mechanical Age." Apollo 89 (March 1969) 23a.

Review of the exhibition "Charles Sheeler" held at the National Collection of Fine Arts, Smithsonian Institution, Washington, D.C., 10 October—24 November 1968, and which traveled to the Whitney Museum of American Art, New York, 11 March—27 April 1969.

1130 Butler, Joseph T. "The American Way with Art—Charles Sheeler." The Connoisseur 170 (January 1969) 64-65.

Review. See entry 1129.

1131 Davidson, Abraham A. "Charles Sheeler: Paintings and Photographs at the Whitney." <u>Arts Magazine</u> 43 (March 1969) 39-41.

 Review. See entry 1129.

1132 Kramer, Hilton. "Charles Sheeler: American Pastoral." <u>Artforum</u> 7 (January 1969) 36-39. Reprinted in <u>The Age of the Avant-Garde: An Art Chronical 1956-1972</u> by Hilton Kramer, 292-295. New York: Farrar, Straus and Giroux, 1973.

 Review. See entry 1129.

1133 Mellow, James R. "New York Letter." <u>Art International</u> 13 (20 May 1969) 55.

 Review. See entry 1129.

1134 Pomeroy, Ralph. "New York. Super-Real is Back in Town." <u>Art and Artists</u> 4 (May 1969) 26-27.

 Review. See entry 1129.

1135 Bell, Jane. "Art Reviews—Charles Sheeler." <u>Arts Magazine</u> 48 (June 1974) 57.

 Review of the exhibition "Charles Sheeler: The Works on Paper" held at the Museum of Art, Pennsylvania State University and which traveled to Terry Dintenfass, Inc., New York, 2-20 April 1974.

1136 "Reviews and Previews—Charles Sheeler: Works on Paper." <u>Art News</u> 73 (Summer 1974) 110.

 Review. See entry 1135.

1137 Fillen-Yeh, Susan. "The Rouge." <u>Arts Magazine</u> 53 (November 1978) 8.

 Review of the exhibition "The Rouge: The Image of Industry in the Art of Charles Sheeler and Diego Rivera" held at the Detroit Institute of Arts, 15 August—1 October 1978.

1138 Miro, Marsha. "The Nation—Detroit: Man and Machine." <u>Art News</u> 77 (December 1978) 117, 119.

 Review. See entry 1137.

1139 Andre, Linda. "The Rhetoric of Power: Machine Art and Public Relations." <u>Afterimage</u> 11 (February 1984) 5-7.

Review of the exhibition "Photography and the Industrial Image" held at the Photo Center Gallery of New York University, 4 November—1 December 1983. Andre discusses Sheeler's 1929 photograph Ladle Hooks, an interior view of Ford's River Rouge plant, which appeared in the February 1928 issue of Vanity Fair and was featured on the cover of the 15 February 1929 issue of Ford News.

1140 Cohrs, Timothy. "Art Reviews—Charles Sheeler." Arts Magazine 60 (December 1985) 122.

Review of an exhibition of ten Sheeler photographs from 1915 to 1939 held at the Pace/MacGill Gallery, New York, 1 October—16 November 1985.

1141 Agee, William C. "'Helga' and Other Problems." The New Criterion 6 (April 1988) 47-48.

Review of the exhibition "Charles Sheeler: Paintings, Drawings, Photographs" held at the Museum of Fine Arts, Boston, 13 October 1987—3 January 1988, and which traveled to the Whitney Museum of American Art, New York, 28 January—17 April 1988. Agee remarks, "It must be said, though, that as good as Sheeler is, he is no match for Schamberg, whose art demands that we accord him his place as a major artist."

1142 Hammer, Martin. "Exhibition Reviews—New York, Whitney Museum, Charles Sheeler." The Burlington Magazine 130 (February 1988) 164.

Review. See entry 1141.

1143 Roth, Evelyn. "Precision Revision." American Photographer 29 (November 1987) 46.

Review. See entry 1141.

1144 Stevens, Mark. "Art—The Poet and the Engineer." Newsweek 111 (4 January 1988) 55.

Review. See entry 1141.

V. Book Reviews

1145 Baur, John I. H. "A 'Classical' Modern." The Brooklyn Museum Quarterly 26 (January 1939) 23-24.

Review of Constance Rourke's Charles Sheeler: Artist in the American Tradition (New York: Harcourt, Brace, 1938).

1146 Lozowick, Louis. "Review and Comment—American Artist." New Masses 29 (11 October 1938) 25-26.

Review. See entry 1145.

1147 Marshall, Margaret. "Books and the Arts—The Artist in America." The Nation 147 (17 September 1938) 270-271.

Review. See entry 1145.

1148 Rubin, Joan Shelley. "A Convergence of Vision: Constance Rourke, Charles Sheeler, and American Art." American Quarterly 42 (June 1990) 191-222.

Review. See entry 1145.

1149 Watson, Forbes. "New Books on Art—In the American Tradition." Magazine of Art 31 (October 1938) 600, 608.

Review. See entry 1145.

1150 Driscoll, John Paul. "Books in Review." Art Journal 36 (Fall 1976) 90, 92, 94.

Review of Martin Friedman's Charles Sheeler (New York: Watson-Guptill, 1975).

1151 Goldberg, Vicki. "Books—Painter as Photographer: Charles Sheeler's Lasting Brush with the Camera." American Photographer 20 (May 1988) 20, 22.

Review of Theodore E. Stebbins' and Norman Keyes' Charles Sheeler: The Photographs (Boston: Little, Brown, 1987).

VI. Reference Sources

1152 Auer, Michael. Photographers Encyclopaedia International, 1839 to the Present. Geneva, Switzerland: Editions Camera Obscura, 1985. S.v. "Sheeler, Charles."

1153 Baigell, Matthew. Dictionary of American Art. New York: Harper & Row, 1982. S.v. "Sheeler, Charles."

1154 Browne, Turner and Elaine Partnow. Macmillan Biographical Encyclopedia of Photographic Artists and Innovators. New York: Macmillan, 1982. S.v. "Charles Sheeler."

1155 "Charles Sheeler (1883-1965)." In American Art Analog. Vol. 3, 1874-1930, comp. Michael David Zellman, 835. New York: Chelsea House, in association with American Art Analog, 1986.

A brief biographical sketch accompanied by auction price information for the artist's works.

1156 "Charles Sheeler—Painter and Photographer." Index of Twentieth Century Artists, 1933-1937, 521-523, 526. New York: Arno Press, 1970.

1157 Contemporary Photographers. 2d ed. Chicago: St. James Press, 1988. S.v. "Sheeler, Charles."

1158 Cummings, Paul. Dictionary of Contemporary American Artists. 5th ed. New York: St. Martin's, 1988. S.v. "Sheeler, Charles."

1159 Current Biography Yearbook 1950. New York: H.W. Wilson, 1951. S.v. "Sheeler, Charles."

1160 Encyclopedia of American Art. New York: E.P. Dutton, 1981. S.v. "Sheeler, Charles," by Alfred V. Frankenstein.

1161 Falk, Peter Hastings, ed. Who Was Who in American Art: Compiled from the Original Thirty-four Volumes of "American Art Annual: Who's Who in Art." Madison, Conn.: Sound View Press, 1985. S.v. "Sheeler, Charles."

1162 Fielding, Mantle. Mantle Fielding's Dictionary of American Painters, Sculptors & Engravers. 2d enl. ed. Edited by Glenn B. Opitz. Pougkeepsie, N.Y.: Apollo, 1986. S.v. "Sheeler, Charles R., Jr."

1163 Garraty, John A., ed. Dictionary of American Biography, Vol. 11, supp. 7. New York: Scribner's 1981. S.v. "Sheeler, Charles R., Jr.," by Elwood C. Parry.

1164 Gilbert, Dorothy B., ed. Who's Who in American Art. New York: R.R. Bowker, 1959. S.v. "Sheeler, Charles."

1165 The IPC Encyclopedia of Photography. New York: Crown, 1984. S.v. "Sheeler, Charles."

1166 The Larousse Dictionary of Painters. New York: Larousse, 1976. S.v. "Sheeler, Charles," by Daniel Robbins.

1167 Myers, Bernard S., ed. McGraw-Hill Dictionary of Art, Vol. 5. New York: McGraw-Hill, 1969. S.v. "Sheeler, Charles," by Jerome Viola.

1168 Osborne, Harold, ed. The Oxford Companion to Twentieth-Century Art. New York: Oxford University Press, 1981. S.v. "Sheeler, Charles R."

1169 Phaidon Dictionary of Twentieth-Century Art. London ; New York: Phaidon, 1973. S.v. "Sheeler, Charles R., Jr."

1170 Pile, John. Dictionary of 20th-Century Design. New York: Facts on File, 1990. S.v. "Sheeler, Charles (1883-1965)."

1171 Praeger Encyclopedia of Art, Vol. 5. New York: Praeger, 1971. S.v. "Sheeler, Charles," by Ila Weiss.

1172 Who Was Who in America. Vol. 4, 1961-1968. Chicago: Marquis Who's Who, 1968. S.v. "Sheeler, Charles."

1173 Vollmer, Hans. Allgemeines Lexikon der bildenden Kunstler des xx. Jahrhunderts, Volume 4. Leipzig: E.A. Seemann, 1953-1962. S.v. "Sheeler, Charles."

VII. Dissertations and Theses

1174 Dochterman, Lillian Natalie. "The Stylistic Development of the Work of Charles Sheeler." 2 vol. Ph.D. diss., University of Iowa, 1963.

Dochterman's dissertation is an important analysis of Sheeler's stylistic development, which she divides into five time periods. Also of value are a catalogue raisonne of Sheeler's works from 1904 to 1959, an exhibition history, and a detailed bibliography. Dochterman feels that Sheeler's development of Cubist-Realism ". . . was important not only because it helped to unseat the prevalent academicism and naturalism, but also because it helped to establish a means of incorporating the formal and advanced lessons of Cubism into a style of realism in which Americans were grounded." She observes that Cubist-Realism served as a link between America's first Cubist phase of 1910-17 and its resurgence in the late 1920s as well as the move to abstraction that followed in the 1930s.

1175 Fillen-Yeh, Susan. "Charles Sheeler and the Machine Age." Ph.D. diss., City University of New York, 1981.

Fillen-Yeh begins her dissertation with a general discussion of the Machine Age in America during the 1920s. The following chapter is devoted to Sheeler's Self-Portrait of 1923 and its Dada influences. This is followed by a survey of Sheeler's artistic and photographic career up to 1940 with a stylistic analysis of numerous works and a discussion of the ways in which his compositions differed from those of his fellow Precisionists. Fillen-Yeh next focuses on Sheeler's Upper Deck of 1929 in terms of its importance as a major prototype

for his machine paintings of the 1930s, which she discusses in her concluding chapter in the context of Sheeler's specialized sense of time and his willingness to use unique and unconventional subject matter.

1176 Jacob, Mary Jane. "The Impact of Shaker Design on the Work of Charles Sheeler." M.A. thesis, University of Michigan, 1976.

1177 Korber, Louise A. "Studies in Drawing Using the Works of Thomas Eakins, John Sloan, Charles Sheeler, and George Grosz." M.A. thesis, University of Delaware, 1962.

1178 Lucic, Karen. "The Present and the Past in the Work of Charles Sheeler." Ph.D. diss., Yale University, 1989.

1179 Meloy, Margaret Mary. "Charles Sheeler: Cubist-Realism and Photography." M.A. thesis, Northwestern University, 1972.

1180 Pellerano, Maria. "Paul Strand and Charles Sheeler: A Modern Collaboration." M.A. thesis, Rutgers University, 1985.

1181 Piron, Alice O'Mara. "Urban Metaphor in American Art and Literature, 1910-1930." Ph.D. diss., Northwestern University, 1982.

In a subsection of Chapter VII entitled "Charles Sheeler, American Functionalism Past and Present" (pp. 281-301), Piron argues that Sheeler adhered to the Emersonian philosophy of focusing upon the important truths of one's time, which for Sheeler involved the functional and the technological. She feels that Sheeler, like Emerson, subscribed to a philosophy of social idealism in which the artist takes on the role of a social reformer whose vision ultimately serves to improve society. Piron also believes that Sheeler, like Henry Adams, sought to shape an ideal vision of society through drawing upon the best qualities of the past, which for Sheeler were to be found in the simple craftsmanship of the Shakers. Piron discusses a number of Sheeler's works, including his Doylestown, Chartres, and River Rouge photographs; the film Manhatta; and various paintings such as his urban landscapes of the early 1920s and Upper Deck, American Landscape, Classic Landscape, and View of New York. She comments on the symbolism in Sheeler's works including that of the railroad. Piron concludes that Sheeler found a simple functional beauty in technology and he sought to portray industry as harmoniously coexisting with nature in an idealized, impersonal, pristine, and silent world.

1182 Rosenblum, Naomi. "Paul Strand: The Early Years, 1910-1932." Ph.D. diss., City University of New York, 1978.

Chapter 4 of Rosenblum's dissertation, "Film Work During the 'Twenties," includes a discussion of Strand's relationship with Sheeler as well as an analysis of their 1921 film Manhatta.

1183 Stewart, Patrick Leonard. "Charles Sheeler, William Carlos Williams, and the Development of Precisionist Aesthetic, 1917-1931." Ph.D. diss., University of Delaware, 1981.

Stewart advances the thesis that Precisionism, properly understood, was a unified movement in art and literature that combined an awakening sense of place with a growing objectivist viewpoint, resulting in a broad functionalist aesthetic with an underlying quest for an indigenous artistic tradition. Stewart devotes his first two chapters to an examination of the ways in which Sheeler and Williams exemplified this dual nature of Precisionism in their early work. In his concluding chapter, Stewart discusses the works of Sheeler and Williams that he feels most clearly exemplify the Precisionist aesthetic, namely, Sheeler's Upper Deck of 1929, American Landscape of 1930, Classic Landscape of 1931, and Home Sweet Home of 1931; and Williams' Spring and All (1923).

1184 Tepfer, Diane. "Edith Gregor Halpert and the Downtown Gallery: Downtown, 1926-1940; A Study in American Art Patronage." 2 vol. Ph.D. diss., University of Michigan, 1989.

Tepfer's dissertation is both a biography of Edith Gregor Halpert, founder of the Downtown Gallery, and a detailed chronicle of the gallery's organization, operations, exhibitions, and publications during the period from 1926 until 1940, focusing on the dynamic interaction of Halpert, her artists, and her clients. Tepfer made extensive use of the Downtown Gallery papers in the Archives of American Art for her study, which include correspondence, scrapbooks, catalogues, press releases, clippings, photographs, and gallery records. Tepfer discusses Sheeler's association with the Downtown Gallery and his relationship with Halpert (pp. 94-105). An extensive bibliography is included along with a checklist of Downtown Gallery exhibitions for the time period covered.

VIII. Archival Sources

1185 Alfred Stieglitz Collection. Collection of American Literature, Beinecke Rare Book and Manuscript Library, Yale University, New Haven, Connecticut.

This collection contains twenty letters from Sheeler to Stieglitz and five letters from Stieglitz to Sheeler, dated 1914 and 1922.

1186 Archives of American Art. The Card Catalog of the Manuscript Collections of the Archives of American Art, Vol. 9. Wilmington, Del.: Scholarly Resources, 1980. S.v. "Sheeler, Charles."

1187 _____. The Card Catalog of the Manuscript Collections of the Archives of American Art, Supplement 1981-1984. Wilmington, Del.: Scholarly Resources, 1985. S.v. "Sheeler, Charles."

This circulating microfilm collection contains numerous sources on Sheeler including material from the Downtown Gallery Papers, the Pennsylvania Academy of the Fine Arts Collection, the Whitney Museum Papers, and the National Gallery of Fine Arts Papers; Sheeler's personal papers and writings, including the manuscript for his unpublished autobiography; and his correspondence with various individuals such as William Macbeth, J. B. Neumann, Frederick S. Wight, and William Carlos Williams.

1188 _____. The Card Catalog of the Oral History Collections of the Archives of American Art. Wilmington, Del.: Scholarly Resources, 1984. S.v. "Sheeler, Charles."

This oral history collection contains two transcribed interviews of Sheeler, the first conducted by Bartlett Cowdrey on 9 December 1958, and the second conducted by Milton Friedman on 18 June 1959.

1189 "Charles Sheeler." In Reliable Sources: A Selection of Letters, Sketches and Photographs from the Archives of American Art, 98-99. Washington, D.C.: Published for the Archives of American Art by the Smithsonian Institution Press, 1988.

A facsimile reproduction and transcription of a letter from Sheeler to New York dealer William Macbeth, dated 26 September 1910, concerning Macbeth's criticism and rejection of some of the artist's latest paintings.

See also entries 1017 and 1019.

IX. Annotated Reproductions

Aerial Gyrations, 1953. SAN FRANCISCO/2 (c) 134-135, 248-249.

Aldous Huxley [photograph], 1927. TRAVIS (b/w) 98, 173.

American Interior, 1934. YALE (b/w) 125.

American Landscape, 1930. MOMA/6 (c) 119.

_____. MOMA/11 (b/w) Pl. 80; p. 17.

_____. MOMA/13 (b/w) 228, 588.

Bleeder Stacks, Ford Plant, Detroit [photograph], 1927. CARTER/2 (b/w) 116, 146.

The Blue Roof, 1947. MONTCLAIR (b/w) 174.

Bucks County Barn [photograph], 1918. CARTER/2 (b/w) 113, 145.

Bucks County Barn, 1918. HOWLAND (b/w) 100-101.

Bucks County Barn, 1926. KUSHNER (c) 38-39, 85.

Bucks County House, Interior Detail (staircase) [photograph], ca. 1914-17. EASTMAN/
 2 (b/w) 232-233, 454.

_____. MOMA/15 (b/w) 233, 326.

_____. STIEGLITZ/1 (b/w) Pl. 45; p. 64.

Bucks County House, Interior Detail (stove) [photograph], 1917. MARONEY/1 (b/
 w) 14-15, 62-63.

_____. STIEGLITZ/1 (b/w) Pl. 44; p. 64.

_____. TRAVIS (b/w) 75, 173.

Buildings at Lebanon, 1949. WALKER (c) 468-469.

Cactus, 1931. ARENSBERG (b/w) Pl. 191.

_____. PENNSYLVANIA/2 (b/w) 6, 80, 107.

Cactus and Photographer's Lamp [photograph], 1931. MOMA/7 (b/w) 106-107.

California, 1957. DALLAS/1 (b/w) Pl. 63.

Calla Lilly, ca. 1918-22. MARONEY/1 (c) front cover; p. [2].

Canyons, 1951. HALPERT (c) Pl. 26.

_____. THYSSEN (c) 144-147.

Catastrophe No. 2, 1944, MURDOCK (b/w) 186-187.

Catwalk, 1947. EBSWORTH (c) 162-163, 215.

Counterpoint, 1949. HIRSCHL/2 (b/w) 71.

Crisscrossed Conveyors, River Rouge Plant, Ford Motor Company [photograph], 1927. FORD (b/w) 20, 22.

_____. INDUSTRY (b/w) 79, 91.

_____. LEVY (b/w) 66-67, 88.

_____. NEW VISION (b/w) [frontispiece].

Dahlias, 1923. MARONEY/3 (c) Pl. 4.

Dahlias and Asters, 1912. CORCORAN/3 (b/w) 117.

Dahlias and White Pitcher, n.d. HOWLAND (b/w) 102, 103.

Delmonico Building, 1926. LINDEMANN (b/w) 439, 444.

_____. PRINTS/1 (b/w) Pl. 79.

_____. PRINTS/2 (b/w) Pl. 80.

_____. PRINTS/3 (b/w) Pl. 54; pp. 123-124.

Doylestown Interior, Bucks County (Open Window) [photograph], 1915. MARONEY/1 (b/w) 58-59.

Drive Wheels [photograph], 1939. DETROIT/2 (b/w) 176-177.

_____. RAILROAD (b/w) 128.

Electric Power, n.d. MARONEY/1 (b/w) 16, 84-85.

Ephrata, ca. 1934. HIRSCHL/2 (c) 70.

_____. SPRINGFIELD (b/w) 51.

Fallen Sequoia, 1956. KENNEDY/8 (b/w) [front cover].

Farm Buildings, Connecticut, 1941. NEWARK (b/w) 193, 375.

Feline Felicity, 1934. HARVARD/1 (b/w) Pl. 144.

Flower Details, 1918. HIRSCHL/4 (b/w) 92.

Flower Forms, 1919. MARONEY/1 (c) 10-11, 66-69.

_____. PHILADELPHIA/1 (b/w) 514.

_____. QUINN/2 (c) 144.

Fortieth Street looking West toward Broadway, New York City [photograph], ca. 1920. ARCHITECTURE/1 (b/w) Pl. 124; pp. 263-264.

Fuel Tanks, Wisconsin [photograph], 1952. MADDOX (b/w) Pl. 45; [biographical note].

Fugue, 1945. HIRSCHL/2 (c) [frontispiece]; p. 73.

Funnel [photograph], 1927. EASTMAN/1 (b/w) xiv, 18.

General Motors Research, 1956. BRANDEIS (b/w) 48, 52.

Geranium, ca. 1926. ANDERSON (c) 68-69.

Gladioli in White Pitcher, 1925. SANTA BARBARA (b/w) Pl. 122.

Golden Gate, 1955. ELIOT (c) 179-181.

Grey Barns, 1946. MARONEY/1 (c) 16-17, 82-83.

Hallway (Interior), 1919. YORK/1 (c) Pl. 22.

Home, Sweet Home, 1931. DETROIT/1 (b/w) 174.

_____. HERITAGE (b/w) P. 43.

House with Trees (Landscape No. 7), 1915. RHODE ISLAND/3 (b/w) 214-215.

Incantation, 1946. BROOKLYN/2 (b/w) Pl. 42.

Industrial Architecture, 1931. HIRSCHL/2 (b/w) 72.

Industrial Architecture, 1949. DABROWSKI (b/w) 197, 275.

_____. HALPERT (c) 30.

Industrial Forms, 1947. LANE (c) Pl. 50; p. 168.

Industrial Series No. 1, 1928. HIRSCHL/2 (b/w) 72.

_____. PRINTS/1 (b/w) Pl. 80.

_____. PRINTS/4 (b/w) Pl. 119.

Industry [photo-mural], 1927. MOMA/9 (b/w) unpaginated.

Industry [photograph], 1932. TRAVIS (b/w) 95, 174.

Interior, 1940. GOLDSTONE (b/w) 84.

Interior, Bucks County Barn [photograph], ca. 1915. MARONEY/1 (b/w) 15-16, 60-61.

Interior, Bucks County Barn, 1932. WHITNEY/5 (b/w) Pl. 28; p. 115.

Interior with Stove, 1932. SACHS/2 (b/w) 221, 257.

It's a Small World, 1946. NEWARK (b/w) 193, 375.

Landscape, n.d. HARVARD/1 (b/w) Pl. 130.

Landscape, 1914. HARVARD/1 (b/w) Pl. 129.

Landscape, 1915. LANE (c) Pl. 42; p. 167.

_____. PARIS-NEW YORK (b/w) 326-327, 718.

_____. QUINN/1 (b/w) 25, 180.

Landscape, 1925. ARENSBERG (b/w) Pl. 190.

Lhasa, 1916. COLUMBUS (c) 100-101, 198-199.

_____. HOWLAND (b/w) 96, 99, 101.

_____. MARONEY/1 (c) 10, 52-53.

Lily [photograph], 1918. MARONEY/1 (b/w) 54-55.

_____. TRAVIS (b/w) 91, 173.

Lunenburg, 1954. LANE (c) Pl. 54; p. 169.

Magnolia, 1946. LANE (c) Pl. 47; p. 168.

La Marseillaise [photograph], ca. 1925. POLLACK (b/w) 254.

Massachusetts Barn, 1948. LANE (c) Pl. 49; p. 168.

Mechanization, 1946. WHITNEY/4 (b/w) 91.

Midwest, 1954. ILLINOIS/55 (b/w) Pl. 80; p. 241.

_____. WALKER (c) 470-471.

New England Irrelevancies, 1953. LANE (c) Pl. 52; p. 169.

New York, 1920. METROPOLIS (b/w) 463, 606.

New York [photograph], 1920. HOUSTON/1 (b/w) 137.

_____. METROPOLIS (b/w) 463, 606.

_____. TRAVIS (b/w) 97, 173.

New York, 1950. KENNEDY/2 (c) Pl. 54.

_____. KENNEDY/6 (c) Pl. 27.

New York City [photograph], 1928. MADDOX (b/w) Pl. 43; [biographical note].

New York No. 2, 1951. MUNSON (c) 188-189.

Newhaven, 1932. LANE (c) Pl. 46; pp. 167-168.

Nude, 1920. MARONEY/1 (c) 11, 70-71.

_____. PHILADELPHIA/1 (b/w) 522-523.

Objects on a Table (Still Life with White Teapot), 1924. HOWLAND (b/w) 102, 104, 105.

_____. PHILADELPHIA/1 (b/w) 526-527.

Offices, 1922. PHILLIPS/1 (b/w) Pl. CXXX; pp. 65, 107.

Old Abandoned Mill, 1948. KENNEDY/3 (b/w) Pl. 10.

_____. KENNEDY/6 (c) Pl. 28.

On a Connecticut Theme, 1958. WHITNEY/4 (b/w) 91.

The Open Door, ca. 1932. CARTER/2 (b/w) 120, 146.

Ore Into Iron, 1953. HALPERT (c) 28.

_____. LANE (c) Pl. 51; p. 169.

_____. THYSSEN (c) 148-151.

Panama Canal, 1946. CORPORATE (c) 142-143.

Philadelphia Barn [photograph], 1915. PARIS-NEW YORK (b/w) 327, 718.

Portrait of Maurice Bratter [photograph], ca. 1928. RINEHART (b/w) 115, 135-136.

Powerhouse, 1943. DALLAS/2 (b/w) 146-147.

Primitive Power, 1939. MARONEY/1 (c) 11-13, 74-77.

Production Foundry, Ford Plant, Detroit, 1927. CARTER/2 (b/w) 117, 146.

Red Tulips, ca. 1926. MARONEY/1 (c) 72-73.

_____. MARONEY/2 (c) 23-29, 68-69.

River Rouge Industrial Plant, 1928. HOOPES (c) 137, 149, 201.

_____. KUSHNER (c) 39, 86.

Rock at Steichen's, 1937. BALTIMORE (b/w) 148-149.

_____. GUSSOW (b/w) 98-99.

Rolling Power, 1939. RAILROAD (b/w) 128-129.

Rose, 1920. HALPERT (b/w) 113.

San Francisco, 1956. ILLNOIS/57 (b/w) Pl. 28; p. 247.

Self-Portrait, 1923. MOMA/3 (b/w) 23, 63.

_____. MOMA/8 (b/w) 146-147.

_____. PARIS-NEW YORK (b/w) 354, 718.

Self-Portrait, 1924. SELF-PORTRAITS (b/w) 132-133, 242.

_____. WHITNEY/1 (b/w) 16, 57.

Shaker Barns, 1945. FRAAD (b/w) 106-107.

Shaker Detail, 1941. NEWARK (b/w) 184, 375.

Side of a Barn, 1917. HIRSCHL/4 (b/w) 68.

_____. JANSS (b/w) 47, 224.

Side of the White Barn (Bucks County Barn) [photograph], 1915. MARONEY/1
 (b/w) 56-57.

Skyline, 1950. MURDOCK (b/w) 188-189.

Skyscrapers, 1922. PHILLIPS/2 (b/w) Pl. 1598.

Spring Interior, 1927. LANE (c) Pl. 45; p. 167.

Staircase, Doylestown, 1925. HIRSHHORN (c) Pl. 388; pp. 745-746.

_____. PHILADELPHIA/1 (b/w) 527-528.

_____. WASHINGTON (c) 150-151.

Stairway (Doylestown Staircase) [photograph], 1915. PHILADELPHIA/1 (b/w) 501-
 502.

Stair Well [photograph], 1914. MOMA/14 (b/w) 486-487.

Stairwell, Williamsburg [photograph], 1935. MARONEY/1 (b/w) 64-65.

Still Life, 1921. HOWLAND (b/w) 100, 102.

Still Life, 1931. MICHENER (b/w) 298.

Still Life, 1938. EBSWORTH (c) 168-169, 219.

Still Life and Shadows, 1924. COLUMBUS (c) 102-103, 199.

Still-Life—Spanish Shawl, 1912. LANE (c) Pl. 40; p. 167.

_____. PARIS-NEW YORK (b/w) 225, 718.

CHAPTER ELEVEN
Niles Spencer

Niles Spencer was born in Pawtucket, Rhode Island, on 16 May 1893. His artistic education began at the Rhode Island School of Design in nearby Providence from 1913 to 1915. He continued his studies for a short period under Robert Henri and George Bellows at the Ferrer School in New York. Spencer spent a number of summers in Ogunquit, Maine, where he attended the Woodbury School and later joined a more advanced group of painters associated with the Perkins Cove Art Colony, founded by Hamilton Easter Field. He was employed as an evening instructor at the Rhode Island School of Design during 1915, but his appointment was soon terminated because his "advanced ideas" were found to be unacceptable.

After his marriage in 1917 to his first wife Betty, the couple decided to live year-round in Ogunquit. Spencer's early landscapes were in an impressionistic vein, but his style changed following a trip to Europe in 1921-22 where he was introduced to the Cubist works of Picasso, Braque, and Gris in Paris. In Italy he was impressed by the works of Giotto, Mantegna, and Pierro della Francesca he viewed in Arezzo and Padua.

Upon returning to New York in 1923, Spencer rented a studio on Washington Square and his works began to be exhibited in the progressive New York galleries, including the Whitney Studio Club and the Daniel Gallery (where he was given his first one-man show in 1925). His compositions of the mid-1920s, like Bristol Houses of 1923, became more Cubist and architectonic in their orientation. Spencer began to make regular summer visits to Provincetown until around 1940, whereupon he would vary his summer residences, always returning to New York in the fall.

As compared with his more generalized Precisionist works of the 1930s, Spencer's Provincetown canvases, such as New England Houses of 1924, are more atmospheric and capture a better sense of place. During the winter of 1927-28, Spencer visited Bermuda where he painted a number of landscapes. From 1930 to 1949 he would spend part of every winter at the Lafayette Hotel in Greenwich Village and, like George Ault, favored painting the scenes he viewed from his hotel window. In 1937 the U.S. Treasury Department's Section of Fine Arts awarded him a commission to execute a mural for the Aliquippa, Pennsylvania, Post Office.

Spencer's Precisionist works of the 1930s, like Blast Furnace of 1935, feature rather somber, and often gritty, views of urban and industrial vistas. Their weighty, simplified geometrical forms are rendered with a Cubist palatte generally restricted to greys, umbers, ochers, and terra-cotta reds. Spencer seldom shows atmospheric

effects, topical elements, light sources, or any indication of the season of the year. The perspective in these works tends to be exaggerated and the architecture has the appearance of building blocks stacked one upon the other. Spencer's still lifes, however, convey more personal and romantic moods as in The Green Table of 1930.

After his divorce in 1943, Spencer married his second wife Catherine in 1947. He divided his time between his New York studio and his homes in Dingman's Ferry, Pennsylvania, and Sag Harbor on Long Island. Spencer's works of the late 1940s and early 1950s, such as The Silver Tanks of 1949, became increasingly abstract and two-dimensional, showing evidence of his conscious manipulation of stylized forms. This direction in Spencer's art was undoubtedly prompted by his friendship with Ralston Crawford, although their relationship was one of mutual influence. Spencer died on 15 May 1952 of a heart attack following a brief illness. Of all the Precisionists, Spencer was probably the closest adherent to the Cubist principles underlying the movement. Always a slow and methodical worker, his compositions reflect a disciplined process of selectivity and a classical sense of order. The reserved, serene, and timeless world Spencer portrayed truly exemplifies the essence of the Precisionist spirit.

I. Spencer's Writings and Statements

1190 "To the Editor of Art News." The Art News 43 (September 1944) 19.

Spencer's comments concerning "The Fur-lined Museum," a controversial article by Emily Ganauer in Harper's (July 1944) which was highly critical of the Museum of Modern Art and its director Alfred H. Barr, Jr.

See also entries 017, 056, 074, 1191, 1196, 1205, 1208, and 1236-1237.

II. Monographs and Exhibition Catalogues

1191 Downtown Gallery. Niles Spencer. New York: The Gallery, 1947.

Catalogue of an exhibition held at the Downtown Gallery, New York, 11-19 November 1947. The press release issued in advance of the exhibition, "The Artist Speaks," contains a statement by Spencer.

1192 Freeman, Richard B. Niles Spencer. Lexington: University of Kentucky Press, 1965.

Catalogue of an exhibition held at the University of Kentucky Art Gallery, Lexington, 10 October—6 November 1965. Freeman's catalogue introduction is a lengthy biographical essay on the artist. Ralston Crawford, in his "Niles Spencer—A Tribute," says, "He was a constructive force in my life." The catalogue contains a "preliminary checklist" of 120 works, a chronology, a list of selected exhibitions, a list of public collections owning Spencer's work, and a selected bibliography. Forty-six works are illustrated (two in color).

1193 Guild Hall Museum. Niles Spencer, 1893-1952. East Hampton, N.Y.: The Museum, 1966.

Catalogue of an exhibition held at the Guild Hall Museum, East Hampton, New York, 19 July—9 August 1966. Catalogue essay by Eloise Spaeth.

1194 Museum of Modern Art (New York, N.Y.) Niles Spencer. New York: The Museum, 1954.

Checklist of an exhibition held at the Museum of Modern Art, New York, 22 June—15 August 1954, which lists thirty-five canvases executed between 1921 and 1951 and also mentions an unspecified group of the artist's drawings exhibited for the first time. Although no formal catalogue was published, the press release issued in advance of the exhibition, "First Large Retrospective Exhibition of the Paintings of Niles Spencer," contains a biographical sketch of the artist.

1195 Newark Museum. American Art in the Newark Museum: Paintings, Drawings, and Sculpture, 379-381. Newark, N.J.: The Museum, 1981.

This catalogue of the collection of the Newark Museum, Newark, New Jersey, contains a complete checklist of the Catherine Brett Spencer Bequest (Spencer's second wife) and the Mary Reffelt, Christopher Harrington Gift (the sister and nephew of Mrs. Spencer), which together totaled sixty works by the artist.

1196 University of Illinois—Urbana. College of Fine and Applied Arts. University of Illinois Exhibition of Contemporary American Painting. Urbana: University of Illinois, College of Fine and Applied Arts, 1952.

Catalogue of an exhibition held at the Galleries of the College of Fine and Applied Arts, University of Illinois, Urbana, 2 March—13 April 1952, which includes Spencer's In Fairmont of 1952. The biographical note on Spencer contains a statement by the artist (pp. 233-234).

1197 Washburn Gallery. Drawings by Niles Spencer. New York: The Gallery, 1972.

Catalogue of an exhibition of six drawings by Spencer held at the Washburn Gallery, New York, 25 October—25 November 1972. Catalogue introduction by Martin L. Friedman.

1198 Whitney Museum of American Art at Equitable Center. Niles Spencer. New York: The Museum, 1990.

Catalogue of an exhibition held at the Whitney Museum of American Art at Equitable Center, New York, 25 April—20 June 1990. The catalogue contains

two essays: "Porches and Windows: The Art of Niles Spencer," by Karal Ann Marling, and "Niles Spencer," by Wendy Jeffers. A checklist of the forty paintings, drawings, and lithographs in the exhibition is included. Six works are illustrated in black and white and three in color.

1199 Wilson, Edmund. The Thirties: From the Notebooks and Diaries of the Period. Edited with an introduction by Leon Edel. New York: Farrar, Straus and Giroux, 1980.

Wilson's notebooks and diaries of the 1930s contain a number of passages pertaining to Spencer and his first wife, Betty, principally centering around their activities in Provincetown.

III. Articles and Essays

1200 Cahill, Holger. "Niles Spencer." Magazine of Art 45 (November 1952) 313-315.

In assessing Spencer's achievement, Cahill notes the architectural strength; the sensitive and profound feeling for form, design, and space; and the disciplined use of color, in the artist's canvases.

1201 Freeman, Richard B. "Damaged Mural." Art Journal 31 (Winter 1971-1972) 178, 180.

Freeman discusses the extensive damage suffered by Spencer's mural Western Pennsylvania during its removal from the Post Office in Aliquippa, Pennsylvania, in 1969. "Before" and "After" photographs are included.

1202 Geldzahler, Henry. "Niles Spencer." In American Painting of the Twentieth Century, by Henry Geldzahler, 140-141. New York: Metropolitan Museum of Art ; Greenwich, Conn.: New York Graphic Society, 1965.

Geldzahler discusses Spencer's Erie Underpass of 1949.

1203 Kootz, Samuel M. "Seven Modern Americans." In Modern American Painting, by Samuel M. Kootz, 63. New York: Brewer & Warren, 1930.

Kootz gives a brief biographical sketch of Spencer. Corporation Shed, Bermuda of 1928 is illustrated on a black and white plate.

1204 Mannes, M. "Niles Spencer: Painter of Simplicities." Creative Art 7 (July 1930) 58-61.

Mannes' biographical sketch of Spencer is accompanied by some comments on the artist's working methods. Mannes argues that Spencer's paintings, far from

being vacuous or hollow in their simplicity, actually exhibit what he calls "an uncanny inner order, a poise that comes only from long thinking."

1205 Miller, Dorothy C. "Niles Spencer." In New Art in America: Fifty Painters of the 20th Century, ed. John I. H. Baur, 103-107. Greenwich, Conn.: New York Graphic Society, in cooperation with Praeger, New York, [1957].

A biographical sketch of Spencer accompanied by five illustrations. Statements by Spencer are reprinted from A New Realism and A Museum in Action.

1206 "Niles Spencer." Art Digest 26 (1 June 1952) 10-11.

An obituary.

1207 "Recent Acquisitions—Gas House District, 1932." Bulletin. City Art Museum of Saint Louis n.s. 2 (July-August 1966) 2-3, 5.

A discussion of Spencer's Gas House District of 1932, which is illustrated.

1208 Watson, Ernest W. "Niles Spencer." American Artist 8 (October 1944) 14-17.

Although this purports to be an interview with Spencer, it is actually a general stylistic analysis of Spencer's work accompanied by comments on his working methods, the latter presumably based on Watson's conversations with the artist. Seven works are illustrated and Watson provides a caption comments for each.

IV. Exhibition Reviews

1209 Comstock, Helen. "Niles Spencer Exhibits." The Art News 23 (11 April 1925) 7.

Review of the exhibition "Paintings in Niles Spencer" held at the Daniel Gallery, New York, March-April 1925. This was Spencer's first one-man show.

1210 Watson, Forbes. "A Note on Niles Spencer." The Arts 8 (September 1925) 167-169.

Review. See entry 1209.

1211 Coates, Robert M. "The Art Galleries—Out of the Past." The New Yorker 23 (22 November 1947) 87-88.

Review of the exhibition "Niles Spencer" held at the Downtown Gallery, New York, 11-29 November 1947.

1212 Hess, Thomas B. "Spotlight On: Spencer." Art News 46 (October 1947) 37.

Review. See entry 1211.

1213 Lansford, Alonzo. "Niles Spencer Exhibits Anew After 19 Years." The Art Digest 22 (15 November 1947) 15.

Review. See entry 1211.

1214 Coates, Robert M. "The Art Galleries—The Whitney Annual and Niles Spencer." The New Yorker 28 (15 November 1952) 166-167.

Review of the "Niles Spencer Memorial Exhibition" held at the Downtown Gallery, New York, 28 October—15 November 1952.

1215 Fitzsimmons, James. "Urban Classicist." Art Digest 27 (1 November 1952) 17, 26.

Review. See entry 1214.

1216 Porter, Fairfield. "Reviews and Previews—Niles Spencer." Art News 51 (November 1952) 46.

Review. See entry 1214.

1217 Ashton, Dore. "Fortnight in Review—Spencer's Cityscapes." Arts Magazine 28 (1 August 1954) 25-26.

Review of the exhibition "Niles Spencer" held at the Museum of Modern Art, New York, 22 June—15 August 1954.

1218 Devree, Howard. "Spencer Revalued: Museum of Modern Art Opens Notable Show." The New York Times (27 June 1954) 6X.

Review. See entry 1217.

1219 McBride, Henry. "An Elegant American Painter." Art News 53 (March 1954) 20-21, 61-62.

Review. See entry 1217.

1220 Coates, Robert M. "The Art Galleries—The Quiet One." The New Yorker 42 (5 March 1966) 93, 95-96.

Review of the exhibition "Niles Spencer" held at the University of Kentucky Art Gallery, Lexington, 10 October—6 November 1965 and which traveled to the Whitney Museum of American Art, New York, 8 February—6 March 1966.

1221 Berston, William. "In the Museums: Recent Exhibitions—Niles Spencer." <u>Arts Magazine</u> 40 (April 1966) 54.

Review. See entry 1220.

1222 Brown, Gordon. "Galleries—Niles Spencer." <u>Arts Magazine</u> 47 (December-January 1973) 93.

Review of the exhibition "Drawings by Niles Spencer" held at the Washburn Gallery, New York, 25 October—25 November 1972.

1223 Campbell, Lawrence. "Reviews and Previews—Niles Spencer." <u>Art News</u> 71 (November 1972) 76-77.

Review. See entry 1222.

1224 Ratcliff, Carter. "New York Letter." <u>Art International</u> 17 (January 1973) 60.

Review. See entry 1222.

1225 Loughery, John. "Early Moderns: Benton, Marin, Spencer." <u>The Hudson Review</u> 43 (Autumn 1990) 459-466.

Review of the exhibition "Niles Spencer" held at the Whitney Museum of American Art at Equitable Center, New York, 25 April—20 June 1990.

V. Reference Sources

1226 Baigell, Matthew. <u>Dictionary of American Art</u>. New York: Harper & Row. S.v. "Spencer, Niles."

1227 Cummings, Paul. <u>Dictionary of Contemporary American Artists</u>. 5th ed. New York: St. Martin's, 1988. S.v. "Spencer, Niles."

1228 <u>Encyclopedia of American Art</u>. New York: E.P. Dutton, 1981. S.v. "Spencer, Niles," by Alfred V. Frankenstein.

1229 Falk, Peter Hastings, ed. <u>Who Was Who in American Art: Compiled from the Original Thirty-four Volumes of "American Art Annual: Who's Who in Art</u>." Madison, Conn.: Sound View Press, 1985. S.v. "Spencer, Niles."

1230 Fielding, Mantle. <u>Mantle Fielding's Dictionary of American Painters, Sculptors & Engravers</u>. 2d enl. ed. Edited by Glenn B. Opitz. Pougkeepsie, N.Y.: Apollo, 1986. S.v. "Spencer, Niles."

1231 Myers, Bernard S., ed. <u>McGraw-Hill Dictionary of Art</u>, Vol. 5. New York: McGraw-Hill, 1969. S.v. "Spencer, Niles."

1232 "Niles Spencer (1893-1952)." In <u>American Art Analog</u>. Vol. 3, <u>1874-1930</u>, comp. Michael David Zellman, 895. New York: Chelsea House, in association with American Art Analog, 1986.

A brief biographical sketch accompanied by auction price information for the artist's works.

1233 <u>Phaidon Dictionary of Twentieth Century Art</u>. London ; New York: Phaidon, 1973. S.v. "Spencer, Niles."

1234 <u>Praeger Encyclopedia of Art</u>, Vol. 5. New York: Praeger, 1971. S.v. "Spencer, Niles," by John Ashbery.

1235 Vollmer, Hans. <u>Allgemeines Lexikon der bildenden Kunstler des xx. Jahrhunderts</u>, Vol. 4. Leipzig: E.A. Seeman, 1953-1962. S.v. "Spencer, Niles."

VI. Archival Sources

1236 Archives of American Art. <u>The Card Catalog of the Manuscript Collections of the Archives of American Art</u>, Vol. 9. Wilmington, Del.: Scholarly Resources, 1980. S.v. "Spencer, Niles."

1237 _____. <u>The Card Catalog of the Manuscript Collections of the Archives of American Art, Supplement 1981-1984</u>. Wilmington, Del.: Scholarly Resources, 1985. S.v. "Spencer, Niles."

The circulating microfilm collection contains numerous sources on Spencer including Richard B. Freeman's research materials relating to the artist (1954-1972), and materials from the Downtown Gallery Papers and the Forbes Watson Papers.

VII. Annotated Reproductions

<u>Above the Excavation</u>, 1950. LANE (c) Pl. 72, pp. 171-172.

<u>Above the Excavation #3</u>, 1950. NEWARK (b/w) 149, 379.

<u>Across the Tracks</u>, 1934. MICHENER (b/w) 310-311.

Back of the Town (Provincetown), 1926. CZESTOCHOWSKI (c) Pl. 161.

_____. DALLAS/2 (b/w) 130-131.

Bedside Table, ca. 1928. HALPERT (b/w) 122.

Bristol Houses, 1923. HIRSCHL/2 (c) 75.

Buildings, 1926. COLUMBUS (c) 120-121, 203.

_____. HOWLAND (b/w) 105, 107.

The Cement Mixer, 1949. LANE (c) Pl. 71; p. 171.

City Walls, 1921. MOMA/13 (b/w) 231, 590.

_____. MOMA/14 (b/w) 151.

_____. NEW YORK/2 (b/w) 54, 97, 107.

Corporation Shed, 1928. HOWLAND (b/w) 106, 107.

The Cove, 1922. MAINE (c) 11, 70, 121, 126.

_____. NEWARK (b/w) 148, 379.

The Desk, 1948. CATHCART (b/w) 101, 134.

_____. SAN FRANCISCO/2 (b/w) 373.

The Dormer Window, 1927. PHILLIPS/2 (b/w) Pl. 1649.

Edge of the City, 1943. HIRSHHORN (c) Pl. 504; p. 750.

Entrance to the Fort, Bermuda, 1929. SHELDON (b/w) 344.

Farm Houses, ca. 1934. ACKLAND (b/w) 31.

From the Lafayette, 1947. BEAR (b/w) front cover; Pl. 37.

Gray Buildings, 1925. PHILLIPS/1 (b/w) Pl. CXXXI; pp. 73, 108.

_____. PHILLIPS/2 (b/w) Pl. 1650.

House on a Hill, 1917. NEWARK (b/w) 148, 379.

In Fairmont, 1951. ILLINOIS/52 (b/w) Pl. 33; pp. 233-234.

_____. MOMA/13 (b/w) 231, 590.

In the Cabin, 1947. CINCINNATI/2 (b/w) 12.

In the Town, 1930. MICHIGAN/2 (b/w) 7, 19.

Near Avenue A, 1933. MOMA/4 (b/w) Pl. 120.

_____. MOMA/13 (b/w) 231, 590.

Near New London, 1940. LANE (c) Pl. 70; p. 171.

Near Washington Square, ca. 1928. DABROWSKI (b/w) 198, 275.

New England Houses, 1924. ALBRIGHT-KNOX/2 (b/w) 568.

The New Ice Plant, 1947. HALPERT (b/w) 31.

_____. MONTCLAIR (b/w) 104-105.

New York Alley, ca. 1922. NEWARK (b/w) 148, 379.

Ordnance Island, Bermuda, 1928. MOMA/2 (b/w) Pl. 99; p. 39.

_____. MOMA/13 (b/w) 231, 590.

Power House, 1936. LANE (c) Pl. 69; p. 171.

Provincetown in Winter, ca. 1936. HIRSCHL/2 (b/w) 78.

Provincetown Landscape, n.d. HIRSCHL/2 (b/w) 74.

The Red Table, 1927. LANE (c) Pl. 68; p. 171.

Sheridan Square, New York, 1922. KENNEDY/1 (c) Pl. 10; [biographical note].

Signal at Highland, ca. 1940. MURDOCK (b/w) 196-197.

Still Life, 1924. GOLDSTONE (b/w) 94.

Studio Table, ca. 1925. HALPERT (b/w) 20.

Study for Buildings, ca. 1926. HIRSCHL/2 (c) 77.

Study for <u>Gray Buildings (Provincetown)</u>, n.d. HIRSCHL/2 (b/w) 76.

Study for <u>The Watch Factory</u>, ca. 1950. NEWARK b/w) 149, 379.

<u>Tables, Chairs, With Sea Beyond</u>, n.d. NEWARK (b/w) 139, 380.

<u>Two Bridges</u>, 1947. MOMA/1 (c) 87, 155.

_____. NEUBERGER (b/w) 427, 432-434.

<u>University Place</u>, n.d. HIRSCHL/2 (c) 79.

<u>Ventilators</u>, 1948. GINGOLD (b/w) 42-43.

<u>Viaduct</u>, 1929. NEWARK (b/w) 149, 379.

<u>Wake of the Hurricane</u>, 1951. WALKER (c) 492-493.

<u>The Watch Factory</u>, 1950. LONG ISLAND (c) 38-39.

<u>White Factory</u>, 1929. MOMA/11 (b/w) Pl. 83; pp. 17-18.

Indexes

Keyword Index to
Source Volumes

ACA ACA Galleries. <u>Social Art in America, 1930-1945</u>. New York: The
 Galleries, 1981.

ACKLAND William Hayes Ackland Memorial Art Center. <u>Catalogue of the
 Collection</u>. Vol. 1, <u>Paintings and Selected
 Sculpture</u>. Chapel Hill, N.C.: The Center, 1971.

ACTON Acton, David. <u>A Spectrum of Innovation: Color in American
 Printmaking, 1890-1960</u>. Worcester, Mass.:
 Worcester Art Museum ; New York: W.W.
 Norton, 1990.

ADLER Weber, Bruce. <u>Drawn from Tradition: American Drawings and
 Watercolors from the Susan and Herbert Adler
 Collection</u>. New York: Hudson Hills Press, in
 association with the Norton Gallery of Art, West
 Palm Beach, Florida, 1989.

ALBRIGHT-KNOX/1 Albright-Knox Art Gallery. <u>Masterworks on Paper from the
 Albright-Knox Art Gallery</u>. New York: Hudson
 Hills Press, in association with the Gallery,
 Buffalo, 1987.

ALBRIGHT-KNOX/2 Albright-Knox Art Gallery. <u>Painting and Sculpture from
 Antiquity to 1972</u>. New York: Rizzoli
 International, 1979.

AMHERST Amherst College. <u>American Drawings and Watercolors from
 Amherst College</u>. San Francisco: Art Museum
 Association of America, 1985.

ANDERSON Anderson, Dennis R. <u>American Flower Painting</u>. New York:
 Watson-Guptill, 1980.

ARCHITECTURE/1 Canadian Centre for Architecture. <u>Photography and
 Architecture, 1839-1939</u>. Montreal, Canada: The
 Centre ; New York: Calloway Editions, 1982.

ARCHITECTURE/2 Robinson, Cervin and Joel Herschman. <u>Architecture
 Transformed: A History of the Photography of
 Buildings from 1839 to the Present</u>. New York:

Architectural League of New York ; Cambridge, Mass.: MIT Press, 1987.

ARENSBERG Philadelphia Museum of Art. The Louise and Walter Arensberg Collection: 20th Century Section. [Philadelphia]: The Museum, 1954.

ARMORY Amherst College. Mead Art Building. The 1913 Armory Show in Retrospect. [Amherst, Mass.]: Amherst College, 1958.

ARTIST & BOOK Museum of Fine Arts, Boston. The Artist & the Book, 1860-1960, in Western Europe and the United States. Boston: The Museum ; Cambridge, Mass.: Harvard College Library, Department of Printing and Graphic Arts, 1961.

BALTIMORE Baltimore Museum of Art. Master Drawings and Watercolors of the Nineteenth and Twentieth Centuries. New York: American Federation of Arts, 1979.

BARKER Barker, Virgil. From Realism to Reality in Recent American Painting. Lincoln: University of Nebraska Press, 1959.

BARO Baro, Gene. 30 Years of American Printmaking, Including the 20th National Print Exhibition. Brooklyn, N.Y.: Brooklyn Museum, 1976.

BEAR Santa Barbara Museum of Art. Donald Bear Memorial Collection. Santa Barbara, Calif.: The Museum, [1964].

BENJAMIN Yale University Art Gallery. The Helen W. and Robert M. Benjamin Collection. [New Haven, Conn.: The Gallery, 1967.]

BOHAN Bohan, Ruth L. "American Drawings and Watercolors, 1900-1945." Bulletin of the Saint Louis Art Museum n.s. 19 (Summer 1989).

BOSTON/1 "Centennial Acquisitions: Art Treasures for Tomorrow." Bulletin of the Museum of Fine Arts, Boston 68, nos. 351/352 (1970).

BOSTON/2 Museum of Fine Arts, Boston. <u>Masterpiece Paintings from the Museum of Fine Arts, Boston</u>. Boston: The Museum ; New York: H.N. Abrams, 1986.

BOSTON/3 Museum of Fine Arts, Boston. <u>Masterpieces from the Boston Museum</u>. [Boston]: The Museum, 1981.

BOSTON/4 Boston University. Art Gallery. <u>Social Concern and Urban Realism: American Painting of the 1930s</u>. Boston: The Gallery, 1983.

BOSWELL Boswell, Peyton. <u>Modern American Painting</u>. New York: Dodd, Mead, 1948.

BRADLEY Milwaukee Art Center. <u>The Collection of Mrs. Harry Lynde Bradley</u>. Milwaukee, Wis.: The Center, 1968.

BRANDEIS Brandeis University. Poses Institute of Fine Arts. <u>American Art Since 1950</u>. [Waltham, Mass.: S.n., 1962.]

BROOKLYN/1 Brooklyn Museum. <u>American Watercolors, Pastels, Collages: A Complete Illustrated Checklist of Works in the Museum's Collection</u>. New York: The Museum, 1984.

BROOKLYN/2 Brooklyn Museum. <u>Masterpieces of American Painting from the Brooklyn Museum</u>. Brooklyn, N.Y.: The Museum, 1976.

CANADAY Canaday, John. <u>Metropolitan Seminars in Art</u>. Portfolio 11, <u>The Artist as a Social Critic</u>. New York: Metropolitan Museum of Art, 1959.

CARNEGIE Carnegie Institute. Museum of Art. <u>American Drawings and Watercolors in the Museum of Art, Carnegie Institute</u>. Pittsburgh: The Museum ; Distributed by the University of Pittsburgh Press, 1985.

CARTER/1 Amon Carter Museum of Western Art. <u>American Paintings: Selections from the Amon Carter Museum</u>. Birmingham, Ala.: Oxmoor House, 1986.

CARTER/2 Amon Carter Museum of Western Art. Masterworks of American Photography: The Amon Carter Museum Collection. Birmingham, Ala.: Oxmoor House, 1982.

CATHCART Cathcart, Linda L. American Still Life, 1945-1983. Houston, Tex.: Contemporary Arts Museum; New York: Harper & Row, 1983.

CHICAGO Art Institute of Chicago. Master Paintings in the Art Institute of Chicago. [Chicago]: The Institute, 1988.

CINCINNATI/1 Cincinnati Art Museum. Cincinnati Art Museum Handbook. Cincinnati, Ohio: The Museum, 1975.

CINCINNATI/2 "Paintings of the Later Nineteenth and Earlier Twentieth Centuries." The Cincinnati Art Museum Bulletin 8 (October 1968).

CITYSCAPE Cityscape 1910-39: Urban Themes in American, German, and British Art. London, England: Arts Council of Great Britain, [1977].

CLEVELAND Cleveland Museum of Art. Handbook. Cleveland, Ohio: The Museum, 1966.

COLUMBUS Columbus Museum of Art. The American Collections: Columbus Museum of Art. Columbus, Ohio: The Museum, in association with H.N. Abrams, New York, 1988.

COMMERCE Modern American Painting from the Commerce Trust Company Collection. [Lawrence, Kan.: s.n., 1966.]

CORCORAN/1 Corcoran Gallery of Art. American Masters: Works on Paper from the Corcoran Gallery of Art. Washington, D.C.: Smithsonian Institution Traveling Exhibition Service : The Gallery, 1986.

CORCORAN/2 Corcoran Gallery of Art. Of Time and Place: American Figurative Art from the Corcoran Gallery. Washington, D.C.: Smithsonian Traveling Exhibition Service: The Gallery, 1981.

CORCORAN/3 Philips, Dorothy W. A Catalog of the Collection of American
 Paintings in the Corcoran Gallery of Art. Vol. 2,
 Painters Born From 1850 to 1910. Washington,
 D.C.: Corcoran Gallery of Art, 1973.

CORPORATE Art, Inc., American Paintings from Corporate Collections.
 Montgomery, Ala.: Montgomery Museum of
 Fine Arts, in association with Brandywine Press,
 1979.

CRANBROOK The Cranbrook Collections. New York: Sotheby, Park-Bernet,
 1972.

CUMMINGS Cummings, Paul. American Drawings: The 20th Century. New
 York: Viking, 1976.

CURRIER Currier Gallery of Art. The Currier Gallery of Art: Handbook of
 the Collection. Manchester, N.H. : The Gallery,
 1979.

CZESTOCHOWSKI Czestochowski, Joseph S. The American Landscape
 Tradition: A Study and Gallery of Paintings.
 New York: E.P. Dutton, 1982.

DABROWSKI Dabrowski, Magdelena. Contrasts of Form: Geometric Abstract
 Art, 1910-1980. New York: Museum of Modern
 Art, 1985.

DALLAS/1 Fort Worth Art Center. Dallas Collects. Fort Worth, Tex.: The Center
 ; Dallas, Tex.: Museum for Contemporary Arts,
 [1959].

DALLAS/2 Nash, Stephen A. Dallas Collects American Paintings: Colonial
 to Early Modern. Dallas, Tex.: Dallas Museum
 of Fine Arts, 1982.

DETROIT/1 Detroit Insitute of Arts. The Detroit Institute of Arts Illustrated
 Handbook. Detroit: Published for the Institute
 by Wayne State University Press, 1971.

DETROIT/2 Detroit Institute of Arts. 100 Masterworks from the Detroit Institute
 of Arts. New York: Hudson Hills Press, in
 association with the Founders Society, Detroit
 Institute of Arts, 1985.

DREIER Yale University. Art Gallery. <u>The Societe Anonyme and the Dreier Bequest at Yale University: A Catalogue Raisonne</u>. New Haven, Conn.: Published for the Gallery by Yale University Press, 1984.

EASTMAN/1 George Eastman House. <u>Photography in the Twentieth Century</u>. New York: Horizon Press, in collaboration with the George Eastman House, Rochester, N.Y., 1967.

EASTMAN/2 International Museum of Photography at George Eastman House. <u>Masterpieces of Photography: From the George Eastman House Collections</u>. New York: Abbeville, 1985.

EBSWORTH Buckley, Charles E. <u>The Ebsworth Collection: American Modernism, 1911-1947</u>. [St. Louis, Mo.]: Saint Louis Art Museum, 1987.

ELIOT Eliot, Alexander. <u>Three Hundred Years of American Painting</u>. New York: Time, Inc., 1957.

FLAG Allentown Art Museum. <u>The American Flag in the Art of Our Country</u>. Allentown, Pa.: The Museum, 1976.

FLINT Flint Institute of Arts. <u>The First Flint Invitational—An Exhibition of Contemporary Painting and Sculpture</u>. Flint, Mich.: The Institute, [1966].

FORD Hambourg, Maria Morris. "Photography Between the Wars: Selections from the Ford Motor Company Collection." <u>The Metropolitan Museum of Art Bulletin</u> 45 (Spring 1988).

FOREIGN Milwaukee Art Center. <u>From Foreign Shores: Three Centuries of Art by Foreign Born American Masters</u>. Milwaukee, Wis.: The Center, 1976.

FORT WORTH Fort Worth Art Association. <u>Selections from Fort Worth Collections</u>. Fort Worth, Tex.: The Association, 1963.

FRAAD Ayers, Linda and Jane Myers. <u>American Paintings, Watercolors, and Drawings from the Collection of Rita and Daniel</u>

Fraad. Fort Worth, Tex.: Amon Carter Museum, 1985.

GEORGIA/1 Georgia Museum of Art. A University Collects: Georgia Museum of Art, The University of Georgia. [Athens, Ga.]: The Museum, 1969.

GEORGIA/2 Morrin, Peter and Eric Zafran. Drawings from Georgia Collections: 19th and 20th Centuries. Atlanta, Ga.: High Museum of Art, 1981.

GERDTS Gerdts, William H. Art Across America: Two Centuries of Regional Painting. Volume 1, New England, New York, Mid-Atlantic. New York: Abbeville, 1990.

GINGOLD Gingold, Diane J. American Art, 1934-1950: Selections from the Whitney Museum of American Art. Montgomery, Ala.: Montgomery Museum of Fine Arts, 1978.

GOLDSTONE Goldstone, Herbert A. The Herbert A. Goldstone Collection of American Art. Brooklyn, N.Y.: Brooklyn Museum, 1965.

GRUBER Gruber, Renate and L. Fritz Gruber. The Imaginary Photo Museum: With 457 Photographs from 1836 to the Present. New York: Harmony Books, [1982], c1981.

GUSSOW Gussow, Alan. A Sense of Place: The Artist and the American Land. San Francisco: Friends of the Earth, [1972].

HALPERT Highly Important 19th and 20th Century American Paintings, Drawings, Watercolors and Sculpture from the Estate of the Late Edith Gregor Halpert (The Downtown Gallery). New York: Sotheby Parke Bernet, 1973.

HARVARD/1 Harvard University. Fogg Art Museum. American Art at Harvard. Cambridge, Mass.: The Museum, 1972.

HARVARD/2 Harvard University Art Museums. Harvard University Art Museums. A Guide to the Collections. Cambridge, Mass.: The Museums ; New York: Abbeville, 1986.

HAYES Hayes, Bartlett H. American Drawings. Boston: Little, Brown, 1965.

HERITAGE Heritage and Horizon: American Painting 1776-1976. [Toledo, Ohio]: Toledo Museum of Art, 1976.

HIGH High Museum of Art. The Advent of Modernism: Post-Impressionism and North American Art, 1900-1918. Atlanta, Ga.: The Museum, 1986.

HIRSCHL/1 Hirschl & Adler Galleries. American Art from the Gallery's Collection. New York: The Galleries, 1980.

HIRSCHL/2 Hirschl & Adler Galleries. Buildings: Architecture in American Modernism. New York: The Galleries, 1980.

HIRSCHL/3 Hirschl & Adler Galleries. A Gallery Collects. New York: The Galleries, 1977.

HIRSCHL/4 Hirschl & Adler Galleries. Realism and Abstraction: Counterpoints in American Drawing, 1900-1940. New York: The Galleries, 1983.

HIRSCHL/5 Hirschl & Adler Galleries. Selections from the Collection of Hirschl & Adler Galleries: American Paintings, 1876-1963. New York: The Galleries, [n.d.].

HIRSHHORN The Hirshhorn Museum & Sculpture Garden, Smithsonian Institution. New York: H.N. Abrams, [1974].

HOOD Hood Museum of Art. Treasures of the Hood Museum of Art, Dartmouth College. New York: Hudson Hills Press, in association with the Hood Museum of Art, Dartmouth College, 1985.

HOOPES Hoopes, Donelson F. American Watercolor Painting. New York: Watson-Guptill, 1977.

HOUSTON/1 Museum of Fine Arts, Houston. The Museum of Fine Arts, Houston: A Guide to the Collection. Houston, Tex.: The Museum, 1981.

HOUSTON/2 "The Private Eye: Selected Works from the Collections of Friends of the Museum of Fine Arts, Houston." Bulletin. Museum of Fine Arts, Houston 13 (Fall 1989).

HOWLAND Columbus Gallery of Fine Arts. <u>American Paintings in the Ferdinand Howland Collection</u>. [Columbus, Ohio]: The Gallery, 1969.

HULTEN Hulten, Karl Gunnar Pontus. <u>The Machine, as Seen at the End of the Mechanical Age</u>. New York: Museum of Modern Art ; Greenwich, Conn.: Distributed by New York Graphic Society, [1968].

ILLINOIS/49 University of Illinois—Urbana. College of Fine and Applied Arts. <u>University of Illinois Exhibition of Contemporary American Painting</u>. Urbana: University of Illinois, College of Fine and Applied Arts, 1949.

ILLINOIS/50 University of Illinois—Urbana. College of Fine and Applied Arts. <u>University of Illinois Exhibition of Contemporary American Painting</u>. Urbana: University of Illinois, College of Fine and Applied Arts, 1950.

ILLINOIS/51 University of Illinois—Urbana. College of Fine and Applied Arts. <u>University of Illinois Exhibition of Contemporary American Painting</u>. Urbana: University of Illinois Press, 1951.

ILLINOIS/52 University of Illinois—Urbana. College of Fine and Applied Arts. <u>University of Illinois Exhibition of Contemporary American Painting</u>. Urbana: University of Illinois, College of Fine and Appleid Arts, 1952.

ILLINOIS/53 University of Illinois—Urbana. College of Fine and Applied Arts. <u>Contemporary American Painting and Sculpture</u>. Urbana: University of Illinois, College of Fine and Applied Arts, 1953.

ILLINOIS/55 University of Illinois—Urbana. College of Fine and Applied Arts. <u>Contemporary American Painting and Sculpture</u>. Urbana: University of Illinois, College of Fine and Applied Arts, 1955.

ILLINOIS/57 University of Illinois—Urbana. College of Fine and Applied Arts. <u>Contemporary American Painting and Sculpture</u>. Urbana: University of Illinois Press, 1957.

ILLINOIS/59 University of Illinois—Urbana. College of Fine and Applied Arts. Contemporary American Painting and Sculpture. Urbana: University of Illinois Press, 1959.

INDUSTRY Industry and the Photographic Image: 153 Great Prints from 1850 to the Present. Rochester, N.Y.: George Eastman House ; New York: Dover, 1980.

JANIS Janis, Sidney. Abstract and Surrealist Art in America. New York: Reynal & Hitchcock, 1944.

JANSS Martin, Alvin. American Realism: Twentieth-Century Drawings and Watercolors from the Glenn C. Janss Collection. San Francisco: San Francisco Museum of Modern Art, in association with H.N. Abrams, New York, 1986.

KENNEDY/1 Kennedy Galleries. The American Tradition of Realism. Part II, Painting and Sculpture of the 20th Century. New York: The Galleries, 1983.

KENNEDY/2 Kennedy Galleries. The City as a Source. New York: The Galleries, 1977.

KENNEDY/3 Kennedy Galleries. Important American Art, 1903-1972. New York: The Galleries, 1972.

KENNEDY/4 Kennedy Galleries. Insights and Outlooks: American 20th Century Watercolors and Drawings. New York: The Galleries, 1986.

KENNEDY/5 Kennedy Galleries. Recently Acquired American Masterpieces of the 19th and 20th Centuries. New York: The Galleries, 1974.

KENNEDY/6 Kennedy Galleries. A Selection of 20th Century American Masterpieces. New York: The Galleries, 1973.

KENNEDY/7 Kennedy Galleries. Sixty American Paintings, 1840-1980. New York: The Galleries, 1980.

KENNEDY/8 Kennedy Galleries. The Spontaneous Eye: American Drawings of the Twentieth Century. New York: The Galleries, 1985.

KUSHNER

Kushner, Marilyn. <u>The Modernist Tradition in American Watercolors, 1911-1939</u>. Evanston, Ill.: Mary and Leigh Block Gallery, Northwestern University, 1991.

LANE

Stebbins, Theodore E. and Carol Troyen. <u>The Lane Collection: 20th-Century Paintings in the American Tradition</u>. Boston: Museum of Fine Arts, Boston, 1983.

LEAGUE/1

Art Students League of New York. <u>The Kennedy Galleries are Host to the Hundredth Anniversary Exhibition of Paintings and Sculptures by 100 Artists Associated with the Art Students League of New York</u>. New York: The League, 1975.

LEAGUE/2

Metropolitan Museum of Art (New York, N.Y.) <u>The 75th Anniversary Exhibition of Painting and Sculpture by 75 Artists Associated with the Art Students League of New York</u>. New York: The Museum, 1951.

LEVY

Travis, David. <u>Photographs from the Julien Levy Collection Starting with Atget</u>. Chicago: Art Institute of Chicago, 1976.

LEWISOHN/1

Lewisohn, Sam A. <u>Painters and Personality: A Collector's View of Modern Art</u>. Rev. ed. New York: Harper & Brothers, 1948.

LEWISOHN/2

Metropolitan Museum of Art (New York, N.Y.) <u>The Lewisohn Collection</u>. New York: The Museum, 1951.

LINDEMANN

Lindemann, Gottfried. <u>Prints & Drawings: A Pictorial History</u>. New York: Praeger, 1970.

LITTLETON

Littleton, Taylor D. and Maltby Sykes. <u>Advancing American Art: Painting, Politics, and Cultural Confrontation at Mid-Century</u>. Tuscaloosa: University of Alabama Press, 1989.

LONG ISLAND

Pisano, Ronald. <u>Long Island Landscape Painting</u>. Volume II, <u>The Twentieth Century</u>. Boston: Little, Brown, 1990.

LOS ANGELES Los Angeles County Museum of Art. <u>American Art: A Catalogue of the Los Angeles County Museum of Art Collection</u>. Los Angeles, Calif.: The Museum, 1991.

MCDONOUGH Bullard, Edgar John. <u>A Panorama of American Painting: The John J. McDonough Collection</u>. [New Orleans]: New Orleans Museum of Art, 1975.

MCNAY Marion Kooger McNay Art Institute. <u>The Marion Kooger McNay Art Institute Selective Catalogue</u>. San Antonio,

Tex.: Published for the Institute by Trinity University Press, 1980.

MADDOX Maddox, Jerald C. <u>The Pioneering Image: Celebrating 150 Years of American Photography</u>. New York: Universe, 1989.

MAINE Skolnick, Arnold, ed. <u>Paintings of Maine</u>. New York: Clarkson Potter, 1991.

MARONEY/1 James Maroney, Inc. <u>The Elite and Popular Appeal of the Art of Charles Sheeler.... Also a Selection of Other Fine 19th and 20th Century Paintings of Particular Note</u>. New York: James Maroney, Inc., 1986.

MARONEY/2 James Maroney, Inc. <u>The Odd Picture: Distinctive and Yet Not Necessarily Predictable Efforts by Recognized Masters, All Modern in Their Several Ways</u>. New York: James Maroney, Inc., 1984.

MARONEY/3 James Maroney, Inc. <u>A Small Group of Especially Fine American Works on Paper</u>. New York: James Maroney, Inc., 1984.

MEAD Amherst College. Mead Art Building. <u>A Summary Catalog of the Collection at Mead Art Gallery</u>. [Cover title: <u>American Art at Amherst.</u>] Middletown, Conn.: Distributed by Wesleyan University Press, 1978.

MET/1 Metropolitan Museum of Art (New York, N.Y.) <u>American Pastels in the Metropolitan Museum of Art</u>. New York: The Museum, in association with H.N. Abrams, 1989.

MET/2 American Watercolors from the Metropolitan Museum of Art. New
 York: American Federation of Arts, in association
 with H.N. Abrams, 1991.

MET/3 Sims, Lowery Stokes. The Figure in 20th Century American Art:
 Selections from the Metropolitan Museum of
 Art. New York: Metropolitan Museum of Art ;
 American Federation of Arts, 1984.

MET/4 Metropolitan Museum of Art. Recent Acquisitions, 1985-1986. New
 York: The Museum, 1986.

METROPOLIS Montreal Museum of Fine Arts. The 1920s: Age of the Metropolis.
 Montreal, Canada: The Museum, 1991.

MICHENER University of Texas at Austin. University Art Museum. The James
 A. Michener Collection: Twentieth-Century
 American Painting. Austin, Tex.: The Museum,
 1977.

MICHIGAN/1 University of Michigan. Museum of Art. The Federal Art Project:
 American Prints from the 1930s in the Collection
 of the University of Michigan Museum of Art.
 Ann Arbor, Mich.: The Museum, 1985.

MICHIGAN/2 University of Michigan. Museum of Art. Modern Master
 Drawings: Forty Years of Collecting at the
 University of Michigan Museum of Art. Ann
 Arbor: The Museum, 1986.

MINNESOTA Minnesota Museum of Art. American Style: Early Modernist
 Works in Minnesota Collections. [St. Paul,
 Minn.]: The Museum, 1981.

MISSOURI University of Missouri—Columbia. Museum of Art and
 Archaeology. Illustrated Museum Handbook.
 Columbia: University of Missouri Press, 1982.

MOMA/1 Museum of Modern Art (New York, N.Y.) Abstract Painting and
 Sculpture in America. New York: The Museum,
 1951.

MOMA/2 Museum of Modern Art (New York, N.Y.) American Painting and
 Sculpture, 1862-1932. New York: The Museum,
 1932.

MOMA/3 Museum of Modern Art (New York, N.Y.) <u>American Realists and Magic Realists</u>. New York: The Museum, 1943.

MOMA/4 Museum of Modern Art (New York, N.Y.) <u>Art in Our Time: An Exhibition to Celebrate the Tenth Anniversary of the Museum of Modern Art and the Opening of Its New Building Held at the Time of the New York World's Fair</u>. New York: The Museum, 1939.

MOMA/5 Museum of Modern Art (New York, N.Y.) <u>Fantastic Art, Dada, Surrealism</u>. 3d ed. New York: The Museum ; Distributed by Simon & Schuster, 1947.

MOMA/6 Museum of Art (New York, N.Y.) <u>An Invitation to See: 125 Paintings from The Museum of Modern Art</u>. New York: The Museum ; Greenwich, Conn.: Distributed by New York Graphic Society, 1973.

MOMA/7 Museum of Modern Art (New York, N.Y.) <u>Looking at Photographs: 100 Pictures from the Collection of The Museum of Modern Art</u>. New York: The Museum ; Greenwich, Conn.: Distributed by New York Graphic Society, 1973.

MOMA/8 Elderfield, John. <u>The Modern Drawing: 100 Works on Paper from the Museum of Modern Art</u>. Boston: Distributed by New York Graphic Society Books, Little, Brown, 1983.

MOMA/9 Museum of Modern Art (New York, N.Y.) <u>Murals by American Painters and Photographers</u>. New York: The Museum, 1932.

MOMA/10 Museum of Modern Art (New York, N.Y.) <u>New Horizons in American Art</u>. New York: The Museum, 1936.

MOMA/11 Museum of Modern Art (New York, N.Y.) <u>Painting and Sculpture by Living Americans: Ninth Loan Exhibition</u>. New York: The Museum, [1930].

MOMA/12 Museum of Modern Art (New York, N.Y.) <u>Paintings by Nineteen Living Americans</u>. New York: The Museum, 1930.

NEW YORK/1 ACA Galleries. <u>19th and 20th Century Masterpieces in New York Private Collections</u>. New York: The Galleries, 1978.

NEW YORK/2 New York University. Art Collection. <u>The New York Painter: A Century of Teaching: Morse to Hoffman</u>. New York: Distributed by New York University Press, 1967.

NEWARK Newark Museum. <u>American Art in the Newark Museum: Paintings, Drawings, and Sculpture</u>. Newark, N.J.: The Museum, 1981.

PARIS-NEW YORK Musee National d'art Moderne (France). <u>Paris-New York</u>. [Paris]: Centre Georges Pompidou Musee National d'art Moderne, [1977].

PENNSYLVANIA/1 Fressela-Lee, Nancy. <u>The American Paintings in the Pennsylvania Academy of the Fine Arts: An Illustrated Checklist</u>. Philadelphia: Pennsylvania Academy of the Fine Arts; Seattle: In association with the University of Washington Press, 1989.

PENNSYLVANIA/2 Westmoreland Museum of Art. <u>Penn's Promise: Still Life Painting in Pennsylvania, 1795-1930</u>. Greensburg, Pa.: The Museum, 1988.

PHILADELPHIA/1 Philadelphia Museum of Art. <u>Philadelphia, Three Centuries of American Art</u>. Philadelphia: The Museum, 1976.

PHILADELPHIA/2 Philadelphia Museum of Art. <u>Treasures of the Philadelphia Museum of Art and the John G. Johnson Collection</u>. Philadelphia: The Museum, 1973.

PHILLIPS/1 Phillips, Duncan. <u>A Collection in the Making: A Survey of the Problems Involved in Collecting Pictures Together With Brief Estimates of the Painters in the Phillips Memorial Gallery</u>. New York: E. Weyhe ; Washington, D.C.: Phillips Memorial Gallery, 1926.

PHILLIPS/2 Phillips Collection. <u>The Phillips Collection: A Summary Catalogue</u>. Washington, D.C.: The Collection, 1985.

and Prints. 2d ed. Charlottesville: University
Press of Virginia, 1977.

RHODE ISLAND/1 Rhode Island School of Design, Museum of Art. A Handbook
of the Museum of Art, Rhode Island School of
Design. Providence, R.I.: The School, 1985.

RHODE ISLAND/2 "Selection I: American Watercolors and Drawings from the
Museum's Collection." Bulletin of Rhode Island
School of Design. Museum Notes 58 (January
1972).

RHODE ISLAND/3 "Selection VII: American Paintings from the Museum's
Collection, c. 1800-1930." Bulletin of Rhode
Island School of Design. Museum Notes 63
(April 1977).

RHODE ISLAND/4 Urbanelli, Lora S. "Department of Prints, Drawings, and
Photographs." Bulletin of Rhode Island School
of Design. Museum Notes 73 (October 1986).

RINEHART Fels, Thomas Weston. O Say Can You See: American Photographs,
1839-1939: One Hundred Years of American
Photographs from the George R. Rinehart
Collection. Pittsfield, Mass.: Berkshire Museum;
Cambridge, Mass.: MIT Press, 1989.

ROBY Mecklenburg, Virginia M. Modern American Realism: The Sara Roby
Foundation Collection. Washington, D.C.:
Published for the National Museum of American
Art by the Smithsonian Institution Press, 1987.

ROCHESTER University of Rochester. Memorial Art Gallery. Memorial Art
Gallery: An Introduction to the Collection.
Rochester, N.Y.: The Gallery, in association
with Hudson Hills Press, New York, 1988.

ROCKEFELLER/1 Boltin, Lee. The Nelson A. Rockefeller Collection:
Masterpieces of Modern Art. New York: Hudson
Hills Press, 1981.

ROCKEFELLER/2 Richardson, Edgar Preston. American Art: A Narrative and
Critical Catalogue. [Cover title: An Exhibition
from the Collection of Mr. & Mrs. John D.

Rockefeller, 3rd.] [San Francisco]: The Fine
Arts Museums of San Francisco, 1976.

SACHS/1 Harvard University. Fogg Art Museum. Memorial Exhibition: Works
 of Art from the Collection of Paul J. Sachs (1878-
 1965): Given and Bequeathed to the Fogg Art
 Museum, Harvard University, Cambridge,
 Massachusetts. New York: Garland, 1965.

SACHS/2 Sachs, Paul. Modern Prints and Drawings. New York: Alfred A.
 Knopf, 1954.

SAN DIEGO Fine Arts Gallery of San Diego. Color & Form, 1909-1914: The
 Origin and Evolution of Abstract Painting in
 Futurism, Orphism, Rayonnism, Synchromism,
 and the Blue Rider. [San Diego, Calif.]: The
 Gallery, 1971.

SAN FRANCISCO/1 Fine Arts Museums of San Francisco. The American Canvas:
 Paintings from the Fine Arts Museums of San
 Francisco. New York: Hudson Hills Press, in
 association with The Fine Arts Museums of San
 Francisco, 1989.

SAN FRANCISCO/2 San Francisco Museum of Modern Art. San Francisco
 Museum of Modern Art: The Painting and
 Sculpture Collection. New York: Hudson Hills
 Press, in association with the Museum, 1985.

SANTA BARBARA Santa Barbara Museum of Art. Two Hundred Years of
 American Painting: A Handbook Listing the
 Museum's Holdings, Including the Newly
 Acquired Preston Morton Collection. [Santa
 Barbara, Calif.]: s.n., 1961.

SELF-PORTRAITS Van Devanter, Ann C. and Alfred V. Frankenstein. American
 Self-Portraits, 1670-1973. Washington, D.C.:
 International Exhibitions Foundation, 1974.

SHELDON Sheldon Memorial Art Gallery. The American Painting Collection
 of the Sheldon Memorial Art Gallery. Lincoln:
 University of Nebraska Press, 1988.

SPENCER Helen Foresman Spencer Museum of Art. Handbook of the Collection.
 Lawrence: University of Kansas Press, 1978.

SPRINGFIELD Museum of Fine Arts (Springfield, Mass.) The American and European Collections. Springfield, Mass.: Published for the Museum by the Springfield Library and Museums Association, 1979.

STIEGLITZ/1 "The Art of Seeing: Photographs from the Alfred Stieglitz Collection." The Metropolitan Museum of Art Bulletin 35 (Spring 1978).

STIEGLITZ/2 Young, Mahroni Sharp. Early American Moderns: Painters of the Stieglitz Group. New York: Watson-Guptill, 1974.

SYNCHROMISM Synchromism and Color Principles in American Painting, 1910-1930. New York: M. Knoedler & Co., 1965.

TANNAHILL Detroit Institute of Arts. The Robert Hudson Tannahill Bequest to the Detroit Institute of Arts. Detroit: The Institute, 1970.

THYSSEN Levin, Gail. Twentieth-Century American Painting: The Thyssen-Bornemisza Collection. London, England: Sotheby's Publications, 1987.

TIME-LIFE Modern American Painting. Alexandria, Va.: Time-Life Books, 1970.

TOLEDO Toledo Museum of Art. American Paintings, the Toledo Museum of Art. Toledo, Ohio: The Museum ; University Park: Distributed by the Pennsylvania State University Press, 1979.

TRAVIS Travis, David. Photography Rediscovered: American Photographs, 1900-1930. New York: Whitney Museum of American Art, 1979.

TWEED Tweed Museum of Art. American Painting at the Tweed Museum of Art and Glensheen, the University of Minnesota, Duluth. [Duluth, Minn.]: The Museum, 1982.

VINSON Vinson, James, ed. International Dictionary of Art and Artists. Volume 2, Art. Chicago: St. James Press, 1990.

WADSWORTH Wadsworth Atheneum. American Drawings and Watercolors from the Wadsworth Atheneum. New York:

Hudson Hills Press, in association with American Federation of Arts, 1987.

WALKER Walker Art Center. <u>Walker Art Center: Paintings and Sculpture from the Permanent Collection</u>. Minneapolis, Minn.: The Center ; New York: Rizzoli International, 1990.

WASHINGTON Brown, Milton. <u>One Hundred Masterpieces of American Painting from Public Collections in Washington, D.C.</u> Washington, D.C.: Smithsonian Institution Press, 1983.

WERTHAM Harvard University. Busch-Reisinger Museum. <u>The Fredric Wertham Collection: Gift of his Wife Hesketh</u>. Cambridge, Mass.: The Museum, 1990.

WHITNEY/1 Cummings, Paul. <u>Drawing Acquisitions, 1981-1985</u>. New York: Whitney Museum of American Art, 1985.

WHITNEY/2 Whitney Museum of American Art. <u>Geometric Abstraction in America</u>. New York: The Museum, 1962.

WHITNEY/3 Goldman, Judith. <u>Print Acquisitions, 1974-1984</u>. New York: Whitney Museum of American Art, 1984.

WHITNEY/4 Whitney Museum of American Art. <u>Painting & Sculpture Acquisitions, 1973-1986</u>. New York: The Museum, 1986.

WHITNEY/5 <u>Twentieth-Century Drawings: Selections from the Whitney Museum of American Art</u>. New York: Dover, 1981.

WICHITA/1 <u>Edwin A. Ulrich Museum of Art, Wichita State University</u>. Wichita, Kan.: Wichita State University, 1980.

WICHITA/2 Wichita Art Museum. <u>The Neglected Generation of American Realist Painters, 1930-1948</u>. Wichita, Kan.: The Museum, 1981.

WIGHT Wight, Frederick S. <u>Milestones of American Painting in Our Century</u>. Boston: Institute of Contemporary Art ; New York: Chanticleer Press, 1949.

YORK/1 Richard York Gallery. <u>An American Gallery</u>, Vol. V. New York:
 The Gallery, 1989.

YORK/2 Richard York Gallery. <u>An American Gallery</u>, Vol. VI. New York:
 The Gallery, 1990.

Author Index

-C-

Cahill, Holger, 056, 1200
Cahill, Homer, 071
Calas, Nicholas, 745
Campbell, Lawrence, 306, 418, 427, 737, 740, 744, 746, 747, 896, 898, 961, 1123, 1223
Carnegie Institute. Museum of Art, 016
Castango, John, 138
Cedar Rapids Art Center, 997
Celender, Donald Dennis, 149
Champa, Kermit, 513
Chanin, A. L., 1120
Channin, Richard, 425
Chevlowe, Susan, 040
Cincinnati Art Museum, 349, 665
Cincinnati Modern Art Society, 017, 350
Clark, Mary Helen, 150
Clark-Langager, Sarah A., 018
Cloudman, Ruth, 655
Coates, Robert M., 122, 212, 283, 286, 287, 291, 294, 299, 302, 305, 402, 407, 593, 732, 738, 741, 1106, 1122, 1124, 1211, 1214, 1220
Coe Kerr Gallery, 219
Cohen, George Michael, 1039
Cohen, Ronny, 964
Cohrs, Timothy, 1140
Coke, Van Deren, 061, 952, 999
Cole, Sylvan, 842, 843, 882
Comstock, Helen, 680, 1209
Conrad, Peter, 748
Conway, Robert P., 844
Cooke, Susan, 369
Cooper, Helen A., 514
Cooper, Immanuel, 480
Corcoran Gallery of Art, 019
Cortissoz, Royal, 572
Costello, Bonnie, 135
Cowdrey, Bartlett, 1070, 1188
Cowley, Malcolm, 239, 252
Cowley, Robert, 253
Cox, Richard William, 151
Craven, George M., 1040
Craven, Thomas, 515, 667, 677, 1041
Crawford, Ralston, 338-346, 351, 373, 719
Creighton University. Fine Arts Gallery, 352

-H-

-X-

-Y-

-Z-

Short-Title Index to Exhibition Catalogues

-G-

Gallery of Living Art, 055
George Ault (Whitney Museum), 160
George Ault: Memorial Exhibition, 161
George Ault: Nocturnes, 165
George Ault: Watercolors of the 1920s, 170
George Ault: Works on Paper with Related Paintings, 162
George Ault 1891-1948, 168
George Ault (1891-1948): Paintings & Works on Paper, 163
George C. Ault: Drawings, 169
George C. Ault: Exhibition of Water Colors and Drawings, 158
George C. Ault: Recent Work, 159
The Golden Door, 853
Graphics '73, 366
The Great King, 1011
Guglielmi: Exhibition of New Paintings, 711
Guglielmi: Exhibition of Paintings 1931 to 1954, 712

-H-

The Highway, 076
A History of American Watercolor Painting, 507
Homage to Charles Demuth, 494

-I-

Images of America, 072

-J-

-K-

-L-

The Lane Collection, 067
Lines of Power, 038
Lithographs by Louis Lozowick (Hirschl & Adler Galleries), 850
Lithographs by Louis Lozowick (Weyhe Gallery), 868
Lithographs of Louis Lozowick, 849
The Long Island Landscape, 057
Louis Lozowick: American Precisionist Retrospective, 852
Louis Lozowick: Drawings and Lithographs, 865
Louis Lozowick: Graphic Retrospective, 856
Louis Lozowick: Lithographs (Richard York Gallery), 861

-P-

Painter as Photographer, 995
Painters of the Humble Truth, 033
Painting a Place in America, 040
Paintings and Lithographs by Louis Lozowick, 870
Paintings by Charles Demuth, 478
Paintings by Louis Guglielmi, 714
Paintings by Morton L. Schamberg, 944
Paintings by Preston Dickinson, 656
Paintings, Drawings, and Lithographs by Louis Lozowick, 869
Paris and the American Avant Garde, 023
Paul Magriel Collection, 240
Pennsylvania Academy Moderns, 053
Pennsylvania Modern, 484
Peter Blume (Durlacher Brothers), 224-228
Peter Blume (Kennedy Galleries), 230
Peter Blume: "From the Metamorphoses," 238
Peter Blume: "Recollection of the Flood," 221
Peter Blume: Retrospective Exhibition, 232
Peter Blume: Selected Paintings, Drawings and Sculpture Since 1964, 234
Peter Blume: The Italian Drawings, 217
Peter Blume in Retrospect, 220
Photography: Bonge, Dwight, Guglielmi, Siskind, White, 719
The Photography of Ralston Crawford, 365
Photography's Response to Constructivism, 061
Pioneers of American Abstraction, 007
Preston Dickinson, 660
Preston Dickinson 1889-1930 (Sheldon Memorial Art Gallery), 655
Preston Dickinson (1889-1930) (Zabriskie Gallery), 663
The Precisionist Painters, 035
Precisionist Perspectives, 084
The Precisionist View in American Art, 077
The Prints of Louis Lozowick (Associated American Artists), 843, 844
The Prints of Louis Lozowick (National Museum of American Art), 866
The Prints of Ralston Crawford (Heckscher Museum), 357
The Prints of Ralston Crawford (Hirschl & Adler Galleries), 359
Provincetown Painters, 029

-Q-

The Quest of Charles Sheeler, 1024

-V-

-W-

-X-

-Y-

-Z-

Subject Index

-D-

-E-

-J-

James, Henry, 543, 555, 560, 639
James Yu Gallery, 720
Jewish-American artists, 040, 314, 329, 775, 777, 832, 833, 851, 853, 858, 860,
 875, 876, 883, 913, 920, 921, 927
Jewish Art Center, 040
John Reed Club, 820, 881, 929
Johns, Jasper, 529
Josephson, Matthew, 1047

-K-

Kaiser, George, 785

-L-

Lachaise, Gaston, 1003
Lacombe, George, 1060
Landscape painting, 010
Lane Collection, 067, 134, 1008, 1017
Leger, Fernand, 517, 780, 796
Levi, Julien, 231, 454-455
Lissitsky, Eliezer, 783, 802, 808
Lithography, 001, 006, 059, 084, 128, 141, 148
Locher, Robert Evans, 525, 540, 643, 648-649
Lockwood Memorial Library. State University of New York at Buffalo, 650
Loeb, Harold A., 934
Long Island (N.Y.) in art, 057
Loony (film), 889
Lozowick, Louis, 001, 005, 006, 013, 018, 026, 031, 035, 038, 040, 052, 057, 059,
 065, 072, 077, 084, 085, 087, 090, 091 093, 094, 100, 106-108, 110, 116,
 122-126, 128-133, 138, 141-142a, 147-149, 151, 152, 335, 761-936
 Machine Ornaments, 085, 094, 110, 847, 853, 875, 880, 890, 891, 929,
 930-932
 on Russian art, 763, 771, 774, 778, 783, 802, 804, 808, 813, 816, 821,
 823, 834, 836, 837
 on Soviet theater, literature, and film, 762, 766, 768, 770, 790, 793, 795,
 800, 806, 807, 811, 813, 819, 826, 839

-M-

Macbeth, William, 985, 1070, 1186-1187, 1189
Macbeth Gallery, 699-700, 1070
MacDowell Colony, 720

About the Compiler

R. SCOTT HARNSBERGER is Assistant Professor and Collection Development Librarian for the Humanities at Newton Gresham Library, Sam Houston State University, Huntsville, Texas. His articles have appeared in *Reference Services Review*, *Behavioral & Social Sciences Librarian*, and *Magazines for Libraries*.

About the Technical Editor

DAVID L. HENDERSON, a specialist in research and computers, is a Professor in the Division of Teacher Education at Sam Houston State University.